EXAMPLES OF METAMERISM

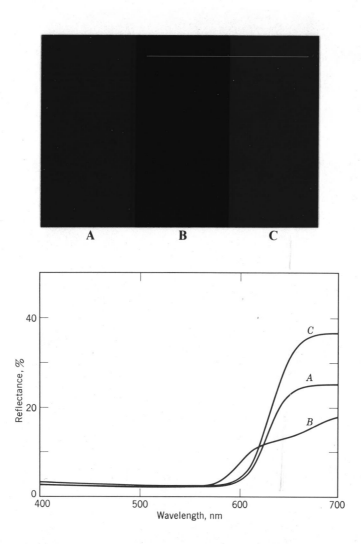

The painted samples on this page exhibit the phenomenon of metamerism. Because of the differences in their spectral reflectance curves, shown in the figure above, the samples match under one light source but not under a second source. For viewers with normal color vision, samples A and B match under Macbeth 7500 K Daylight, B and C match under cool white fluorescent light, and none of the colors match under incandescent light. Many light booths for color matching, such as the Macbeth "Spectralight" shown on pages 73 and 144, contain these three light sources.

The color chips were furnished by Munsell Color, Macbeth Division, Kollmorgen Corporation, 2441 N. Calvert St., Baltimore, MD 21218.

Principles of
Color Technology

Principles of
Color Technology

SECOND EDITION

Fred W. Billmeyer, Jr.

Professor of Analytical Chemistry
Department of Chemistry
Rensselaer Polytechnic Institute
Troy, New York

Max Saltzman

Adjunct Professor of Chemistry
Rensselaer Polytechnic Institute
and Research Specialist
Institute of Geophysics and Planetary Physics
University of California, Los Angeles

A Wiley-Interscience Publication
JOHN WILEY & SONS
New York • Chichester • Brisbane • Toronto • Singapore

Library of Congress Cataloging in Publication Data:

Billmeyer, Fred W
 Principles of color technology.

 "A Wiley-Interscience publication."
 Bibliography: p.
 Includes indexes.
 1. Color. I. Saltzman, Max, joint author.
II. Title.

QC495.B45 1981 667 80-21561
ISBN 0-471-03052-X

Printed and bound in the United States of America by Braun-Brumfield, Inc.

20 19 18 17 16 15 14 13 12

To the memory of Walter H. Bauer, whose encouragement and support made possible the establishment of The Rensselaer Color Measurement Laboratory.

Preface

It is our feeling that the major reasons for a new edition of *Principles of Color Technology* arise from a need for realignment of our emphasis on what is important, based on our experience in industry and in teaching for the past 15 years. During that period, the *principles* we wish to emphasize have not changed, but in many cases the practice has become considerably more automated. Consequently, the practitioner can tend to lose sight of what the principles really are. This leads us to the need to place emphasis on the following topics, among others:

• Metamerism, which we consider to be of major importance in virtually all aspects of the practice of color technology.

• Some "noncolor" problems, such as the need for adequate techniques of sampling and sample preparation, the application of simple statistics, and good quality-control practices.

• How to select instruments most suited to the prospective user's needs, in place of detailed descriptions of current instruments—probably the topic going "out of date" most rapidly in the book.

As anticipated, virtually all of the material formerly in Chapter 6B, "Some Guesses About the Future," has either found its rightful place in earlier chapters or has been tried, superseded, and discarded. In its place, we have this time chosen to draw attention to what we see as continuing problem areas in the application of the principles of color technology. Similarly, both the Annotated Bibliography and the Bibliography have been completely revised and are up to date through 1980.

We have been gratified to see the unexpectedly wide use of *Principles of Color Technology* as a textbook. We found, however, very little need to change the text to accommodate this use: a few numerical examples have been added to assist both the instructor and the student.

Finally, we wish to reiterate that we have limited the content of the book to topics within the scope of our personal knowledge. Topics such as color vision, color reproduction, and color photography are covered only briefly,

with reference to the literature in those fields included in the Annotated Bibliography.

The color plates in this edition have been made possible by the generous support of the following organizations: The Federation of Societies for Coatings Technology; Gardner Laboratory Division, Pacific Scientific Company; Harcourt Brace Jovanovich, Inc.; Inmont Corporation; Mobay Chemical Corporation; Munsell Color; Macbeth Division, Kollmorgen Corporation; Sandoz Colors and Chemicals; and we wish to thank them for their contributions. We wish to express special thanks to Munsell Color for providing the samples of metamers in the frontispiece. We express our thanks to Mr. Paul Miller of Los Angeles for providing the portraits of our two "Standard" Observers.

<div align="right">

FRED W. BILLMEYER, JR.
MAX SALTZMAN

</div>

Troy, New York
Los Angeles, California
January 1981

Preface to the First Edition

Over the years we, the authors, have been closely involved with the use of color in various industries. We have been asked many questions by colleagues and associates, and by customers and suppliers. In many instances, the same questions are asked over and over again. The answers to most of these questions are found in the literature. Often these answers are in such excellent (and available) books as *An Introduction to Color* (Evans 1948), *Color in Business, Science, and Industry* (Judd 1952; 1963), *The Science of Color* (OSA 1953) or *The Measurement of Colour* (Wright 1964)—all advanced and authoritative works in the field.

To us, the persistence of these questions indicated the need for a truly elementary book serving as an introduction to the field of color and the use of color in industry. This book attempts to answer some of these questions in a relatively simple way, drawing its examples from daily practice in the field.

Our book is primarily for use (and we hope it will be *used,* not merely *read*) by people who are actively working with color; in the production of colorants or the coloring of materials in industry. It presupposes some technical background, but places no emphasis on mathematics. Secondarily, the book is directed towards those who use color, as in design, sales, and advertising, but whose needs are somewhat different from those working directly in the production of colored materials.

We make no claim that this book is either complete or comprehensive. It represents largely our personal opinions, although we have drawn heavily on, and referred heavily to, the published literature.

Originally, and only partly in jest, we considered titling this book *What Everybody Knows About Color. Or Do They?* Again and again, in our experience, we have found complicated arguments and important decisions based on the assumption that "everybody knows" It is to attempt to supply these elusive facts that "everybody knows" but people so often forget that we have written this book.

Contents

xiv

CHAPTER **1**

What Is Color?

A. What This Book Is About

This is a book about *color, colorants,* and the *coloring* of materials. *Color* can mean many things. In this book, color may mean a certain kind of light, its effect on the human eye, or (most important of all) the result of this effect in the mind of the viewer. We shall describe each of these aspects of color, and relate them to one another.

Colorants, on the other hand, are purely physical things. They are the dyes and pigments used in the process of coloring materials. *Coloring* is a physical process, that of applying dyes to textiles or incorporating, by dispersion, pigments into paints, inks, and plastics. A part of this book is devoted to describing these physical substances and processes.

But color is much more than something physical. Color is what we see—and we shall repeat this many times—the result of the physical modification of light by colorants as observed by the human eye (called a perceptual process) and interpreted in the brain (which introduces psychology). This is an enormously complicated train of events. To describe color and coloring, we must understand something of each aspect of it. A large portion of the book deals with this problem.

With an understanding of color in this broad sense, we can approach some commercial problems involving color. These problems are concerned with answering such questions as: "Does this sample have the same color as the one I made yesterday—or last week, or last year?" (Or, more simply: "Do these two colors match?") "How much of what colorants do I use to produce a color just like this one?" "How can I choose colorants that will perform satisfactorily in a certain application?"

Traditionally, most of these questions have had only subjective answers, based on the skill and memory of the trained color matcher. Fortunately, through the application of the principles of

> "For the Rays (of light) to speak properly are not coloured. In them there is nothing else than a certain Power and Disposition to stir up a Sensation of this or that Colour."
>
> **Newton 1730**

color technology and the use of color measurement, it is now often possible to provide objective answers. We shall consider the industrial application of color technology largely in this objective vein.

In summary, we provide a brief résumé of the present state of the art of color, coloring, and colorants—a very complex field. To simplify, we have omitted much. Among our omissions are conflicting points of view: We tend to present our best current opinion rather than a studied evaluation of all sides of any question. We hope our readers will be stimulated to seek more detailed and more varied information on many of the subjects we touch upon only briefly.

To this end we provide—and consider of major importance—an annotated bibliography (Chapter 7). In listing these references we have tried to indicate content, depth, level of presentation, and usefulness as a source of further information. We hope that our readers will recognize with us that this book can be no more than a beginning, and that they will make use of its bibliography as a guide into the extensive and often complex literature on color.

This book is *not* a "how to do it" manual for any process or any industry. It does not tell you the best way to make a pink shade in vinyl plastic at the lowest cost. Nor does it provide a detailed study of what colorants to avoid in making outdoor paints. It *does* tell you in principle how to avoid having that pink go off-shade in tungsten light; it *does* tell you how to locate pigments with good lightfastness and other technical properties.

This book is *not* an instrument manual or a catalog of instruments; it does not tell you how to operate any specific color-measuring instrument to measure samples of a given material. It *does* tell you what types of instruments are available, and for what purposes they can or cannot be used.

This book is *not* a mathematical treatise on color theory. But there are some things that we cannot say without numbers, and some things that can be said much easier with a simple graph or equation than with many words. We do not hesitate to use the best and simplest means to express our thoughts.

This book does *not* attempt to give the "best" ways to use color, the "best" ways to use colorants, or the "best" colorants to use for any application. These are important practical questions, but to answer them would require much more detail than can be put into this elementary book. For these subjects, as for others we do not discuss, there are references to the literature.

"What you see is your best guess as to what is out front."

A. Ames, Jr.

B. The Physical Stimulus

To describe color we must talk about both physical actions, such as producing a stimulus in the form of light, and subjective results, such as receiving and interpreting this stimulus in the eye and the brain. Since color exists only in the mind of the viewer, these latter effects are the more important to us. To aid in understanding them, we first consider the physical aspects of color, which are simpler.

From the purely physical point of view, the production of color requires three things: a source of light, an object that it illuminates, and the eye and brain to perceive the color. Alternatively, the eye

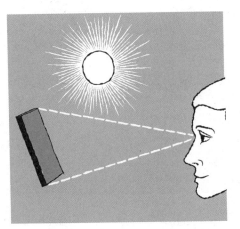

A source of light, an object, and the eye and brain . . .

. . . or a source of light, an object, and a photoelectric detector and meter.

may be replaced by a photosensitive detector and auxiliary equipment that approximate its action in detecting light. While a light source may be seen directly as having color without illuminating anything but the eye (the *illuminant mode* of viewing; see Evans 1948, Judd 1961), we always refer to seeing a material sample illuminated by a light source (the *object mode* of viewing) unless we specify otherwise.

Sources of Light

Visible light is a form of energy, part of the family that includes radio waves and x-rays, as well as ultraviolet and infrared light. Light can be described by its *wavelength*, for which the *nanometer*

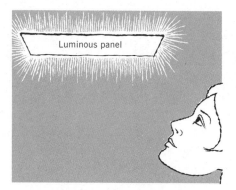

The illuminant mode of viewing.

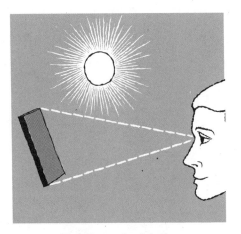

The object mode of viewing.

(nm) is a convenient unit of length. Formerly called the *millimicron* (mμ), one nanometer is 1/1,000,000 mm.

The relation of visible light to the other members of its family is shown in the figure on this page. The relative insensitivity of the eye limits the visible part of the spectrum to a very narrow band of wavelengths between about 380 and 750 nm. The hue we recognize

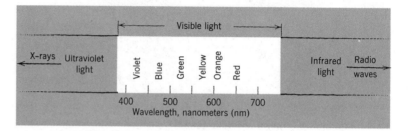

The visible spectrum and its relation to other kinds of radiation (not to scale).

as blue lies below about 480 nm; green, roughly between 480 and 560; yellow, between 560 and 590; orange, between 590 and 630; and red at wavelengths longer than 630 nm. Purple, which is produced by mixing red and blue light from the extremes of the spectrum, is the one common hue not found in the spectrum.

Many of the objects we think of as sources of light emit light that is white or nearly white—the sun, hot metals like the filaments of light bulbs, and fluorescent lamps, among others. Sir Isaac Newton showed many years ago (Newton 1730), by using a prism to disperse light into a spectrum, that white light is normally made up of all the visible wavelengths. The light from any source can be described in terms of the relative power (or amount of light) emitted at each wavelength. (Since energy is simply power × time, the word *energy* is sometimes used instead of power.) Plotting this power as a function of the wavelength gives the *spectral power distribution curve* of the light source. A typical example is the spectral power distribution of average daylight, shown on the facing page.

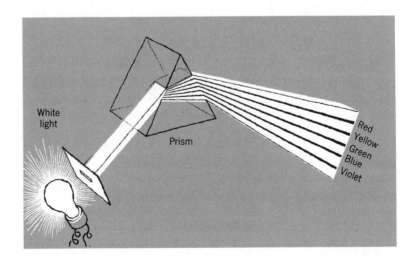

Dispersing white light into a spectrum.

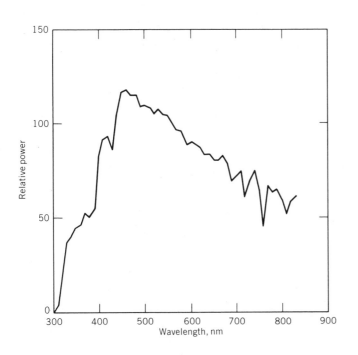

The spectral power distribution, or relative power at each wavelength, for typical daylight (Judd 1964, CIE 1971).

One very important group of light sources is called *blackbodies*, which belie their name in that they do not look black except when cold. On being heated, they glow like metals, first a dull red like a hot electric stove, then progressively brighter and whiter like the filaments of incandescent light bulbs. Real blackbodies are hollow heated chambers, important because their spectral power distribution, and therefore their color, depends only on their temperature and not on their composition. The temperature of blackbodies is called their *color temperature*. Tungsten filaments, such as those in common incandescent lamps, are close approximations to blackbodies, but their color temperatures are not exactly equal to their actual temperatures.

The spectral power distribution curves for two blackbodies, representing the range of color temperatures of interest in color problems, are shown on page 6. The curve for 2854 K is typical of the spectral power distribution from a 100-watt tungsten-filament lamp, while that for 6500 K is in the color range of actual daylight. Note, however, that real daylight, as the spectral power distribution curve on this page shows, is not a blackbody, nor are many other practical light sources including the sun, fluorescent lamps, and various arc lamps.

(The symbol K stands for Kelvin, or absolute temperature. The degree sign and the word degree are not used with Kelvin temperatures. These temperatures are obtained by adding 273 to degrees Celsius, °C.)

Most arc lamps, such as the mercury, neon, and sodium arcs, do not emit light of all wavelengths but of only a few specific wavelengths (lines) characteristic of the materials of the arc. Their

spectral power distributions are not continuous, as are those described so far. Rather, all the power they emit is concentrated in a few very narrow wavelength regions. Fluorescent lamps have continuous spectral power distributions on which are superimposed a few lines (page 7).

Several standard light sources have been defined by the International Commission on Illumination (Commission International de l'Éclairage, or CIE) for use in describing color (OSA 1953,

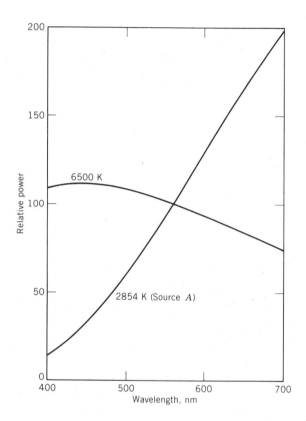

The spectral power distributions of blackbodies with color temperatures of 2854 K (Source *A*) and 6500 K (Pivovonski 1961). (The curves are adjusted to a relative power of 100 at 560 nm.)

Source: a physically realizable light, whose spectral power distribution can be experimentally determined. When the determination is made and specified, the source becomes a *standard source.*

Illuminant: a light defined by a spectral power distribution, which may or may not be physically realizable as a *source.* If it is made available in physical form, it becomes a *standard source.*

Wyszecki 1967, CIE 1971). One of these, CIE Source *A*, is a tungsten-filament lamp operating at a color temperature of 2854 K; its spectral power distribution curve is shown on this page. CIE Sources *B* and *C* are derived from Source *A* by passing its light through liquid filters. Source *B*, with a color temperature of about 4800 K, is an approximation of noon sunlight; Source *C*, about 6500 K, is an approximation of average daylight. Other light sources widely used in color matching are the xenon arc and Macbeth 7500 K Daylight, the latter obtained by modifying light from a tungsten-filament lamp with glass filters. The spectral power distribution curves for some of these sources are shown on the facing page.

Here we must point out a distinction, in CIE terminology, between a source and an illuminant. A *source* is a real physical light that can be turned on and off and used in real color-matching experiments. *A, B,* and *C* are sources, although *B* and *C* are very

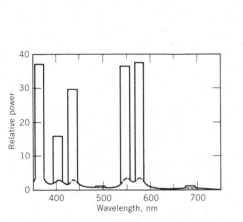

The spectral power distribution of a typical line source, a mercury arc lamp (IES 1981).

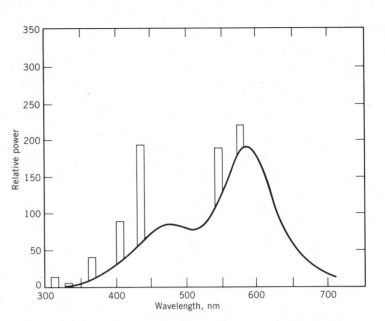

The spectral power distribution of a cool white fluorescent lamp (IES 1981).

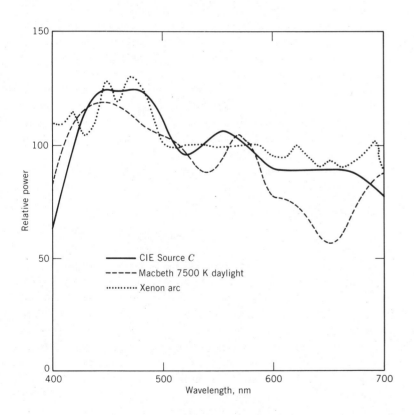

The spectral power distributions for some standard light sources used in describing color (Wyszecki 1967, 1970).

Source: a physically realizable light, whose spectral power distribution can be experimentally determined. When the determination is made and specified, the source becomes a *standard source*.

Illuminant: a light defined by a spectral power distribution, which may or may not be physically realizable as a *source*. If it is made available in physical form, it becomes a *standard source*.

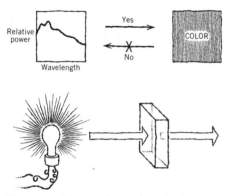

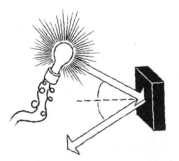

The transmission of light through a transparent object.

The specular, or mirrorlike, reflection of light from the smooth surface of glossy object. In specular reflection all the light is reflected in a direction such that equal angles are made by the incident and reflected light beams with the normal to the surface.

seldom used in this way. The spectral power distribution of a *source* is determined by experiment (for Sources *A, B,* and *C,* see Davis 1953, CIE 1971). An *illuminant,* on the other hand, is defined by a spectral power distribution, and it may or may not be possible to make a *source* representing it. The CIE Daylight *D* series of illuminants described on page 36 are illuminants by definition, representing average natural daylight, but so far there are no artificial sources available duplicating them (Wyszecki 1970). A source can also be an illuminant, as are *A, B,* and *C* because their spectral power distributions are known, and in such cases it is correct to speak of illuminants *A, B,* and *C.* All standard sources today have corresponding illuminants, but not all standard illuminants have corresponding sources.

It is important to note that various common sources designed to simulate daylight, such as those in color-matching booths, may be quite different in spectral power distribution from any real daylight, even though they are labeled "daylight" or, perhaps, "D_{65}." They may also differ from one to another, and most color-matching booths do not provide *any* CIE standard source in either their "daylight" or "tungsten" or other position. This is of special importance in the examination of color matches that depend on the nature of the light source. Such matches are called *conditional,* or *metameric,* and are discussed on p. 144.

Many nonblackbody light sources can be described by the color temperature of the blackbody that they most nearly resemble. This is called their *correlated color temperature.* However, as the drawings on pages 5–7 show, many of these sources have spectral power distributions quite different from those of blackbodies. This important observation, recognized over a hundred years ago (Grassmann 1853), will be encountered again as we consider the light reflected from or transmitted through material objects: Many different spectral power distribution curves can yield the same visual effect which we call *color.* It follows that the color of an object or a light source does *not* tell us the nature of its spectral power distribution. The reverse, however, *is* true: Knowledge of the spectral power distribution *does* allow the description of color.

How Materials Modify Light

When light strikes an object, one or more things pertinent to color can happen:

Transmission. The light can go through essentially unchanged. It is said to be *transmitted* through the material, which is described as *transparent.* If the material is colorless, all the light is transmitted except for a small amount that is *reflected* from the two surfaces of the object.

This reflection, and the more important scattering of light, described below, occur whenever there is a change in a quantity called the *refractive index,* which measures how much light is slowed down in a material, relative to its speed in air. At every boundary between two different materials, light changes its speed. As a result, a small fraction of the light is reflected and (unless the boundary is hit straight on—that is, at normal incidence) the direc-

tion of the light beam is changed. For many common materials, with refractive index near 1.5, the amount reflected is about 4% at each boundary with air, for normal incidence. The change in direction for other angles of incidence is by an amount dependent on the wavelength and explains how light is dispersed into a spectrum by a prism.

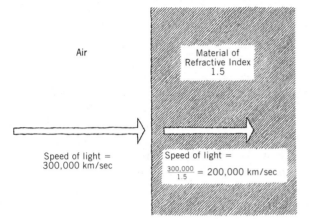

Refractive index is equal to the speed of light in air (strictly, vacuum, but the two speeds are almost identical) divided by the speed of light in the material. Air has a refractive index very near 1.

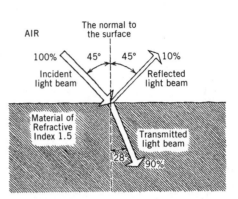

At every boundary where there is a change in refractive index, some of the light is reflected. The direction of the light beam is changed by an amount depending on the change in refractive index and the original direction of the beam. For the case shown, with incidence at 45° from the normal, 10% of the light is reflected at each surface.

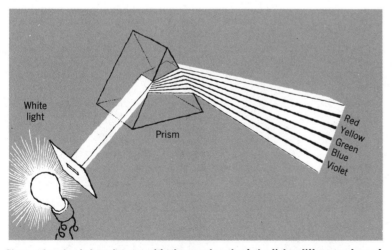

Since refractive index changes with the wavelength of the light, different colors of light change direction by different amounts on passing through a prism. The experiment shown here was first performed by Sir Isaac Newton, using sunlight, in 1667 (Newton 1730).

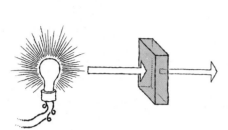

The absorption of light by a transparent, colored object.

Absorption. In addition to being transmitted, light may be *absorbed*, or lost as visible light. (If a very large amount of light is absorbed, we can sense that at least part of it is converted into heat.) If the material absorbs part of the light, it appears colored but is still transparent; if all the light is absorbed, the material is black and is said to be *opaque*.

A fundamental law of light absorption (Lambert's law) states that equal amounts of absorption result when light passes through equal thicknesses of material. If 1 cm of material absorbs half the light incident on it, another centimeter behind it absorbs half of the amount passing the first layer, so that only $\frac{1}{2} \times \frac{1}{2}$, or $\frac{1}{4}$, of the original light emerges from 2 cm of material, and so on. If each wavelength is considered separately, Lambert's law is always true *in the absence of scattering.*

A second absorption law, Beer's law, states that equal amounts of absorption result when light passes through equal amounts of absorbing material. This law is important in explaining the effect of colorant concentration on the color of a transparent material. Like Lambert's law, Beer's law must be applied to each wavelength of light separately. Not all materials follow Beer's law.

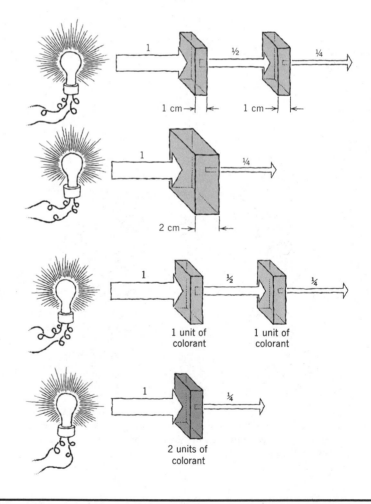

Lambert's law states that equal thicknesses of material cause equal amounts of absorption.

Beer's law states that equal amounts of absorbing material cause equal amounts of absorption.

Scattering. Finally, light may be scattered when it interacts with matter. Some light is absorbed and reemitted at the same wavelength, but now part of the light travels in one direction, part in another, until ultimately some light travels in many different directions. The effects of light scattering are both common and important. Light scattering by the molecules of the air accounts for the blue color of the sky, and scattering from larger particles accounts for the white colors of clouds, smokes, and most white pigments.

When there is enough scattering, we say that light is *diffusely reflected* from a material. If only part of the light passing through the material is scattered, and part is transmitted, the material is said to be *translucent*; if the scattering is so intense that no light passes through the material (some absorption must be present, too), it is said to be *opaque*. The color of the material depends on the amount and kind of scattering and absorption present: If there is no absorption and the same amount of scattering at each wavelength, the material looks white; otherwise, colored.

It should be pointed out here, however, that scattering is caused by light falling on small particles with refractive index different from that of the surrounding material. The amount of light that is scattered depends strongly on the difference in refractive index between the two materials. When the two have the same refractive index, no light is scattered and the boundary between them, as every microscopist knows, cannot be seen. The amount of light scattering also depends strongly on the size of the scattering particles. *Very* small particles scatter very little light. Scattering

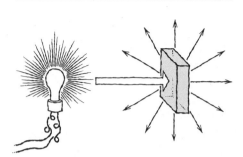

The scattering of light by a turbid or translucent material. In such a material some light is transmitted and some is diffusely reflected by scattering.

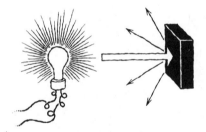

In an opaque material no light is transmitted, but some is diffusely reflected by scattering. In both opaque and translucent materials there may also be some reflection at the surface.

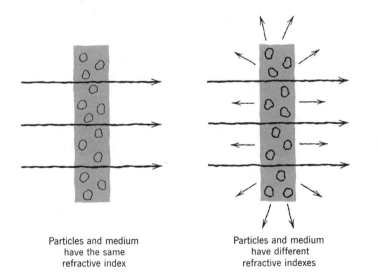

Particles and medium have the same refractive index

Particles and medium have different refractive indexes

If particles are placed in a medium of the same refractive index, there is no scattering, but if there is a difference in the refractive indices, scattering results.

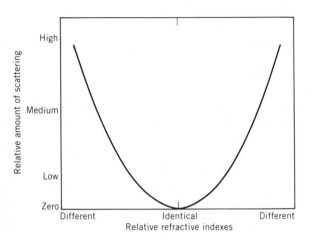

increases with increasing particle size until the particles are about the same size as the wavelength of light, and then decreases for still larger particles.

For these reasons pigments are most efficient as light scatterers when their refractive index is quite different from that of the resin with which they are to be used and their particle diameter is about equal to the wavelength of light. When pigments are of very small particle size and have about the same refractive index as the resin with which they are used, they scatter so little light that they look transparent. Scattering can therefore be controlled by selection of pigments with appropriate differences in refractive index or by control of particle size. One can get transparent coatings with very small particle iron oxide pigments in spite of the difference in refractive index between the resin and the pigment. By control of the particle size, one can get scattering with organic pigments in spite of a relatively close match for refractive index.

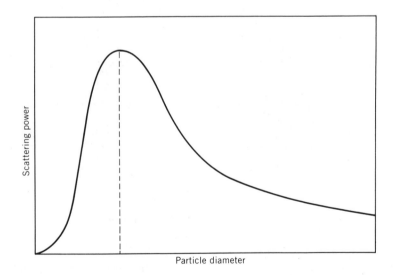

Scattering as a function of particle size for a typical pigment (Gall 1971).

The laws of light scattering are more complex than Lambert's or Beer's law, and we leave their statement to the discussion of complex-subtractive color mixing on page 139.

Other Aspects of Appearance. In this book on color we place almost no emphasis on phenomena other than color which contribute to the appearance of objects, such as gloss and metallic reflex, haze and turbidity, or fluorescence. Although they are often important in determining the appearance of things, we mention them only briefly as required (but see Evans 1948, Hunter 1975, Christie 1979).

Gloss results from the *specular* reflection of light from a smooth surface. As the surface becomes rougher, the gloss is reduced, and the diffuse reflection from the surface increases. A completely matte or nonglossy rough surface is a diffuse reflector. Diffuse reflection can also arise from scattering beneath a smooth surface. In this case there is both specular and diffuse reflection at the same time. Most translucent and opaque materials behave in this way.

Spectral Characteristics of Materials. From the standpoint of color, the effect of an object on light can be described by its *spectral transmittance* or *reflectance curve* (for transparent or opaque materials, respectively; both are needed for translucent objects). These curves show the fraction of the light reflected at each wavelength from the material (compared to that reflected from a suitable white reflecting standard; p. 84) or transmitted through it (compared to that transmitted by a suitable standard, often air). These curves describe the object just as the spectral power distribution curve describes a source of light. The spectral reflectance curves of several opaque colored materials are shown on page 14. By comparing these figures with the hue names of the colors of the spectrum (page 4), and noting that colored materials always reflect light of at least their own hue and absorb that of complementary hues, one can readily develop the ability to recognize colors in a general way from their spectral reflectance or transmittance curves.

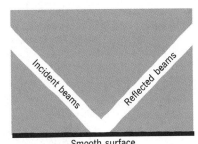

Specular reflection of light from a mirrorlike surface.

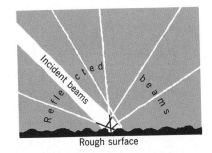

Diffuse reflection of light from a rough surface.

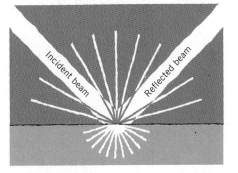

Combination of diffuse and specular reflection due to scattering from beneath, plus reflection from, a smooth surface . . .

. . . which is expressed quantitatively in a figure called an *indicatrix*, in which the length of each arrow represents the amount of light scattered or reflected in that direction.

Specular: referring to the mirrorlike reflection from smooth surfaces.

Spectral: referring to the way a quantity changes with the wavelength of light.

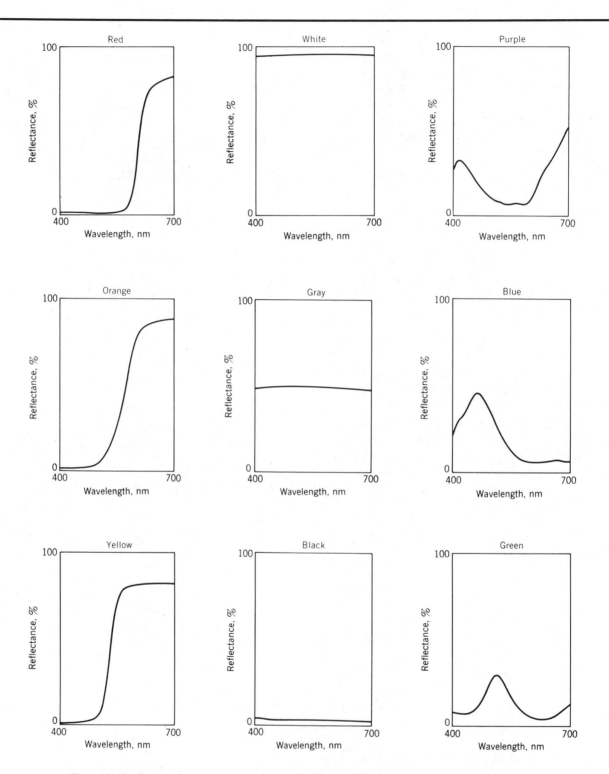

The spectral reflectance curves of several opaque colored materials, with their color names. We adopt the common term *reflectance* and symbol *R*, but more precise definitions exist (CIE 1970), and other symbols (ρ, β) accompany them.

For our friends who feel that no book on color is complete without a diagram showing a cross section of the human eye (from Burnham 1963).

Detecting Light and Color

By far the most important detector of *color* is the system comprising the eye, the nervous system, and the brain. We do not know exactly how it works, but all other detector systems attempt to duplicate its results in one way or another (LeGrand 1968, Wasserman 1978, Boynton 1979). Fortunately, it is not essential for our purposes in this book to know in detail how the eye and brain work to detect color. It is enough to say that the eye acts much like a camera, with the lens forming an image of the scene on the light-sensitive retina. Here there are several kinds of light detectors, called rods and cones because of their shapes. The rods allow us to see in very dim light, but they do not impart color vision, and we shall not dwell on them.

It is generally accepted that there are three types of cone receptors in the retina, and that they respond to light of various wavelengths in different ways; that is, they have different spectral response curves. This allows the eye to sense color, but the details of how the signals from the cones are mixed and sent to the brain are very complicated and need not concern us. The cones are especially concentrated in the central region of the retina, called the *fovea*, and there are no rods there. This is the area where visual acuity is greatest.

A small fraction of all people have color-deficient vision (Wright 1946, Burnham 1963). Most commonly, they cannot distinguish between reds and greens. They are said to be *colorblind*. This condition may result from one type of cone being missing, or from

"... the eye—that superb trick of adaptation which Nature has brought off ... in the course of evolution."

Rushton 1962

"... The eye is the external part of the central nervous system. The magnificence of man's central nervous system sets him apart from the beasts ..."

Kodak 1965

some other defect in the eye or the nervous pathways between it and the brain. Colorblindness affects only some 8% of men and less than ½% of women, and serious cases are perhaps a quarter as many.

What is more important to color technology than the plight of the colorblind is the fact that every person's color vision is a little different from anyone else's. This is not difficult to demonstrate in the laboratory, and it leads to some serious problems in color perception which are discussed in Section D and Chapter 5 (Billmeyer 1980a).

For color measurement photomultiplier tubes and silicon photodiodes are the only important detectors of light other than the eye. Their response is different for different wavelengths. The *spectral response* curves of these detectors and the eye are shown below. As developed in Section D, the fact that the spectral response curves of photodetectors are unlike that of the eye is of considerable importance in color measurement.

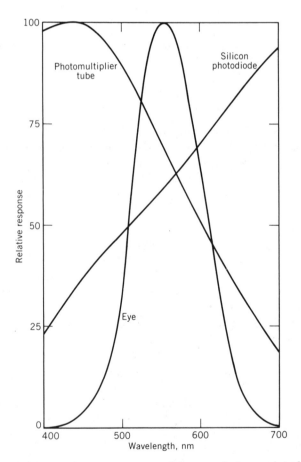

The curves of spectral response to power of the eye and of some photoelectric detectors of light.

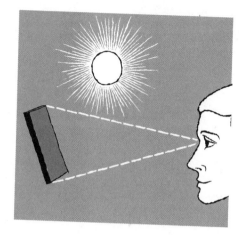

Summary

In this section we said that the physical production of color requires three things: a source of light, an object that it illuminates, and a detector of some sort, usually the eye and brain. We saw how each of these three is described by an appropriate curve plotted against the wavelength: the light source, by its spectral power distribution curve; the object, by its spectral reflectance or transmittance curve; and the detector, by its spectral response curve.

The combination of these provides the *stimulus*, or signal, which the brain converts into our perception of color. We must now consider some psychophysical and perceptual, rather than physical, concepts that are essential to understanding and talking about the appearance of color.

C. The Description of Color

At this point we invite the reader to approach the subject of color with us from an entirely different point of view, setting aside for the moment almost everything that was said in Section B. Almost, but not quite: We will not be allowed to forget the importance of the triad of source, object, and observer.

Our first objective is to describe color as we see it. In this section we shall simplify this problem by considering only the description by a single observer of how colors when illuminated by one source of light appear to him. Specifically, we shall ask how a person with normal color vision describes colors seen in daylight. In Section D we shall add to this picture some of the variations that can be obtained by changing the characteristics of the source or the observer or both.

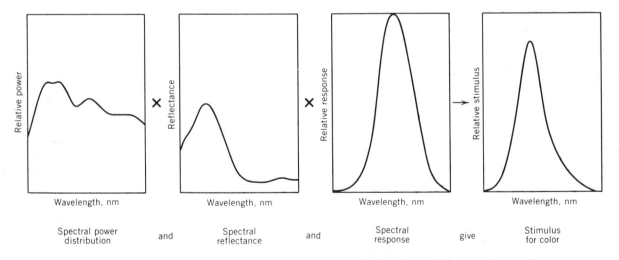

The stimulus that the brain (or an instrument) interprets as a color is made up of the spectral power distribution curve of a light source times the spectral reflectance or transmittance curve of an object times the spectral response curve of a detector (here, the eye). (Although the stimulus curve looks superficially like the spectral response curve of the eye, careful examination shows that they are really quite different.)

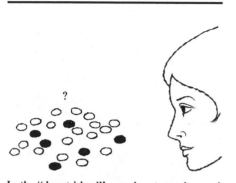

In the "desert island" experiment, an observer is faced with a large number of colored pebbles. To arrange them in an orderly way by color . . .

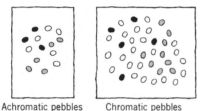

Achromatic pebbles Chromatic pebbles
(black, gray, white)

. . . she first separates out the *achromatic* or "hue-less" stones . . .

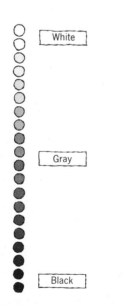

White

Gray

Black

. . . and arranges them in order of *lightness*, from white through gray to black. . . .

We still shall not have found a complete description of perceived color, for to do that would require consideration of all the myriad stimuli that make up the complex scene that we actually observe (Evans 1974). For simplification, and because this challenging subject is still largely unexplored, we consider only the perception of an isolated color stimulus.

The "Desert Island" Experiment

One of the many possible approaches to describing color is the so-called "desert island" experiment discussed by Judd (1975a) and others. Suppose a person with no previous experience in dealing with colors were idling away her time on a desert island, surrounded by a large number of pebbles having a wide variety of colors. Suppose, further, she wished to arrange these pebbles in some orderly way, according to their color. How can we describe color in terms of what she might do?

One can think of many different ways in which our lonely castaway might solve this problem; we shall describe only one. Let us assume that our experimenter, thinking about color in terms of the common names red, blue, green, and so forth, as most of us do, chooses first to separate all of this kind from those without hue—that is, those that are white, gray, or black. In other words we can say she separates the *chromatic* pebbles from the *achromatic* ones. (These terms, as well as many others in this section, are formally defined in Sections 2D and 6B.)

On examining the achromatic stones, our observer would find that they could be arranged in logical order in a series going from white through light gray to dark gray and finally black. This arrangement in terms of a single varying quality, *lightness*, provides a place for every achromatic pebble in the collection. Another common name for this quality is *value*.

The chromatic pebbles provide a more complicated situation, because they differ from one another in several ways, not just by differences in lightness. Our experimenter could separate them first by *hue*—that is, into different piles she calls red, yellow, green, blue, and so on. Each of these piles might be further subdivided as finely as she wants, for example, by separating the green group into yellow-green, green, and blue-green piles.

Each group of pebbles of a given hue could then be separated by *lightness* just as the achromatic stones were. The red pebbles, for example, could be separated into a series starting with the lightest pinks and becoming gradually darker, ending with very dark cherry reds. Each red pebble would be recognized as being equivalent in lightness to one of the gray pebbles in the achromatic series and, if the subdivisions were fine enough, equivalent in hue to all the other reds in its group.

But our friend would recognize that some of her red pebbles (and those of other hues too) differ from others in some way besides hue and lightness. She might, for example, compare a brick-red stone with one having a vivid tomato-red color. She would have to admit they have the same hue: Neither is a yellower or bluer red than the other. Likewise, she would see that they have the same lightness,

... Next she separates the *chromatic* or colored stones, first by hue ...

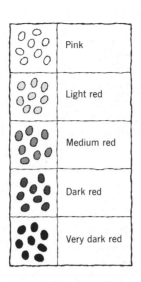

... and then by lightness within each hue. ...

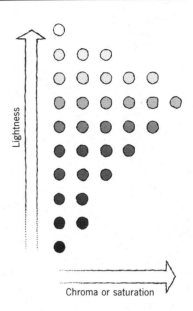

... Recognizing that the stones in each pile are still not all alike, she subdivides them, finally, on the basis of difference from gray, or amount of chromaticness, which we call *chroma.*

HUE
VALUE OR LIGHTNESS
CHROMA or SATURATION
Color coordinates

being equivalent in that quality to the same medium-gray stone taken from the achromatic series. Yet they are distinctly different. She might, after some thought, recognize that this third kind of difference relates to how much the colors of the stones differ from gray—in crude terms, how much color, or chromaticness, or *chroma,* they contain. Other names for this third variable quantity in color are *saturation* and *colorfulness.* In Section 6B we shall explore the fine distinctions among these terms.

Color Coordinates

Once our castaway had separated all her stones by hue, lightness, and colorfulness (or hue, value, and chroma) she would find that her systematic arrangement provided a place for all the pebbles on the island. None, in fact, that she could imagine to exist would be left out. She would conclude, correctly, that three and only three quantities (let us call them *color coordinates*) must be specified to describe color.

Note that we said three and only three quantities must be specified to describe *color,* but this does not completely describe the *appearance* of objects. As we mentioned on page 13, other qualities, such as its size, gloss, and surface texture, and the colors of nearby things (the *surround*), also affect the appearance of an object (Evans 1948).

The scheme we have described, with hue, value, and chroma as its color coordinates, is widely used to describe color in a systematic way, as in the Munsell color-order system described on page 28. Although these three coordinates are widely used, it would be possible to pick others on which to base the systematic description of color. For example, one might choose *brightness,* a combination of lightness and saturation, as one of the variables. This

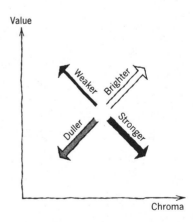

Color coordinates commonly used in the dyeing industry. Hue or "shade" is another variable not considered here.

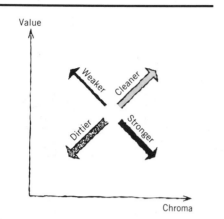

Color coordinates commonly used in the paint industry. Again, hue is another important variable.

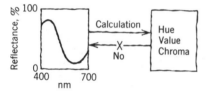

does not mean that more than three coordinates at a time are needed to describe color in the simple case of isolated color stimuli.

The word brightness is, unfortunately, used in several ways. We talk here about "dyer's brightness," a combination of saturation and lightness (Davidson 1950). When applied to the appearance of light sources, brightness is a quantity like the lightness of objects; the distinction between them is made in Section 6B.

Now that we have a description of color as it appears to the observer, can we relate these psychological concepts of what color is to the physical picture that was developed in Section B, where the color of an object was stated to depend on its spectral reflectance curve? The answer is "yes" or at least "almost." As developed in Chapter 2, we can calculate, from the spectral reflectance or transmittance curve, sets of three numbers that describe color. If we make the calculations complex enough, the numbers begin to correlate with what we see as hue, lightness, and saturation. Quite probably we shall never be able to improve the calculations to the point where the numbers represent *exactly* what the marvelous human eye sees, or even to recognize when or how we have failed to do this. For practical purposes, this is not very important.

It *is* important to note, however, that the spectral reflectance curve of the object contains more information than do the color coordinates hue, value, and chroma, or any other set. In Chapter 2 we see how one can calculate color coordinates from the spectral reflectance curve, and that it is not possible to go back the other way. In short, many different spectral reflectance curves can lead to the same set of color coordinates. The repercussions of this fact make up a large part of the discussion of the next section, and are fundamental to all of color technology.

D. The Appearance of Color

Now that we have developed a framework for describing the way colors appear to an observer, we may consider how this appearance changes when the three important factors influencing color—the source of light, the object, and the observer—are changed.

Light Sources, Color Rendition, and Chromatic Adaptation

Let us consider first a common situation in which the object and the observer remain constant but the light source changes. As a familiar example, you purchase a rich-brown suit in the tailor's shop, lighted with warm-colored tungsten bulbs, only to find it has a distinctly unpleasant greenish hue when you get it under daylight in the street. What has happened?

In the summary on page 17 we point out that the physical stimulus that the brain converts into our concept of color is made up by combining (by multiplying, wavelength by wavelength) the spectral power distribution of the source, the spectral reflectance curve of the object, and the spectral response curve of the detector (here, the eye); the curves on page 17 illustrate this combination. If the illumination changes, the stimulus to the brain differs; and we can expect the perceived color to differ also. In terms of the per-

ceptual description of Section C rather than the physical description of Section B, we may say that the change in illumination has made the object appear greener, darker, and less colorful. We conclude also that the color coordinates of an object, like its perceived color, change when the light source changes. This property of light sources to influence the colors of objects is called *color rendition*. It is discussed more fully in Section 6A.

We expect that similar effects take place if the source and the object remain the same but the observer changes. This is harder to prove, but some people have been found whose eyes differ sufficiently in their spectral response curves to bear this out.

The eye and brain are wonderful devices, and they usually try to compensate for the changes presented to them. In one of his famous demonstration lectures Ralph M. Evans showed a series of very similar color slides, modifying the source slightly for each one until the last was shown with tungsten light whereas the first was seen in daylight. The eye adapts to the small changes differentiating each slide from the next and the audience was usually unaware of what was going on until, at the end, the first and last slides were shown side by side in startling contrast.

The point we wish to make is that the power of adaptation of the eye is such that if everything changed in the same way with change in source (or object or observer), even large effects might go unnoticed. But there are many examples where this is not the case, and they are quite important for the practice of making and selling colored objects.

Chromatic adaptation is, in fact, one of the greatest unsolved mysteries of color science today (Evans 1974, Bartleson 1978). We know that the perception of colors depends on the state of adaptation of the eye, and that this depends on all the stimuli in the visual field. The phenomenon of simultaneous contrast (Chevreul 1854, Albers 1963) shows this beautifully: Colors look different depending on what other colors are adjacent to, or surround, them. Chevreul knew this very well and utilized the principle of simultaneous contrast to explain the color effects he perceived in Gobelin tapestries. The same principle applies today, in the textile industry and many other industries. We are just beginning to learn how to predict the results of chromatic adaptation quantitatively (Bartleson 1979a,b).

Metamerism

Since we are now looking for differences in the way objects behave when the source or the observer changes (but not both at once), we must think in terms of pairs of objects. The specific situation of importance is this: Two objects are seen to have the same color— that is, to *match*—when viewed under one source. They do not match, however, under another source. This must mean that the two objects have different spectral reflectance curves. If they do match under one source, they must have the same color coordinates. There is no conflict between these two statements, for the spectral reflectance curve contains much more information than the set of three color coordinates derived form it. Many different

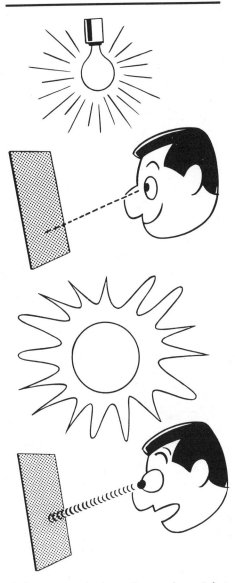

It is a common (and sometimes unpleasant) fact that the same object can have different colors when seen by the same observer under different light sources. This is sometmes called *flare*.

"The art of the tapestry-weaver is based upon the *principle of mixing colours*, and on the *principle of their simultaneous contrast*."

Chevreul 1854

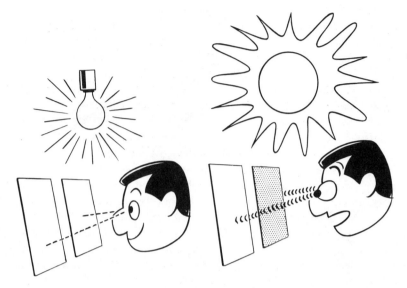

It is a common (and sometimes unpleasant) fact that pairs of colors with different spectral reflectance curves can match under one light source, but fail to match under another. They are called *metameric pairs* or *metamers,* and the phenomenon is called *metamerism.* Some authors call nonmetameric pairs that always match *isomeric,* but we do not like this usage because, to a chemist, metamerism and isomerism are the same, not opposites.

spectral reflectance curves correspond to the same set of color coordinates.

We define a pair of objects having different spectral reflectance curves but the same color coordinates for one set of conditions as *metameric objects,* or a *metameric pair.* They are said to exhibit *metamerism.* Pairs of objects having the same spectral reflectance curve and, therefore, the same color coordinates for all sources, are *nonmetameric* and form an *invariant* pair.

The concept of metamerism can also be applied to cases where two objects appear to some observers to have the same color, but to other observers the same objects do not match. We call this *observer metamerism.* It results from minor differences in the spectral response curves of the observers, none of whom can be said to be colorblind. It is important to note, as described on page 16, that the two "observers" need not be human, but can be two instruments with significantly different spectral response characteristics.

An understanding of metamerism is important in color matching. As discussed further in Section 5B, if two objects are to match invariably, under all sources, they must have identical spectral reflectance curves. This can be achieved most simply by using the same colorants for the two samples. If this cannot be done, as for example when different materials such as a textile and a paint are to be matched, such invariant matches are very difficult to achieve, and all the skill of the colorist is required to avoid conditional or metameric matches.

The properties of the eye are important in many other ways in color matching, as anyone familiar with this art knows. Some examples are the effects of adaptation, sample size, surroundings, and separation between samples (Evans 1948, 1972, 1974; Albers 1963). It is perhaps not as often realized that instruments vary in their sensitivity to other aspects of appearance, and this affects their usefulness for color matching and color measurement.

E. Summary

If we were to single out one important fact to leave with you at the close of this chapter, it is this: In the simplest case of an isolated color stimulus, three factors are essential for the production, perception, and measurement of color: the source of light, the illuminated object, and a human or instrumental observer.

This is not, unfortunately, true throughout the real world. In the complex fields of view of ordinary experience, the perceived color of any object is determined in part also by the state of adaptation and sensitivity of the observer's eye, as interpreted in the brain. No instrument or computer can simulate this. Nor can it be illustrated on the printed page, as the late Ralph M. Evans pointed out in his posthumous book (1974) and did illustrate vividly in his famous demonstration lectures. Fortunately, the industrial use of color technology can be restricted, without severe loss, to the simple cases for which the principle we wish to emphasize is true.

Describing Color

The orderly description and specification of color is an essential part of solving problems of talking about color. Universally accepted languages are needed to express across a distance, over a span of time, or in the absence of the right physical samples, our ideas about the appearance of colored materials. Since we may wish to talk about color measurement, color perception, or the description of a particular product, we require many different languages to describe all aspects of color. In this chapter we describe and classify existing systems for arranging and describing color— that is, *color-order systems* or *color spaces*—with the objective of facilitating the choice of one most appropriate for a given purpose. The much more difficult problem of describing how these colors really look, that is, the specification of color appearance, is discussed in Section 6B.

Of the many ways of classifying color-order systems, we choose to distinguish between collections of physical samples and systems that are not based on actual samples. The first group is subdivided according to the presence or absence of a guiding principle (such as equal visual perception) followed in building up the collection. Within each class and subdivision we describe one or more typical examples, but our list is not meant to be all inclusive. Many other systems are described by Wyszecki (1967) and Judd (1975a).

A. Systems Based on Physical Samples

Random Arrangements

Collections of physical samples put together without major concern for a guiding principle are quite common. They range from completely random atlases to semiordered arrays. Most collections of samples designed to illustrate the colors available in a given product are random or nearly random groups of samples. Mode shade cards (for seasonal fashions), color cards (for telephones or

"A nomenclature of colours, with proper coloured examples of different tints, as a general standard to refer to in the description of any object, is long wanted in arts and sciences. It is singular, that a thing so obviously useful, and in the description of objects of natural history and arts, where colour is an object indispensably necessary, should have been so long overlooked."

Syme 1814

"Dining Room. To be yellow, and a very *gay yellow*. Just make it a bright sunshiny yellow and you cannot go wrong. Ask one of your workmen to get a pound of the A&P's best butter and match it *exactly*."

Hodgins 1946

damask napkins), and other manufacturers' catalogs are typical examples. The *Federal Color Card for Paint* (Federal Specification TT-C-595), the *House and Garden Colors* (Bertin 1978), and the *Color Forecasts of the Color Association of the United States, Inc.* are well-known collections of this type. An important defect of this type of array, which might be considered a criterion for calling a collection "random," is that it is *not* possible to deduce the colors of intermediate samples from those of the samples displayed.

Arrangements Based on Colorant Behavior

In several industries, such as paint and printing ink, it is common to produce a wide variety of colored samples by the systematic mixing of a relatively few high-chroma colorants with one another and with white, black, and gray. Not only are the samples produced in this manner, but the product that is sold is made in the same way. Most major producers of house paint, as well as makers of industrial and automotive finishes, have systems of this type utilizing either custom mixing, frequently from elaborate dispensing and mixing devices, or factory prepackaged units. Similar systems are offered in the printing ink industry and by suppliers of colorants for plastics. A collection of considerable historical importance produced in this manner is the Maerz and Paul *A Dictionary of Color* (Maerz 1930). A unique collection of this type is the transparent *Lovibond glasses* with which a wide range of colors can be produced (Judd 1962*a, b*) by subtractive mixing in a visual color comparator, the *Lovibond Tintometer* (p. 76). Similar modern systems based on systematic colorant mixing are the *Pantone* system, widely used for printing inks in the graphic arts, and the *ICI Colour Atlas*.

It is characteristic of most of these systems that interpolation between samples *is* possible. Moreover, some of the samples, such as the Lovibond glasses, have been measured and can be related, in an approximate way, to other color-order systems.

Arrangements Based on Color-Mixing Laws

It is well known that when colorants, or colored lights, are mixed in the same amounts the same results are always obtained. Thus there must be laws or rules allowing the prediction of these results; they are discussed in Chapter 5. The laws describing the mixing of colored lights by the method of disk colorimetry (page 135) have been used to provide a number of color-order systems, both old and new.

The Ostwald System. Probably the best known system based on the results of disk colorimetry is the Ostwald system (Ostwald 1931, 1969; Jacobson 1948). Ideally, colors in the Ostwald system are produced by light reflected from a spinning disk consisting of segments of white, black, and a high-chroma sample designated a *full color*. There are enough of these full colors to provide a circle of hues. Colors on a page of the Ostwald system are described by their *full color content, white content*, and *black content*. The organization of the Ostwald system emphasizes scales of colors having

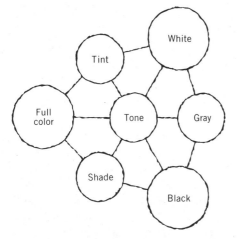

Colors in the Ostwald system consist of mixtures of a full color, black, and white, producing intermediate tints, shades, and tones (Birren 1969).

The principle of disk colorimetry.

approximately constant hue, constant black content, and constant white content. It is particularly convenient for artists, painters, ink makers, and others who work with mixtures of a colored pigment with black and white pigments.

There is currently no widely available collection of samples based on the Ostwald system, but until recently one could obtain an approximation in the form of the *Color Harmony Manual* (Granville 1944). A historically important collection based on the results of disk colorimetry is the Ridgway *Color Standards and Color Nomenclature* (Ridgway 1912). Other modern systems based on various principles of color mixing are described by Gerritsen (1975, 1979) and by Küppers (1973, 1979).

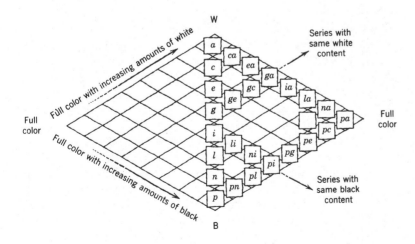

Each full color page in the Ostwald system contains a pigment approximation to an Ostwald full color (color with no black or white content) and mixtures of it with black and white forming approximate scales of constant black content, constant white content, and constant full-color content.

Hue: that quality of color which we describe by the words red, yellow, green, blue, etc.

Value: that quality of color which we describe by the words light, dark, etc., relating the color to a gray of similar lightness.

Chroma: that quality which describes the extent to which a color differs from a gray of the same value.

Arrangements Based on Steps of Equal Visual Perception

The Munsell System. Perhaps the best known of all color-order systems is the *Munsell System* (Munsell 1929, 1963, 1969; Nickerson 1940, 1969). Based on the guiding principle of equal visual perception, the Munsell System is both a collection of samples painted to represent equal intervals of visual perception between adjacent samples, and a system for describing all possible colors in terms of its three coordinates, *Munsell Hue, Munsell Value,* and *Munsell Chroma.* These coordinates correspond to three variables commonly used to describe color; *hue* is that quality of color described by the words red, yellow, green, blue, and so forth; *value* is that quality by which a color can be classified as equivalent in lightness to some member of a series of gray samples ranging from white to black; *chroma* is the quality that describes the degree of difference between a color (which is itself not a white, gray, or black) and a gray of the same value or lightness.

The samples of the *Munsell Book of Color* (Munsell 1929) are usually arranged in planes or pages of constant hue, as shown in color Plate I. On each page samples are arranged by Munsell Value in the vertical direction and by Munsell Chroma in the horizontal direction. A scale of grays, with white at the top and black at the bottom, may be thought of as the "trunk" of the Munsell color "tree," (Plate II) or as the zero-chroma column on each page. Each sample carries a *Munsell Notation* denoting its position; this notation consists of three symbols representing the Munsell Hue, Value, and Chroma in that order. Munsell Hue is expressed by a number and letter combination such as 5 Y or 10 GY where the letters are taken from the 10 major hue names (*R*ed, *Y*ellow, *G*reen, *B*lue, *P*urple, and the five adjacent pairs of these, e.g., *Green-Y*ellow), and the numbers run from 1 to 10. Munsell Value and Munsell Chroma are written after the hue designation and are separated by a diagonal line (/). A typical complete Munsell designation is 5 R 5/10. The variables of the Munsell system are shown in three dimensions in Plate III.

Several outstanding features of the Munsell System contribute to its usefulness and wide acceptance. The first is its conformance to equal visual perception. Within the limits of chroma (6–10) set by the samples of the original *Munsell Book of Color*, there is very little evidence for deviation from equal steps of perception in any of the Munsell coordinates. Few other color systems are nearly as good in this respect; the Munsell System is the standard to which all other systems are compared.

A second major advantage of the Munsell System is that its notation is not linked to or limited by existing samples. Any conceivable color can be fitted into the system, whether it can be produced with existing colorants or not. In contrast, most collections of physical samples are based on highly colored specimens and could not accommodate a still more highly colored sample if one were found. This is particularly true of systems based on color-mixing laws or colorant behavior; they inevitably are based on the

most suitable colorants available at the time, and cannot readily be modified to include newer developments.

Still another advantage of the Munsell System is that the samples of the *Munsell Book of Color* are prepared to very close tolerances, so that the user can rely on the samples in his copy being very close in color to those from other copies or other modern editions of the *Munsell Book of Color*. Again, the user should be warned that this may not be true in other systems, which often suffer from a serious defect in that the same notation corresponds to different colors in different editions. Thus in such systems a color notation is useful *only* to designate *a specific sample in a specific edition.*

A second warning applies to the use of the Munsell Book of Color or any other collection of physical samples: in the vast majority of cases, the chip from the collection will be compared to a sample that, except by accident, will not be made with the same colorants. The two will have different spectral reflectance curves and will form a metameric pair. All the precautions described in Section 5B must be observed when judging such conditional or metameric matches. The recommendations of the manufacturer of the collection on the illumination and viewing conditions must be followed, and it must be remembered that an observer with different color-vision characteristics may not see the match the same way. Since the chips in most collections are rather far apart, the chances that a different chip will be selected as the closest match are rather small. Thus this metamerism does not impair the usefulness of color-order systems if they are used in the manner called for by the manufacturer. This warning applies to all the collections of physical samples we know of.

Many years ago, the *Munsell Book Notations* of the original, matte finish, Munsell samples were adjusted somewhat to correct certain obvious errors in the original spacing. The new designations were known as *Munsell Renotations*, and the revised system as the *Munsell Renotation System* (Newhall 1943). Both glossy and matte samples are now painted (Davidson 1957) to whole-number Munsell Renotation designations, for which the term *Munsell Notation* is now universally used. The Munsell System is thus related to the

results of color measurement for all possible colors even though they cannot be produced by existing colorants.

The Munsell System forms the basis of the ISCC-NBS system for designating color names (Kelly 1955, 1976), which is a part of the Universal Color Language described below.

The OSA Uniform Color Scales System. An independent approach to the development of a catalog of colors exhibiting uniform visual spacing was undertaken by a Uniform Color Scales Committee of the Optical Society of America (OSA). The OSA Uniform Color Scales samples that are the result of this work (MacAdam 1974, 1978; Nickerson 1978, 1981; OSA 1977) consist of 558 colors spaced according to redness–greenness, yellowness–blueness, and lightness. Except for edge samples, each of these has 12 nearest neighbors (4 at the same lightness level, 4 lighter, and 4 darker), all of which are perceived to be equally distant in color from the central one. The arrangement of colors in this system has not previously been used for a color-order system, and allows the creation of many uniformly spaced color scales never seen before because the samples were not available.

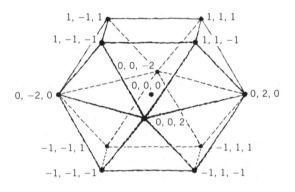

Arrangement of a central sample at lightness $L = 0$, red-greenness $g = 0$, and yellow-blueness $j = 0$, and its 12 nearest neighbors with the values of L, j, g shown. This is the arrangement of samples in the OSA uniform color scales system (Nickerson 1981).

The Natural Color System. A color-order system based in part on steps of equal visual perception has been developed in Sweden (Hård 1970) and adopted as a Swedish standard. Its hue circle is based on the concept of the four unique hues: the red that is perceived not to contain any yellow or blue, the yellow that is perceived not to contain any red or green, and similarly defined green and blue. (Putting the four unique hues 90° apart on a hue circle does not, however, lead to equal perceptual steps of hue around the circle.) At each hue the samples of the Natural Color System are arranged in scales of equal perceptual steps in saturation and "blackness" in triangular arrays.

Chroma Cosmos 5000. The Japan Color Research Institute has issued an extensive collection of samples based on the Munsell system, Chroma Cosmos 5000, reviewed by Birren (1979). The collection contains 5000 samples arranged in pages of constant chroma, rather than by constant hue as in the Munsell Book of Color.

The Universal Color Language

We have often thought that many of the problems of color technology could be more readily solved if everyone used a universal color language that could be understood by all, at least in a general way. Such a language should allow colors to be described with different degrees of accuracy, by names or numerical notations, relate directly to the best known color-order systems, and provide meaningful translations of exotic or promotional color names.

Such a language has existed for over 15 years (Kelly 1963, 1976), and it is surprising that it has not yet been more widely adopted. It provides for the use of any of six levels of fineness or accuracy to describe colors by names (levels 1–3) or numerical designations (levels 4–6).

The use of the Universal Color Language (UCL) can be illustrated by the example of a housewife who buys an upholstered

What Color Do They Mean?

Daybreak
Desert Glass
Sophisticated Lady
Surrender
Whimsical
Hepatica
Mignon
Nuncio
Nymphea
Pomp and Power
(The answer is on p. 34.)

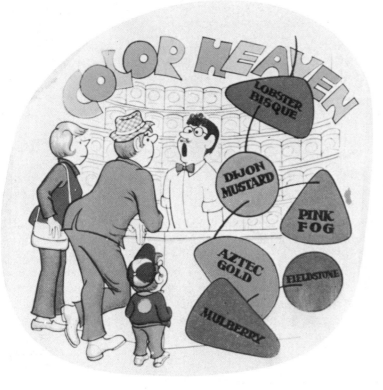

"Brown?" Well, I suppose we could have it made up for you." (Reprinted by permission of The Sterling Lord Agency, Inc., copyright © 1978 by Stanley and Janice Berenstain.)

The Six Levels of the Universal Color Language (Kelly 1976)

	Color name designations			Numeral and/or letter color designations		
Level of fineness of color designation	Level 1 (least precise)	Level 2	Level 3	Level 4	Level 5	Level 6 (most precise)
Number of divisions of color solid	13	29	267[a]	943–7056[a]	\simeq100,000	\simeq5,000,000
Type of color designation	Generic hue names and neutrals (see circled designations in diagram below)	All hue names and neutrals (see diagram below)	ISCC-NBS All hue names and neutrals with modifiers	Color-order systems (collections of color standards sampling the color solid systematically)	Visually interpolated Munsell Notation (From *Munsell Book of Color*)	CIE (*x*, *y*, *Y*) or instrumentally interpolated Munsell Notation
Examples of color designation	Brown	Yellowish brown	Light yellowish brown (centroid #76)	Munsell 10YR 6/4[b]	$9\frac{1}{2}$YR 6.4/4$\frac{1}{4}$	$x = 0.395$ $y = 0.382$ $Y = 35.6$ or 9.6YR 6.4$_5$/4.3[b]
General applicability	\longrightarrow Increased fineness of color designation \longrightarrow \leftarrow Statistical expression of color trends (roll-up method) \leftarrow					

[a] Figures indicate the number of color samples in each collection.
[b] The smallest unit used in the Hue, Value, and Chroma parts of the Munsell Notation in Levels 4 (1 Hue step, 1 Value step, and 2 Chroma steps), 5 ($\frac{1}{2}$ Hue step, 0.1 Value step, and $\frac{1}{4}$ Chroma step), and 6 (0.1 Hue step, 0.05 Value step, and 0.1 Chroma step) indicates the accuracy to which the parts of the Munsell Notation are specified in that level.

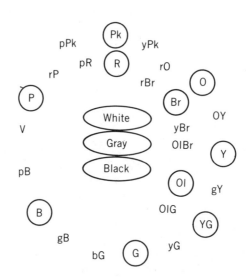

Abbreviations for color names making up levels 1 (circled) and 2 (uncircled) of the Universal Color Language (Kelly 1976).

chair sold under the promotional name *suntan*. To her, it is simply *brown*. This is a designation in level 1 of the UCL. If asked for more detail, she might describe the chair as *yellowish brown* (level 2), distinguishing it from reddish brown or olive brown, or even as *light yellowish brown*, but this is about as far as one can go with universally understood color names.

The name light yellowish brown is a designation on level 3 of the UCL, which is also the *ISCC-NBS Method of Designating Colors* (Kelly 1955, 1976). Here modifiers are added to the hue names used in levels 1 and 2, allowing the two other dimensions of color, value

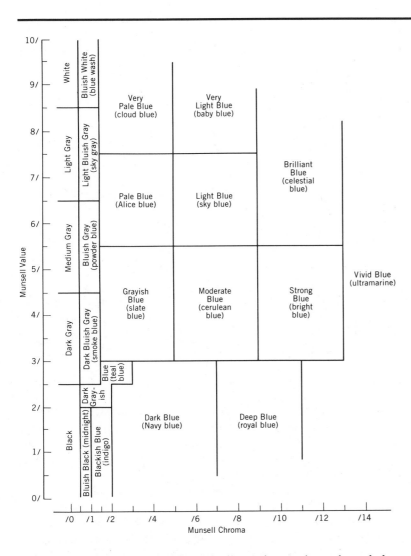

This page from the ISCC-NBS Dictionary of color names (Kelly 1955, 1976) shows the ISCC-NBS names assigned to colors with various Munsell Values and Chromas, and Munsell Hues between 9B and 5 PB. We have added some corresponding common names in parentheses.

and chroma, to be described in easily understood words and, by means of charts, related to Munsell Value and Munsell Chroma. The published method tells how to assign an ISCC-NBS name to a color from its Munsell Notation and includes a dictionary of common color names with their ISCC-NBS equivalents. Samples have been painted to represent the center of each region in Munsell color space corresponding to an ISCC-NBS name (Kelly 1958, NBS 1965).

The merchandiser of our housewife's chair might wish to specify its light yellowish brown color more closely. While it is likely he would continue to use promotional names such as suntan, or bamboo, biscuit, blond, or many, many more, how much more useful it would be if he went to level 4 of the UCL, which is the designation of the color in the Munsell System! The Munsell Notation 10 YR 6/4, and the other approximately 1500 like it, once learned, provide a far more meaningful description than suntan, which has been used to describe colors in no less than five ISCC-NBS color blocks.

All the color names listed on p. 31 have been used to describe the colors designated Light Purple or Moderate Purple in the ISCC-NBS System. Could you guess?

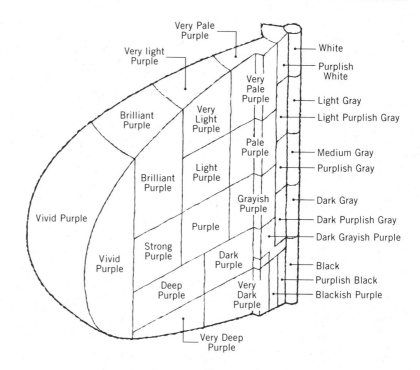

A three-dimensional illustration of the ISCC-NBS color-name chart for purple, showing the block structure that provides an ISCC-NBS designation for any region in color space (Kelly 1976).

The supplier of the fabric for the chair would no doubt require a still more precise color designation, which he would find in levels 5 or 6 of the UCL, consisting of visually or instrumentally interpolated Munsell Notations or other designations, like those in the CIE system now to be described.

B. The CIE System

We come now to the description of color-order systems that are only incidentally, if at all, associated with collections of physical samples. By far the most important of these systems, which are usually used in connection with instruments for color measurement, is the CIE system (Commission International de l'Éclairage or International Commission on Illumination) (CIE 1931, 1971; Judd 1933, Wyszecki 1967). This system starts with the premise developed on page 17 that the stimulus for color is provided by the proper combination of a source of light, an object, and an observer. In 1931 the CIE introduced the element of standardization of source and observer, and the methodology to derive numbers that provide a measure of a color seen under a standard source of illumination by a standard observer.

CIE Standard Sources and Illuminants

On page 6 we saw that in 1931 the CIE recommended the use of standard sources *A*, *B*, and *C*, which were soon defined as standard illuminants when their spectral power distributions were measured. These sources and illuminants served the purposes of color technology well until, as is discussed in Chapter 4, the increased use of fluorescent whitening agents made it necessary to

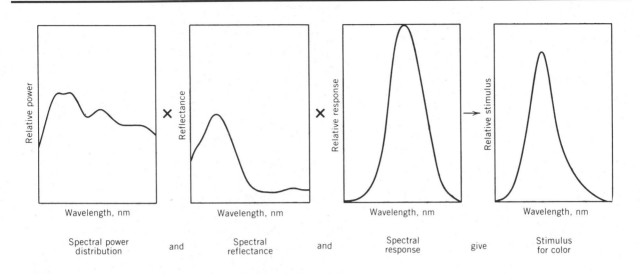

Relative power		Reflectance		Relative response		Relative stimulus
Wavelength, nm	×	Wavelength, nm	×	Wavelength, nm	→	Wavelength, nm
Spectral power distribution	and	Spectral reflectance	and	Spectral response	give	Stimulus for color

specify illuminants (and, it was hoped, sources) containing power in the ultraviolet region more nearly representative of that in natural daylight.

In 1965 the CIE recommended a series of illuminants to supplement A, B, and C, based on definitive studies of the spectral power distribution of natural daylight (Judd 1964). They represent average daylight over the spectral range 300–830 nm and have correlated color temperatures (Section 1B) between 4000 and 25,000 K. The most important of these is D_{65}, having a correlated color temperature of 6500 K, with illuminants at 5500 and 7500 K as alternates. The recommendation states, "For general use in colorimetry illuminants A and D_{65} should suffice." It has taken over a decade, but illuminant D_{65} is now finally becoming widely used.

CIE Source A = Incandescent light (2854 K blackbody)

CIE Source B = Simulated noon sunlight

CIE Source C = Simulated overcast-sky daylight

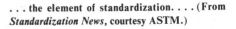

. . . the element of standardization. . . . (From *Standardization News*, courtesy ASTM.)

The Spectral Power Distributions of CIE Standard Illuminants A, B, C, and D_{65}, Tabulated at 5-nm Intervals (CIE 1971)

Wavelength (nm)	P_A	P_B	P_C	P_{D65}
380	9.80	22.40	33.00	50.0
385	10.90	26.85	39.92	52.3
390	12.09	31.30	47.40	54.6
395	13.35	36.18	55.17	68.7
400	14.71	41.30	63.30	82.8
405	16.15	46.62	71.81	87.1
410	17.68	52.10	80.60	91.5
415	19.29	57.70	89.53	92.5
420	20.99	63.20	98.10	93.4
425	22.79	68.37	105.80	90.1
430	24.67	73.10	112.40	86.7
435	26.64	77.31	117.75	95.8
440	28.70	80.80	121.50	104.9
445	30.85	83.44	123.45	110.9
450	33.09	85.40	124.00	117.0
455	35.41	86.88	123.60	117.4
460	37.81	88.30	123.10	117.8
465	40.30	90.08	123.30	116.3
470	42.87	92.00	123.80	114.9
475	45.52	93.75	124.09	115.4
480	48.24	95.20	123.90	115.9
485	51.04	96.23	122.92	112.4
490	53.91	96.50	120.70	108.8
495	56.85	95.71	116.90	109.1
500	59.86	94.20	112.10	109.4
505	62.93	92.37	106.98	108.6
510	66.06	90.70	102.30	107.8
515	69.25	89.65	98.81	106.3
520	72.50	89.50	96.90	104.8
525	75.79	90.43	96.78	106.2
530	79.13	92.20	98.00	107.7
535	82.52	94.46	99.94	106.0
540	85.95	96.90	102.10	104.4
545	89.41	99.16	103.95	104.2
550	92.91	101.00	105.20	104.0
555	96.44	102.20	105.67	102.0
560	100.00	102.80	105.30	100.0
565	103.58	102.92	104.11	98.2
570	107.18	102.60	102.30	96.3
575	110.80	101.90	100.15	96.1
580	114.44	101.00	97.80	95.8
585	118.08	100.07	95.43	92.2
590	121.73	99.20	93.20	88.7
595	125.39	98.44	91.22	89.3
600	129.04	98.00	89.70	90.0
605	132.70	98.08	88.83	89.8
610	136.35	98.50	88.40	89.6
615	139.99	99.06	88.19	88.6
620	143.62	99.70	88.10	87.7

The Spectral Power Distributions of CIE Standard Illuminants *A*, *B*, *C*, and *D*$_{65}$, Tabulated at 5-nm Intervals (CIE 1971) *Continued*

Wavelength (nm)	P_A	P_B	P_C	P_{D65}
625	147.24	100.36	88.06	85.5
630	150.84	101.00	88.00	83.3
635	154.42	101.56	87.86	83.5
640	157.98	102.20	87.80	83.7
645	161.52	103.05	87.99	81.9
650	165.03	103.90	88.20	80.0
655	168.51	104.59	88.20	80.1
660	171.96	105.00	87.90	80.2
665	175.38	105.08	87.22	81.2
670	178.77	104.90	86.30	82.3
675	182.12	104.55	85.30	80.3
680	185.43	103.90	84.00	78.3
685	188.70	102.84	82.21	74.0
690	191.93	101.60	80.20	69.7
695	195.12	100.38	78.24	70.7
700	198.26	99.10	76.30	71.6
705	201.36	97.70	74.36	73.0
710	204.41	96.20	72.40	74.3
715	207.41	94.60	70.40	68.0
720	210.36	92.90	68.30	61.6
725	213.27	91.10	66.30	65.7
730	216.12	89.40	64.40	69.9
735	218.92	88.00	62.80	72.5
740	221.67	86.90	61.50	75.1
745	224.36	85.90	60.20	69.3
750	227.00	85.20	59.20	63.6
755	229.59	84.80	58.50	55.0
760	232.12	84.70	58.10	46.4
765	234.59	84.90	58.00	56.6
770	237.01	85.40	58.20	66.8

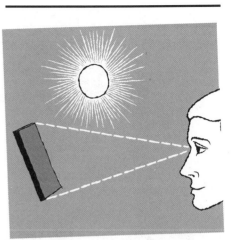

The CIE system for describing color is no different from any other except for its standardization of illuminants and of observers.

Unfortunately, despite extensive effort (Wyszecki 1970), no sources closely simulating the CIE daylight *D* illuminants have been developed, and the CIE has made no recommendation in this area. Such standard sources would be most valuable for the visual observation of objects, especially fluorescent samples, in standard daylight.

The spectral power distributions of the most important CIE standard illuminants are tabulated on this and the facing page.

CIE Standard Observers

The 1931 CIE Standard Observer. The second major recommendation of the CIE in 1931 was that of a standard observer whose color vision is representative of the average of that of the human population having normal color vision.

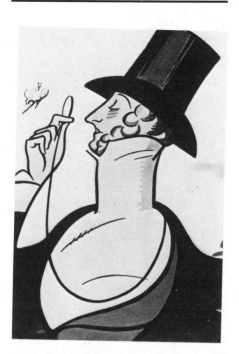

This is Eustace Tilley; he is *not* really the CIE standard observer. (Drawing by Rea Irvin © 1925, 1953 The New Yorker Magazine, Inc.)

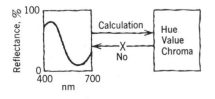

The way in which the data representing the CIE standard observer are derived, transformed, and used is one of the most difficult concepts in the CIE system to understand. We do not attempt to discuss it in detail, but recommend further study of the literature (Wright 1969, Bouma 1971) for those who wish to develop a detailed understanding of the mathematics involved. Here is a simplified description.

In a very old experiment (Newton 1730, Grassmann 1853), light from a test lamp shines on a white screen and is viewed by an observer. A nearby part of the screen is illuminated by light from one or more of three lamps, equipped to give light of three widely different colors, say, red, green, and blue. These *primary* lights are arbitrarily selected but closely controlled. By adjusting the intensities of these lights, the observer can make their combined color on the screen match that of the test lamp. The amounts of the three primaries are three numbers describing the test color, called the *tristimulus values* of that color.

It should be noted that the spectral power distribution of the test light usually differs from that of the combination of primaries matching it. They form a metameric pair of light sources (p. 21) and their spectral power distributions cannot be inferred from their colors.

If the colors of the three primary lights are quite different, a wide variety of test colors can be matched in this way, but in no case can all possible test colors be matched with combinations of any one set of primaries, even if the spectrum colors are used as primaries. This problem can be overcome in several ways. In one, light from one of the primaries can be added to the test color, rather than mixed with that from the other two primaries. For describing the test color, this light can be thought of as being subtracted from the other primaries. Thus the test color can be described by a combination of negative and positive amounts of primary light colors.

By use of negative amounts of light as described above, we can match any test light by mixing only three colored lights. In a very important experiment, for example, all the spectrum lights can be matched by combining positive and negative amounts of three primary lights. If we select for these primaries the spectrum colors in the red at 700 nm, in the green at 546 nm, and in the blue at 436 nm, the figure on page 39 shows the relative amounts, which we call \bar{r}, \bar{g}, and \bar{b}, of these needed by a person with normal color vision to match any of the other spectrum colors, provided each of the spectrum light sources emits the same amount of power. Thus \bar{r}, \bar{g}, and \bar{b} are the *tristimulus values of the spectrum colors* for this particular set of red, green, and blue primaries. In its 1931 recommendation the CIE adopted the average \bar{r}, \bar{g}, \bar{b} data for a small number of observers as the experimental definition of the CIE 1931 standard observer.

In 1931, however, it was considered important to eliminate negative numbers among the tristimulus values. Therefore a mathematical transformation of the standard observer data was made, representing a change from the original red, green, and blue primaries to a new set, which cannot be produced by any real lamps,

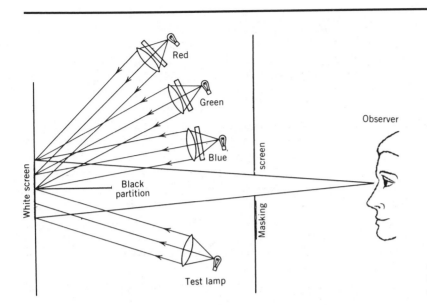

An arrangement for producing a large number of colors by mixing the light from three different colored lamps.

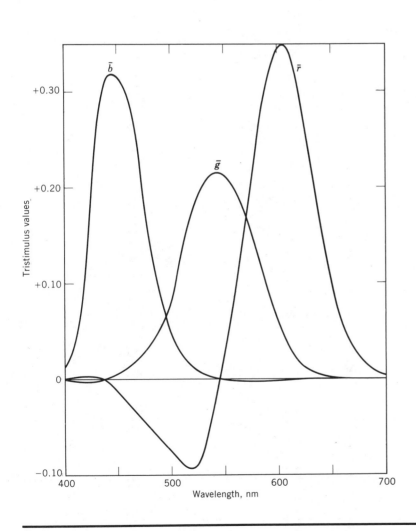

These curves show, for each wavelength, the tristimulus values \bar{r}, \bar{g}, and \bar{b} of the equal-energy spectrum colors for a particular set of red, green, and blue primary lights. They provide the experimental definition of the 2° 1931 CIE standard observer.

called simply the X, Y, and Z primaries. The tristimulus values of the equal-power spectrum colors in the CIE X, Y, Z system, shown below and tabulated on the facing page provide the definition of the 1931 CIE standard observer in its most widely used form.

The CIE could have selected any of an infinite number of sets of "imaginary" primaries of the X, Y, Z type in defining the standard observer. The one they did select had a number of advantages that will become apparent in the coming pages. One of these is that \bar{y} was selected to be exactly the same as the eye's response curve to total amount of power, which we first saw on page 16. As a result, the corresponding tristimulus value Y provides the information on a color's lightness, regardless of anything else. The \bar{y} curve is sometimes called the *spectral luminous efficiency* $V(\lambda)$; at each wavelength it shows how efficient the eye is in converting power to luminous sensation.

The 1964 CIE Supplementary Standard Observer. It has long been known that the structure of the eye is a little different in the central region of the retina, the fovea, and in the surrounding

The tristimulus values of the equal-energy spectrum colors in the X, Y, Z system define the 2° 1931 CIE standard observer as it is usually used.

The CIE Color-Matching Functions \bar{x}, \bar{y}, and \bar{z} of the 2° 1931 CIE Standard Observer, Tabulated at 5-nm Intervals of Wavelength (CIE 1971)

Wavelength (nm)	\bar{x}	\bar{y}	\bar{z}	Wavelength (nm)	\bar{x}	\bar{y}	\bar{z}
380	0.0014	0.0000	0.0065	580	0.9163	0.8700	0.0017
385	0.0022	0.0001	0.0105	585	0.9786	0.8163	0.0014
390	0.0042	0.0001	0.0201	590	1.0263	0.7570	0.0011
395	0.0076	0.0002	0.0362	595	1.0567	0.6949	0.0010
400	0.0143	0.0004	0.0679	600	1.0622	0.6310	0.0008
405	0.0232	0.0006	0.1102	605	1.0456	0.5668	0.0006
410	0.0435	0.0012	0.2074	610	1.0026	0.5030	0.0003
415	0.0776	0.0022	0.3713	615	0.9384	0.4412	0.0002
420	0.1344	0.0040	0.6456	620	0.8544	0.3810	0.0002
425	0.2148	0.0073	1.0391	625	0.7514	0.3210	0.0001
430	0.2839	0.0116	1.3856	630	0.6424	0.2650	0.0000
435	0.3285	0.0168	1.6230	635	0.5419	0.2170	0.0000
440	0.3483	0.0230	1.7471	640	0.4479	0.1750	0.0000
445	0.3481	0.0298	1.7826	645	0.3608	0.1382	0.0000
450	0.3362	0.0380	1.7721	650	0.2835	0.1070	0.0000
455	0.3187	0.0480	1.7441	655	0.2187	0.0816	0.0000
460	0.2908	0.0600	1.6692	660	0.1649	0.0610	0.0000
465	0.2511	0.0739	1.5281	665	0.1212	0.0446	0.0000
470	0.1954	0.0910	1.2876	670	0.0874	0.0320	0.0000
475	0.1421	0.1126	1.0419	675	0.0636	0.0232	0.0000
480	0.0956	0.1390	0.8130	680	0.0468	0.0170	0.0000
485	0.0580	0.1693	0.6162	685	0.0329	0.0119	0.0000
490	0.0320	0.2080	0.4652	690	0.0227	0.0082	0.0000
495	0.0147	0.2586	0.3533	695	0.0158	0.0057	0.0000
500	0.0049	0.3230	0.2720	700	0.0114	0.0041	0.0000
505	0.0024	0.4073	0.2123	705	0.0081	0.0029	0.0000
510	0.0093	0.5030	0.1582	710	0.0058	0.0021	0.0000
515	0.0291	0.6082	0.1117	715	0.0041	0.0015	0.0000
520	0.0633	0.7100	0.0782	720	0.0029	0.0010	0.0000
525	0.1096	0.7932	0.0573	725	0.0020	0.0007	0.0000
530	0.1655	0.8620	0.0422	730	0.0014	0.0005	0.0000
535	0.2257	0.9149	0.0298	735	0.0010	0.0004	0.0000
540	0.2904	0.9540	0.0203	740	0.0007	0.0002	0.0000
545	0.3597	0.9803	0.0134	745	0.0005	0.0002	0.0000
550	0.4334	0.9950	0.0087	750	0.0003	0.0001	0.0000
555	0.5121	1.0000	0.0057	755	0.0002	0.0001	0.0000
560	0.5945	0.9950	0.0039	760	0.0002	0.0001	0.0000
565	0.6784	0.9786	0.0027	765	0.0001	0.0000	0.0000
570	0.7621	0.9520	0.0021	770	0.0001	0.0000	0.0000
575	0.8425	0.9154	0.0018	775	0.0000	0.0000	0.0000

At a normal viewing distance of 45 cm (18 in.), the circle on the left represents the 2° field on which the 1931 CIE standard observer is based. The figure on the right is the 10° field on which the 1964 CIE supplementary standard observer is based.

regions. The experiments leading to the 1931 CIE standard observer were performed using only the fovea, which covers only about a 2° angle of vision. In 1964 the CIE recommended the use of a somewhat different observer to supplement use of the 1931 observer whenever more accurate correlation with visual perception for large samples, covering an angle of more than 4° at the eye of the observer, is desired. The supplementary standard observer functions, \bar{x}_{10}, \bar{y}_{10}, \bar{z}_{10}, were derived from color-matching experiments of the type described above but using a 10° area on the retina of the observer's eye with the observers instructed to ignore the central 2° spot, while the 1931 CIE color-matching functions \bar{x}, \bar{y}, and \bar{z} were based on experiments using just the central 2° of the eye. The 1931 standard observer is sometimes called the 2° standard observer, and the 1964 supplementary standard observer, the 10° observer. The 1964 supplementary observer was just beginning to be widely used more than a decade after its adoption. The tabulated values of \bar{x}_{10}, \bar{y}_{10}, and \bar{z}_{10} are given on page 43. A word of warning: \bar{y}_{10} is *not* the same as \bar{y} or $V(\lambda)$, and the corresponding tristimulus value Y_{10} does *not* directly represent a color's lightness. The difference is not great, however.

Strocka (1970) has pointed out that there is only poor agreement between the visual assessment usually carried out in practice (large field of vision) and that of the 2° standard observer. A much better agreement with the average visual assessment can be obtained by making use of the 10° standard observer. If, on the other hand, the 2° standard observer is applied properly (small field of vision) there is fairly good agreement with actual observers.

The CIE standard observers are averages, or composites, based on experiments with small numbers (roughly 15–20) of people with normal color vision. Even within such a group, individuals vary

The Color-Matching Functions \bar{x}_{10}, \bar{y}_{10}, and \bar{z}_{10} of the 10° 1964 CIE Supplementary Standard Observer, Tabulated at 5-nm Intervals of Wavelength (CIE 1971)

Wavelength (nm)	\bar{x}_{10}	\bar{y}_{10}	\bar{z}_{10}	Wavelength (nm)	\bar{x}_{10}	\bar{y}_{10}	\bar{z}_{10}
380	0.0002	0.0000	0.0007	580	1.0142	0.8689	0.0000
385	0.0007	0.0001	0.0029	585	1.0743	0.8256	0.0000
390	0.0024	0.0003	0.0105	590	1.1185	0.7774	0.0000
395	0.0072	0.0008	0.0323	595	1.1343	0.7204	0.0000
400	0.0191	0.0020	0.0860	600	1.1240	0.6583	0.0000
405	0.0434	0.0045	0.1971	605	1.0891	0.5939	0.0000
410	0.0847	0.0088	0.3894	610	1.0305	0.5280	0.0000
415	0.1406	0.0145	0.6568	615	0.9507	0.4618	0.0000
420	0.2045	0.0214	0.9725	620	0.8563	0.3981	0.0000
425	0.2647	0.0295	1.2825	625	0.7549	0.3396	0.0000
430	0.3147	0.0387	1.5535	630	0.6475	0.2835	0.0000
435	0.3577	0.0496	1.7985	635	0.5351	0.2283	0.0000
440	0.3837	0.0621	1.9673	640	0.4316	0.1798	0.0000
445	0.3867	0.0747	2.0273	645	0.3437	0.1402	0.0000
450	0.3707	0.0895	1.9948	650	0.2683	0.1076	0.0000
455	0.3430	0.1063	1.9007	655	0.2043	0.0812	0.0000
460	0.3023	0.1282	1.7454	660	0.1526	0.0603	0.0000
465	0.2541	0.1528	1.5549	665	0.1122	0.0441	0.0000
470	0.1956	0.1852	1.3176	670	0.0813	0.0318	0.0000
475	0.1323	0.2199	1.0302	675	0.0579	0.0226	0.0000
480	0.0805	0.2536	0.7721	680	0.0409	0.0159	0.0000
485	0.0411	0.2977	0.5701	685	0.0286	0.0111	0.0000
490	0.0162	0.3391	0.4153	690	0.0199	0.0077	0.0000
495	0.0051	0.3954	0.3024	695	0.0138	0.0054	0.0000
500	0.0038	0.4608	0.2185	700	0.0096	0.0037	0.0000
505	0.0154	0.5314	0.1592	705	0.0066	0.0026	0.0000
510	0.0375	0.6067	0.1120	710	0.0046	0.0018	0.0000
515	0.0714	0.6857	0.0822	715	0.0031	0.0012	0.0000
520	0.1177	0.7618	0.0607	720	0.0022	0.0008	0.0000
525	0.1730	0.8233	0.0431	725	0.0015	0.0006	0.0000
530	0.2365	0.8752	0.0305	730	0.0010	0.0004	0.0000
535	0.3042	0.9238	0.0206	735	0.0007	0.0003	0.0000
540	0.3768	0.9620	0.0137	740	0.0005	0.0002	0.0000
545	0.4516	0.9822	0.0079	745	0.0004	0.0001	0.0000
550	0.5298	0.9918	0.0040	750	0.0003	0.0001	0.0000
555	0.6161	0.9991	0.0011	755	0.0002	0.0001	0.0000
560	0.7052	0.9973	0.0000	760	0.0001	0.0000	0.0000
565	0.7938	0.9824	0.0000	765	0.0001	0.0000	0.0000
570	0.8787	0.9556	0.0000	770	0.0001	0.0000	0.0000
575	0.9512	0.9152	0.0000	775	0.0000	0.0000	0.0000

widely in their color-matching functions; therefore it is unlikely that any real observer is exactly the CIE standard observer. We discuss the consequences of this on page 175.

Calculating the CIE Tristimulus Values

We now indicate how to calculate CIE tristimulus values from information on the object in question, a CIE standard illuminant,

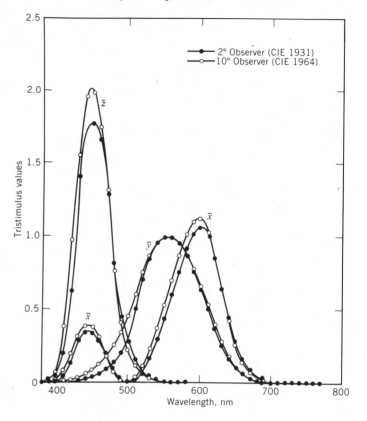

The color matching functions \bar{x}, \bar{y}, \bar{z} of the 1931 CIE standard observer and \bar{x}_{10}, \bar{y}_{10}, \bar{z}_{10} of the 1964 CIE supplementary standard observer are compared here (data from CIE 1971). These sets of tristimulus values of the spectrum colors, defining the 1931 CIE standard observer and the 1964 CIE supplementary standard observer, respectively, in terms of the same X, Y, and Z primaries, are a little bit different. Most significantly, \bar{y}_{10} is *not* the same as \bar{y} or $V(\lambda)$.

and one of the CIE standard observers. The figures on pages 45 and 46 illustrate the method, and the table on page 45 provides a numerical example. The values of P, at each of many equally spaced wavelengths across the spectrum (the 16 illustrated in the table is a *minimum* number), are multiplied together with R and \bar{x}, \bar{y}, or \bar{z} to give products at each wavelength $PR\bar{x}$, $PR\bar{y}$, and $PR\bar{z}$. These are summed up (mathematically equivalent to finding the areas under the curves) to give the tristimulus values.

By convention, when dealing with reflecting objects, we assign the value $Y = 100$ to an ideal nonfluorescent white reflecting 100% at all wavelengths, and when dealing with transparent objects, we assign the value $Y = 100$ to the perfect colorless sample (that is, no sample at all) that transmits 100% at each wavelength. The way to do this is to adjust the values of the products $P\bar{x}$, $P\bar{y}$, and $P\bar{z}$ such that the sum of all the values of $P\bar{y}$ is equal to 1. The numbers in that table on page 45 have been so adjusted, and the mathematical equations for making the adjustment and calculating the tristimulus values are given on page 47. For a discussion of tables like

Wavelength (nm)	R (%)	$P_C\bar{x}$	$P_CR\bar{x}$	$P_C\bar{y}$	$P_CR\bar{y}$	$P_C\bar{z}$	$P_CR\bar{z}$
400	23.3	0.00044	0.01	−0.00001	0	0.00187	0.04
420	33.0	0.02926	0.97	0.00085	0.03	0.14064	4.64
440	41.7	0.07680	3.20	0.00513	0.21	0.38643	16.11
460	50.0	0.06633	3.32	0.01383	0.69	0.38087	19.04
480	47.2	0.02345	1.11	0.03210	1.52	0.19464	9.19
500	36.5	0.00069	0.03	0.06884	2.51	0.05725	2.09
520	24.0	0.01193	0.29	0.12882	3.09	0.01450	0.35
540	13.5	0.05588	0.75	0.18268	2.47	0.00365	0.05
560	7.9	0.11751	0.93	0.19606	1.55	0.00074	0.01
580	6.0	0.16801	1.01	0.15989	0.96	0.00026	0
600	5.5	0.17896	0.98	0.10684	0.59	0.00012	0
620	6.0	0.14031	0.84	0.06264	0.38	0.00003	0
640	7.2	0.07437	0.54	0.02897	0.21	0	0
660	8.2	0.02728	0.22	0.01003	0.08	0	0
680	7.4	0.00749	0.06	0.00271	0.02	0	0
700	7.0	0.00175	0.01	0.00063	0	0	0
			Sum = X = 14.27		Sum = Y = 14.31		Sum = Z = 51.52

this for use in color-measuring instruments, see pages 81 and 180. The CIE has defined the ideal white to be used as the standard of reflectance, and it is discussed further on page 84.

If \bar{x}_{10}, \bar{y}_{10}, and \bar{z}_{10} are used instead of \bar{x}, \bar{y}, and \bar{z} in these examples, the results are the tristimulus values for the 1964 supplementary standard observer, X_{10}, Y_{10}, and Z_{10}, instead of those for the 1931 standard observer, X, Y, and Z. In the 1931 system Y is known as the *luminance factor,* or the *luminous reflectance* or the *luminous transmittance,* whichever is appropriate, and is expected to correlate well with the perceived lightness of the sample.

How to calculate tristimulus values from spectral distribution data. The spectral distribution of the illuminant, P, and the standard observer functions \bar{x}, \bar{y}, and \bar{z} are tabulated in many books (Wyszecki 1967, CIE 1971, Hunter 1975, Judd 1975a). They are multiplied together to give products $P\bar{x}$, $P\bar{y}$, $P\bar{z}$, as is done here for CIE Illuminant C and the 1931 standard observer. [These products (Foster 1970, Stearns 1975) have been normalized so that the sum of $P\bar{y}$ is 1.000.]

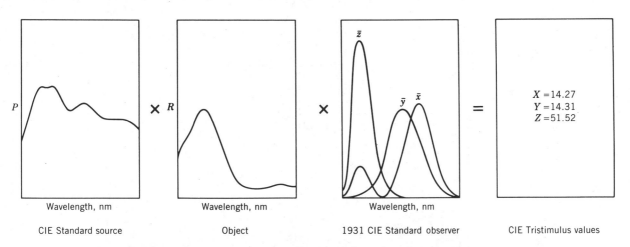

| CIE Standard source | Object | 1931 CIE Standard observer | CIE Tristimulus values |

The CIE tristimulus values X, Y, and Z of a color are obtained by multiplying together the relative power P of a CIE standard illuminant, the reflectance R (or the transmittance) of the object, and the standard observer functions \bar{x}, \bar{y}, and \bar{z}. The products are summed up for all the wavelengths in the visible spectrum to give the tristimulus values, as indicated in the diagrams here and on page 46 and by the mathematical equations on page 47.

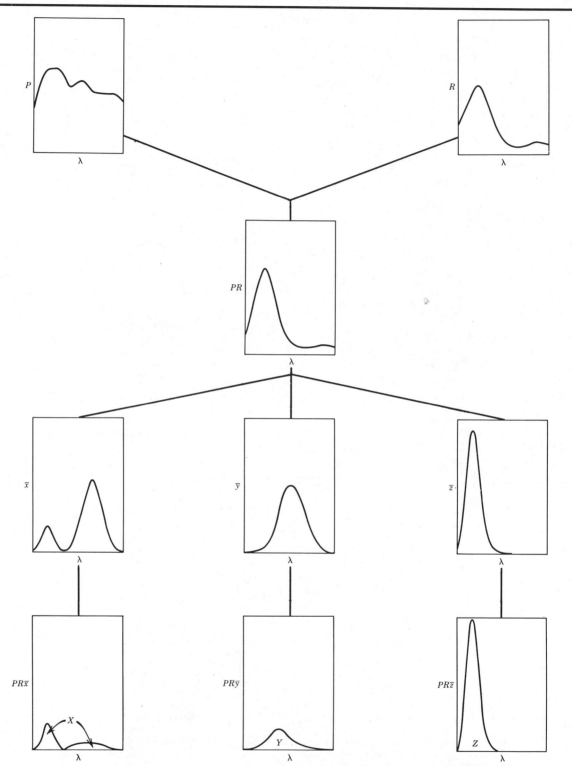

In a little more detail than in the figure on page 45, here are all the spectral curves needed to calculate CIE tristimulus values X, Y, and Z. Wavelength by wavelength, the values of the curves of P and R are multiplied together to give the curve PR. Then this curve is multiplied, in turn, by \bar{x}, by \bar{y}, and by \bar{z}, to obtain the curves $PR\bar{x}$, $PR\bar{y}$, and $PR\bar{z}$. The areas under these curves, suitably normalized as described in the text, are the tristimulus values X, Y, and Z.

The value $Y = 100$, assigned to a perfect white object reflecting 100% at all wavelengths, or to the perfect colorless sample transmitting 100% at all wavelengths, is the maximum value that Y can have for nonfluorescent samples. There is no similar restriction to a maximum value of 100 for X or Z, however; their values for the ideal cases are determined by the spectral power distribution of the illuminant used and the spectral characteristics of the standard observer selected, and may be greater or less than 100. For example, when illuminant C and the 1931 standard observer are used, the values for the perfect white or colorless sample are approximately $X = 98$ and $Z = 118$, as can be confirmed from the tables on page 45. The exact values depend slightly on things such as the choice of wavelength interval.

Fluorescent samples can have higher values of X, Y, and Z than those for the perfect reflecting white if what is measured is the sum of the fluoresced and reflected power. Further details are given in Sections 4C and 6A.

Chromaticity Coordinates and the Chromaticity Diagram

As a convenience in obtaining two-dimensional maps of colors, it is usual to calculate *chromaticity coordinates*, which describe the qualities of a color in addition to its luminance factor—that is, its *chromaticity*, which should correlate to some extent with its hue and chroma. In the CIE system, the chromaticity coordinates x, y, and z are obtained by taking the ratios of the tristimulus values to their sum, $X + Y + Z$. Since the sum of the chromaticity coordinates is 1, they provide only two of the three coordinates needed to describe the color. One of the tristimulus values, usually Y, must also be specified.

Color as described in the CIE system can be plotted on a *chromaticity diagram*, usually a plot of the chromaticity coordinates x and y. Perhaps the most familiar feature of the chromaticity diagram is the horseshoe-shaped *spectrum locus*, the line connecting the points representing the chromaticities of the spectrum colors. The chromaticities of blackbody illuminants, as well as of the CIE standard illuminants A, B, C, and D_{65}, are also shown in the figure on page 48.

The chromaticity diagrams for the 1931 and 1964 CIE observers are slightly different, but their basic features are very much the same. Throughout the remainder of this book we limit our discussion to the more familiar 1931 standard observer and chromaticity diagram.

An alternative set of coordinates in the CIE system, sometimes called the Helmholtz coordinates, *dominant wavelength* and *purity*, correlate more nearly with the visual aspects of hue and chroma, although their steps and spacing are not visually uniform. The dominant wavelength of a color is the wavelength of the spectrum color whose chromaticity is on the same straight line as the sample point and the illuminant point. Purity is the distance from illuminant point to sample point, divided by that from illuminant point to spectrum locus. Dominant wavelength and purity are most readily obtained by reading them off large-scale graphs of the x, y

$$X = k \, \Sigma \, PR\bar{x} \quad \text{or} \quad X = k \int PR\bar{x} \, d\lambda$$

$$Y = k \, \Sigma \, PR\bar{y} \quad \text{or} \quad Y = k \int PR\bar{y} \, d\lambda$$

$$Z = k \, \Sigma \, PR\bar{z} \quad \text{or} \quad Z = k \int PR\bar{z} \, d\lambda$$

where

$$k = \frac{100}{\Sigma \, P\bar{y}} \quad \text{or} \quad k = \frac{100}{\int P\bar{y} \, d\lambda}$$

and P, R, \bar{x}, \bar{y}, and \bar{z} all are functions of the wavelength λ.

$$x = \frac{X}{X + Y + Z}$$

$$y = \frac{Y}{X + Y + Z}$$

$$z = \frac{Z}{X + Y + Z}$$

These equations define the CIE *chromaticity coordinates* x, y, and z. In some older books x, y, and z are known as the *trichromatic coefficients*.

By convention lowercase letters are used to designate chromaticity coordinates (such as x, y), and capital letters to designate tristimulus values (such as X, Y, Z) *except* that the tristimulus values of the spectrum colors defining the standard observer are designated \bar{x}, \bar{y}, and \bar{z}.

chromaticity diagram in A. C. Hardy's *Handbook of Colorimetry* (Hardy 1936), or by computer programs (Warschewski, 1980). If the sample point lies between the illuminant point and the purple boundary connecting the ends of the spectrum locus, the construction is made as shown in the figure on page 49, and the wavelength is known as the *complementary dominant wavelength,* designated λ_c.

Examination of the chromaticity diagram discloses two additional advantages of the choice of the particular set of X, Y, and Z primaries made by the CIE in 1931. First, the white point was made to lie near the center of the diagram, for example, at $x = 0.310$, $y = 0.317$ for illuminant C and the 1931 standard observer. Second, over as large a wavelength range as possible, one of the standard-observer functions, \bar{z}, was made equal to zero. This means that for spectrum colors with wavelengths greater than about 600 nm, Z is negligible, and these colors are described by only the two tristimulus values X and Y.

We are often asked where the X, Y, and Z primaries lie on the chromaticity diagram: the answer is at $x = 1$, $y = 0$; $x = 0$, $y = 1$; and $x = 0$, $y = 0$ (where $z = 1$), respectively. Like all other points outside the area bounded by the spectrum locus and the purple boundary, they do not represent real colors.

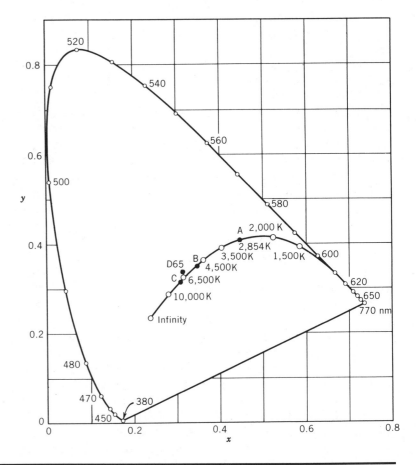

This is the famous CIE 1931 chromaticity diagram, showing the horseshoe-shaped spectrum locus with the spectrum colors identified by their wavelengths, the purple line joining the ends of the spectrum locus, the locus of blackbody light sources identified by their color temperatures in Kelvins, and the locations of the CIE standard illuminants A, B, C, and D_{65}.

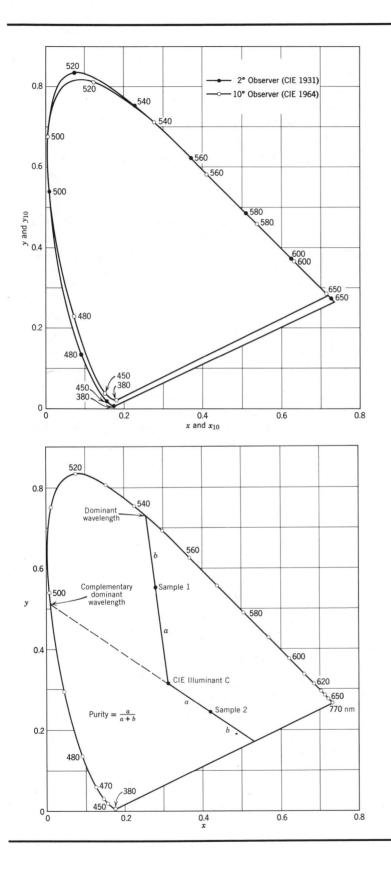

The 1931 x, y and 1964 x_{10}, y_{10} chromaticity diagrams are very similar (Judd 1975a).

The definitions of dominant wavelength, complementary dominant wavelength, and purity are shown on this CIE chromaticity diagram. These are also known as the Helmholtz coordinates (page 47).

It is important to note that the CIE system is not associated with any particular set of physical samples. Only incidentally have sets of samples been produced to illustrate the system. Nor is the system based on steps of equal visual perception in any sense, although many modifications of the CIE system have been proposed as approaches to equal perception. Indeed, the CIE system is intended to do no more than tell whether two colors match (they match if they have the same tristimulus values, otherwise not). The CIE chromaticity diagram, likewise, is properly used only to tell whether two colors have the same chromaticities, not what they look like, or how they differ if they do not match.

Nevertheless it is often desirable to know *approximately* where certain colors lie on the chromaticity diagram, and if we restrict ourselves to colors seen in daylight-type illumination by an observer adapted to that illumination, we will not be too far off. This is the basis on which color names were assigned in the diagram below.

Only two of the three dimensions of color can be shown on a chromaticity diagram. Often, a three-dimensional CIE color space is made by plotting an axis of Y rising from the illuminant point of the chromaticity diagram. Only colors of very low luminance factor, such as spectrum colors, can lie as far away from the illuminant axis as the spectrum locus; all other colors have lower purity. The limits within which all colors having a given luminance must lie have been calculated (Rösch 1929, MacAdam 1935) and are shown projected onto the plane of the chromaticity diagram in the figure on page 51. They serve to outline the volume in x, y, Y space within which all real colors lie.

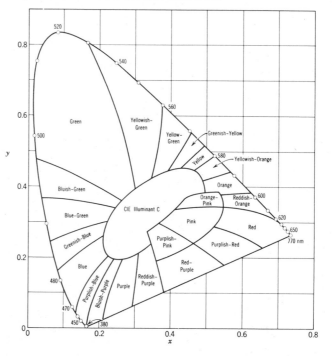

The names of various colors are shown on this CIE chromaticity diagram (Judd 1950, 1952). They are *approximately* correct for colors viewed in daylight by an observer whose eyes are adapted to that daylight.

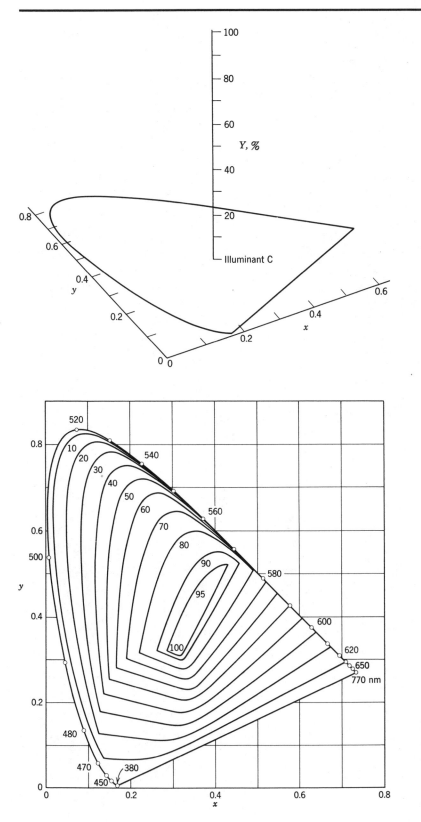

The third dimension of color is conveniently added to the CIE chromaticity diagram by thinking of the luminance-factor axis rising up from it. Lighter colors lie in space at their proper level of Y and above the point representing their chromaticity x, y.

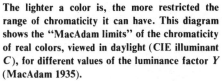

The lighter a color is, the more restricted the range of chromaticity it can have. This diagram shows the "MacAdam limits" of the chromaticity of real colors, viewed in daylight (CIE illuminant C), for different values of the luminance factor Y (MacAdam 1935).

Note that there is a significant difference in concept as well as in shape between the three-dimensional CIE *x, y, Y* space and the Munsell Hue, Value, Chroma space described on page 28. Both have white located at a single point on the top of an axis of lightness. In the Munsell space black is located at a single point at the bottom of that axis (the Munsell Value axis), as our perceptual senses tell us it should be. But in CIE *x, y, Y* space the location of black is not well defined, for it corresponds to all three tristimulus values *X, Y,* and *Z* equal to zero, and by the mathematical definitions of *x* and *y*, black can lie anywhere on the chromaticity diagram. This is but one of many examples supporting our earlier warning that one should *not* associate the appearance of colors with locations on the CIE diagram!

Metamerism

The fundamental principle of the CIE system—that if two colors have the same tristimulus values for a given illuminant and observer, they would match if seen by that observer under the source corresponding to that illuminant—provides an explanation of the phenomenon of metamerism, first discussed on page 21. We can now see exactly the relation between the spectral reflectance curves of objects and their color coordinates, and the role played by the source (or its equivalent for calculations, the illuminant) and the observer.

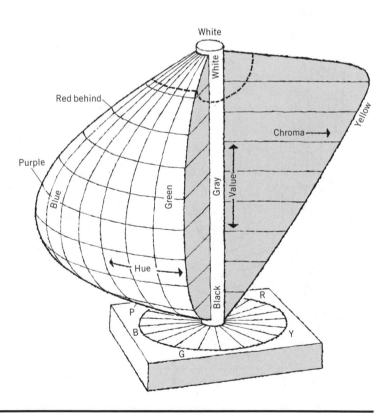

In the Munsell System, which is based on the perceived colors of objects, white and black have unique positions at the top and bottom, respectively, of the value axis (from Hunter 1975). All the other colors lie between them, with the Munsell color solid bulging out to accommodate those that are farther away from the neutral value axis.

. . .

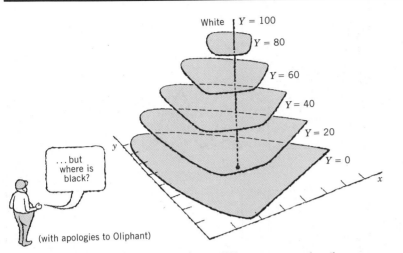

... but where is black?

(with apologies to Oliphant)

Even though two objects may have different spectral reflectance curves, they match if their CIE tristimulus values are the same for a given illuminant and observer. If this is the case, they form a metameric pair. It is easy to see why they are unlikely to continue to match if either the source or the observer is changed: They no longer have the same tristimulus values. [In the figures on page 54 we consider only the change in illuminant, for convenience, but we wish to emphasize that the change from one observer to another, *all with "normal" color vision,* is equally important (Billmeyer 1980a), a fact all too often overlooked!]

In contrast, the tristimulus values of pairs of samples with the same spectral reflectance curves are the same for both members of the pair regardless of the choice of source or observer. The tristimulus values depend on the selection of illuminant and of observer, but the colors still match.

Metamerism is without doubt one of the basic and most important aspects of color technology, and we return to the subject again and again in the remainder of this book.

... In contrast, the CIE *x, y, Y* color space, which does *not* deal with the appearance of colors but only with whether or not they match, is defined in such a way that black does not have a unique position.

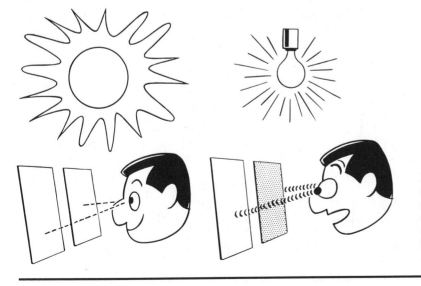

It is a common (and sometimes unpleasant) fact that pairs of colors with different spectral reflectance curves can match to one observer or under one source, but fail to match to another observer or (as shown here) to the same observer but under a different source. They are called *metameric pairs* or *metamers. ...*

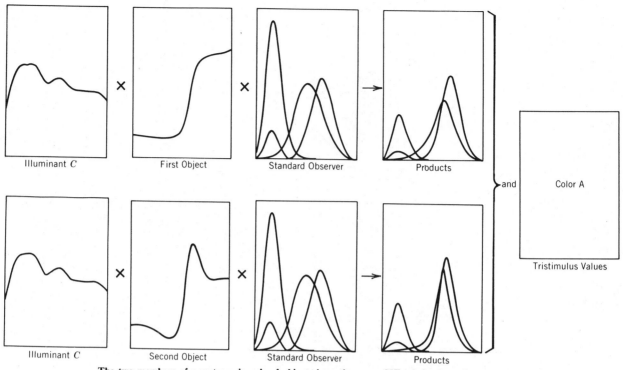

... The two members of a metameric pair of objects have the same CIE tristimulus values calculated for the illuminant and observer for which they match, even though they have different spectral reflectance curves ...

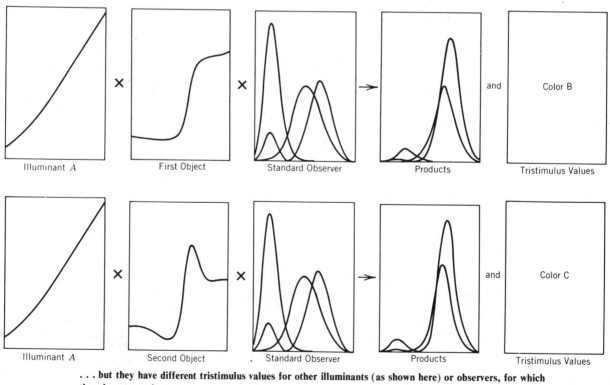

... but they have different tristimulus values for other illuminants (as shown here) or observers, for which they do not match. ...

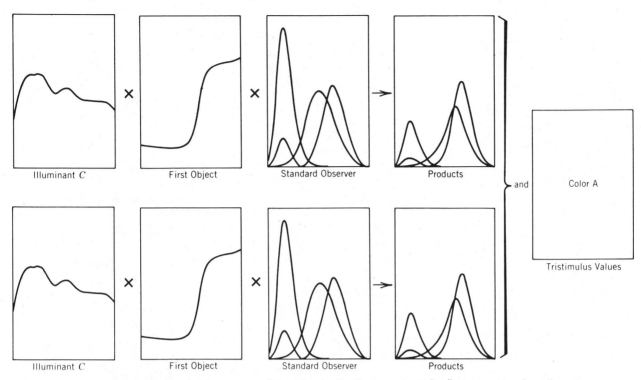

... In contrast, a pair of *nonmetameric* samples, having the same spectral reflectance curves, have the same tristimulus values, and therefore match ...

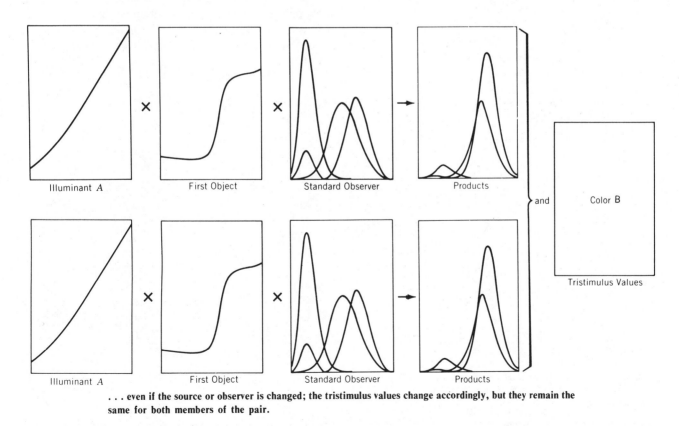

... even if the source or observer is changed; the tristimulus values change accordingly, but they remain the same for both members of the pair.

C. More Nearly Uniformly Spaced Systems

It has often been said that one of the greatest disadvantages of the CIE system is that it is far from equally visually spaced. But why should it be, since it is not meant to give any information about the appearance of colors?

Again being aware that caution is required at every stage in attempting to relate perceived colors to locations on the CIE chromaticity diagram, we may liken that "map" of color space to the familiar flat map of the world based on the Mercator projection. This is also a very nonuniform map, distorting the sizes and shapes of countries and continents severely, as is well known.

The visual nonuniformity of the CIE diagram leads to similar distortions. For example, lines of constant visually perceived hue, which are straight lines in the Munsell System, are generally somewhat curved when plotted on the CIE x, y diagram, and curves of constant Munsell Chroma are not circles, but distorted ovals. It is easy to see that, as a consequence, the CIE coordinates dominant wavelength and purity cannot be expected to correlate perfectly with visually perceived hue and chroma.

For reasons we do not quite understand, these properties of the CIE system have led to many, many attempts over the years to transform or modify the CIE system, or to devise entirely new systems that are more nearly visually spaced and at the same time allow easy transformation of color coordinates to and from CIE tristimulus values. [This transformation is not easy between the CIE and Munsell systems. A computer program (Rheinboldt 1960) has found some use, but requires a rather large machine even by today's standards.] The search for an "ideal color space" (Judd 1970) has proved to be vastly difficult, and success is not yet in sight.

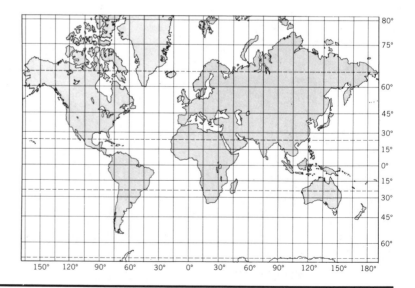

Just as the Mercator projection of a map of the world (Strahler 1965) distorts the Arctic and Antarctic continents severely, and Australia and Greenland less so, compared to countries nearer the equator . . .

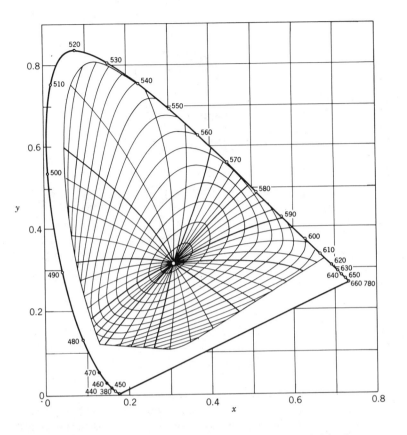

Why should the goal be so important? We quickly learn to accept the errors of the Mercator system, and compensate for them, and experience has shown that people can and do get used to describing colors and color differences in many different systems, whether they are perceptually uniform or not. Sometimes we wonder exactly what a person would do that he could not do otherwise with a perfect perceptually uniform system if he had one.

Linear Transformations of the CIE System

In considering how to transform the CIE system to improve its perceptual uniformity, it is advantageous to consider separately two kinds of transformations: linear and nonlinear. Mathematicians will recognize and understand the implications of the terms, but it is enough for us to say that linear transformations preserve some important features of the CIE system assocated with additive color mixing, discussed on page 134, which are important for color television and certain graphic arts applications. We consider the linear transformations first, largely for historical reasons.

One of the first linear transformations developed to improve the visual spacing of the CIE system was the Uniform Chromaticity Scale (UCS) system of Judd (1935). Later, a rectangular UCS or RUCS system was devised by Breckenridge (1939) for use in describing the colors of signal lights. MacAdam (1937) developed a system (u, v system) that in 1960 was tentatively recommended by the CIE as an approximation to uniform visual perception. [Later,

... so the CIE *x, y* chromaticity diagram distorts the straight lines of constant hue and circles of constant chroma of the Munsell System (Judd 1953), here shown plotted for Munsell Value 5. . . .

A *linear transformation* is an equation defining a quantity as the sums or differences of other quantities, such as

$$x = \frac{X}{X + Y + Z}$$

A *nonlinear transformation* involves other mathematical operations (squares, or square or cube roots, for example), such as (p. 61)

$$L^* = 116 \left(\frac{Y}{Y_n}\right)^{1/3} - 16$$

The Now-Superseded 1960 CIE u, v System

$$u = \frac{4X}{X + 15Y + 3Z}$$

$$= \frac{4x}{-2x + 12y + 3}$$

$$v = \frac{6Y}{X + 15Y + 3Z}$$

$$= \frac{6y}{-2x + 12y + 3}$$

. . . Many attempts have been made to stretch or otherwise alter the familiar diagram to overcome this distortion (Chamberlin 1955).

The CIE 1976 Metric Chromaticity Coordinates u', v'

$$u' = u = \frac{4X}{X + 15Y + 3Z}$$

$$= \frac{4x}{-2x + 12y + 3}$$

$$v' = 1.5v = \frac{9Y}{X + 15Y + 3Z}$$

$$= \frac{9y}{-2x + 12y + 3}$$

The reverse transformation is

$$x = \frac{27u'}{18u' - 48v' + 36},$$

$$y = \frac{12v'}{18u' - 48v' + 36}$$

he developed (MacAdam 1943) another system, widely used for the calculation of small color differences, but it cannot be described by simple equations and is very nonlinear.]

Of all these, only the 1960 CIE tentative recommendation (now superseded) is worth a closer look. In its *u, v* chromaticity diagram, the spectrum locus can easily be recognized, but the white point is no longer near the center. The equations for the transformation are relatively simple, but the spacing of the Munsell colors is still far from uniform.

The Munsell spacing was later found to be improved (Eastwood 1973) by the simple expedient of increasing the *v* coordinate 50%, and the CIE has recommended (CIE 1978) that the 1960 *u, v* diagram be superseded by the 1976 CIE *u′, v′ uniform-chromaticity-scale diagram.* At this writing this is the latest in a long line of linear transformations of the 1931 CIE *x, y* diagram to appear in the search for the perfect uniform chromaticity diagram.

The 1960 CIE *u, v* chromaticity diagram (now superseded), showing the spectrum locus and white point (illuminant *C*).

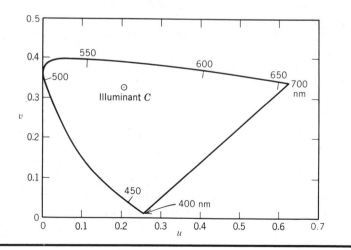

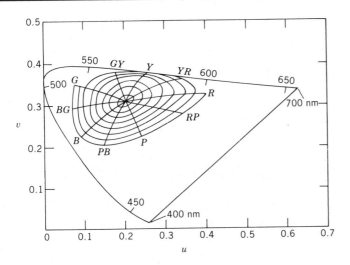

Loci of constant Munsell Hue and Chroma at Munsell Value 5 on the 1960 CIE _u, v_ chromaticity diagram.

Opponent-Type Systems

We digress at this point to introduce an alternative way of describing color, in terms of what are often called _opponent-color coordinates_. The ideal behind these is that, somewhere between the eye and the brain, signals from the cone receptors in the eye get coded into light-dark, red-green, and yellow-blue signals (Hering 1964). In opponent-color coordinates (Plate IV), the argument is that a color cannot be red and green at the same time, or yellow and blue at the same time, though it can be both red and yellow as in oranges, or red and blue as in purples, and so on. Thus redness _or_ greenness can be expressed as a single number, usually called _a_, which is positive if the color is red and negative if it is green. Similarly, yellowness _or_ blueness is expressed by a coordinate _b_, which is positive for

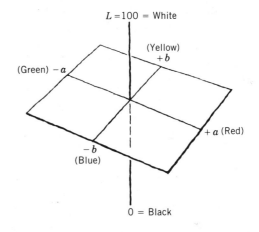

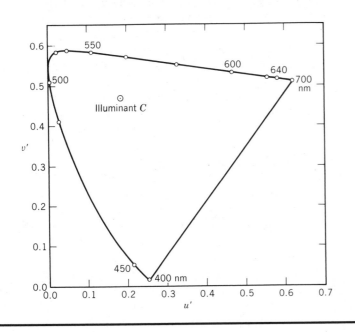

The currently recommended 1976 CIE uniform-chromaticity-scale _u´, v´_ diagram, showing the spectrum locus and white point (illuminant _C_) (Robertson 1977).

$$V = Y^{1/2}$$

This equation (Priest 1920) and those following are approximate relations between CIE Y and Munsell Value. The Priest equation was later used by Hunter to define his lightness variable L:

$$L = 10Y^{1/2}$$

$$\frac{Y}{Y_{\text{MgO}}} = 1.2219V - 0.23111V^2$$
$$+ 0.23951V^3 - 0.021009V^4$$
$$+ 0.0008404V^5$$

The Munsell Value function as defined by Newhall (1943) in the Munsell Renotation System. In 1979 Y_{MgO} for the geometric conditions used (45° illumination, 0° viewing) was assigned the value 1.026; consequently the Munsell Value function can now be written (McLaren 1980, Hemmendinger 1980):

$$Y = 1.1913V - 0.22532V^2$$
$$+ 0.23351V^3 - 0.020483V^4$$
$$+ 0.00081935V^5.$$

yellows and negative for blues. The third coordinate describes the lightness of the color, and is usually called L.

In the next section we see several of the opponent-color coordinate systems. The oldest of them in wide use today is that developed by Hunter (1942), which is closely related to the readings of his color-measuring instruments.

Nonlinear Transformations of the CIE System

Nonlinear transformations of the familiar CIE x, y chromaticity diagram change it in ways that are quite different from those we have seen so far; for example, straight lines in the x, y diagram usually become curved after a nonlinear transformation. In CIE terminology the resulting figures should no longer be called chromaticity diagrams, nor their coordinates chromaticity coordinates, though of course they still display the chromatic character of colors. Hunt (1978b) has proposed to the CIE that they be called *psychometric chroma diagrams,* which we shorten to *chroma diagrams.*

Most of the nonlinear transformations of the CIE system include a nonlinear transformation of lightness as well as chromaticity, and lead to more nearly uniform color spaces. Most of them, also, are based on opponent-type coordinates. We consider those of current interest as color spaces later in this chapter.

The most important nonlinear transformation of CIE space was developed by E. Q. Adams (1942) as a consequence of his studies of color-vision theory. It has been widely used as the basis for color-difference equations, as discussed in Chapter 3. With only slight modification, it forms the basis of a 1976 CIE recommendation (CIE 1978) discussed below.

Other nonlinear transformations, now largely of historical interest, were devised by Hunter (1942), Moon and Spencer (Moon 1943), Saunderson and Milner (Saunderson 1946), and Glasser (1958). Those of Hunter and Glasser are closely related to colorimeter readings, and Hunter's color space is described below, and in relation to instruments in Chapter 3. Still other systems exist that are only remotely related to the CIE system, but these are not considered in this book [DIN system (Richter 1955), Coloroid System (Nemcsics 1980)].

Lightness Scales. Since the lightness of an object is one of its most important color coordinates, much attention has been paid to devising scales of lightness corresponding to uniform visual perception in this variable. The early Munsell lightness scale (Priest 1920) assumed that lightness is proportional to the square root of luminance factor. This is approximately correct when the samples of a gray scale are viewed on a white background. This scale was later adopted by Hunter (1942), who made his colorimeters direct-reading in lightness, L. If the samples are viewed against a background of middle gray, the equation must be modified to take into account the reflectance of the background. This led to the Munsell Value scale (Newhall 1943), probably the most widely accepted lightness

scale at the time. Later, Glasser (1958) showed that a cube-root function is a good approximation to the Munsell Value equation.

Later still, the CIE adopted the use of the cube-root function, first to accompany the 1960 *u, v* diagram in a now-superseded 1964 *U* V* W** uniform color space, and then as the currently recommended *L** function (CIE 1978) used in the 1976 uniform color spaces described below. This function, known as *CIE 1976 psychometric* (or metric) *lightness,* is much easier to evaluate than the 1943 Munsell Renotation value function, for which table lookup followed by interpolation was usually required. The use of *L** is restricted to values of *Y* greater than 1 (1%), but a simple alternative formula for lower values of *Y* is available.

$$L^* = 116 \left(\frac{Y}{Y_n}\right)^{1/3} - 16,$$

$$\frac{Y}{Y_n} > 0.01$$

CIE 1976 metric lightness. Y_n is the value of Y for the reference white (or the reference light source). By convention $Y_n = 100$. The equation is correct only when Y/Y_n is greater than approximately 0.01—that is, Y is greater than 1%.

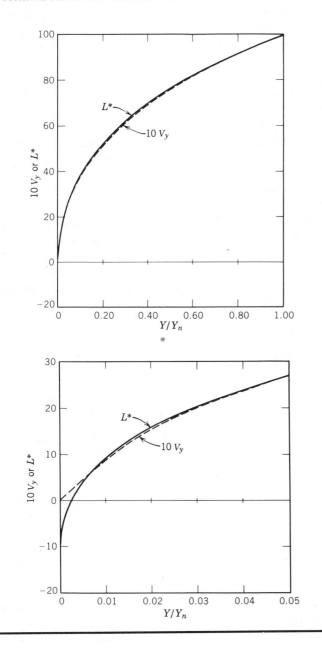

Comparison of Munsell Value (V_y) and CIE 1976 metric lightness (L^*) (from Robertson 1977).

"In calculating L^*, values of Y/Y_n less than approximately 0.01 may be included if the normal formula is used for values of Y/Y_n greater than 0.008856, and the following modified formula is used for values of Y/Y_n equal to or less than 0.008856:

$$L^* = 903.29 \left(\frac{Y}{Y_n}\right)"$$

CIE 1978

Comparison of Munsell Value (V_y) and CIE 1976 metric lightness (L^*) for Y/Y_n less than 0.05 (from Robertson 1977).

Equations for the Coordinates of Hunter's Color Space

For CIE illuminant *C*, 2° standard observer:

$$L = 10Y^{1/2}$$

$$a = \frac{17.5(1.02X - Y)}{Y^{1/2}}$$

$$b = \frac{7.0(Y - 0.847Z)}{Y^{1/2}}$$

For any other white-light illuminant and either the 2° or the 10° standard observer:

$$L = 100\left(\frac{Y}{Y_n}\right)^{1/2}$$

$$a = 175\left[\frac{0.0102X_n}{(Y/Y_n)}\right]^{1/2}$$

$$\times \left[\left(\frac{X}{X_n}\right) - \left(\frac{Y}{Y_n}\right)\right]$$

$$b = 70\left[\frac{0.00847Z_n}{(Y/Y_n)}\right]^{1/2}$$

$$\times \left[\left(\frac{Y}{Y_n}\right) - \left(\frac{Z}{Z_n}\right)\right]$$

where X_n, Y_n, and Z_n are the tristimulus values of the reference white for the selected illuminant and observer (Hunter 1966). Some useful values of X_n, Y_n, and Z_n are given below.

Some Tristimulus Values of the Reference White for 20-nm Integration Intervals (Stearns 1975)

Illuminant	Observer	X_n	Y_n	Z_n
A	2°	109.83	100.00	35.55
	10°	111.16	100.00	35.19
C	2°	98.04	100.00	118.10
	10°	97.30	100.00	116.14
D_{65}	2°	95.02	100.00	108.81
	10°	94.83	100.00	107.38

Uniform Color Spaces. Realizing that the term is only an approximation, for the ideal uniform color space has not been, and may never be, achieved, we now consider the "uniform" color spaces most widely used and most authoritatively recommended at this writing. All those described are opponent-type spaces and are nonlinear transformations of the 1931 CIE *X, Y, Z* system.

Probably the most widely used of all color spaces except the 1931 CIE space is Hunter's 1942 *L, a, b* space. It served to introduce the opponent-type color scales to wide industrial use, to the extent that this type of system is often known as an *L, a, b* system regardless of whether Hunter's coordinates are used. A major factor in the early popularity of the Hunter system was the fact that instruments were available, long before the day of modern computers, to provide values of Hunter's *L, a,* and *b* directly.

As one means of indicating the degree of uniformity of the Hunter space, we show here (as in the figures on pages 57 and 59 for the *x, y* and *u, v* chromaticity diagrams) lines of constant Munsell Hue and figures of constant Munsell Chroma at Munsell Value 5 on the Hunter chroma diagram.

The Adams Chromatic Value space (Adams 1942) has also found wide use, primarily because of its associated color-difference equation described in Chapter 3. Nickerson (1950b) published tables of the Munsell Renotation value function which greatly facilitated the use of the Adams space, and it is sometimes known as Adams-Nickerson or ANLAB space.

In 1973 MacAdam suggested to the CIE that ANLAB space could be modified for easier calculation by substituting the cube-root function incorporated in *L** for the troublesome Munsell Value function. This modification was officially recommended in 1976 and became known as the 1976 CIE *L* a* b** space, with the official abbreviation CIELAB (CIE 1978).

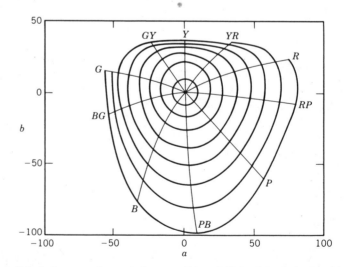

Munsell loci of constant hue and chroma at Munsell Value 5 plotted on the Hunter chroma diagram (from Nickerson 1950a).

At the same time the CIE recommended a second approach to a uniform color space, based on the combination of the u', v' chromaticity diagram (page 59) with the L^* metric lightness function. The coordinates of this system were made into opponent-type variables, with neutrals at the 0,0 point, by subtracting the values of u' and v' for the perfect white (or, alternatively, the same coordinates for the light source) from those of the sample. The difference, $u' - u'_n$ (where n designates the white or source), is a red-green opponent coordinate, for which positive values denote redness and negative values, greenness. Similarly, $v' - v'_n$ is a yellowness-blueness coordinate for which positive values denote yellowness and negative values, blueness.

The uncertainty about the location of black which exists in the x, y system was then eliminated by multiplying each of these opponent coordinates by L^*, so that they become zero when L^* is zero, placing black uniquely on the neutral axis. The resulting coordinates are called u^* and v^*, and the system is known (CIE 1978) as the 1976 CIE L^* u^* v^* system, with the official abbreviation CIELUV.

It should be noted that, although the CIE 1976 uniform-chromaticity-scale diagram is a linear transformation of the x, y diagram, the u^* v^* metric chroma diagram is not.

As part of its 1976 recommendation, the CIE also defined the following color terms (see also Section 6B): *metric hue angle*, *metric chroma*, and *metric saturation*. Note that there are two different kinds of metric hue angle and metric chroma, defined for the CIELAB and CIELUV systems, respectively, but only one metric saturation, that in the CIELUV system. The reason for this is that saturation, related to and derived from chromaticity, is defined only for a linear transformation of the CIE x, y system. The relations among metric hue angle, metric chroma, and metric satura-

*Equations for CIE 1976 $L^*a^*b^*$ (CIE-LAB) Color Space*

$$L^* = 116(Y/Y_n)^{1/3} - 16$$

$$a^* = 500[(X/X_n)^{1/3} - (Y/Y_n)^{1/3}]$$

$$b^* = 200[(Y/Y_n)^{1/3} - (Z/Z_n)^{1/3}]$$

Here X_n, Y_n, and Z_n are the tristimulus values of the reference white. For values of X/X_n, Y/Y_n, or Z/Z_n less than 0.01:

$$L^* = 116\left[f\left(\frac{Y}{Y_n}\right) - \frac{16}{116}\right]$$

$$a^* = 500\left[f\left(\frac{X}{X_n}\right) - f\left(\frac{Y}{Y_n}\right)\right]$$

$$b^* = 200\left[f\left(\frac{Y}{Y_n}\right) - f\left(\frac{Z}{Z_n}\right)\right]$$

where $f(Y/Y_n) = (Y/Y_n)^{1/3}$ for Y/Y_n greater than 0.008856 and $f(Y/Y_n) = 7.787(Y/Y_n) + 16/116$ for Y/Y_n less than or equal to 0.008856; $f(X/X_n)$ and $f(Z/Z_n)$ are similarly defined.

The reverse transformation (for $Y/Y_n > 0.008856$) is

$$X = X_n\left(\frac{L^* + 16}{116} + \frac{a^*}{500}\right)^3$$

$$Y = Y_n\left(\frac{L^* + 16}{116}\right)^3$$

$$Z = Z_n\left(\frac{L^* + 16}{116} - \frac{b^*}{200}\right)^3$$

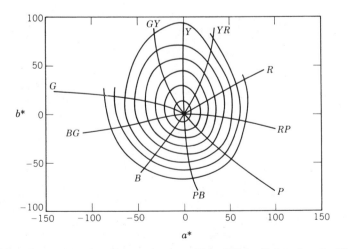

Munsell loci of constant hue and chroma at Munsell Value 5 plotted on the CIELAB chroma diagram (from Robertson 1977).

Equations for the Adams-Nickerson ANLAB 40 Color Space

$$L = 9.2V_y$$

$$a = 40(V_x - V_y)$$

$$b = 16(V_y - V_z)$$

(The "40" refers to a scaling factor making the size of unit distance approximately the same as that of the other spaces considered.) V_y is the Munsell Value function defined on page 60. V_x is obtained by substituting $X/0.9804$ for Y in the same equation, and V_z is obtained by similarly substituting $Z/1.1810$ for Y.

Equations for CIE 1976 L u* v* (CIE-LUV) Color Space*

$$L^* = 116\left(\frac{Y}{Y_n}\right)^{1/3} - 16$$

$$u^* = 13L^*(u' - u'_n)$$

$$v^* = 13L^*(v' - v'_n)$$

Equations for u' and v' were given on page 58. The quantities u'_n and v'_n refer to the reference white or light source; for the 2° observer and illuminant C, $u'_n = 0.2009$, $v'_n = 0.4610$; other values can be calculated from X_n, Y_n, and Z_n given on page 62. For Y/Y_n less than 0.01, use the alternative equation on page 61.

Psychometric Hue Angle in the CIE-LUV and CIELAB Systems

$$h_{uv} = \tan^{-1}\left(\frac{v^*}{u^*}\right)$$

$$= \arctan\left(\frac{v^*}{u^*}\right)$$

$$h_{ab} = \tan^{-1}\left(\frac{b^*}{a^*}\right)$$

$$= \arctan\left(\frac{b^*}{a^*}\right)$$

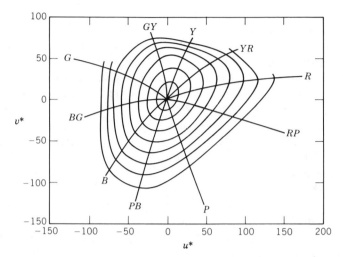

Munsell loci of constant hue and chroma at Munsell Value 5 plotted on the CIELUV chroma diagram (from Robertson 1977).

tion in the CIELAB and CIELUV systems are shown in the figures on this page.

An obvious question at this point is why the CIE found it necessary to recommend not one but two uniform color spaces in 1976. Since the answer is closely associated with the color-difference equations accompanying these spaces, we discuss it with that topic on p. 104.

One-Dimensional Color Scales

Just as lightness scales are used to describe that single property of colored objects, many other systems have been devised for describing the color of a series of related objects in terms of a single

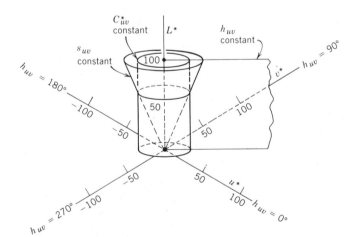

The CIE 1976 ($L^* u^* v^*$) (CIELUV) space, showing surfaces of constant CIE 1976 u, v hue angle, h_{uv}, CIE 1976 u, v chroma, C_{uv}^*, and CIE 1976 psychometric saturation, s_{uv}. Similar surfaces occur in the CIE 1976 ($L^* a^* b^*$) (CIELAB) space except in the case of psychometric saturation (from Hunt 1978a, b).

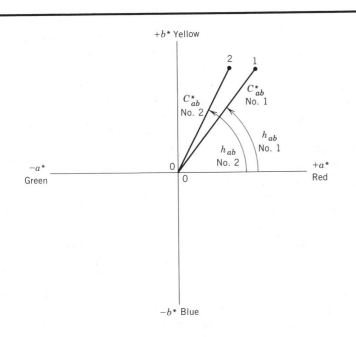

Psychometric Chroma in the CIELUV and CIELAB Systems

$$C_{uv}^* = (u^{*2} + v^{*2})^{1/2}$$

$$C_{ab}^* = (a^{*2} + b^{*2})^{1/2}$$

Psychometric Saturation in the CIE-LUV System

$$s_{uv} = 13[(u' - u_n')^2$$
$$+ (v' - v_n')^2]^{1/2}$$
$$= \frac{C_{uv}^*}{L^*}$$

CIE 1976 *L* a* b (CIELAB) metric hue angle and metric chroma.** Hue angle is measured in degrees starting with $h_{ab} = 0$ in the +a* (red) direction and increasing counterclockwise. Chroma is measured as the length of the line from the neutral point ($a^* = b^* = 0$) to the sample point. Sample point 2 has a larger value of h_{ab} than point 1 and therefore is yellower in hue. Point 2 also has a smaller value of C_{ab}^* than point 1 and is therefore lower in chroma or duller.

number. More often than not, these objects differ in a single respect, such as the amount of a colored component or impurity, and their color varies with this amount over a relatively narrow and well-defined range, for example, from colorless through yellow to orange or red.

The assignment of a color number in such a case usually involves visual comparison of the test object to a series of standards. If the standards are selected to have color and spectral transmittance (or reflectance) curves similar to those of the test object, the comparison is not difficult and the position of the test object on the scale can be determined easily and precisely. In these cases, single-number or one-dimensional scales are very useful.

Yellowness Scales. Since the presence of small amounts of yellowness in nearly white (or nearly colorless) samples is both common and, usually, objectionable, considerable attention has been paid to devising uniform yellowness scales. Some colorimeters (Hunter 1942, 1958) are direct-reading in a yellowness coordinate, *b*. The ASTM (ASTM D 1925) has adopted a yellowness scale (Billmeyer 1966b) based on CIE color coordinates. These scales correlate with visual perception only for colors seen as yellow or blue; in the latter case, the yellowness index is a negative number. They should never be used to describe colors that are visibly reddish or greenish.

On Hunter's colorimeters the color coordinate *b* measures yellowness.

Yellowness coordinate = +*b*

A yellowness index based on CIE tristimulus balues for standard illuminant C and the 1931 standard observer (ASTM D 1925, Billmeyer 1966b).

$$Y.I. = \frac{128X - 106Z}{Y}$$

or more accurately

$$Y.I. = \frac{127.50X - 105.84Z}{Y}$$

Other One-Dimensional Color Scales. Many scales have been devised in attempts to define the color of natural or commercial products (water, lubricating oils, rosin, paint vehicles, and other transparent materials) by single numbers. Some of these are described by Judd (1975a). Correlations among them have been studied by the Inter-Society Color Council (Johnston 1971b). These scales are very valuable when used with the proper precautions.

Limitations of One-Dimensional Scales. Single-number color scales work reasonably well as long as the test sample is quite similar in both color and spectral reflectance or transmittance to the set of standards used to calibrate and maintain the scale.

However, the test sample may differ in color from the standards in some other way than that in which the standards differ among themselves. Then the test sample may neither look like any of the standards nor appear to fall between them, since the sample and standard form a metameric pair (Section 1D). In cases like this it becomes difficult or impossible to make a reliable judgment of the position of the sample on the scale, and indeed it may well be said not to have such a position. Here attempts to use a single-number scale may produce erroneous and misleading results. A common example is the estimation of the yellowness of a reddish or greenish sample, using a set of pure yellow standards: It cannot be done in a satisfactory way.

Whiteness

The following whiteness formula was recommended for field trial by the whiteness subcommittee of the CIE colorimetry committee in 1979:

$$W = Y - a(x - x_n) - b(y - y_n)$$

where W is whiteness, Y is luminance factor, x, y are the chromaticity coordinates of the sample, and x_n, y_n those of the perfect reflecting diffuser. The constants a and b are not yet finally selected and vary with the hue preference (e.g., greenish blue or reddish blue), but a preliminary set for neutral hue preference is $a = 800$, $b = 1700$.

The concept of whiteness is a little different from those of the one-dimensional color scales just described. Whiteness is associated with a region or volume in color space within which objects are recognized as white; degree of whiteness is, in principle, measured by the degree of departure of the object from a "perfect" white. Unfortunately, there appear to be strong prejudices associated with industrial and national preferences which have prevented agreement on exactly what the "perfect" white is, and which directions of departure from it (toward blue, yellow, red) are preferred or avoided. As a result no single formula for whiteness is now widely accepted. The principles to be used for deriving such a formula when and if better agreement is reached are described, together with many current formulas, by Ganz (1976, 1979). In 1979 the CIE recommended field trial of a new whiteness formula, shown on this page.

D. Summary

This chapter has described a few of the ways in which colors may be classified and specified in an orderly fashion. What we have begun to do is assign numbers to the colors and the effects we described in Chapter 1. The next step in this process is to see how such numbers can be obtained; this is the subject of Chapter 3.

Color and Color-Difference Measurement

We have seen—several times by now—that three factors are needed for the production of color: a light source, an object to be illuminated, and an observer who both detects the light and converts the signal it detects into what the human brain recognizes as color. We have seen also that, for many reasons, it is useful to assign numbers to this response called color so that it can be described accurately to someone else, somewhere else, at some other time. Now we come to the question of how this can be done, the subject of color measurement.

When we see the words "color measurement" most of us think of the use of instruments. But this is only one way to measure color, and probably not the most common or the simplest way at that. The visual, rather than instrumental, examination and comparison of colored materials is just as much a measurement of color as that involving an elaborate and complex instrumental method. There is no need to consider the eye and an instrument as fundamentally different tools for measuring color.

We must, of course, never forget that color is what we see; and the measurement of the purely physical aspects of color can never provide an exact duplication of what our brain tells us is "out front."

A. Basic Principles of Measuring Color

Regardless of the techniques used, color measurement can be divided into two major steps: *examination* and *assessment*.

Examination

The step of examination of a color involves just the familiar triad that we have mentioned so many times:

a. A source of light that illuminates the sample and the standard.

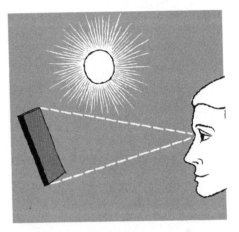

A source of light, an object, and the eye and brain . . .

. . . or a source of light, an object, and a photoelectric detector and meter.

In the visual examination of colored objects, the sample and standard are usually placed side by side and viewed at the same time.

Examination

a. Light source
b. Sample and standard
c. Detector

Assessment

a. Difference or not
b. Description of difference
c. Acceptable or not

Statement of Difference

1. Standardized terminology:
 Sample greener, grayer, and darker than standard

2. Instrument readings:

	Standard	Sample
X	52.21	50.96
Y	59.64	58.61
Z	88.77	84.31

3. Opponent-color differences:

 $\Delta L^* = -0.56$
 $\Delta a^* = -0.83$
 $\Delta b^* = +2.13$
 $\Delta E_{ab}^* = 2.35$

4. Metric differences:

 $\Delta L^* = 0.56$
 $\Delta C_{ab}^* = -0.68$
 $\Delta H_{ab}^* = -2.18$
 $\Delta h_{ab} = -6.2°$

b. The sample that is to be evaluated and the standard against which it is to be compared. In visual examination and in some instruments the standard and the sample are viewed at the same time. Viewing the sample and standard in succession is not good practice visually (Newhall 1957) but is commonly used in instrumental color measurement.

c. Some means of detecting the light that comes from the material being examined.

Assessment

The second step in color measurement is conveniently divided into the three operations necessary to make a decision as to whether the sample is the same as the standard:

a. A statement must be made as to whether there is a difference between the sample and the standard. This statement may be in terms of instrument readings or in words, whether thought, spoken, or written down.

b. Assuming a difference does exist, the statement about it must be expressed in terms that have the same meaning to all the people involved. These terms can be a standardized verbal description, using color terminology previously agreed on (Longley 1979), or the simple statement of the instrument readings themselves, or the coordinates of a point in some acceptable color-order system, to which the visual or instrumental data are converted.

c. The difference, however expressed, must be evaluated, and a decision must be made as to the acceptability of the sample. We have chosen to group these two steps together, although in practice they may be carried out separately, even by people other than those making the measurements.

It is this final step that is the most difficult in the whole procedure of color measurement and evaluation, but it is the one that fulfills the objective of the entire process.

THINK and LOOK

It is clear that people, rather than machines, must get involved in the final steps of the assessment procedure, if nowhere else. The reason for this is obvious: Machines cannot think.

Many of us have seen, and perhaps been amused by, the signs prominently displayed by a large corporation that say THINK. If we have ever seen a machine, such as a large computer, turning out incorrect and useless data at an incredible rate, the signs get somewhat less amusing. They serve as a reminder that so far no machine, but only people (and perhaps not even all people) can do this. So our first word of advice in the measurement of color by any technique is THINK.

A second word of advice is an obvious one since we are dealing with a visual phenomenon: LOOK. This advice also is all too frequently ignored. No matter what methods of color examination are used, we cannot stress too strongly that the samples should be looked at for, in the final analysis, the color match is eventually judged by somebody looking at it.

We feel that, in every place where color is examined, the two words THINK and LOOK should be prominently displayed as a continuous reminder to all.

B. The Sample

As we start our consideration of the steps involved in color measurement, we come first to the origin and preparation of the sample. We believe that these points should be considered in some detail.

Samples for Analysis

One thing that we in the business of coloring frequently forget is that color measurement is nothing more than a special technique of analysis. As such, it shares with all other analytical techniques the fundamental problem of obtaining a representative sample (Walton 1959). Care must be taken in the way in which the sample for analysis is selected, regardless of the means to be used for examining and evaluating the sample. If a decision is to be made on the basis of color measurement about a run of molded-plastic articles, painted parts, or bolts of dyed cloth, we must be certain that the sample to be examined truly represents the material being considered.

Our justification in mentioning this fact, which seems so obvious, lies in our experience that the question of sampling for color measurement is so often ignored. Laboratories in which standard products such as hydrochloric acid are carefully sampled according to statistical plans, and in which the results of replicate analyses must agree within previously stated tolerances, frequently make their color judgments on the basis of a single measurement on a single sample obtained in some fashion unknown to the analyst. Why this should be so we cannot say, except that there is a general aura of mystery and confusion surrounding the question of color measurement in many laboratories.

The first law of analytical chemistry says the analysis is no better than the sample. The second law says that it's no better than the standard, either.

Ben Luberoff

Form Suitable for Inspection

Whether a sample truly represents the material being examined is the first question to be asked before undertaking any color measurement, visual or instrumental. This question includes both selecting a sample and the further step of converting it into a form suitable for inspection. While there are a few cases where a finished article is already in a form suitable for either visual or instrumental examination after proper sampling, most materials require that the sample be handled in some special way. For example, a sample of fabric must be folded so that a standard number of layers is presented for examination, or a sample of paint or plastic molding powder must be converted to a colored object.

In the case of colorants, such as dyes or pigments, the problems are much more difficult, for it is not possible to make a suitable

Munsell Notations of Color Swatches

		H	V	C
Printing ink	50%	5.7G	8.4/3.2	
	75%	6.0G	7.5/7.7	
	Solid	4.9G	6.6/12.6	
Acrylic lacquer	25%	6.0G	5.8/10.2	
	5%	8.1G	7.5/7.2	
	1%	9.7G	8.6/3.7	
Acrylic lacquer on foil	1.6%	5.3G	4.3/10.4	
Vinyl plastisol	1.0 PHR	3.7G	4.2/10.0	
	0.2 PHR	4.3G	5.8/12.7	
Pigment powder		4.4BG	4.3/6.3	

Most colorants look quite different as raw materials (for example, the dry pigment powder sprinkled on the shade card) and as prepared in a form suitable for examination (for example, dispersed in a paint film or a plastic). The Munsell color coordinates of the samples are given above to illustrate the difference.

judgment of the performance of the colorant on the basis of its appearance as a dry powder. There is no substitute for the conversion of the colorant to the final form in which it is to be used, and it is difficult to get a technique on a laboratory scale to duplicate results obtained in the plant with a given dye or pigment (Saltzman 1963a,b).

The conversion of any sample of colored material into a form suitable for examination requires a standardized procedure that is both repeatable (by the same person in the same laboratory) and reproducible (by different people in different laboratories at different times). It is only within the past few years that any amount of data has become available on the ability of the laboratory to produce replicate samples from the same colored materials (Peacock 1953, Billmeyer 1962, Johnston 1963, Saltzman 1965). Only after this ability is acquired and reliable data are available as to the repeatability of the test can one begin to discuss a comparison of a batch of material with any accepted standard. We cannot emphasize too strongly the need to examine every sample-preparation procedure, by statistical means (Fournier 1978), to ensure that precise knowledge of its repeatability has been obtained. As we see in the remainder of this chapter, color-measuring instruments have become so precise in recent years that all too often the ability to prepare suitable samples is the weakest link in the measurement chain.

Again, LOOK

The question of converting a colorant into a form suitable for inspection assumes greater importance where the measurement of color is done by instruments. Reliance on the use of measurements by instruments in laboratories where a sample is simple "fed" to the machine and the results handed back to a central point may lead to serious errors due to improperly prepared samples. When, for example, a paint panel is being looked at and compared with a standard, a trained observer can notice whether or not the sample and standard are in good condition. This is something that no machine, however complex, can do yet. Machines, though useful, cannot think. It is for this reason that we emphasize that the samples that are to be examined for color *must be looked at* before any evaluation is attempted, regardless of the techniques to be employed. This is especially true in large laboratories where sample preparation is done by someone other than the person who makes the examination.

C. Visual Color Measurement

For convenience in discussion, and not because of any fundamental differences, we choose to separate the subject of color measurement into discussions of visual methods and instrumental tests. In each section the three subdivisions of the steps of examination and assessment remain all important. In purely visual examination, however, some of the steps in the assessment procedure may be combined. In many such examinations the evaluation is a simple decision as to acceptability or nonacceptability (go/no-go type of

Examination

a. Light source
b. Sample and standard
c. Detector

Assessment

a. Difference or not
b. Description of difference
c. Acceptable or not

judgment) without any attempt to describe the difference or express it in other than rough qualitative terms.

Sample and Single Standard

The visual examination and evaluation of color is the one most commonly used today. There are many standard methods for making this type of measurement (ASTM D 1535, D 1729, Huey 1972). In the simplest form the essential elements are the sample to be evaluated and a single standard, both viewed at the same time by an observer using a standardized light source. If agreement can be obtained between buyer and seller on the standard to be used and the standard conditions of viewing (including the exact type of light source or sources used), a great step forward has been made, even though the evaluation has been left to the eyes and brains of two different individuals.

For the determination of whether the color of two samples is or is not identical, the visual examination of the two samples, side by side, under standardized lighting conditions, is unsurpassed. In many cases a single light source is not adequate for proper inspection, and two or more standardized sources may be agreed on.

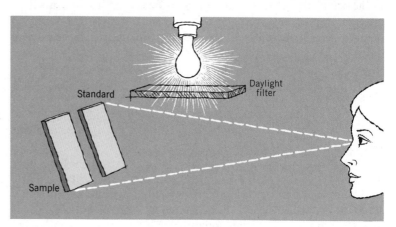

While the eye is an excellent judge of whether or not a color difference exists between two samples . . .

With the increased use of varied light sources, especially those that are quite different from daylight or tungsten lamps, it has become almost essential to use at least two (and in many cases three) standardized sources of illumination for the examination. Furthermore, it is important that buyer and seller, as well as all laboratories within a single company, agree on the particular make and model of standardized source of illumination, since the properties of viewing booths vary significantly from one manufacturer to another.

The related problem of variability in observers has not yet yielded to standardization in a like manner. Differences among observers, all with normal color vision by the usual tests, can lead to at least as great a variation in the judgment of what constitutes a match as can the use of different light sources (Brown 1957, Nimeroff 1962, Smith 1963, Billmeyer 1980a, Kaiser 1980). Unless observer differences are recognized and taken account of, for

... especially if precautions are taken to view them under properly standardized lighting conditions (Macbeth Spectralite, courtesy Macbeth Division, Kollmorgen Corporation) ...

example, by prior agreement, no amount of standardization of light sources can lead to satisfactory results. Again, the importance of this often unrecognized variable cannot be overemphasized. Simple test instruments are available (Color Rules; Hemmendinger 1967) using metameric sample pairs to demonstrate observer (as well as light source) variations. They should be used to screen observers for unusual departures from the average, even within the range of normal color vision. Where standardization among observers in this manner is not possible, more reliance should be placed on the average of observations from a panel of observers.

Sample and Multiple Standards

The use of a single standard against which the sample is compared leads to immediate difficulties when the two are not identical. This stems from the fact that the single standard represents only one point in a three-dimensional world of color. If the sample does not match the standard, we would like both to describe the difference accurately and to say whether it falls within certain limits previously agreed on. That is, we would like to know both *how* and by *how much* the sample and standard differ.

This brings us to an area of quantitative and analytical judgment in which the eye is less adept than it is at judging whether two materials are alike. To use the jargon of the world of instrumentation, the eye is an excellent *null detector*—that is, a detector of the point at which there is no difference. It is considerably less trustworthy in estimating how big a given difference is, or in estimating the nature of the difference.

This limitation of the human eye can be compensated for by giving it more than one standard with which to make comparisons. If the observer has a second standard that is a known distance away from the first (in a given direction in color space), his judgment of whether the sample is closer to or farther away from the primary or *target standard* than is the second or *limit standard* (in the same direction) is made much simpler.

Visual examination with the aid of one or more limit standards in addition to the target standard is becoming quite common. The number of limit standards as well as the degree of difference from the target depend on the level of color tolerance involved (Kelly 1976). In sets of standards of a type commonly used for color signal specifications (such as plastic insulated wire and cable and highway marker signs) as well as for purchase or product specifications, limit standards are provided in six directions from the target standard (Plate V). In addition to the target standard, there are high and low limits for lightness (Munsell Value), hue (Munsell Hue), and chroma (Munsell Chroma). The use of a complete set of limit standards combined with standardized sources provides a very satisfactory procedure for plant control work. It is essential that these limit standards be nonmetameric to the products being inspected. This is not always the case with commercially available systems of this type.

It is important to remember that there is frequently a great difference between the conditions under which colored materials are examined and those under which they are used. The use of color-coded wire and cable is an excellent example. Here it is required that two different colored wires always look different when seen under field conditions. Color standards that provide this assurance must be quite different from those needed to control the color of objects that must look exactly alike under viewing conditions that permit the slightest color difference to be perceived. Limit standards must be adapted to both the tolerance level involved (Kelly 1976) and the purpose for which color control is being sought.

The procedure involving limit standards leads logically to the use of instruments. Since the limit standards define the range of

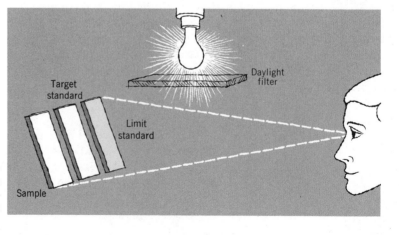

. . . it can estimate the size of such a difference (as between sample and target standard) much better in direct comparison with another color difference (as between limit standard and target standard) viewed at the same time.

acceptable materials, their measurement with an instrument of adequate sensitivity provides numerical values for these limits. The actual numbers obtained depend on the type of instrument and should only be used as previously agreed. This is discussed in Section F of this chapter.

The use of limit standards is quite common in the field of the measurement of the color of liquids or solids where the variation from a standard is primarily in a single dimension of the color solid. Where variation is in more than one direction but consistent for all materials being examined, these one-dimensional scales (Section 2C) have proved to be quite satisfactory in practical use.

Another type of visual comparison, using multidimensional standards of a type with which most people are still unfamiliar, is the United States Department of Agriculture Standards for the grading of cotton (Nickerson 1957). In this instance limit standards, carefully prepared for both color and degree of contamination, have been used for many years and are accepted in all parts of the world where cotton is graded.

Instruments Using the Eye as Detector

In this section we bridge the gap between purely visual and purely instrumental techniques of color measurement by describing a series of methods in which the eye is used to detect the point at which the instrument is adjusted to achieve a color match. In these methods the impressive sensitivity of the eye as a null detector is used to fullest advantage.

Disk Colorimetry. One of the simplest methods, in terms of equipment, for expressing color differences in numerical terms is that of disk colorimetry (Nickerson 1957). This method takes advantage of the ability of the eye and brain to see as a single color the combined effect of several different colors presented to it in rapid succession. This presentation is carried out by preparing a disk made up of sectors composed of different colors and spun rapidly by a small electric motor.

For control work the sample is rotated and compared with a spinning disk consisting of sectors composed of the standard

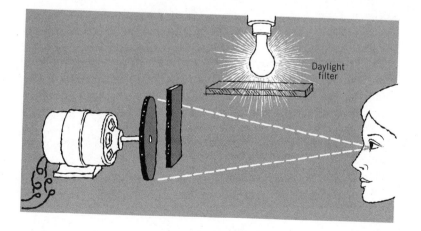

Disk colorimetry.

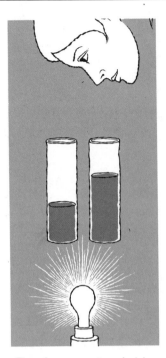

The color comparator principle.

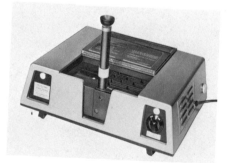

The Lovibond Tintometer.

colorants used in the preparation of the sample. By varying the area of each standard colorant exposed, one can match the sample. It is possible with this procedure to obtain numerical data in terms of the area of each color used and to express the difference between a standard and the sample being examined. This technique, properly used, can be applied to materials of varying textures, such as deep embossings on vinyl plastic, or to printed materials where the printed area is only part of the pattern. Proper use of this method, combined with a knowledge of the colorants used, makes it possible to prepare disks so that a wide variety of application conditions may be simulated, and comparisons with finished materials made in a quantitative manner where no other method of color measurement can be used.

Color Comparators for Liquids. In the examination of the color of liquids, a common technique is the use of a color comparator often called a *chemical colorimeter* (this is a misnomer from the point of view of those of us who measure color, but it is a term widely used by chemists). In a typical comparator, one example of which is the Duboscq color comparator, the thickness of the layer of either the standard or the sample can be varied and, provided the materials have similar chromaticities, a match can be made. The relative depth of solution required to make the match is an indication of the color difference.

It is very easy to see how, in this simple type of visual comparison, the substitution of a photodetector for the eye to judge the balance between the sample and the standard results in an instrumental method of analysis. Here it is quite clear that there is relatively little difference between a visual examination and a fully instrumental one. The one exception—and it is a very important one—is that, even in such a simple comparison, the trained observer can LOOK and see whether the variation between the standard and the sample is such that the balance made by adjustment of cell thickness is enough to bring about a color match. It will not be adequate if there is a difference in hue, if the sample contains suspended material, or if sample and standard differ in still other ways.

In the examination of transparent materials, the half-way point between a completely instrumental examination and a completely visual examination of the sample is exemplified by the Lovibond Tintometer, in which carefully standardized Lovibond colored glasses (page 26) are combined to match a sample that is viewed at the same time. Since the glasses are standardized, it is possible, from the nat of the glasses used to make a match, to describe the sample in numerical terms.

More Refined Instruments. Many spectrophotometers and colorimeters using the eye as a detector were used in the years before photoelectric detectors were developed. Two such instruments of historical importance are the Koenig-Martens spectrophotometer (McNicholas 1928, Priest 1935) and the Donaldson colorimeter (Donaldson 1947).

D. Instrumental Color Measurement

The problem of replacing the eye with an instrument for color measurement can be looked on as one in which a detector that is very sensitive to qualitative differences—in short, one that can THINK—is replaced with one that does not have this remarkable ability but which instead has a much improved ability to measure in a quantitative way. To obtain numbers, and the same numbers every time, we must sacrifice the ability of the human observer to look at a sample in any reasonable sort of light and tell us its hue, lightness, saturation, and many other aspects of its appearance.

If the instrument is to have any value at all, we must build some of this discrimination into it, and this must be done at some place other than the detector, for the properties of available detectors are such that they cannot be changed drastically or readily.

Our well-studied triad of light source, object, and detector suggests how to do this. For a given object and an available detector, we must vary the nature of the light to introduce the ability of the instrument to recognize differences in color. Light is our probe, our surgeon's scalpel, and the nature and amount of information a color-measuring instrument gives depends on the manner and extent to which the light it uses is varied in viewing the sample. We are thus led to a classification of instrumental color-measurement techniques by the way in which the light is treated in the measurement process.

Classification of Methods

Unaltered Light. It is not quite trivial to consider the methods in which unaltered white light is used to illuminate the sample. This is, after all, the common situation where visual examination of colored materials is involved.

Subdividing further, we may note that it makes little difference what kind of light is used when color is not at all involved in the product. An example of a measurement of this kind is the densitometry of black-and-white photographic film: Almost any kind of light source or detector is suitable to measure the amount of blackening in such a system.

If, however, it is required that the instrument measure some one aspect of the appearance of colored objects, specifically their lightness or something related to it (luminous reflectance, luminous transmittance, haze, etc.), in a way that correlates with what the human observer sees, a little more care is needed. The requirement is that the product of the spectral power of the light source times the spectral response of the detector, summed over the visible wavelengths, equals the product of the spectral power of whatever standard illuminant is desired (traditionally illuminant C) and the spectral luminous efficiency $V(\lambda)$ of the standard observer. Light filters are available which allow this requirement to be met for common sources and detectors.

Three Colored Lights. The next step of refinement is in using light as a probe to detect color with instruments in which the sample is viewed in three different kinds of light. They are selected

Instrumental Methods

a. Unaltered light
b. Three colored lights
c. Monochromatic light

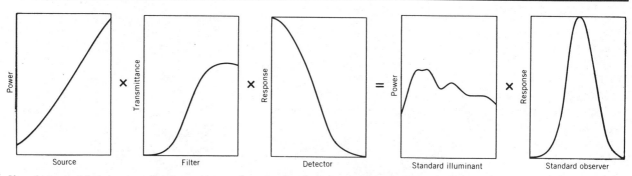

If an instrument is to measure lightness or a quantity related to it in a way that correlates with visual observations, then the product of the spectral power distribution of the instrument's light source and the spectral response of its detector must be adjusted, by the use of an appropriate light filter, to equal the product of the eye's spectral luminous efficiency $V(\lambda)$ and the spectral power distribution of a standard illuminant.

so that the instrument readings are in the form of three numbers which, with suitable standards, are either directly equal to the three CIE tristimulus values or are converted to them by simple calculation. These instruments are called *colorimeters* (in the correct sense of the word, not as it is sometimes used by the chemist). Colorimetry is described later in this section.

Monochromatic Light. The word *monochromatic* means one color, and monochromatic light is light containing only one color of the spectrum. A *monochromator* is a device, which may contain a prism like that first used by Newton (1730) (page 4), for producing such light by splitting white light into a spectrum and isolating one part of it at a time. A color-measuring instrument using monochromatic light can measure the spectral reflectance (or transmittance) curve of the sample. As we saw in Section 1B, this curve contains all the information needed to calculate the color of the sample for any source and observer. We now see how this type of measurement, called *spectrophotometry*, is carried out and review how color coordinates are obtained from the spectrophotometric or spectral reflectance curve.

Spectrophotometry

Spectrophotometry, the measurement of the spectral reflectance or transmittance curves of materials, has many uses besides color measurement. We shall describe only spectrophotometry in the visible region of the spectrum, which we saw on page 4 to be between about 380 and 750 nm, as carried out on instruments especially designed or adapted for color measurement.

Source, Monochromator, and Detector. The principal components of all spectrophotometers are a source of radiation, some means of isolating monochromatic light, and a suitable photoelectric detector. In most analytical instruments and some color-measuring spectrophotometers, white light from the source, often a tungsten-filament bulb, is spread out into a spectrum by means of a prism or a diffraction grating. A slit is used to select a small portion of the spectrum to illuminate the sample. This portion may be between a few tenths and 10 nm wide, depending on the instrument. The wavelength of the light passing through the slit is varied, by

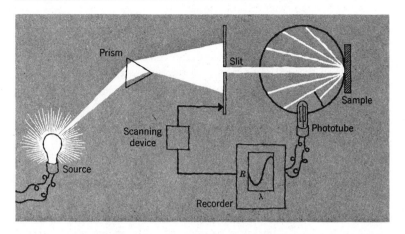

In a spectrophotometer using *monochromatic illumination* of the sample, light is dispersed into a spectrum, made approximately monochromatic by means of a slit, and used to illuminate the sample (in this sketch, using integrating-sphere geometry). The reflectance of the sample is plotted against the wavelength of the light to give the sample's *spectrophotometric* (or spectral reflectance) curve. . . .

automatic scanning, to cover the entire visible spectrum. The monochromatic radiation illuminates the sample, and the light reflected from it is collected and falls on the detector. This mode of operation is known as *monochromatic illumination*. Many other color-measuring instruments reverse this procedure to utilize *polychromatic illumination*. Here the full light from the source, usually a filtered tungsten-filament lamp or a xenon arc, either one simulating daylight, illuminates the sample. The reflected light is passed through the monochromator and falls on the detector.

Abridged Spectrophotometry. This term is used to describe the measurement of a few (often 16–19) preselected regions of the spectrum (often about 20 nm wide), in contrast to the traditional continuous scanning of a narrower band of wavelengths. Abridged spectrophotometers may utilize a series of 16–19 interference filters, transmitting bands of light 20 nm wide, to obtain as many points on the spectral reflectance curve. Or, 16–19 separate detectors may be utilized to measure reflectance at as many wavelengths simultaneously. Instruments using these techniques are somewhat simpler and therefore less expensive, but they provide less information about the spectral reflectance curve.

Sample Illumination and Viewing. Two relatively well-standardized but quite different arrangements of light source, sample,

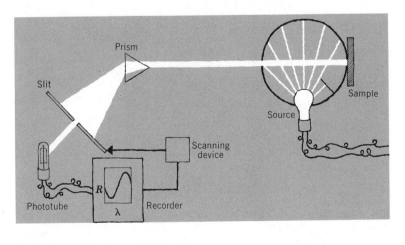

. . . In the reverse procedure, called *polychromatic illumination*, white light (usually filtered to simulate daylight) illuminates the sample. The reflected light goes through the monochromator and is detected.

The 45°/0° bidirectional illuminating and viewing geometry.

The 0°/45° geometry.

and detector are in common use for color measurement, and form the basis of the current CIE recommendation in this regard. One is a *bidirectional geometry*, in which a well-defined beam of light falls on the sample from one direction, and the sample is viewed from a second well-defined direction. In the usual case the sample is illuminated at 45° from the normal to its surface, and viewed along the normal; this is known as 45°/0° geometry. These conditions, or the reversed 0°/45° geometry, which usually gives equivalent results, correspond closely to conditions often used in the visual examination of color.

The other viewing conditions in common use involve an *integrating sphere*, a hollow metal sphere several inches in diameter painted white inside. An integrating sphere collects all the light reflected from the surface of a sample placed against an opening (called a port) in its side. Provision is usually made for including or excluding that part of the light reflected in the mirror, or specular, direction from a glossy sample. Either the detector or the light source is placed to illuminate or view the inside of the sphere, the other viewing or illuminating the sample through a second port.

The integrating sphere has a great advantage for measuring the

Wavelength (nm)	% Reflectance (R)	Weight factor ($P_C\bar{y}$)	Product ($P_C R\bar{y}$)
400	23.3	−0.00001	0
420	33.0	0.00085	0.03
440	41.7	0.00513	0.21
460	50.0	0.01383	0.69
480	47.2	0.03210	1.52
500	36.5	0.06884	2.51
520	24.0	0.12882	3.09
540	13.5	0.18268	2.47
560	7.9	0.19606	1.55
580	6.0	0.15989	0.96
600	5.5	0.10684	0.59
620	6.0	0.06264	0.38
640	7.2	0.02897	0.21
660	8.2	0.01003	0.08
680	7.4	0.00271	0.02
700	7.0	0.00063	0

CIE Y, illuminant C, = 14.31

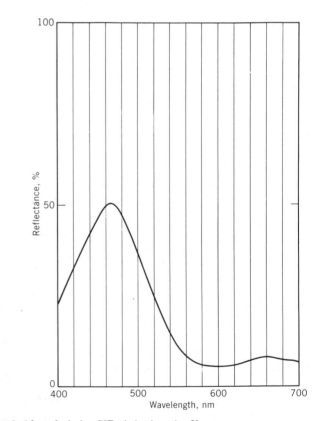

An example of the use of the weighted-ordinate method for calculating CIE tristimulus value Y.

transmittance of translucent samples, since virtually all the transmitted light is collected. For this purpose and for measuring haze and related quantities, these illuminating and viewing conditions must be used. Unfortunately, the integrating sphere and 45°/0° conditions do not give identical results for the reflectance of some samples (Middleton 1953, Billmeyer 1969).

Calculation of CIE Coordinates. As described elsewhere (page 45), the CIE tristimulus values are obtained from spectrophotometric data by multiplying together, wavelength by wavelength, the spectral reflectance of the sample, the relative spectral power of the illuminant, and the tristimulus values of the spectrum colors defining the CIE standard observer. These products are then added up for all the wavelengths in the visible region of the spectrum. Tables are available (Wyszecki 1967, Foster 1970, Stearns 1975), giving the products of the tristimulus values of the spectral colors and the power for various CIE illuminants. These products are called weighting factors, and this method of calculating the CIE tristimulus values is known as the *weighted-ordinate* method (facing page).

All spectrophotometers produced today for color measurement are provided with a built-in digital microprocessor or interfaced to a digital computer that is programmed to store the appropriate weighting factors and compute CIE tristimulus values and chromaticity coordinates, and many other quantities derived from them. Before this use of computers became widespread, another, less accurate, method was used in which the multiplication step at each wavelength was avoided by choosing certain special wavelengths at which the spectral reflectance was measured and added up. This technique was called the *selected-ordinate* method (page 82).

In the application of the weighted-ordinate method, it is important that the tables of weighting factors for small numbers of wavelengths (say 16–19) be calculated to take proper account of the ends of the spectrum which are not included in the measurements, and to weight the intervening unused wavelengths properly. As of 1980 the CIE had not recommended methods for these calculations, but we consider the techniques of Foster (1970) and Stearns (1975) correct, and recommend use of their tables (page 180) of weighting factors.

It must be pointed out that, except for fluorescent materials (page 118), the nature and spectral power distribution of the source in the spectrophotometer are of relatively little importance for the measurement of reflectance (or transmittance) or for the calculation of tristimulus values. All that is required is that the source must be stable and emit sufficient power at each wavelength in the visible region to allow the instrument to function properly in measuring the spectral reflectance curve; the curve is independent of the nature of the instrument source.

Once that curve is obtained, the tristimulus values are calculated from it using numerical data stored for the purpose. These data can be for any desired illuminant, or for several different illuminants if that is desired. The instrument source need not be one of these, and indeed it usually is not.

Reflectance measurement with an integrating sphere. The specular, or mirror, reflection can be excluded from the measured result by being absorbed in a light trap. This sketch illustrates 0°/*d* geometry . . .

. . . whereas *d*/0° geometry is shown in this arrangement.

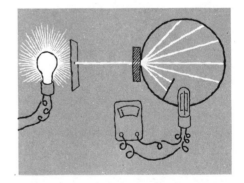

Measurement of diffuse transmittance with an integrating sphere. All the light transmitted or scattered in the forward direction by the sample is included in the measurement. The reversed geometry, with the illuminated integrating sphere providing diffuse illumination of the sample, gives entirely equivalent results.

Standardization and Accuracy. Modern color-measuring instruments are capable of very high precision—that is, repeated measurements of the same, stable sample give the same results with high statistical precision. No longer is the uncertainty of such measurements a serious part of the color-measurement problem. (The same cannot be said of the uncertainty of sample preparation in the usual case, for example!) But no color-measuring instrument can give results that are more accurate than the procedures and material standards with which it is calibrated. When these are carefully controlled, the instrument can hold its calibration better than do many product standards (Marcus 1978a).

The important steps of calibrating a spectrophotometer, testing the accuracy of that calibration by checking the performance of the entire measurement-and-calculation system, and diagnosing the origins of any discrepancies, require the regular use of a variety of material standards (Carter 1978, 1979). The first of these steps, calibration, requires regularly scheduled testing of the adjustments of the wavelength and reflectance scales to ensure that the basic instrument is in good working order. Material standards for this purpose are usually furnished by the instrument manufacturer.

Ordinate number	Wavelength (nm)	Reflectance (R) (%)
1	489.4	42.8
2	515.1	26.9
3	529.8	18.4
4	541.4	13.1
5	551.8	9.6
6	561.9	7.3
7	572.5	6.3
8	584.8	5.8
9	600.8	5.6
10	627.3	6.3

$$142.1 \times 0.100 = 14.21$$

CIE Y, illuminant C, = 14.21

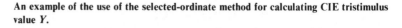

An example of the use of the selected-ordinate method for calculating CIE tristimulus value Y.

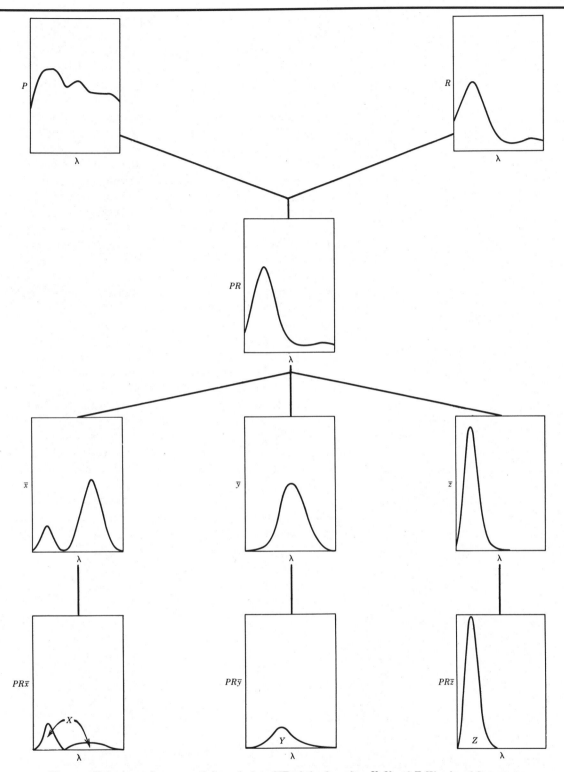

Here are all the spectral curves needed to calculate CIE tristimulus values X, Y, and Z. Wavelength by wavelength, the values of the curves of P and R are multiplied together to give the curve PR. Then, this curve is multiplied, in turn, by \bar{x}, by \bar{y}, and by \bar{z}, to obtain the curves $PR\bar{x}$, $PR\bar{y}$, and $PR\bar{z}$. The areas under these curves, suitably normalized as described on page 47, are the tristimulus values X, Y, and Z.

A part of this calibration procedure is the use of a white reference material to set the reflectance scale at or near its 100% point. The CIE recommends that the *primary standard* of reflectance be the perfect reflecting diffuser, which reflects 100% of the power incident on it, with equal amounts of power being reflected in all possible directions. This primary standard is an ideal that can never be exactly duplicated, but national standardizing laboratories (such as the U.S. National Bureau of Standards) have developed means of measuring real diffuse-reflecting white substances in absolute terms, with the primary standard taken as 100%. These materials, of which the white chemical barium sulfate ($BaSO_4$) pressed to a smooth-surfaced cake is probably the most commonly used, are called *transfer standards* because they can be used to "transfer" the absolute reflectance scale to any reflectance spectrophotometer (Grum 1977, Erb 1979). Other more durable materials such as pressed plaques of certain fluorinated polymers (Grum 1976), porcelain-enamel plates, ceramic tiles, or opal glasses are often calibrated in terms of the transfer standard and then used as day-to-day *working standards* of reflectance. Most modern color-measuring spectrophotometers can store the calibration data for a working standard and compute the absolute reflectances of the samples measured.

The second and third steps of standardization, performance testing and diagnostic testing, are often carried out by measuring sets of calibrated standards of system performance. Two such sets should be mentioned: the NBS Standard Reference Materials 2101–2105 (Keegan 1962, Eckerle 1977), a set of five transmission filters (regrettably no longer available) and the National Physical Laboratory tiles (Clarke 1968, 1969), a set of 12 reflection standards.

Unfortunately, differences in construction and computer programming among commercially available color-measuring spectrophotometers make it very difficult to standardize them so that instruments of different make and model give exactly the same

CIE Standard source	Object	1931 CIE Standard observer	CIE Tristimulus values

$X = 14.27$
$Y = 14.31$
$Z = 51.52$

A reminder of the way in which the CIE tristimulus values are obtained.

readings for identical samples. Some of the reasons for this unsolved problem are discussed in Section 6A.

The newest instruments of the same make and model do provide excellent repeatability and reproducibility, and there has been some consideration of storing numerical standards against which matches can be made, instead of relying on physical standards (Marcus 1978a). This is a risky proposition at best, requiring extreme care in maintenance and calibration, rarely available in an industrial situation. We have not yet seen data indicating that the long-term reliability of the instruments is adequate for this very critical application. It is still the best practice to measure sample and standard on the same instrument at the same time to ensure that the difference between them is correctly evaluated.

Colorimetry

In this section we use the word colorimetry in a somewhat restricted sense. In general, it is taken to mean any technique for measuring color, but here we refer solely to color measurement with photoelectric instruments using three (or four) colored lights.

Source-Detector Response. In Section 2B we saw that the CIE tristimulus values of a sample, that set of three numbers representing its color, can be obtained by combining the sample's spectral reflectance curve with the spectral power distribution of one of the standard CIE illuminants and the response of the CIE standard observer, in the form of the tristimulus values of the spectrum colors. If we wish to duplicate this same process in an instrument, we must make provision for adjusting the combined response of the source and detector used to equal that of the combination of one of the CIE standard illuminants (usually illuminant C) and the tristimulus values of the spectrum. It is usual for this purpose to use glass filters in the light beams in the instrument. The filters thus provide an optical analogue of the numerical data used to obtain CIE coordinates from spectrophotometric data. The degree to which the instrument readings approximate the true CIE tristim-

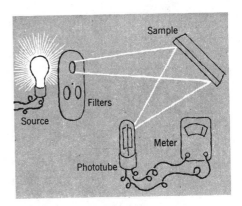

In a colorimeter, light from a source passes through colored filters onto the sample. The reflectance of the sample is measured as it is illuminated, in turn, by the light passing through each filter.

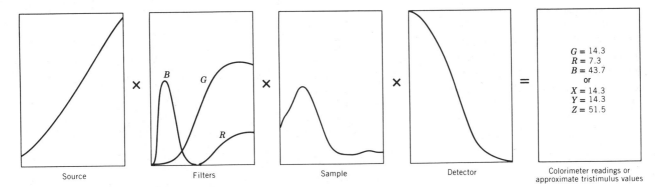

| Source | | Filters | | Sample | | Detector | | Colorimeter readings or approximate tristimulus values |

$G = 14.3$
$R = 7.3$
$B = 43.7$
or
$X = 14.3$
$Y = 14.3$
$Z = 51.5$

In *colorimetry* the tristimulus values or numbers closely related to them are obtained from measurements with the instrument's response (light source times filter times detector) adjusted to that required by the CIE system and sketched in the figure just preceding this one. It is important to note that it is difficult to do this with absolute accuracy.

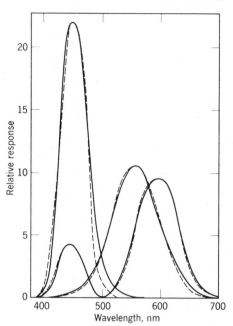

This figure shows how well the CIE color-matching functions (solid lines) are duplicated (dashed lines) in a typical colorimeter.

$$X = 0.98(0.8R + 0.2B) \quad \text{(3 filters)}$$

or

$$X = 0.98(0.8R + 0.2R') \quad \text{(4 filters)}$$

$$Y = G$$

$$Z = 1.18B$$

These equations relate the R (or A), G, and B readings to the tristimulus values by including the weighting factors to give the correct tristimulus values for the perfect diffuser for CIE illuminant C and the 1931 2° standard observer.

The R (or A), G, and B readings of colorimeters, proportional to the tristimulus values X, Y, and Z, are given by the source-filter-photocell combinations indicated in this figure.

ulus values of samples depends on how well these filters duplicate the CIE data.

The curves to be duplicated are shown in the figures on this page, with the curves derived from a typical set of filters. One source of difficulty in duplicating the curves lies in the presence of two peaks in the curve for the X tristimulus value. In some older instruments the small X peak was taken to be identical in shape to the Z curve, but not as high. This procedure has limited accuracy, however, and most instruments use a separate filter to obtain this part of the X curve.

Coordinate Scales. Colorimeter readings can be expressed in several different ways. Perhaps the simplest set of scales is that in which a white working standard is used to set the scales so that the

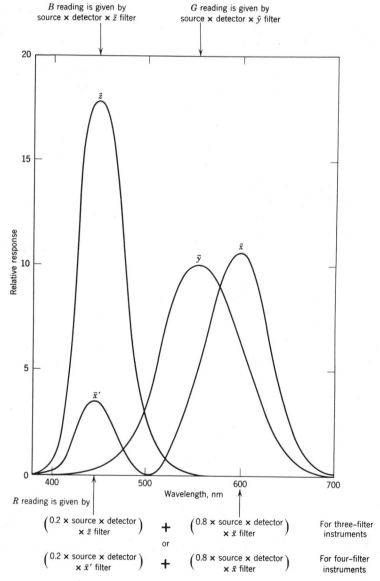

perfect diffuser would read 100 for light coming through each of the filters. These readings are often called G (for green, corresponding to CIE tristimulus value Y), R (for red, or sometimes A for amber, related to the large peak of the X curve), and B (for blue, related to Z). If a fourth filter were used corresponding to the small peak of the X curve, it might be called R'.

Approximate values of CIE X, Y, and Z can be calculated from these readings by adding a fraction of the B reading (three-filter instruments) or R' reading (four-filter instruments) to the R reading, and then multiplying the modified R, G, and B by the proper factors to give the tristimulus values for pure white. Since Y for the perfect diffuser is 100, G and Y are identical by definition.

Many colorimeters are direct reading in opponent-type color scales. A common set (Hunter 1958) consists of L (lightness, related to Y), a (redness, if positive, or greenness, if negative), and b (yellowness, if positive, or blueness, if negative). These are calculated, in modern instruments, by a built-in microprocessor. Most modern instruments are also direct-reading in CIE tristimulus values, CIELAB coordinates L^*, a^*, and b^*, and more. But all are *approximate* values only, because of the limitations on the accuracy of the fit of the filters to the CIE illuminant and observer functions.

Instrument Metamerism. On page 72 we describe a phenomenon known as *observer metamerism*, in which two objects look alike to one observer but not to another, as a result of differences in the spectral response curves of the observers. Exactly the same situation can exist with instruments, and it was once a common and serious defect of colorimeters that they gave different readings from instrument to instrument, sometimes even of the same make and model, for the same sample. These differences resulted from the fact that, with existing sources, filters, and detectors, it was very difficult to make the response curves of different colorimeters exactly alike. In earlier years the filters in each individual instrument were custom tailored to the closest possible correspondence to the CIE functions. With improvements in instrument components, particularly the adoption of silicon-photodiode detectors, this is no longer practiced.

Despite improvements in technology, the practical result of the individual differences in the response of colorimeters is that, when standardized in the usual way on a white sample, different colorimeters still give different readings for the same colored samples (Billmeyer 1962, 1965, 1966a). The differences are greater for darker and more highly saturated samples. For this reason, colorimeter readings obtained in this way *should never* be considered to have any "absolute" significance and *should never* be used for standardization, purchase specification, or the like. Moreover, filter colorimeters provide coordinates for only one CIE illuminant and observer, and therefore can never detect the presence of illuminant metamerism.

Standardization and Differential Use. Perhaps the greatest virtue of colorimeters is their sensitivity in detecting and measuring small differences in color between two samples that are nearly

$$L = 10G^{1/2}$$

$$a = 70G^{1/2} \times \frac{A - G}{A + 2G + B}$$

$$b = 28G^{1/2} \times \frac{G - B}{A + 2G + B}$$

Hunter's opponent-type color coordinates are calculated from colorimeter readings by these equations.

Equations for CIE 1976 L^ a^* b^* (CIELAB) Color Space:*

$$L^* = 116 \left(\frac{Y}{Y_n}\right)^{1/3} - 16$$

$$a^* = 500 \left[\left(\frac{X}{X_n}\right)^{1/3} - \left(\frac{Y}{Y_n}\right)^{1/3}\right]$$

$$b^* = 200 \left[\left(\frac{Y}{Y_n}\right)^{1/3} - \left(\frac{Z}{Z_n}\right)^{1/3}\right]$$

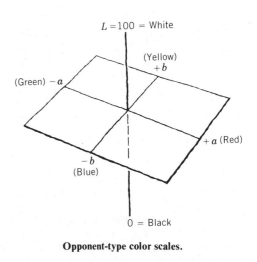

Opponent-type color scales.

alike. This *differential* measurement is highly reproducible from one properly adjusted colorimeter to another (Billmeyer 1962, 1965) and represents the correct way to use these instruments.

The key to achieving this good reproducibility, and thereby extending the correct use of the colorimeter to other situations, lies in the principle of "local" calibration of the instrument. A standard must be provided which has very nearly the same color and spectrophotometric curve shape as the samples to be measured. The smaller the color difference is between the samples and standard, the better will be the reproducibility of the measurements. The requirement of similar spectrophotometric curve shape in general implies that standard and sample must be made of the same material and colored with the same colorants; that is, they should not be metameric.

If the only measurement required is that of the color difference between samples, the standard may be one of the samples, and no absolute significance need be attached to its colorimeter readings. If, however, absolute values of the color coordinates of the samples are to be determined, then such absolute values must be obtained for the standard by some independent method of known accuracy, such as spectrophotometry. If the colorimeter is adjusted to read these values for the standard, it will read correct absolute values for samples with colors lying *within a small region of color space* surrounding the standard.

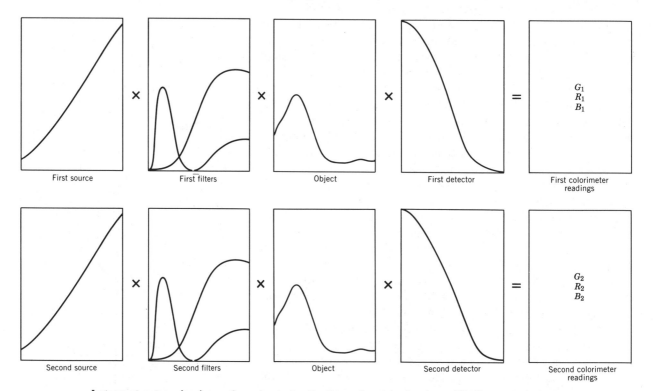

Instrument metamerism is exactly analogous to other types of metamerism (page 52): if two colorimeters have different response curves, they in general give different sets of readings for a pair of samples that match but are a metameric pair. All filter colorimeters suffer from instrument metamerism to some degree.

Differential measurement is not, of course, restricted to colorimeters. Differential spectrophotometry can also be practiced to great advantage, and most modern color-measuring spectrophotometers provide for this by allowing the readings of one specimen to be retained "in memory" as a "standard." The next specimen is then measured as a "trial," and the color difference between the two is calculated (see Section E). With the improved precision and speed of modern spectrophotometers, many of the advantages of colorimeters for this type of measurement have disappeared.

Selecting a Color-Measuring Instrument

A decision about which color-measuring instrument to use should never be undertaken without careful consideration. Too little or too much instrumentation for the task at hand can lead to dissatisfaction and loss of investment. Johnston (1970, 1971a) has pointed out the need to define one's measurement problem as the first step toward the selection of the proper instrument to use. The checklist (Johnston 1970) on this page provides a summary of possible uses for color-measuring instruments, indicating those for which colorimeters or spectrophotometers are more useful.

The nature of the sample should next be considered: State (solid,

A. ☐ Quality control
 1. Visual viewing conditions — ☐ Supplier ☐ defined ☐ normal — ☐ Purchaser ☐ not defined ☐ abnormal — ☐ not known
 2. Visual observer's color vision:
 3. Tolerances: (c)* — ☐ defined ☐ realistic — ☐ not defined ☐ not realistic — ☐ ?
 4. Sampling variability: (c) — ☐ known — ☐ not known
 5. Sample preparation repeatability: (c) — ☐ known — ☐ not known
 6. Reliability of assessment of closeness of match: (c) — ☐ known — ☐ not known
 7. Standards: (c) — ☐ known ☐ stable and unchanging — ☐ not known ☐ not stable, change with time and usage
 (s)† — ☐ non-metameric ☐ same in all aspects of appearance — ☐ metameric ☐ different in appearance
 (s) — ☐ adequate supply ☐ defined and preserved master standard — ☐ inadequate supply ☐ no master standard or reference

B. ☐ Processing (c and s can be helpful)
 1. Accuracy of formula — ☐ very accurate — ☐ approximate only
 2. Control of components — ☐ good — ☐ poor
 3. Control of processing conditions — ☐ good — ☐ poor

C. ☐ Formulation
 1. Match to submitted sample — ☐ must be nonmetameric (s) ☐ use identical colorants (s) ☐ same appearance — ☐ can be metameric (s) ☐ not identical (s) ☐ different appearance
 2. Closeness of match — ☐ very close (c) — ☐ approximate (c)

D. ☐ Other — ☐ Research — ☐ Design

* (c) Based on colorimetry.
† (s) Based on spectrophotometry.

liquid, powder), opacity, fluorescence, texture and surface quality, gloss, uniformity and directionality, sensitivity to heat, light, or moisture, and size must all be taken into account. One can then turn to the manufacturers' literature or summary articles (Billmeyer 1978c, Rich 1979) to find the proper selection of an instrument with capabilities and cost matched to the requirements of the tasks at hand.

Features of Current Instruments

Between 1976 and 1978 an entire new generation of color-measuring instruments became available, featuring unconventional approaches as well as advances in conventional optics and electronics over those previously used. Although experience dictates that the lifetime of a given generation of instruments is far less than that of a given edition of a book, the most important of these instruments are described in the remainder of this section. Some other instruments, available in the same period or in the recent past, are also mentioned.

The important new instruments have in common a number of greatly improved characteristics, including the following:

Speed. Spectrophotometers as well as colorimeters can now provide tristimulus values from measurements at 20-nm intervals in only a few seconds; the use of smaller intervals takes a little longer. It is therefore possible to make measurements of replicate samples, taking advantage of averaging to reduce the uncertainties resulting from sample variations.

Reproducibility. Modern color-measuring instruments can typically reproduce the measurements of stable, uniform samples with an uncertainty of less than a tenth of the just-perceptible color difference. This performance, resulting in part from internal storage of calibration data and averaging of multiple measurements, means that the instrument is no longer the weak link in the measurement chain.

Computing Power. The important new instruments are all interfaced to digital computers or equipped with microprocessors. Computation of a wide variety of psychophysical and psychometric color coordinates and color differences is rapid and automatic.

Peripherals. Printers, plotters, cathode-ray-tube displays, and paper or magnetic tape or disk accessories are widely available, and virtually all of the new instruments can be obtained as parts of computer-color-matching systems, as described in Chapter 5.

Spectrophotometers

In this section the new spectrophotometers are described by prime manufacturer, arranged in alphabetical order.

Diano Hardy II. While the spectrophotometers based on Arthur C. Hardy's (1935, 1938) design are not new (they were formerly made by General Electric) and the Hardy II has been on the market for several years, it is included here because it was the first to offer many of the technological advances described earlier. It is a true recording integrating-sphere spectrophotometer (and therefore runs more slowly than microprocessor-controlled

abridged instruments) interfaced to a computer and offering either polychromatic illumination for fluorescent samples or the more sensitive monochromatic illumination. Diffuse transmission measurement with the sample at the sphere wall is standard. In all respects it is a precision-made instrument, and in many still the standard for instrument performance. In addition to the recorded curve, a typewriter provides printed output.

The Diano Hardy II spectrophotometer (courtesy Diano Corp.).

Diano Match-Scan. The newest of the instruments to be described, this is an instrument that is essentially conventional in the selection of well-tested components (using, for example, a grating monochromator), yet offering all the exciting features of the new instruments. Minicomputer controlled, its integrating-sphere geometry and choice of polychromatic or monochromatic illumination are patterned after those of the Hardy II. As on that instrument, its area of sample viewed can be varied continuously from about 20 mm down to 2 mm diameter. It is perhaps the most ver-

The Diano Match-Scan spectrophotometer (courtesy Diano Corp.).

satile of the new instruments. Typewriter output is standard, and a recorder is available.

Hunter D54 Series. The first of the new generation of instruments to appear (Christie 1978), the D54P is a single-beam integrating-sphere spectrophotometer utilizing a rotating interference wedge as monochromator. The D54A, utilizing 0°/45° geometry, was announced in late 1979 (Burns 1980). The D54P utilizes polychromatic illumination, and diffuse transmission measurements can be made. The area of view is, however, limited because of the sphere correction to be described. Because this is a single-beam instrument, the sphere efficiency, hence the reflectance reading, depend on the sample reflectance (Goebel 1967). The necessary correction is determined at the factory on suitably aged spheres and programmed into the microprocessor. A neutral gray tile is supplied for periodic measurement to ensure the current validity of the correction. The instrument is sensitive to sphere contamination, and the operator must take care that no colored particles enter the sphere; it does not take much to throw the gray-tile values out of tolerance. A thermal printer is built in, and a sophisticated recorder is available as an accessory.

The Hunter D-54P spectrophotometer with optional Tektronix plotter (courtesy Hunter Associates Laboratory). The ACS Spectro-Sensor is identical in optical and mechanical components to the D-54P measuring unit but has different computing components.

ACS Spectro-Sensor. Applied Color Systems offers an electronically more sophisticated version of the Hunter D54P as the Spectro-Sensor (Stanziola 1979). In this instrument the user is given much more control through the more extensive software. For example, averaging of successive measurements can be accomplished with greater flexibility, and the user can establish his own sphere-efficiency correction factor using gray-tile standards. In other respects the Spectro-Sensor is like the Hunter D54P.

IBM 7409 Series. The IBM 7409 is termed a scanning color sensor, and is available with a variety of sample holders interfaced to the sensor by means of fiber optics. As might be expected from this company, extensive computer facilities are provided. The color sensor includes an incandescent lamp, operating essentially unfiltered. No daylight simulator is available, hence the instrument is not suitable for measuring fluorescent samples as seen under day-

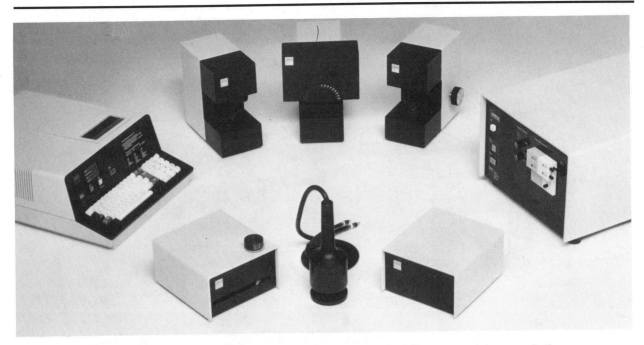

The IBM 7409/10 color-measuring system, showing computer (far left), source and detector unit (far right) and measuring heads for diffuse reflectance, goniophotometry, and multiple-angle measurements (left to right, rear), and specular reflectance, handheld measurements, and transmittance measurements (left to right, front). (Courtesy IBM Instrument Systems.)

light. The sensor also contains a rotating interference filter as a monochromator (the same unit used in the Hunter and ACS instrument) and a silicon photodiode detector. The standard sample holder utilizes 0° illumination and 45° viewing, while accessory sample holders are available, providing viewing at a variety of different angles and providing a handheld sensor head for portable use.

Other color-measuring spectrophotometers, unfortunately no longer available, include the very versatile Zeiss DMC-26 (and its predecessor, the DMC-25), made in Germany. Several analytical spectrophotometers, including the various Cary (made by Varian) instruments and the Unicam (made in England by Pye) can be obtained with integrating-sphere accessories for reflectance measurement, but because of design differences are not likely to be as suitable for color measurement.

Abridged Spectrophotometers

Macbeth 2000 Series. These instruments (Kishner 1978), produced by the Macbeth Division of Kollmorgen, are by far the most innovative of the new color-measuring devices. They utilize a pulsed-xenon flashlamp as the source, providing an extremely brief pulse of light, filtered to simulate daylight, which illuminates the sample. Unlike most of the other instruments, a second incandescent quality source is not available. The Macbeth 2001 uses diffuse illumination with an integrating sphere; in the 2001A and the 4045 (an on-line version), illumination is at 45° with 0°

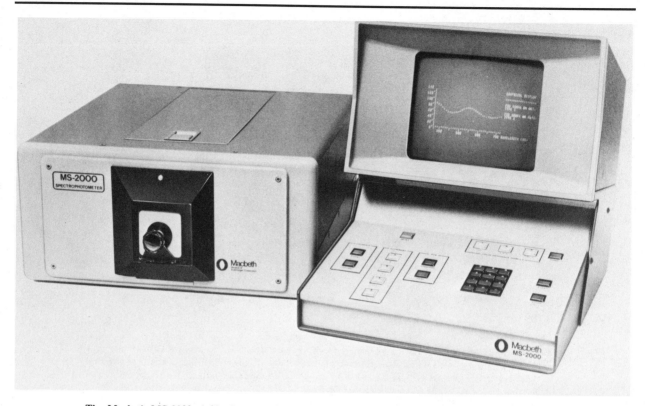

The Macbeth MS-2000 abridged spectrophotometer (courtesy Macbeth Division, Kollmorgen Corporation).

viewing. Externally the instruments appear to be of the single-beam type, as there is no sign of a reference beam or reference standard; this is not the case, however, as they are true double-beam reflectance instruments with an internal reference (in the case of the 2001 it is the wall of the integrating sphere). A fixed grating monochromator projects the entire spectrum of light reflected from the sample onto an array of 17 silicon-photodiode detectors, spaced 20 nm apart across the spectrum, with a spectral bandwidth of 16 nm. Thus 17 points across the spectrum are sensed simultaneously at each firing of the flashtube. A further innovation in these instruments is the use of a logarithmic photometric scale. This provides excellent sensitivity and reproducibility, but does lead to some difficulties for samples transmitting or reflecting nearly 100%, or samples transmitting below 0.1%, which should be of concern to those dealing with such samples. Diffuse transmittance cannot be measured in these instruments. Also, they are true abridged spectrophotometers and can provide no more than the 17 reflectances described above, unlike most of the other instruments described. These instruments are equipped with a cathode-ray-tube display, and both a printer and a plotter that utilizes computer curve smoothing are available as accessories.

The Hunter D25-9 colorimeter showing the 45°/0° measuring head (illuminating at all azimuthal angles) (mounted), and the integrating-sphere and 45°/0° (two azimuthal angles 180° apart) measuring heads (courtesy Hunter Associates Laboratory).

Earlier abridged spectrophotometers that had wide popularity were the Macbeth KCS-18, the Diano ChromaScan, and, in Europe, the Zeiss RFC-3 and the Pretema Spectromat.

Colorimeters

Hunter D25 and Gardner XL Series. Both Hunter and Gardner produce well-tested, reliable, conventional four-filter colorimeters with a variety of illuminating and viewing geometries and comput-

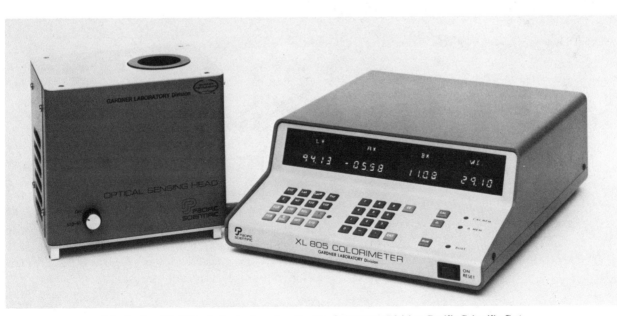

The Gardner XL-805 colorimeter (courtesy Gardner Laboratory Division, Pacific Scientific Co.).

ing facilities. Both series of instruments, in various stages of development, have been on the market for many years with a history of satisfactory performance.

Macbeth 1500 Series. These instruments are optically the same as the 2000 series abridged spectrophotometers, marketed with less extensive software under the designation "colorimeter" (the 1500A is the 45°/0° version, the 1500 the sphere version). The major difference between the two series of instruments is that the "colorimeters" read out only color coordinates and not spectral data. They are, however, much more than conventional tristimulus filter colorimeters because (1) they can be used to detect metamerism and (2) their color coordinates are as accurate as those from the corresponding spectrophotometers since the conventional optical-analogue filters are not required.

The Macbeth 1500 "colorimeter"—actually an abridged spectrophotometer (courtesy Macbeth Division, Kollmorgen Corporation).

Other conventional colorimeters are manufactured by Neotec (Ducolor). In earlier years the Meeco Colormaster and Zeiss Elrepho were popular. Some considerably less expensive colorimeters are currently marketed, but their precision is far less than that required for truly satisfactory color measurement.

E. Color-Difference Assessment

In the beginning of this chapter we divided the subject of color measurement into *examination* and *assessment.* Since these two

parts of the measurement process are usually carried out at the same time when the measurement is done visually, they were considered together in Section C. Since instruments cannot think, however, it is customary—and wise—to consider the problems of assessment before those of instrumental examination.

Assessment by Visual Methods

We have seen that the human eye-brain combination makes an almost unsurpassed null detector. That is, it can tell precisely whether two samples are exactly alike or not. Once there is a perceptible difference between the standard and the sample, however, there is considerable variation in opinion, even among trained observers, as to both the nature and the magnitude of the difference. With untrained observers, this variation is a source of confusion and discouragement. One of the principal reasons instruments are useful is that they have proved quite valuable in reconciling some of these variations in opinion. With instruments the description of the difference between the standard and the sample is unequivocal, even though its meaning in visual terms may be subject to interpretation (Thurner 1965).

The conversion of the description of the relationship between the standard and the sample into some language that is meaningful to all concerned, in terms of color as perceived, is not at all easy. With reliance on trained colorists and a standardized system, it is possible to describe the difference between the standard and the sample in such a way as to make it meaningful to another trained person (Longley 1979). In actual practice even this is not always done. Reliance may be placed on limit standards, and the final assessment may merely be a statement that the measured coordinates of the sample do or do not fall within the region defined by the coordinates of the limit samples as acceptable (Simon 1961). This is best done by the use of color-tolerance charts, as described in Section F.

Assessment by Instrumental Methods

Ideally, the end result of an instrumental color measurement should be a set of numbers describing the nature and magnitude of the difference in color between sample and standard in such a way that the numbers always have the same meaning in terms of visual perception. This has been the goal of the many workers devising the uniform-chromaticity color-order systems described in Section 2C. As we saw there, this goal has not been reached, and there is doubt among many experts that it can ever be reached (Wright 1959).

Nevertheless, there is considerable value in calculating a number representing the magnitude of a color difference, as long as one remembers that the numbers do not usually have the same meaning, in terms of visual perception, for different colors (Nickerson 1944, Davidson 1953, Kuehni 1971, 1972). An additional problem arises, however, in that there are many different ways of calculating such color differences in common use, with much confusion among them, and that these various color-difference numbers do not agree even with one another, let alone with visual perception. Many early

Examination

a. Light source
b. Sample and standard
c. Detector

Assessment

a. Difference or not
b. Description of difference
c. Acceptable or not

Equation	Color difference for		
	Pair 1	Pair 2	Pair 3
Nickerson-Balinkin	5.6	6.1	4.8
NBS	6.4	6.1	5.0
Hunter	2.7	2.5	2.6
Adams Chromatic Value	3.6	5.6	4.4
MacAdam (Simon-Goodwin charts)	10.0	10.9	6.8

These data (Little 1963) illustrate the statement that no two color-difference equations give the same answers for the same sets of data. Therefore, *it is essential that the exact method of calculation be specified whenever color-difference numbers are used.*

The Nickerson Index of Fading Formula:

$$\Delta E = \tfrac{2}{5}C\Delta H + 6\Delta V + 3\Delta C$$

where *H*, *V*, and *C* are Munsell Hue, Value, and Chroma, and the Δ in front of them signifies the difference between sample and standard. Color difference is designated Δ*E*, for reasons that are probably lost in history.

The Balinkin Color-Difference Formula

$$\Delta E = \left[(\tfrac{2}{5}C\Delta H)^2 + (6\Delta V)^2 + \left(\frac{20}{\pi}\Delta C \right)^2 \right]^{1/2}$$

The Adams-Nickerson (ANLAB 40) Color-Difference Equation

$$\Delta E = 40\{(0.23\Delta V_y)^2 + [\Delta(V_x - V_y)]^2 + [0.4\Delta(V_y - V_z)]^2\}^{1/2}$$

where *V* is the Munsell Value function defined on page 60. The factor of 40 for the entire equation has been most frequently used to "normalize" the size of the color difference unit.

studies (Nickerson 1944, Davidson 1953, Ingle 1962, Little 1963) were devoted to demonstrating this fact, now well accepted but too little recognized. Further, it is *not* possible to interconvert between color differences calculated by *any* two methods through the use of average conversion factors (with one exception noted later) despite several earlier papers and books tabulating such factors and advocating their use.

We now describe some of the color-difference formulas that have had (and many of which still enjoy) wide use. In view of the 1976 CIE recommendation that one or the other of two new formulas be used for uniformity of practice (CIE 1978), much of what follows should be considered as historical background and not as recommendations for use. Hunter (1975) provides a more detailed description of the history of color-difference formulas. An extensive review (Wyszecki 1972) and a listing of equations (Friele 1972) provide convenient summaries up to 1971.

By way of introduction it may be noted that all color-difference formulas are designed to provide results that describe or fit well one or another body of visual data (but not more than one, since these data sets are not consistent with one another). Many equations take a form suggested by some theory of color vision, but this is not always the case, others being purely empirical in form.

Equations Based on Munsell Data. The uniformity of spacing of the samples of the *Munsell Book of Color* (page 28) implies constant color difference between adjacent samples (taking account of the cylindrical nature of the *H, V, C* system). These differences are much larger than those of industrial interest, but both the early studies leading to the Munsell spacing and recent work (Marcus 1975, Billmeyer 1978b) show that uniformity of step size is retained down to 4–5 times the just-perceptible difference.

The first color-difference equation known to us, the Nickerson (1936) Index of Fading, simply added up differences in Munsell coordinates between sample and standard. Balinkin (1941) revised this formula to correspond to Euclidean geometry, in which the slant distance between two points is the square root of the sum of the squares of the distances between them along three mutually perpendicular coordinate axes. Ever since, the assumption that color space is Euclidean has been retained, being even questioned in only a few instances (e.g., Judd 1970).

Because of the difficulty of calculating Munsell coordinates from CIE tristimulus values, these equations and later modifications (Godlove 1951, Judd 1970) have not been very popular. Adams (1942), using his chromatic-value theory of color vision, derived a very widely used equation known today as the Adams-Nickerson or ANLAB formula. Tables were widely used to aid in calculating the Munsell-type value functions used in this formula (see Nickerson 1950b, Billmeyer 1963a, McLaren 1970, and most general books on color for abbreviated tables). Later Glasser (1958) introduced the cube-root approximation to the value function described on page 61. Saunderson (1946) and Reilly (1963) provided further modifications. The present CIE-recommended CIELAB equation derives directly from the ANLAB formula, as described on page 103.

More recently, the Optical Society of America Committee on Uniform Color Scales published a color-difference formula (MacAdam 1974) based on the spacing of the OSA samples, but the Committee does not recommend its use for small color differences.

Equations Based on Just-Perceptible-Difference Data. Some of the earliest data on the spacing of colors were obtained, even before the CIE system was devised, from visual judgments of the sizes of just-perceptible color differences. This body of data was used to produce several early transformations of the CIE x, y diagram to more nearly equal visually spaced forms. Several well-known color-difference equations trace their origin to these early data and transformations.

A color-difference unit based on the uniform chromaticity scale of Hunter (1942) was designated the National Bureau of Standards or NBS unit (alternatively, the *judd*, after Deane B. Judd). This system was only rarely used, but the term "NBS unit" was often erroneously applied to the results of other color-difference calculations, including the Adams-Nickerson equation. Another, and quite different, unit of color difference is that derived simply and directly from colorimeter readings in Hunter's L, a, b coordinates (Hunter 1958). Finally, the MacAdam (1937) transformation of the x, y diagram to what became the 1960 CIE u, v diagram was combined with the cube-root lightness scale to give a color space and color-

The Color-Difference Formula for the National Bureau of Standards (NBS) Unit

$$\Delta E = f_g\{[221 Y^{1/4}(\Delta\alpha^2 + \Delta\beta^2)^{1/2}]^2 + [k\Delta(Y^{1/2})]^2\}^{1/2}$$

where f_g takes account of the masking influence of a glossy surface on the detection of color differences, k relates the lightness and chromaticity scales, and α and β are defined below. The gloss factor $f_g = Y/(Y + K)$ where K is usually taken as 2.5, and k is usually taken as 10.

$$\alpha = \frac{2.4266x - 1.3631y - 0.3214}{1.0000x + 2.2633y + 1.1054}$$

$$\beta = \frac{0.5710x + 1.2447y - 0.5708}{1.0000x + 2.2633y + 1.1054}$$

The Color-Difference Formula Using Directly the Readings of Hunter and Gardner Colorimeters

$$\Delta E = (\Delta L^2 + \Delta a^2 + \Delta b^2)^{1/2}$$

where ΔL, Δa, and Δb are the differences in Hunter's $L, a,$ and b coordinates between samples. These coordinates are defined in terms of CIE tristimulus values on page 62.

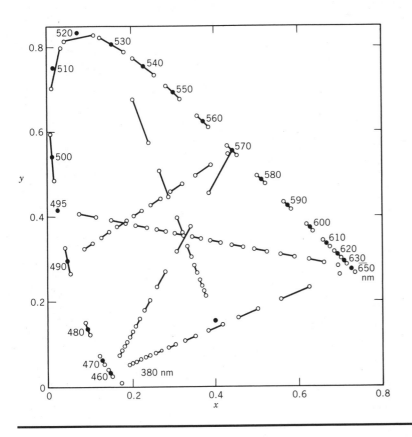

The line segments on this CIE diagram show (magnified 10 times) how far apart two color stimuli must be before the color difference between them can just be seen, on the average. If the x, y diagram were perfectly uniform, all the lines would have the same length, regardless of direction or location (from Judd 1963, after Wright 1941).

The CIE 1964 Color-Difference Equation, Now Superseded by the 1976 CIE Recommendations

$$\Delta E = [(\Delta U^*)^2 + (\Delta V^*)^2$$
$$+ (\Delta W^*)^2]^{1/2}$$

$$W^* = 25Y^{1/3} - 17$$

where

$$Y_{\max} = 100$$

$$U^* = 13W^*(u - u_n)$$

$$V^* = 13W^*(v - v_n)$$

where u_n and v_n are the chromaticity coordinates of the illuminant. For CIE illuminant *C*, u_n = 0.2009, v_n = 0.3073.

difference equation (Wyszecki 1963) adopted by the CIE in its 1964 recommendation. This was superseded by the CIE 1976 recommendation of the CIELUV equation described on page 103.

Equations Based on the Standard Deviation of Color Matching. In a series of papers beginning in 1942 (MacAdam 1942, 1943, 1957; Brown 1949, 1957), MacAdam and his co-workers derived a body of data on the uncertainty with which a match of colored lights could be made. These data comprise the famous MacAdam ellipses in the *x, y* diagram or, if lightness is also taken into account, the corresponding ellipsoids. Later, Brown (1957) found the ellipses for 12 observers, Wyszecki (1971) studied still more, and Rich (1975) obtained similar color-difference-perceptibility ellipses for surface colors. The variations seen represent the spread in color-difference perceptibility from one observer to another within the range of normal color vision.

MacAdam (1943) showed how to use the ellipse data to calculate chromaticity differences. Simon (1958) [and others (Davidson 1955b, Foster 1966)] combined these with a modified Munsell-type lightness calculation to provide sets of charts (available first from the Union Carbide Corporation, now from Diano) very valuable for rapid hand calculation of color differences and, as described in Section F, as color-tolerance charts.

The MacAdam Color-Difference Formula, as Modified for Use with the Simon-Goodwin Charts

$$\Delta E = \left[\frac{1}{K}(g_{11}\Delta x^2 + 2g_{12}\Delta x\Delta y \right.$$
$$\left. + g_{22}\Delta y^2 + G\Delta Y^2) \right]^{1/2}$$

where g_{11}, $2g_{12}$, and g_{22} are constants whose values depend on *x* and *y*, and *G* and *K* are constants whose values depends on *Y*. The value of the constants are "built into" the Simon-Goodwin charts.

These are the famous MacAdam (1942) ellipses; ten MacAdam units in size, they show the areas in the CIE chromaticity diagram corresponding to ten times the standard deviation of color matching for one observer.

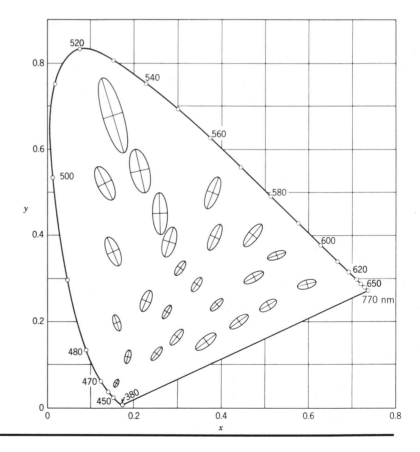

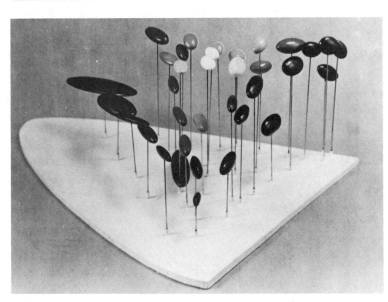

The MacAdam ellipsoids over the CIE *x, y* diagram.

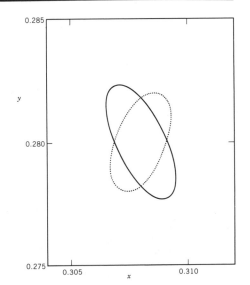

The average ellipse (dotted) for Brown's (1957) 12 observers at one point in the chromaticity diagram compared to the ellipse for one observer.

Later, MacAdam, Friele, and Chickering (1967, 1971) collaborated to produce two color-difference equations known as FMC-1 and FMC-2. The latter was used in the software for several of the first instruments to be interfaced to digital computers, and gained considerable popularity because the computer programs were readily available. Despite the wide use of these equations, neither they nor any others based on MacAdam-type threshold data are represented in the 1976 CIE recommendations.

The Current CIE Recommendations. Color-difference equations known as the CIELAB and CIELUV equations accompany the 1976 CIE recommendation (CIE 1978) for new color spaces, color-difference equations, and color terms discussed on pages 58 and 63. The equations follow directly from the definitions of the psychometric color coordinates described there.

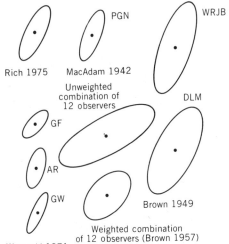

At one location in the chromaticity diagram, this shows the variation in ellipses from observer to observer as studied by MacAdam (1942), Brown (1949, 1957), Wyszecki (1971), and Rich (1975).

A section of a Simon-Goodwin color-difference chart, illustrating the calculation of the MacAdam color difference between a standard with *x* = 0.200, *y* = 0.200, *Y* = 29.0%, and a sample with *x* = 0.205, *y* = 0.195, and *Y* = 25.0%. This chart, drawn according to the values of g_{11}, $2g_{12}$, and g_{22}, for *x* near 0.200 and *y* near 0.200, is used to find the "uncorrected" chromaticity difference between sample and standard. On the original chart, where ½ in. = 1 MacAdam unit, this difference was 8.0 MacAdam units for the test calculation (see page 102). . . .

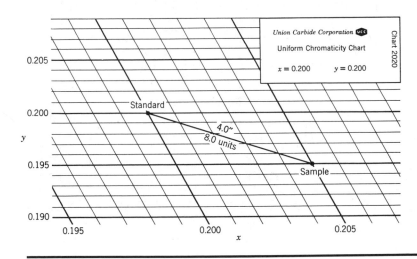

The FMC-1 Color-Difference Formula

$$\Delta E = [(\Delta L)^2 + (\Delta C_{r-g})^2 + (\Delta C_{y-b})^2]^{1/2}$$

$$\Delta L = \frac{K_2 l}{a}\left[\frac{P\Delta P + Q\Delta Q}{(P^2 + Q^2)^{1/2}}\right]$$

$$\Delta C_{r-g} = \frac{K_1}{a}\left[\frac{Q\Delta P - P\Delta Q}{(P^2 + Q^2)^{1/2}}\right]$$

$$\Delta C_{y-b} = \frac{K_1}{b}\left[\frac{S(P\Delta P + Q\Delta Q)}{P^2 + Q^2} - \Delta S\right]$$

$$P = \quad 0.724X + 0.382Y - 0.098\ Z$$

$$Q = -0.480X + 1.370Y + 0.1276Z$$

$$S = \qquad\qquad\qquad 0.686\ Z$$

$$a^2 = \frac{\alpha^2(P^2 + Q^2)}{1 + \dfrac{NP^2Q^2}{P^4 + Q^4}}$$

$$b^2 = \beta^2[S^2 + (pY)^2]$$

$$\alpha = 0.00416 \qquad \beta = 0.0176$$

$$p = 0.4489 \qquad l = 0.279$$

$$N = 2.73 \qquad K_1 = K_2 = 1$$

The FMC-2 Color-Difference Equation Is the Same as FMC-1 with These Added Constants

$$K_1 = 0.55669 + 0.049434Y$$
$$- 0.82575 \times 10^{-3}Y^2$$
$$+ 0.79172 \times 10^{-5}Y^3$$
$$- 0.30087 \times 10^{-7}Y^4$$

$$K_2 = 0.17548 + 0.027556Y$$
$$- 0.57262 \times 10^{-3}Y^2$$
$$+ 0.63893 \times 10^{-5}Y^3$$
$$- 0.26731 \times 10^{-7}Y^4$$

or, alternatively (Judd 1975a, p. 323)

$$K_1 = 0.054 + 0.46Y^{1/3}$$

$$K_2 = 0.465\ K_1 - 0.062$$

. . . The "uncorrected" chromaticity difference ΔC is now measured off at the lightness (Y) level of the *standard* on this chart. The "corrected" chromaticity difference is the distance between this point and the base line, here 9.0 MacAdam units. The total color difference is the slant distance shown, or 13 MacAdam units. (To clarify the test calculation, a rather large color difference was chosen. Note also that in the original Simon-Goodwin charts, Y is expressed as a decimal fraction—for example, 0.25 and 0.29—rather than in percent as is the current CIE convention.)

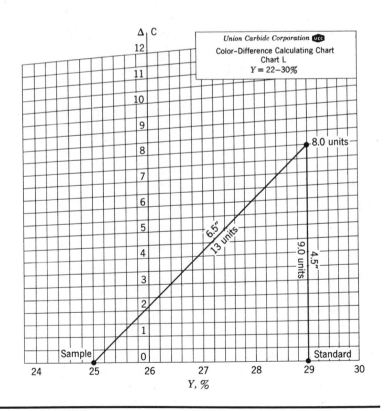

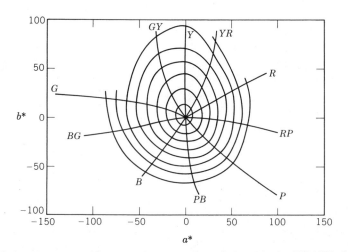

Loci of constant Munsell Hue and Chroma at Value 5 plotted in the CIE 1976 *a* b** diagram (Robertson 1977).

The CIE 1976 L a* b* (CIELAB) Color-Difference Equation*

$$\Delta E_{ab}^* = [(\Delta L^*)^2 + (\Delta a^*)^2 + (\Delta b^*)^2]^{1/2}$$

where the quantities are defined on p. 63.

The CIE 1976 L u* v* (CIELUV) Color-Difference Equation*

$$\Delta E_{uv}^* = [(\Delta L^*)^2 + (\Delta u^*)^2 + (\Delta v^*)^2]^{1/2}$$

where the quantities are defined on p. 58.

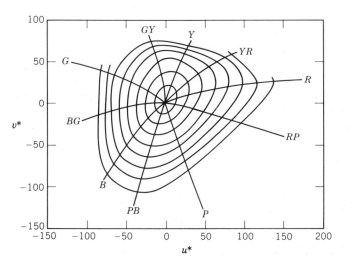

Loci of constant Munsell Hue and Chroma at Value 5 plotted in the CIE 1976 *u* v** diagram (Robertson 1977).

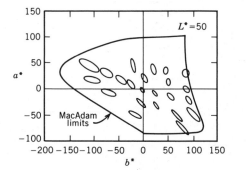

MacAdam ellipses plotted in the CIE 1976 *a* b** diagram (from Robertson 1977).

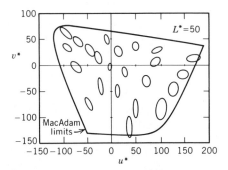

MacAdam ellipses plotted in the CIE 1976 *u* v** diagram (from Robertson 1977).

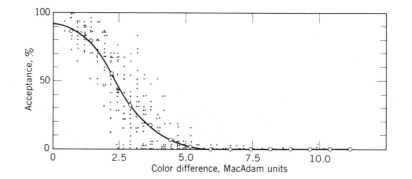

This figure (Davidson 1953) shows that, over a wide range of color differences (here, MacAdam units), some observers will consider a given color difference acceptable, while others will reject it. But the *average* acceptability (solid line) varies smoothly with the size of the color difference.

Breaking Up the CIELAB and CIELUV Color Differences into Metric Hue Differences, Metric Lightness Differences, and Metric Chroma Differences

$$\Delta E_{ab}^* = [(\Delta H_{ab}^*)^2 + (\Delta L^*)^2 + (\Delta C_{ab}^*)^2]^{1/2}$$

$$\Delta E_{uv}^* = [(\Delta H_{uv}^*)^2 + (\Delta L^*)^2 + (\Delta C_{uv}^*)^2]^{1/2}$$

CIE 1976 Metric Hue Differences

$$\Delta H_{ab}^* = [(\Delta E_{ab}^*)^2 - (\Delta L^*)^2 - (\Delta C_{ab}^*)^2]^{1/2}$$

$$\Delta H_{uv}^* = [(\Delta E_{uv}^*)^2 - (\Delta L^*)^2 - (\Delta C_{uv}^*)^2]^{1/2}$$

Relations Between Metric Hue Differences and Metric Hue Angles in the CIELAB and CIELUV Systems, for Small Color Differences Away from the Neutral Axis

$$\Delta H_{ab}^* = C_{ab}^* \Delta h_{ab}(\pi/180)$$

$$\Delta H_{uv}^* = C_{uv}^* \Delta h_{uv}(\pi/180)$$

Unfortunately, the CIE recommendation leaves unanswered, for the average user, the question of which of the two equations, CIELAB or CIELUV, to use. One reason is that there is very little difference in how well (or how poorly) they agree with visual data. Robertson (1977) has shown that neither equation reproduces either the MacAdam ellipses or the spacing of the Munsell colors well. In our opinion, workers in the color-reproduction fields, who prefer a color space that has a chromaticity diagram, that is, a linear transformation of the CIE *x, y* diagram (page 57), will prefer the CIELUV space and probably wish to use the corresponding color-difference equation. Those dealing with the use of colorants in paints, plastics, textiles, and the like, and who may be familiar with the Adams-Nickerson equation, will probably prefer to use CIELAB.

In this respect it should be mentioned that there is just one exception to the rule that it is not possible to convert from one color-difference equation to another by means of average factors: The CIELAB equation is very closely related to the ANLAB, and ANLAB 40 color differences can be converted to CIELAB with good accuracy by multiplying by the constant factor 1.1.

It is convenient to separate the CIELAB or CIELUV color difference ΔE^* into components correlating with hue, value, and chroma. That is, one wishes to have quantities ΔH^*, ΔL^*, and ΔC^* whose squares add up to the square of ΔE^*. Differences in metric lightness L^* and in metric chroma C^* are suitable for this purpose, but differences in the metric hue angle *h* do not have this property. The CIE has therefore defined psychometric hue differences ΔH_{ab}^* and ΔH_{uv}^* to serve this purpose. They can only be calculated from the color difference and the metric lightness and chroma as shown on this page.

The importance of dividing a calculated color difference into its components and examining them separately must not be overlooked. Much valuable information contained in the components of a color difference, whether $\Delta L^*, \Delta a^*$, and Δb^* (using CIELAB as an example) or ΔH^*, ΔL^*, and ΔC^*, is lost in the calculation of ΔE^* (Derby 1973, Fig. 10).

A word of warning: All modern color-measuring instruments calculate color differences to two or more decimal places. Regardless of the equation used or the size of the just-perceptible difference,

there is no significance in visual terms beyond the first decimal place.

Perceptibility Versus Acceptability

Whether or not one has converted instrumental data to single color-difference numbers, heeding all the warnings, the final problem in color measurement is the evaluation of the color difference in terms of the *acceptability* of the sample as compared with the standard. If properly selected and prepared limit standards are used, this final step is made automatically.

If the limits of acceptability are expressed in terms of color-difference numbers, there is a real problem to be faced. Not only is it true that equal color-difference numbers, in any system of calculation so far devised, do not correspond to equal visually perceptible color differences, but it is also found that what constitutes an acceptable color difference is a statistical phenomenon (Davidson 1953). That is, not all people agree on what the size of a commercially acceptable color difference should be. Both individual differences in color perception and personal tastes undoubtedly become important here.

Perhaps the best procedure in cases where customer preference appears to be playing a part is to make color measurements over a sufficiently long period that a historical record is available. If the customer is at all consistent in the way he accepts or rejects material, it is possible in this way to reach agreement as to what constitutes an *acceptable* color difference, even if it bears little relation to what seems to be a perceptible difference. Some colorists (Kuehni 1975a) feel that there is no basic difference between perceptibility and acceptability except that acceptable limits may be somewhat larger than the limits of perceptibility; others (ourselves included) feel that the basic question of what is and what is not acceptable material must be settled in advance by agreement between the buyer and the seller. This is only sound business practice. If instrumental methods are to play a part, they must be defined exactly, including the techniques of measurement, converting the data, plotting or calculating, and evaluating the results. This agreement between buyer and seller is just as much a part of the usefulness of color measurement for purchase specification as are the instruments and computational techniques themselves.

Appropriate Use of Color-Difference Calculations

What, then, is the proper way to make use of color-difference calculations? We think it can be summarized in the following five rules (Billmeyer 1970, 1979b). If they were universally followed, much of the uncertainty, confusion, debate and altercation over commercial color tolerances would disappear, and the lives of many of our colleagues would become significantly happier.

1. Select a Single Method of Calculation and Use It Consistently. For internal use, since it does not make a great deal of difference which equation is used—none of them conforms really well to visual judgments—select on the basis of familiarity, convenience, or experience. *But,* for external use, follow the current

Select a single method of calculating color differences and use it consistently.

Always specify exactly how color-difference calculations are made.

Never attempt to interconvert between color differences calculated by different equations through the use of average factors.

Use calculated color differences only as a first approximation in setting tolerances, until they can be confirmed by visual judgments.

Always remember that nobody accepts or rejects for color because of numbers: it is the way it looks that counts.

CIE recommendation, using the CIELAB or CIELUV equation for uniformity of practice.

2. Always Specify Exactly How the Calculations Are Made. Be sure that the exact formula, with all scaling factors and other variables specified, is written down in some readily referenced and located place, such as a Company report, an ASTM method, a book or publication, or a customer-supplier agreement. Then reference this source consistently. Do not forget that the overall results depend somewhat on the type of instrument used, and see that this is similarly specified.

3. Never Attempt to Interconvert Between Color Differences Calculated by Different Equations Through the Use of Average Factors. With the single exception (Adams-Nickerson to CIELAB) noted above, the only correct way to convert is to go back to the original sample/standard data and recalculate. It must be emphasized that there is, in general, no agreement among the color-difference numbers calculated by any two methods. Comparisons of different methods (Nickerson 1944, Davidson 1953, Ingle 1962, MacKinney 1962, Little 1963) invariably show that the answers obtained are *not* the same, regardless of what "correction" or "adjustment" factors are applied. As a rough rule-of-thumb, however, it is convenient to remember that the MacAdam unit is approximately a just-perceptible difference in color, while several other units, representing approximately an average commercial tolerance, are 2–4 times as large. Among these larger units, all roughly the same size, are the Adams, CIELAB, CIELUV, Hunter, and NBS.

4. Use Calculated Color Differences Only as a First Approximation in Setting Tolerances, Until They Can Be Confirmed by Visual Judgments. If you find that, for a light red, 2 units of type 1 is a good tolerance (unless hue differences get too important)— for example—do not expect that this will hold exactly for a strong yellow, or a maroon, or a bright green, or a dark navy blue. No color-difference calculation is that good today. If you deal with only a few colors, verify the tolerance for each one by using a large number of visual judgments involving as many observers as practical. If you deal with too many colors to make this practical, apply the experience with one color cautiously to other nearby colors until you can see if it *looks* right.

5. Always Remember That Nobody Accepts or Rejects for Color Because of Numbers: It Is the Way It Looks That Counts. Use color-difference calculations for consistency, record-keeping, convenience, objectivity, but always *LOOK*, too.

F. Color Specification and Tolerances

In the final analysis the sale and purchase of colored materials hinge on the conformance of the samples to certain color-difference tolerances. Let us now consider how these tolerances should be set.

Color tolerances are, unfortunately, sometimes set in one of two quite undesirable ways. One is to make the tolerance as tight as possible so long as the vendor can supply satisfactory material. The other is to set the tolerance at the absolute limit of the ability of

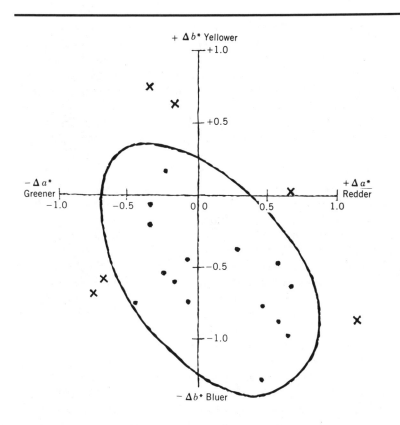

When a history of production of a colored material can be built up, and measurements of the samples can be correlated with customer acceptance (dots) or rejection (crosses), a color-tolerance chart can be produced by plotting sample-standard differences Δa^* and Δb^* on the CIELAB chroma diagram, with the standard at the center. An acceptability locus, which may approximate a circle or an ellipse, or may be an irregular figure, can be drawn. The tolerance figure may not even be centered on the standard (page 108). . . .

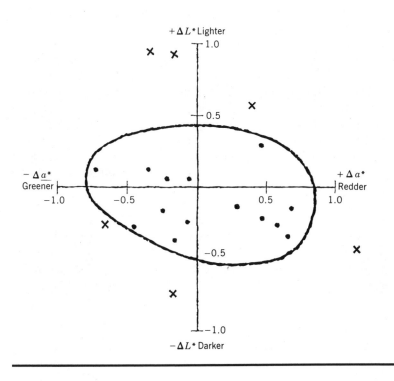

. . . A second diagram is required, in which lightness differences ΔL^* are plotted against either Δa^* or Δb^*, whichever spreads the data out more. Of course, any other uniform-color-space diagram, such as the CIELUV or the Simon-Goodwin charts, could be used instead of the CIELAB diagram chosen for this example.

either the human observer or the instrument to detect a color difference. Both of these methods have a major defect in that they do not relate to what is required. If what is required does call for the utmost in control, then this is what must be furnished, but, to use an example from another industry, it would be foolish (to put it mildly) to order steel bars machined to a tolerance of a thousandth of an inch to be used as reinforcing rods for concrete. One reason this is not done, among others, is the fact that the tighter the tolerance, the higher the price. In this respect the situation in color measurement is unusual in that most requirements still call for "exact" matches. In recent years greater understanding on the part of all involved has resulted in some far more realistic tolerances, especially in the provision of limit standards in the several dimensions of color space. Where an "exact" match is needed, an "exact" match can usually be provided if one is willing to pay for it.

We believe that color tolerances represent and should be set to correspond to agreement between buyer and seller. One way to do this, using instrument readings, is to develop a tolerance chart by keeping a historical record of the measurements of every batch of a given color that is produced. These data should be plotted in an appropriate uniform color space, such as on the Simon-Goodwin charts shown on pages 101–102 or the CIELAB $a*$, $b*$ diagram shown on page 107. As the figures show, the readings for each repeat batch are plotted with an indication of whether it was judged acceptable or not. As the history develops, it should become possible to draw a tolerance figure, which may or may not approximate a circle or an ellipse, or even be symmetrical about the target point, or have the standard at the center (Mackinney 1962, Fig. 75). With experience one can estimate in advance the probability that the next batch made, measured, and plotted will be acceptable. Limit standards for visual judgments can be selected from those batches plotted near the boundary of the tolerance figure.

This procedure, in which great reliance is placed upon instrumental measurements and limit standards, requires extreme caution in the standardization of the techniques employed. Since physical standards may change, it is important that their stability be checked before one uses conformity to these standards as a criterion for acceptability. It must be emphasized that limit standards, whether used only as visual aids or to set up numerical ranges of acceptability, must show the same color change (or lack of change) as the samples with a change of light source.

An alternative way to set up proper limit standards is to select a large number of samples from actual production which show all the possible variations that may be expected from the process. These samples may be separated into acceptable and nonacceptable material by as many qualified observers as are involved in the problem. Measurement of these samples, already separated into categories, provides the coordinates that define the region of acceptable material. These coordinates may then be plotted to provide the tolerance chart.

All the measurements are subject to instrumental errors and care must be taken that the instruments used are in proper operating

condition. It may be self-evident, but the sum of all these errors must not exceed or even use any significant part of any tolerances (Johnston 1963). If these conditions are met, however, it results in a great saving of time and energy when the measurement, whether visual or instrumental, automatically classifies the material without any further calculation or discussion.

The purpose in having a specification—not only in color—is to provide a means for the supplier to offer the user material that is satisfactory for his process (Webber 1976). If the specification is too tight, there will be no supply of satisfactory material; if it is too loose, the end product may be unsatisfactory. Again, this is a case of agreement between buyer and seller: the specification defines a material that the producer can provide and the customer can use, with satisfactory economics. Not all aspects of color are equally important in a specification: hue is usually more important than strength (see p. 149).

The use of instrumental color measurement as a threat or weapon in the buyer-seller relationship, through the measurement of very small color differences that have no significance in terms of function, is an abuse of instrumentation and one that will not contribute to its advance. On the other hand, where instrumentation is used in the measurement of color as an aid to a visual examination; where it is used to show the ability of a method to produce replicate samples that do not differ from each other; where it is used to determine the number of samples that need to be taken to obtain a reliable result; any of these will advance the cause of instrumentation (Johnston 1963, 1964; Saltzman 1965). The use of instruments to determine the variables involved in the procedure for examining colored materials is an appropriate use of instruments and one that will serve to point up the variations due to techniques of measurement as compared with those due to techniques of sampling and sample preparation.

G. Summary

It is our belief that color measurement is the same whether the eye alone is used, or the eye and other instruments are used in combination. The instruments are aids to the eye. Their function, as can be seen from the methods used to convert data obtained from instruments, is to express the color of materials or color differences in terms of what the eye perceives. This does not make the instrument inferior in any way except that it is an aid and not an originator. It does not supersede the trained eye and the mind of the persons involved any more than the pocket calculator takes the place of the person who does the computations. However, like a pocket calculator, a properly working color-measuring instrument can be of great aid to colorists and in many cases a substitute for years of experience in the training period.

In emphasizing that there is no essential difference between color measurement as done by the eye and as done by other instruments, it is our feeling that increased proper use of instruments will resolve some of the problems of color measurement and comparison, especially where quantitative data are desired.

In addition, color measurement serves as a basis for "color memory." The unreliability of the memory, insofar as color is concerned, is well recognized (Bartleson 1960). The proper use of instruments gives to the manufacturer of colored materials a record of production, variation, and limits of acceptability which is independent of the memory of one or more observers. How long it will be before this historical record is accepted by most people in place of their faulty memory is a question best answered by the psychologists. In actual practice we have found that those most familiar with instrumentation are readily convinced by the historical record of instrumental readings on color.

Thus we conclude, and have tried to demonstrate, that there is no contradiction between color measurement with the eye and color measurement with instruments. Properly applied, the instrument can extend the usefulness of the eye. The eye is the final arbiter; the instrument, the aid. Despite our increasing awareness of the fallibility of the eye in critical judgments, requiring the use of panels of observers, no one can deny that it is the visual appearance that counts at the bottom line.

CHAPTER **4**

Colorants

By now we have pointed out to our readers many times that the perceived color of an object depends on the combination of the spectral power distribution of the light source, the spectral transmittance or reflectance of the object on which the light falls, and the spectral response curve of the eye. Yet we do not hesitate to do so again, for it is particularly important to keep in mind in this chapter the threefold nature of the production of what we call color, since this chapter is entirely concerned with only one of these factors. Here we consider the light source and the observer to be constant, and examine those substances used to modify the spectral reflectance or transmittance of an object.

Collectively, those substances that modify the perceived color of objects, or impart color to otherwise colorless objects, are called *colorants*. These are the *dyes* and *pigments* which are added to fabrics, coated on wood or metal with the aid of binders, or incorporated into a plastic mass, to change the original color. Chromatic colorants are characterized by having selective absorption and scattering of light (that is, these quantities vary with the wavelength) so that they selectively modify the spectral power distribution of the light falling on them. Achromatic colorants, such as blacks and grays, are nonselective absorbers. White pigments are nonselective scatterers. We have used the word *substance* in describing these coloring materials so as to exclude those color effects caused by the diffraction of light, such as the colors of feathers or the iridescence of certain insects.

A. Some Matters of Terminology

While colorant is the correct term for describing the materials used to impart color to objects, the word is still somewhat unfamiliar. Most people prefer to speak of dyes or pigments instead of using the more general term. But the need to use two words to include all colorants, as well the confusion existing between dyes and pigments,

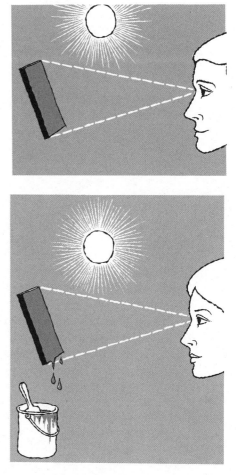

Colorants modify the spectral reflectance curve, hence the color of an object.

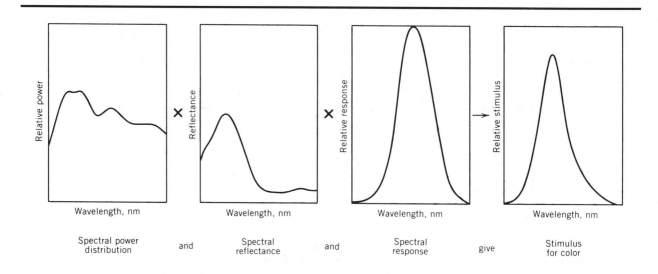

Spectral power distribution and Spectral reflectance and Spectral response give Stimulus for color

described in Section B, is a strong argument for changing to the word colorant.

Even more confusing to those seeking precise definitions is the use of the word *color* in place of *colorant*. This has been traditional, however, as evidenced by the existence of many companies with the word color in their corporate name. Since tradition dies hard, it will be a long time before the word color is no longer used to describe the materials that impart the effect of color. As it is used in this book, *color* means an effect perceived by an observer and determined by the interaction of the three components of light source, object, and observer.

B. Dyes Versus Pigments

In the past, when things were relatively simple, it was easy to distinguish between a dye and a pigment. A dye was a water-soluble substance used to color material from an aqueous solution. A pigment was an insoluble, particulate material dispersed in the medium it colored. While this simple distinction still holds in most cases, there are many exceptions so that additional criteria must be sought to make a distinction between these two types of colorants. No single definition is completely satisfactory since a given chemical compound can be either a dye or a pigment depending on how it is used.

The dictionary definitions depart from the simple criterion of solubility. According to the *Merriam-Webster Unabridged Dictionary* (Webster 1961) a dye may be soluble or insoluble. A pigment, however, is "relatively insoluble." In this book we do not discuss functional or structural pigments. These are normally colorless or only weakly absorbing or scattering materials added to paints and plastics to modify flow or other noncolor properties of the pigmented system.

In the following paragraphs we examine some of the common criteria for distinguishing between dyes and pigments.

Plate I.
Arrangement of samples in the *Munsell Book of Color.* (Courtesy Munsell Color, Macbeth Division, Kollmorgen Corporation.)

Plate II.
The *Munsell Color Tree.* (Courtesy Munsell Color, Macbeth Division, Kollmorgen Corporation.)

Plate III.
Munsell Hue, Value, and Chroma in their relation to one another. The circular band represents the hues in their proper sequence. The upright center axis is the scale of value. The paths pointing outward from the center show the steps of chroma, increasing as indicated by the numerals. (Courtesy Munsell Color, Macbeth Division, Kollmorgen Corporation.)

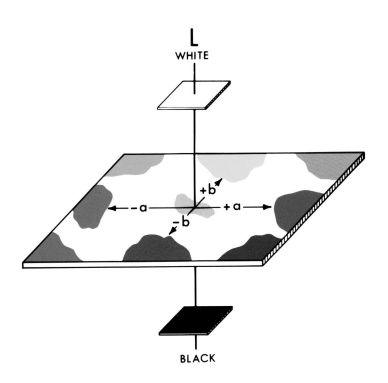

Plate IV.
Coordinates of *L, a, b* color space. In this and similar opponent-color systems, *L* is a lightness coordinate, *a* is a redness-greenness coordinate, and *b* is a yellowness-blueness coordinate. The figure shows which of the colors in each opponent pair is indicated by positive and by negative value of *a* and *b*. (Courtesy Gardner Laboratory Division, Pacific Scientific Company.)

Plate V.
A color tolerance chart, with the color of the standard at the center and six limit-color standards (lighter, darker, stronger, grayer, and differing in hue in each of two directions) around it. Holes cut in the chart allow it to be placed over the color to be judged so that this color is seen in close juxtaposition to the standard and limit colors. (Courtesy Munsell Color, Macbeth Division, Kollmorgen Corporation.)

Foron Blue S-BGL Pat.
Foron Blue S-BGL Paste Pat.

100 parts Granulated = 200 parts Paste

For sublimation-fast ternary combination shades—including thermosol dyed shades—with Yellow-Brown S-2RFL* and Scarlet S-3GFL*, Red S-FL*, Rubine SE-GFL* or Rubine S-2GFL*.

Dacron+ 54 Dyestuff	Thermosol[1] g/l	High temperature (100% PE) %	Carrier (100% PE) %	Daylight ISO	Xenon lamp ISO	Fade-O-meter AATCC	Dry heat ISO 150°C (302°F) 180°C (356°F) 210°C (410°F) S	P	Steam fixation ISO 108°C (226°F) 115°C (239°F) 130°C (266°F) S	P
	1.6	0.072	0.072	6L	6	5	5 / 5 / 5	5 / 5 / 5	5 / 5 / 5	5 / 5 / 5
	6.6	0.6	0.6	6LD	6	5	5 / 5 / 5	5 / 5 / 5	5 / 5 / 5	5 / 5 / 5
	20	1.8	1.8	6DY	6–7	5	5 / 5 / 5	5 / 5 / 4–5	5 / 5 / 5	5 / 5 / 4–5
	40	3.6	3.6	6–7 DY	6–7	5–6	5 / 5 / 5	5 / 4–5 / 3–4	5 / 5 / 5	5 / 5 / 4

Rate of dyeing curves

122 140 158 176 194 212 1h212°F
50 60 70 80 90 100°C 1h100°C.

3,6%
2,7%
1,8%
0,9%
0 %

60 70 80 90 100 110 120 130°C 1h130°C.
140 158 176 194 212 230 248 266 1h 266°F

........................ Carrier process
———— High temperature process

Thermosol curves

100%

50%

180 190 200 210 220°C
356 374 392 410 428°F

— — — — — 100% Polyester fabric 30 g/l
– – – – – – – Polyester/cotton fabric 20 g/l

[1] g/l are valid for the polyester component of a 67/33% polyester/cotton blend, increase of dry weight 60%

Plate VI.
A typical dye shade card. While this example does not show either the *Colour Index* generic classification number or the constitution number, this information is available from the manufacturer. (Courtesy Sandoz Colors and Chemicals.)

Quindo® Magenta RV-6832

Colour Index: Pigment Red 122, 73915

Characteristics and Recommended Uses:

Quindo Magenta RV-6832 is a lightfast, non-bleeding, soft-textured, easy-grinding quinacridone pigment which has a clean magenta undertone and high tinting strength. RV-6832 provides bright full tone reds when combined with organic and inorganic orange pigments, and a full range of darker reds when combined with red oxides. RV-6832 is recommended for automotive OEM, refinish, and all industrial coatings including thermosetting and thermoplastic acrylic, alkyd, nitrocellulose, urethane, epoxy, polyester, and water based systems.

Grinding Equipment and Recommendations:

Recommended for sand mills, stationary and circulating shot mills and ball mills, as well as for two roll mills for chip manufacture.

Lightfastness:

Exterior full shade...Excellent
Exterior tint shade ...Excellent-good

Florida Exposure: 18 months Total Color Change in CIELAB Units	Thermosetting Acrylic
80% RV-6832/20% Aluminum	4
20% RV-6832/80% Aluminum	5.5
20% RV-6832/80% TiO₂ (12 months)	4

Physical Properties:

Bleeding in:

Xylol	None	Water	None
Lacquer Solvents	Trace	5% Hydrochloric	
Ethanol	Slight	Acid	None
Petroleum		5% Soda Ash	None
Solvents	None	10% Caustic	None

Specific Gravity ...1.47
Bulking Value (lbs./gal.) ..12.23
Oil Absorption ...56

Available Forms:

Quindo Magenta RV-6803
Quindo Magenta RV-6823
Quindo Magenta Presscake RV-6831

Empirical Formula:.... $C_{22}H_{16}N_2O_2$
Chem. Abstract No:... 980-26-7
E.P.A. Code No: R110-8688

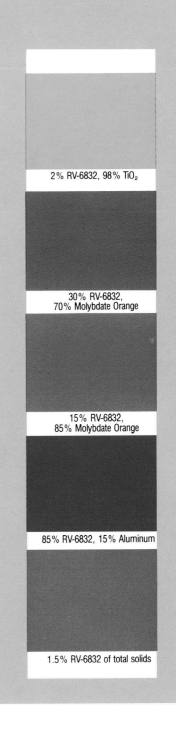

2% RV-6832, 98% TiO₂

30% RV-6832,
70% Molybdate Orange

15% RV-6832,
85% Molybdate Orange

85% RV-6832, 15% Aluminum

1.5% RV-6832 of total solids

Plate VII.
A typical pigment shade card. (Courtesy Mobay Corporation, Dye and Pigment Division.)

Additive Mixing

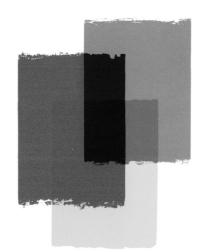

Simple-Subtractive Mixing

Plate VIII.
These illustrations show the results of additive and simple-subtractive color mixing, discussed in Section 5A. The overlapping of the three additive primaries, red, green, and blue (light), in pairs give the colors yellow, magenta, and cyan (blue-green). Where they all three overlap, in the correct amounts, white light results. The primaries for simple-subtractive mixing are yellow, magenta, and cyan, and their overlapping in pairs give the colors red, blue, and green. Where they all three overlap, in the correct amounts, black results.

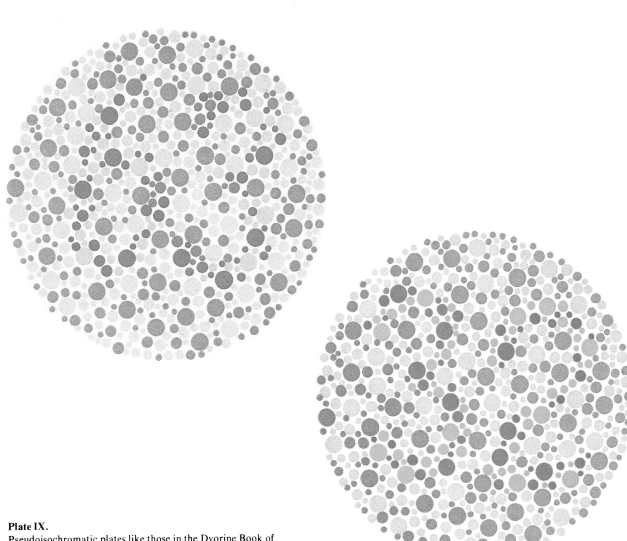

Plate IX.
Pseudoisochromatic plates like those in the Dvorine Book of
Pseudoisochromatic Plates. A normal observer will see two
numbers in these plates; a red-green colorblind observer will
see only unrelated dots. (Simulated Dvorine Pseudoisochro-
matic plates reproduced by permission. Dvorine Color
Vision Test copyright © 1944, 1953, 1958 by Harcourt Brace
Jovanovich, Inc. All rights reserved.)

Plate X.
The Farnsworth-Munsell 100 Hue Test, an excellent test for color discrimination and the type and severity of color-vision defects. (Courtesy Munsell Color, Macbeth Division, Kollmorgen Corporation.)

Plate XI.
The ISCC Color-Matching Aptitude Test, developed by the Inter-Society Color Council and sold by the Federation of Societies for Coatings Technology. (Courtesy of the Federation.)

¹dye \'dī\ *n* -s [ME *dehe,* fr. OE *dēah, dēag;* akin to OE *dīegol* secret, hidden, OS *dōgalnussi* secret, hiding place, OHG *tugōn* to become variegated, *tougan* dark, hidden, secret, L *fumus* smoke — more at FUME] **1 :** color produced by dyeing **2 :** a natural or esp. a synthetic coloring matter whether soluble or insoluble that is used to color materials (as textiles, paper, leather, or plastics) usu. from a solution or fine dispersion and sometimes with the aid of a mordant — called also *dyestuff;* compare PIGMENT, STAIN, TINT; see DYE table — **of deepest dye** *or* **of the deepest dye :** of the worst kind ⟨a scoundrel *of the deepest dye*⟩ **:** of the most pronounced kind ⟨an intellectual *of the deepest dye*⟩

¹pig·ment \'pigmənt\ *n* -s [L *pigmentum* pigment, paint, fr. *pingere* to paint + *-mentum -ment* — more at PAINT] **1 a :** a natural or synthetic inorganic or organic substance that imparts a color including black or white to other materials; *esp* **:** a powder or easily powdered substance mixed with a liquid in which it is relatively insoluble and used in making paints, enamels, and other coating materials, inks, plastics, and rubber and also for imparting opacity and other desirable properties as well as color **b :** a compounding ingredient (as a filler or reinforcing agent) used in the manufacture of rubber or plastics — compare ¹DYE 2 **2 a :** any of various coloring matters in animals and plants; *esp* **:** solid or opaque coloring matter in a cell or tissue **b :** any of various related colorless substances (as various respiratory enzymes)

Solubility

For many years it has been commonly stated that "dyes are soluble; pigments, insoluble." This is generally true: Most dyes are water soluble at some stage in their application to a fiber or fabric. But there are some exceptions, or at least borderline cases. Vat dyes, for example, are normally insoluble in water but are "solubilized" chemically during the dyeing operation. Disperse dyes for synthetic fibers are very slightly soluble, and are so finely dispersed that it is almost academic to argue that they are fundamentally different from completely dissolved substances. In pigment padding an insoluble vat dye is incorporated into a padding paste and applied to the fabric. The dye is converted on the fiber to the soluble form by various techniques that we do not discuss, and then back to the insoluble form that is "fixed" to the fabric. The other ingredients of the padding paste are not required to hold the dye to the fabric and do not remain on the fabric.

While most dyes are applied from aqueous solution, recent concern about the disposition of polluted water in the textile industry has led to considerable experimentation with the application of dyes from solvent solutions. The solvent is recovered, thus reducing the amount of pollution in the plant discharge. Except that an organic solvent is substituted for water, the solubility criterion is satisfied, the solvent being used only to assure intimate contact between the dye and the material being colored.

In contrast to dyes pigments are always insoluble in the medium in which they are used: Any degree of solubility (called *bleed* in pigment-using industries) is considered a defect. We know of no

"When I use a word," Humpty Dumpty said, in rather a scornful tone, "it means just what I choose it to mean—neither more nor less."

Carroll 1960, p. 269

Although transparency or the lack of it is sometimes used to tell a dye from a pigment, this distinction does not always hold. Here, the same colorant is shown to have different transparency depending on its particle size and degree of dispersion. The sample on the right has smaller particle size.

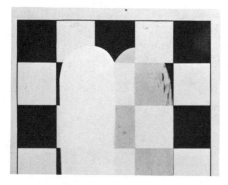

As described on page 12, a colorant must have its refractive index different from that of the material in which it is used to scatter light efficiently. The difference is greater for the sample on the left.

exceptions to this. To put it another way, however, whenever a colorant normally used as the insoluble pigment is utilized in solution, it is simply called a dye!

Chemical Nature

Another traditional distinction between dyes and pigments is that dyes are organic, and pigments inorganic, substances. Again, the situation has changed with time. The number of inorganic dyes is almost zero, but the number of organic pigments has grown steadily since the rise of the organic chemical industry. Today the distinction works only one way: Most dyes are still organic but it is not true that most chromatic pigments are inorganic. In terms of tonnage used, most pigments are inorganic but in terms of dollar value this is no longer the case. Until recently, all white pigments were inorganic, for example titanium dioxide or zinc oxide, but recently plastic microspheres have been shown to be efficient lightweight scattering pigments.

Transparency

Another distinction arose from the use of dyes and pigments to color resins such as paint vehicles or plastics. Colorants that dissolved in the resin and thus gave transparent mixtures were called dyes, in contrast to pigments, which did not dissolve but scattered light and gave turbid, translucent, or opaque formulations. Except that solubility in an organic medium rather than in water is involved, the colorants usually thought of as dyes and pigments satisfy this criterion: If opacity is desired, pigments are used, whereas if one wants to color a transparent resin without spoiling its transparency, dyes soluble in the resin (generally classed as solvent-soluble or oil-soluble dyes) are used.

This distinction still holds for the most part, but many organic pigments (and even a few inorganic pigments) can be so well dispersed that the resulting colored resins or paint films are completely transparent. In many cases they show so little scattering that it is impossible to tell from simple visual examination whether a plastic is colored with a resin-soluble dye or a well-dispersed pigment.

To achieve this degree of transparency requires in most cases that, in addition to an excellent dispersion, the resin and pigment have similar indices of refraction. With organic pigments this condition holds. A few inorganic pigments, such as transparent iron oxide, are of such a small particle size that they do not scatter visible light and are therefore transparent. Opacity, however, is best obtained by taking advantage of the difference in refractive index between the colorant and the resin. Organic materials in general are poor opacifying agents even when they are insoluble because their refractive indices are too close to that of the resin. To achieve opacity with organic pigments one must rely on light scattering by relatively large particle size. This can be achieved at the expense of tinctorial strength. This property of pigments is discussed later in this chapter (pages 117 and 131).

Presence of a Binder

A final distinction, to us the one with greatest validity and fewest exceptions, is based on the mechanism by which the colorant is bound to the substrate. If the colorant has an affinity for the substrate (textile, paper, etc.) and will become a part of the colored material without the need for an intermediate binder, we consider such a colorant to be a dye. This substantivity or affinity for the substrate clearly distinguishes dyes from pigments. Pigments have no affinity to the substrate and require a binder so that the pigment is fixed to the substrate. A pigment applied to a surface without a binder will not adhere to the surface.

The application of this distinction, the need for a binder, to most systems is straightforward. Dyes, whether direct, vat, disperse, solvent-soluble, or other types, are dyes because a binder is *not* required to hold them on the material being colored. (This is true even in "pigment" padding since no binder is left after the process is completed. In the case of "resin-bonded" pigment padding, the colorant—even if it has the same chemical composition—is considered a pigment since the resin is used to fix the colorant on the fabric.)

Pigments, on the other hand, are pigments because they must be incorporated into a binder to be attached to the substrate, as in a paint film attached to the wall of a house. In the case of a plastic that is integrally colored by dispersing an insoluble colorant into the resin, we hedge a little and call the plastic the binder. If a soluble dye is used, we call the same plastic the substrate.

Summary

It is obvious that the criteria we have discussed are all in agreement most of the time. For the most part, the same colorants are likely to be soluble, organic, and transparent, and to require no binder in a given system. These deserve to be called dyes on all counts. In cases of disagreement the choice of a name depends on how the colorant is used. If it is used as a pigment by most of the accepted criteria, it should be called a pigment. The same colorant (see below) if used as a dye by any of the accepted criteria, should be called a dye. To us the most important distinction is that of affinity: will the colorant become part of the substrate without the need for a binder? The colorant that does not need a binder is a dye, otherwise it is a pigment.

C. Classification of Colorants

While colorants can be classified in many ways, in this discussion we follow the system used in the standard work on the subject of dyes and pigments, the *Colour Index* (SDC and AATCC 1971, 1976). In the terminology we advocate in this book this six-volume, 4500-page work should be known as the "Colorant Index."

The Colour Index

In the *Colour Index,* colorants are classified by method of use and are designated by a generic number, for example, C.I. *Vat* Red 13,

C.I. No. 69810 C.I. Vat Blue 14
C.I. Pigment Blue 22

The same chemical compound can be used as either a dye or a pigment depending on the method of application. The *Colour Index* recognizes this by applying the same five-digit number since the chemical compound is the same, but changing the application class numbers as illustrated.

C.I. *Disperse* Blue 7, C.I. *Pigment* Yellow 73, and a five-digit number that gives the chemical constitution of each colorant where this is known (the exact chemical nature of many colorants is still a trade secret). The full designation of our examples would then be C.I. Vat Red 13, C.I. No. 70320, C.I. Disperse Blue 7, C.I. No. 62500, C.I. Pigment Yellow 73, C.I. No. 11138. As users of the *Colour Index* are most often interested in the application properties of colorants, the generic classification by method of use or application makes sense. It is unchanged from the system used in the second edition of the *Colour Index* (1956, 1963) and similar to those used in the first edition (1924, 1928) and in earlier German compilations of this type (Schultz 1921).

The five-digit C.I. number is assigned to a given colorant regardless of the way it is used so that a single C.I. five-digit number may apply to two or more C.I. generic numbers. For example, C.I. Vat Blue 14 and C.I. Pigment Blue 22 are both assigned the same C.I. number, 69810; C.I. Acid Yellow 21 and C.I. Food Yellow 4 both carry the same constitution number, C.I. 19140.

In the third edition of the *Colour Index* there are 31 categories of chemical constitution. Except for the category of Inorganic Pigments more than one C.I. generic or use category is represented in each chemical class. There are 21 generic classes. One class covers all pigments; all the other classes concern themselves with dyes. There are approximately 600 pigments listed as compared with over 7000 dyes. This difference is due primarily to the fact that dyes must have an affinity for the material that they are coloring. The many different materials being dyed require different kinds of dyes. Synthetic fibers, for example, require different dyes than do cellulosics. While some dyes can color different though related types of fibers, generally each type of substrate calls for a special set of dyes.

With pigments the selection of an appropriate binder takes care of the variation in substrates. The same pigment can in many cases be applied to wood, metal, leather, paper, or even textiles by varying the binder or resin in which the pigment is dispersed. Differences in the affinity of a given dye for a specific substrate make it necessary to have a different set of dyes for each of the many

List of generic names of colorant classes in the *Colour Index*, third edition. Note that all pigments are in a single class.

Acid dyes	Fluorescent brighteners	Pigments
Azoic coloring matters	Food dyes	Reactive dyes
Coupling components	Ingrain dyes	Reducing agents
Diazo components	Leather dyes	Solvent dyes
Basic dyes	Mordant dyes	Sulfur dyes
Developers	Natural dyes	Condense sulfur dyes
Direct dyes	Oxidation bases	Vat dyes
Disperse dyes		

substrates to be dyed. A relatively small number of pigments are sufficient for use with the wide variety of resins employed. The nature of the resin and the conditions of application do influence the nature of the pigment which can be used. This is covered in Section E.

By and large, most of the materials listed by the *Colour Index* as dyes are used as such, and those that are listed as pigments are used in that way. There are some exceptions. Some vat dyes are, as we have seen, used as pigments. The same chemicals that are reacted to form azo dyes on the fiber (C.I. Azoic Diazo Components and C.I. Azoic Coupling Components) can also be reacted to form insoluble azo pigments. And there are many instances where a soluble dye is converted into an insoluble pigment by chemical treatment.

The *Colour Index* provides a great deal of useful information about the dyes and pigments listed. Apart from the chemical constitution, it provides methods of application, fastness data, names of manufacturers, and trade names. An excellent discussion on the utility of the *Colour Index* can be found in the paper by Wich (1977).

Without questioning the usefulness of the *Colour Index,* we must insert a word of caution. Commercial colorants, both dyes and pigments, which are listed under both the same chemical constitution and C.I. generic number, may not be identical. In the case of dyes, unless the manufacturer indicates that their product is only "similar to" a given five-digit chemical constitution or a C.I. generic number, the products, while not identical, are generally interchangeable in use. With the pigments we have a different situation. Pigments are insoluble in the medium in which they are used. They therefore must be dispersed. They are generally prepared (or finished) for specific end uses such as paint, plastics, or printing ink. To obtain the best, or the most rapid, or the most stable dispersion, a given chemical entity (as indicated by the five-digit constitution number) may require specific conditioning or finishing. This finishing operation provides the desired combination of average particle size, particle-size distribution, particle shape, or crystal form, with or without the addition of surface-active agents, to optimize the performance of the pigment in a given resin system. Products of identical chemical constitution, such as quinacridone, C.I. No. 46500, which have the single generic number, C.I. Pigment Violet 19, are marketed in at least two crystal modifications, one of which is a violet and the other a red. In some cases the different modifications are recognized by subgroups within a given C.I. generic number. For example, C.I. Pigment Blue 15, 15:2, and 15:3 are all C.I. No. 74160, phthalocyanine blue. However, even within each subgroup are found products prepared for specific applications. Another example is C.I. Pigment Yellow 74, which is sold in at least two very different forms: one is a high-tinctorial-strength, small-particle-size product with relatively poor lightfastness; the other (which carries the same C.I. pigment number) is of larger average particle size, much lower tinctorial strength and correspondingly better lightfastness. Many pigments are interchangea-

C.I. No. 37500
C.I. Azoic Coupling Component 1

2-Naphthol

C.I. No. 37035
C.I. Azoic Diazo Component 37

p-Nitroaniline

Para Red
C.I. No. 12070
C.I. Pigment Red 1

Another case where the same chemical compound can be a dye or a pigment. In the examples shown, Azoic Coupling Component 1 may be combined on the fiber with Azoic Diazo Component 37. The resulting compound is *Colour Index* (C.I.) No. 12070. When the same components are reacted and the resultant product isolated as a dry powder, it is called C.I. Pigment Red 1, the well-known Para Red. In a similar fashion, Permanent Carmine, C.I. No. 12490, can be made on the fiber or as a powder. The combination on the fiber is called a naphthol dyeing; the powder product is called a pigment.

A typical acid dye, C.I. No. 15510, C.I. Acid Orange 7

is converted into the classical lake pigment Persian Orange, C.I. Pigment Orange 17

$$+ \; Al_2O_3 \cdot nH_2O$$

by treatment with $BaCl_2$ (to form the barium salt of the acid dye) and $Al_2(SO_4)_3$ plus Na_2CO_3 (which yields aluminum hydrate, $Al_2O_3 \cdot nH_2O$).

A Soluble Dye is Converted Into an Insoluble Pigment by Reacting it With a Metallic Salt and Absorbing it Onto Aluminum Hydrate.

ble, but not all. The more critical the application, the less likely is it that the general classification of the *Colour Index* will suffice. In such cases it is better to use the *Colour Index* only as a starting point and look at the trade publications of the manufacturers for more specific information.

Up-to-date accounts of the chemistry of synthetic organic colorants can be found in Venkataraman (1952–1978). While most of the volumes deal with dyes, there is an excellent chapter on organic pigments by Lenoir in Volume V (Lenoir 1971). The three-volume treatise edited by Patton (1973) provides information on the chemistry and technology of pigments.

Special Colorants—Fluorescents and Flakes

While perceived colors of all objects depend on the nature of the light, the object, and the observer, there are some special colorants whose presence makes these interactions more complicated than most. These are the fluorescent colorants, both white and chromatic, and the flake pigments such as aluminum and pearlescent particles. Some special problems associated with their use are discussed in Section 6A.

Fluorescent colorants include fluorescent brighteners (also called fluorescent whitening agents—FWAs—or optical brighteners) and chromatic fluorescent dyes and pigments. All these materials absorb light at one wavelength and emit some of it at longer wavelengths. The fluorescent whiteners absorb ultraviolet radiation (at less than 380 nm) and emit it in the visible region. For this reason the amount of light at the wavelength of emission can exceed 100% of the incident light of that wavelength. It is the conversion of invisible radiation to visible light that gives fluorescent whitening agents the ability to make materials look "whiter than white." What happens is that such a material radiates more *visible* light than is incident on it, making it look brighter than a nonfluorescent material which, at best, can only reflect all the visible light that falls on it. To obtain this effect, the light source must contain energy at the appropriate wavelengths in the ultraviolet range to excite the emission in the visible. Lacking the proper spectral power distribution, we cannot obtain fluorescent emission. It is evident that no more *radiation* comes off the sample than has fallen on it. The total radiant power in both the visible and ultraviolet is usually more than the amount of *visible* radiation reflected; the difference in the visible arises from the conversion of ultraviolet radiation to visible light. With fluorescent whitening agents the emission is in the blue region of the spectrum. Since soiled textiles are usually yellowish, the amount of blue light absorbed by the yellow is replaced by the emitted blue light. In the same way fluorescent whitening agents are used to counteract the yellow appearance of many resins. In this function they replace blue pigments (such as laundry bluing) or dyes.

It is important to remember that a special light source containing the proper amount of ultraviolet power is necessary. Natural daylight, as well as many popular fluorescent lamps, contains suffi-

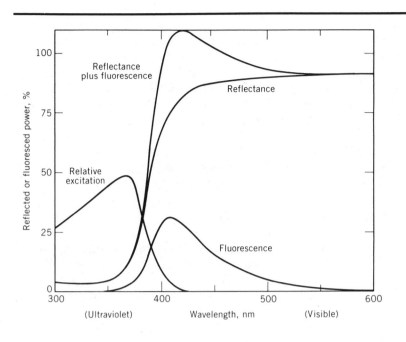

How a fluorescent whitening agent (FWA) works. This figure shows the simulated reflectance curve of a rather yellowed fabric, falling off from a high value in the longer wavelength visible region, and dropping very low in the ultraviolet. The FWA absorbs power in the ultraviolet region (relative excitation curve) and emits fluorescence in the shorter wavelength visible region. This fluoresced light adds to that reflected from the fabric, and it is the sum of the reflected and fluoresced light that is seen. In this case the fabric appears "whiter than white" since the sum exceeds the maximum 100% reflectance possible.

cient ultraviolet power to excite the fluorescent colorants, but by amounts that can differ widely from one source to another.

Materials "whitened" in this manner cannot be measured correctly except with a light source of the proper spectral power distribution to give the desired visual effect. This is different from the measurement of nonfluorescent materials, where any source that contains radiation across the visible spectrum can be used. A second important difference is that fluorescent materials must be measured with polychromatic illumination. Using the proper light source and dispersing the reflected or transmitted radiation yield a spectrophotometric curve that, at least qualitatively, is in agreement with the observed color of the object. To date, however, there is no agreement on a standard method of measuring fluorescent materials (Billmeyer 1979c).

Chromatic fluorescent colorants also exist (Lenoir 1971) and are used for safety and signal purposes as well as for advertising and decoration.

Another class of materials, the flake pigments—either aluminum, widely used in metallic automotive paints, or natural or synthetic pearlescent flakes (Bolomey 1972)—is strongly dependent on the geometry of illumination and viewing. These conditions must be specified precisely for visual examination of paints or plastics containing flake pigments. Special equipment is also needed to measure the color of objects colored with flake pigments. Neither the instruments nor the method of calculation has yet been standardized (Billmeyer 1974).

D. Selecting the Colorants to Use

The ability to select the appropriate colorants for a specific use is of considerably more importance to users of dyes and pigments

than is an understanding of their chemistry or other properties. To cover this subject would require a book many times the size of this one, written by people who are expert in far more areas than we. But the problem is far too important to be ignored. We therefore discuss, in part here and in part in Section E, some of the basic principles to be considered in the choice of a colorant, and indicate the sources of further information on this subject.

Sources of Information

We believe that there are three major sources of information on selecting colorants, valuble both for the beginner in the field of color technology and frequently for his more experienced colleagues.

Experienced Personnel. Perhaps the best source of information on choice of colorants is the senior, more experienced personnel in the laboratory or plant. Given a patient and knowledgeable master and a willing pupil, this source utilizes the best features of the apprentice system. If the knowledge, the time, and the patience are at hand, the information is likely to be the best because it is backed up with actual operating experience in the laboratory or plant concerned. But it is a situation that frequently can serve to perpetuate favorite myths which have grown up in that plant or in that group of people.

Suppliers of Colorants. A major source of information for most people is the suppliers of colorants. Their information is available either through shade cards (Plates VI and VII) and other published material furnished to the customer, or through personal contact between the customer and the supplier's technical representatives. While, admittedly, there may be some commercial bias in the information furnished, this can easily be recognized and discounted; only a little experience is needed to ascertain which companies or representatives furnish reliable information. The technical data provided in the manufacturers' shade card is obtained in a manner that is fully defined in the editorial content of the card. Usually the methods of test are those conforming to international standards, such as those of the International Organization for Standardization (ISO), or national standards, such as ASTM, or the standards of a technical organization in the field, such as the AATCC (Schlaeppi 1974). It is, however, important to note that the fastness data reported for the pigmented systems or dyed systems are valid in a strict sense only for the systems involved and should be used only as a guide if another colored system is of interest. As a starting point in the selection of colorants, the manufacturers' shade cards and, if needed, information from their technical service departments can be a most valuable source of information on the appropriate choice of colorants for a given task.

Books and Periodicals. While there are relatively few books and periodicals relating to the use (in contrast to the chemistry) of dyes and pigments in specific industries, most of them are of very high quality. Unfortunately, apart from the *Colour Index* and the *AATCC Technical Manual,* they contain largely the same information obtainable from the colorant suppliers: it would be most useful if the information were prepared more from the user's point of

References Relating to the Use *of Colorants*

AATCC *Technical Manual,* annually
Modern Plastics Encyclopedia, annually
Patton 1973
Review of Progress in Coloration, annually
Venkataraman 1952–1978
Webber 1979

view. It must be said, however, that the published information differs from direct sales material in that it has been subjected to editing. As with all such published material (including books on the principles of color technology), the combination of the reputation of the writers and the standards of the publisher furnishes a clue to the reliability of the information presented.

The User's Experience. As the colorist gains in experience, his own knowledge will ultimately take precedence over any other information. This must be so, since he alone is working under exactly the conditions that prevail in his plant. Again, as with all generalizations, we must insert a warning note: if the experience of a color technologist relative to a particular problem is contrary to the general experience that has been reported, the entire question should be reexamined. It may well be that something is not being done correctly, and frequently consultation with the dye or pigment supplier may be of great help. This is equally true when, as in many laboratory or plant procedures, the process is "followed exactly" but the results are different from those predicted by the supplier of the colorants involved. While it is perfectly normal and most often justified to take the operating experience in one's own plant as a guide, any serious difference between that experience and the general experience must always be open to question (Wegmann 1960, Smith 1962, Herzog 1965).

General Principles in Choosing Colorants

In the vast majority of cases the class of colorant to be used is dictated by the nature of the material to be colored. Further, this is usually decided by someone other than the colorist in the laboratory. Each class of fabric, each type of plastic, and each kind of paint system has its particular requirements.

One of the principal tasks of a color technologist in industry is to obtain sufficient information from his management or the sales force to make a rational selection of a coloring method in those cases where a choice is possible. Given the problem of coloring a specific material, recourse to the sources of information indicated above will generally give a colorist his preliminary answer. In those cases where there is a choice between dyes and pigments, the decision may be based on economics, availability of equipment, or, as amplified in Section E, the engineering considerations involved.

It would appear, after this lengthy discussion of colorants and comparison of dyes and pigments, that in reality there is little to choose between them. There are indeed differences between them, and there are some cases in which there is a choice of using one or the other of these two classes of colorants. Some examples where such a choice may be made are:

1. Using a pigment or a dye in the preparation of flexographic inks.

2. Coloring a plastic material by fabricating it from precolored polymer (either dyed or pigmented) or by dyeing or painting it after fabrication.

3. Using "spun-dyed" fiber, dyeing staple or yarn, or dyeing or printing (with pigments or dyes) the final fabric.

The Jay. The Bay.

The Blue Jay, as we clearly see,
Is so much like the green Bay tree
That one might say the only clue.
Lies in their dif-fer-ence of hue,
And if you have a color sense,
You'll see at once this difference.

~R.W. Wood 1917

E. Color as an Engineering Material

The Various Meanings of Color

Up to now we have emphasized only one of many meanings of the word color—that which is seen by you and me, the result of our brain's interpretation of the combination of the spectral distribution curves describing a light source, an object, and the response of the eye. At this point it is useful to consider some special ways in which the word *color* is used in present-day technology.

Let us start with the designer or stylist, since it is her concept that ultimately finds its way to the market place. The designer thinks of the effect that she conceives as being a new color: a new hue or shade added to a specific colored material. Of course, in the

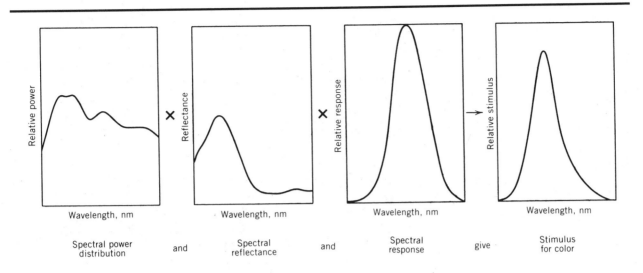

| Spectral power distribution | and | Spectral reflectance | and | Spectral response | give | Stimulus for color |

sense that we use the word, the *color* is not new at all, since all colors already exist. It may be a revival of a style of years gone by, or it may be new to the product involved as a result of new colorants or new coloring methods that make it possible for the first time.

From the point of view of a designer, there are an infinite number of colors, certainly more colors than anyone would want to use at any one time, in a given range of commercial products. This almost infinite number of colors is only apparent, however, since it is not possible to produce all the colors that appear to the eye in the forms in which they can be used industrially. To simplify matters just a little, we will not consider the question of what has been called "appropriateness" of a color. If a designer decides that park benches should be changed from dark green to sky blue with pink polka dots, those who provide the raw materials and the finished products to give this color effect should not place themselves in the position of saying, "Nobody will sit on those benches." We must accept for the moment the designers' or stylists' (the customers') ideas as to what colors they wish to employ in decorating their products.

The manufacturer of colorants speaks of preparing a new *color*, but in a completely different sense. What is meant here is either the preparation of a new chemical entity that can act as a coloring matter or a modification of an old chemical compound to do the same job, sometimes just by making it in a less expensive process. In both cases it is a substance that is new, in either chemical or physical form or both.

Finally, and most important in our discussion, is the colorist's concept of a new *color*. The colorist owes her existence to the need for having a technically trained and skilled person to carry out the designer's wishes, using the appropriate colorants and the best methods of coloring the material chosen. We would like to say that she uses color as an engineering material (Saltzman 1963a,b).

Of course, it is not strictly correct to speak of color, which is a distinctly nonmaterial phenomenon, as a special kind of material, much less an engineering material. What we really mean is the use of colorants and coloring methods in accord with the best engineering practice. Using the word *engineering* in the broadest sense—that is, the use of technically sound principles to carry out a certain operation in a profitable manner—we can consider the use of color from an engineering point of view.

Engineering Properties of Colorants

Let us consider the choices available to a designer who is called on to specify the material and the colorants for a particular object to be colored. Ideally, she would like to have unlimited freedom to specify both materials of construction and color. This happy situation is seldom realized, however, and the colorist interpreting the stylist's demands immediately recognizes a series of limitations within the framework of which she must work. These limitations will no doubt include, but not be limited to, considerations of cost of colorants, methods of coloring, and fastness properties of the product. All these constraints, to some extent, influence the choice of materials, colorants, and coloring methods, and ultimately limit the designer by restricting to some degree the color effects she can achieve.

The ability of a material to be colored is therefore one of its properties and should be considered along with many others in its selection for a particular job. Naturally, the importance that can be placed on colorability varies widely from case to case. In many areas there is no choice of materials and the colorist must simply do the best she can. The selection of a fabric because of some aspects of its performance is an example. But if one is asked to design a container to be used for displaying an object in a retail store, she may well give serious consideration to the question of the colorability of a particular material before making her choice.

Even if the choice of material to be used is dictated by factors other than colorability, the colorist frequently has freedom in the selection of the method of applying the color. It is almost axiomatic that the closer to the final consumer the choice of color is made, the more flexibility the producer has. On the other hand, the earlier in the manufacturing cycle that the color can be selected, the greater the control and uniformity that will result. Both extremes are practiced. Some industries have gone to the coloring of their materials in the earliest possible stage, as in the spin dying of synthetic fibers, while others have decided to color their product at the point of sale, as in the manufacture of house paint by the use of an in-store mixing system in which the colorants are added to base paints at the time of purchase.

As with so many decisions in the industrial world, the choice of colorant and coloring method is usually a compromise between the wishes of the designer or stylist and the real world of available colorants, and the economics that govern the coloring of the object in question. In an ideal world there would be no restriction as to cost, and there would be colorants available for every hue in every

substrate at any desired level of fastness. It is quite evident that this state of affairs does not exist. For this reason the colorist who is to tranform the stylist's designs into the real world of industry must have, at the time the color is planned, a full list of the engineering properties that are needed.

Color Gamuts

Our consideration of colorability really begins at the level of practicability: Can the desires of the stylist be translated into a working material to provide a colored object that satisfies her aesthetic and commercial needs? When we consider this aspect of practicability, we then begin to concern ourselves with the problem of color "gamut," a convenient term used to describe the entire range of perceived color that may be obtained under stated conditions. There are several limitations to the available color effects at our command. These limitations can be discussed in terms of the CIE system (Section 2B). In order of increasing severity they are:

1. The limits of all realizable colors, as indicated by the spectrum locus in the CIE chromaticity diagram.

2. The limits of all possible colors having a given luminance factor (CIE tristimulus value Y, the luminous reflectance or

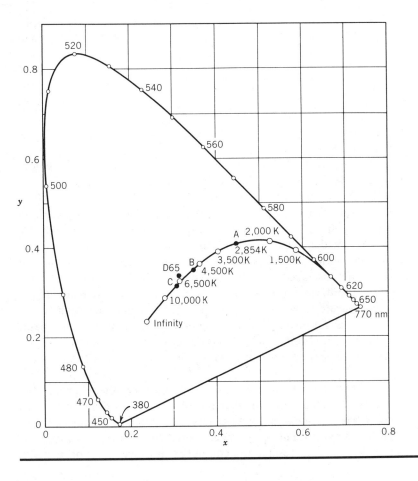

The spectrum locus is the limit of all realizable colors. . . .

... The MacAdam (1935) limits define all possible surface colors having a given luminance factor, ...

transmittance of the sample), as defined by the MacAdam limits (MacAdam 1935).

3. The further limitation to the gamut of surface colors obtainable, resulting from the fact that even the darkest colors reflect some light from the surface, independent of the degree of absorption. The amount of this reflectance varies with gloss and may vary from hue to hue. This may amount to approximately 4% of the incident light. When this correction is applied, we get another series of maps of color space, reduced in area and somewhat displaced in position (Atherton 1955).

4. Limitations set by the working properties and reactivity of the substrate, and the performance requirements of the material after it is finished. (For a discussion of these factors for paint systems, see Moll 1960.) Consideration of these factors again reduces the gamut, but not in as readily calculable a way as in steps 1–3.

5. Limits set by real colorants. We now begin to approach the practical problem of the selection of colorants to obtain a given color. Here we deal, not with theory, not with any system, but with physically realizable color effects based on existing coloring matters. Usually this results in a contour at any given level of lightness

... the Atherton and Peters limits (Atherton 1955) take account of surface reflections, ...

... while the properties of real colorants limit the gamut of possible colors still more (Pointer 1980).

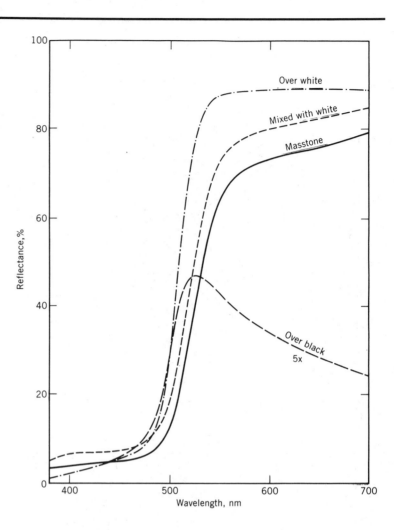

Reflectance of chrome yellow light, when used as a transparent film over titanium dioxide white and when mixed with the same white (from Johnston 1973). The steeper curve of the film over white is indicative of higher chroma. Also shown are curves for the yellow alone at complete hiding (masstone) and for the thin transparent film over a black background, magnified 5×.

which is much smaller than the theoretically realizable contour. In the accompanying figure the inner line encloses the gamut of real surface colors found by Pointer (1980) at $L^* = 50$ ($Y = 20$), while the outer lines are copied from the preceding figures.

Consideration of mixing behavior (Section 6A) shows that the maximum gamut can be obtained from a colorant when it is applied as a thin nonhiding film over a white background, rather than when it is mixed with the same white. It is for this reason that a wider gamut of colors can be produced in printing-ink systems, made in the former way, than with the same pigments in opaque paint systems. The Pointer gamut includes such nonhiding colors, whereas the Atherton limits do not.

6. Finally, limitations set by the fact that only certain colorants, among the ones available for each problem, are economically practical. If we could ignore this, it would indeed increase the number of coloring matters that could be used for any substance, but unfortunately economics cannot be ignored and the cost of obtaining a given color is important. This again cuts down the available number of colorants that can be used. To add the

contours generated by the economic and engineering requirements to the figures would result in a completely different set of contours for each problem.

Taking some liberty with the solids generated by the considerations given above and considering these solids as rough spheres or, at any rate, spheroid figures, we might consider that the limits of theoretical color space would encompass a beach ball (medium size), and the limits of MacAdam color space would be like a basketball. The Atherton color space (theoretical surface-color space modified by surface reflection) might be represented by a soccer ball. If we then go into the field of real and realizable colors in any material without regard for economic considerations (limited only by available colorants), we come to a more irregular shape, probably something nearer that of a football. Going to the next step, that of colors that are realizable in a given system and pass stringent performance tests, we can have anything from an object the size of a football to something the size and shape of a beat-up 50-cent baseball. Finally, we consider the cost. For some materials this last limitation may reduce the choice of colorants so much that the realizable colors are represented by an extremely irregular solid, much like that of a small apple into which several tentative bites have been taken.

While each step reduces the number of available colorants, it by no means restricts us to a small number of colors, since, with colorants well spaced in the hue circle, we can derive a great number of colors even though the exact one may not be attainable.

While the color solid shrinks steadily from its theoretical limits to the physically realizable colors with existing colorants, there are many dyes and pigments in each hue category which may be used by the manufacturer to impart the desired color to his material. As with most things in our world, we do not get any property in a finished object except by paying for it. Thus a product made with an inexpensive pigment generally does not have the fastness properties or the high chroma of one whose color has been obtained with a more expensive colorant of the same or similar hue (Vesce 1959). If bright hues are desired and processing conditions are severe, it is necessary to go to the more expensive pigments. Conversely, if the cost is a primary consideration, one may be limited to less bright colors.

Once a colorant with the correct engineering properties and hue is selected, a systematic study of its mixing properties will allow many conclusions to be drawn about the gamut of colors that can be made with it. Knowledge of this behavior is an essential prerequisite to its use in color matching, as discussed in Section 6B. The gamut of colors realizable from a pigment as its concentration is varied in mixtures with white can be visualized by plotting the chromaticities of these mixtures on the CIE diagram (page 130). Note that many pigments reach maximum purity in their mixtures at a specific concentration; adding more pigment causes the mixture with white to become both darker and less saturated. (As always, information about the lightness of the mixture is not displayed on the two-dimensional chromaticity diagram.)

The changes in chromaticity of some common paint pigments when they are mixed in increasing amounts with titanium dioxide white (from Johnston 1973). The pigments are: 1, phthalocyanine blue; 2, indanthrone blue; 3, carbazole violet; 4, quinacridone magenta; 5, lithol rubine; 6, BON red; 7, molybdate orange; 8, vat orange; 9, flavanthrone yellow; 10, chrome yellow; 11, monoazo yellow; 12, chromium oxide green; 13, phthalocyanine green.

The Selection of Colorants

The selection of a colorant is always a compromise between the properties desired by the designer and the cost of imparting a given hue, value, and chroma to a particular material. There are very few colorants that are suitable for all materials, and those that are suitable for all systems seldom offer the best money value. It must be emphasized that all colorants are chemical materials and as such are more or less reactive with other chemicals. What may be a minor change from the point of view of an additive used (to impart drying, better flow, etc.) may be a major one so far as the colorant is concerned. A material suitable in one formulation, for example, may be completely unsuitable if another manufacturer's resin and catalysts are used. Some of these things are well known, but it is our feeling that these points cannot be overemphasized. It is essential to think automatically in terms of the entire colored system rather than of a specific colorant or a certain material.

Anything added to the system may influence the behavior of the entire system. This fact is only beginning to be recognized. (See Smith 1954; for applications in the paint industry, Vesce 1956, 1959; for plastics, Oehlcke 1954, Carr 1957, Simpson 1963.)

It is not our intention in this book to provide a checklist of what colorants can be used in any given application. Some of the sources of this information were given on page 120. What we do wish to emphasize is that the choice of colorants is invariably influenced by many factors, most of which depend on and can be evaluated for the system as a whole. Many examples could be given, encompassing the areas of colorant reactivity, fastness to light, washing, bleeding, and other treatments, stability at elevated temperatures, ease of incorporation or processing, and above all, economics. But these examples are rather specific for the industry from which they were taken, and for that reason are best discussed elsewhere.

F. A Look Ahead

It seems certain that the dyes and pigments available to the designer and the colorist will continue to change and improve just as will other areas of color technology. There appear to be two major incentives for this improvement.

The first compelling reason for research on improved colorants is an economic one. As the technology of the chemical industry advances new manufacturing methods become available to reduce the cost of old products and to allow the manufacture of new ones at a reasonable price. In addition, the synthesis of entirely new dyes and pigments proceeds at an ever-increasing rate despite the complexity of the chemistry involved (Gaertner 1963, Venkataraman 1952–1978).

This research is not haphazard by any means. The greatest attention is given to the areas of poorest current performance, with the objective of upgrading them so as to approach a constant level of performance throughout the gamut of hues, in all important properties such as brightness of shade, fastness to light and other treatments, ease of processing and application, and of course, cost.

In the field of pigments we can expect what might be called only marginal improvement among the blues and greens because of the excellent properties of the phthalocyanines. Both reds and yellows need to be upgraded to match phthalocyanine green and blue in both cost and working properties. With the enactment of legislation restricting the use of pigments containing lead and chromium there has been a great deal of activity in the synthesis of new yellow and red pigments. As the chrome pigments are opaque, there has been a complete turnaround in the evaluation of new organic pigments in that opacity has become a desirable property. This has resulted in the introduction of a series of high-hiding organic yellows, oranges, and reds. This increased opacity is obtained, in all cases, at the expense of tinctorial strength. The acceptance of weaker, opaque, more lightfast organics in spite of the higher cost brought about by the lower tinting strength is another example of the compromise that is made to obtain what are considered the most important properties in a given pigmented system.

The introduction and wide acceptance of transfer printing has again changed a defect, sublimation at relatively low temperatures, into a virtue: sublimation is the mechanism whereby the dye transfers from the printed paper to the fabric (Consterdine 1976). In the 10 years following the introduction of reactive dyes for cellulosics, the ease of application and high performance properties enabled this new class of dyes to capture a significant share of the market at the expense of vat dyes (Rosenthal 1976).

The second challenge to the makers of colorants comes in the form of new materials for which they are asked to supply their products. Each of these new applications brings new requirements on the colorants, and in many cases this means more research and new products. For example, the need for coloring high-temperature plastics and synthetic fibers led to the development of entirely new families of colorants. In addition, older products are continually reviewed for new applications, while new raw materials produced elsewhere in the chemical industry are examined for their possible use in colorant production.

The history of the colorant industry, like that of so many others, is a mixture of sudden dramatic advances and slow, painstaking improvement by small steps (White 1960, Rattee 1965, Davies 1980). Predicting the major breakthroughs is about like forecasting the next big earthquake, but the possibility should never be overlooked.

G. Summary

While the dyes and pigments available to the color technologist may be different in many physical and chemical properties, they have one important point in common: They exhibit intense absorption and/or scattering of light, so that their addition in relatively small quantities to other materials modifies the interaction of light with matter, hence, their perceived color. This much is basic; all the rest is a matter of added convenience in use, such as solubility in a given solvent, compatibility with a specific resin, or the ability to dye a particular fiber.

Colorants have little or no intrinsic value. They contribute to the value of a finished product, in the last analysis, by virtue of their properties of intensive absorption and scattering of light. This is their reason for existence, the reason for the search for new colorants, and the reason for continuing the process, many thousands of years old, of selecting materials for the coloring of otherwise colorless substances.

The Coloring of Materials in Industry

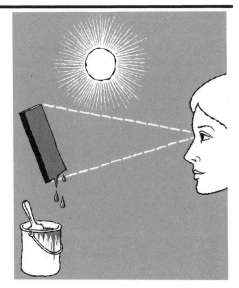

This chapter is concerned with the work of the industrial colorist, the person who is responsible for producing materials that are perceived as matching a physical sample submitted to her or sometimes the verbal descriptions of a color effect stated by a designer or stylist. She should recognize (as we hope our readers do by now) that the phenomenon of perceived color can be approximately described by the combination of the spectral power distribution curve of a light source, the spectral transmittance or reflectance curve of an object, and the spectral response curve of the eye of an observer. She should realize also that her work deals almost entirely with the object, since she cannot alter the sensitivity of the human eye and since she is rarely afforded the opportunity of changing the light under which the material is seen. Her business then is to use colorants, which were loosely classified in Chapter 4

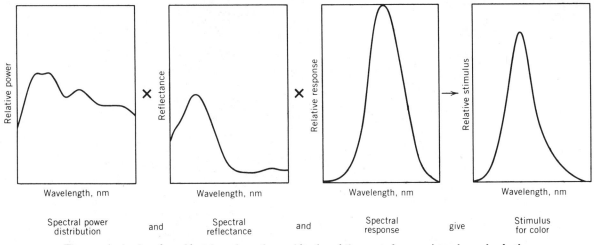

| Spectral power distribution | and | Spectral reflectance | and | Spectral response | give | Stimulus for color |

The perceived color of an object depends on the combination of the spectral curves shown here, plus further interpretation of the color stimulus in the brain.

as dyes or pigments, to modify the spectral transmittance or reflectance curve of a material until the desired color effect is achieved.

Our colorist must also be aware that she is changing *more* than the perceived color of the object. Many other properties of the material must be modified and controlled if the final article is to be functionally useful. Some of these are influenced by the colorants used, and this may result in limitations that must be recognized. These "engineering" aspects of the coloring process are discussed in Section 4E.

A. Color-Mixing Laws

If color matching by mixing colorants is to work at all, and if the colorist is to make any sense out of the color effects she gets as the result of such mixing, then it must be that certain laws of color mixing exist and are obeyed reasonably well. This is true, and although the laws are quite complex in some cases, they furnish both the qualitative basis for the traditional color matcher's skill developed by experience, and the quantitative bases for the calculation techniques that can aid her in many cases. We should look at these laws before considering the techniques of color matching in detail.

Additive Mixing

Perhaps the simplest kind of color mixing, in terms of physical actions, does not involve mixing colorants at all, but rather mixing colored lights. This can be done in several different ways. Colored lights from different lamps can be superimposed on a white screen, as described in Section 2B. Or, the light coming from different portions of a spinning disk can be caused to be seen as a single color, as discussed in Section 3C. (It makes no difference whether this light is reflected from an opaque disk or transmitted through a

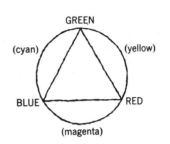

The usual choice of primary colors for additive mixing is shown in capital letters.

transparent disk.) Still another alternative is to place small colored areas close together and view them from a distance so great that the eye cannot distinguish the separate colored spots, as in color television. In these last two cases the adding of the colors takes place in the mind of the observer and must, therefore, be a physiological or psychological effect, but the result is the same as when the colored lights are directly added on a white screen.

As described in Section 2B, a wide variety of colors can be made by additive mixing of the colors from three lamps (Plate VIII). For convenience we call the most useful choice of colors for these lamps the *primary colors* for additive mixing, or the *additive primaries*. They are red, green, and blue. There is nothing magical or unique about them except that they happen to provide a wider range of mixture colors than other choices. Mixtures of red and green give yellow lights, mixtures of green and blue give the blue-greens or cyans, and mixtures of blue and red give the purples or magentas. If the three primaries are properly chosen and mixed together in just the right proportions, they add up to give white or perhaps in the case of reflected-light colors, a light gray.

In most color-television tubes three beams of electrons carry the information corresponding to the three additive primary colors. Kept on their courses by passing through holes in a mask, they strike phosphor dots of the correct primary colors on the face of the tube. The combined effect of these tiny dots gives the desired color by additive mixing (Fink 1960).

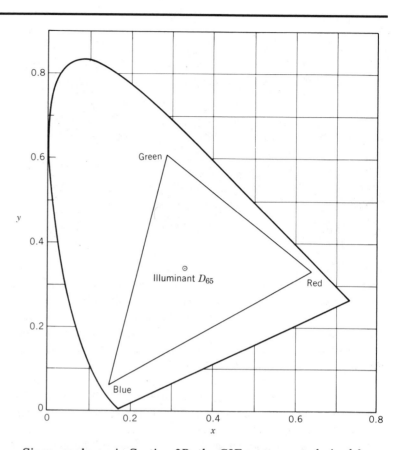

The gamut of colors that can be produced by the additive mixing of three primary lights is made up of all the chromaticities inside the triangle. Here the corner points of the triangle are located at the chromaticities of the three phosphors in a color television tube; the triangle includes all the chromaticities that can be produced on the TV screen.

The absorption of light by a transparent, colored object.

Since, as shown in Section 2B, the CIE system was derived from experiments on the mixing of colored lights, the results of such mixing can be determined very easily with the aid of the CIE x, y chromaticity diagram. Remembering that here we deal with the illuminant mode of viewing (p. 3), we can specify the color of a light by its chromaticity x and y and its luminance Y (pages 45 and 50). Grassmann (1853) showed that the luminance of any additive mixture of lights is the sum of the luminances of each of them, regardless of the spectral power distributions. Grassmann's laws, stated in modern terms to apply to the x, y diagram, show that the chromaticities of lights produced by additive mixing lie on the straight line connecting the chromaticities of the primaries used, and show how to calculate them. With three primaries all the colors inside the triangle formed by joining the chromaticities of the primaries can be produced. The reason for the common choice of red, blue, and green as the additive primary colors now becomes clear—they form larger triangles, hence allow more colors to be matched, than do other choices.

One might think that additive mixing would be found in some printing processes, where dots of three different colors are printed on white paper. This is not the case, however, since the colored dots usually overlap to some extent, and a complicated mixture of additive and subtractive mixing (see below) occurs (Yule 1967, Hunt 1975). Color television, however, does operate by additive mixing, as does theater lighting.

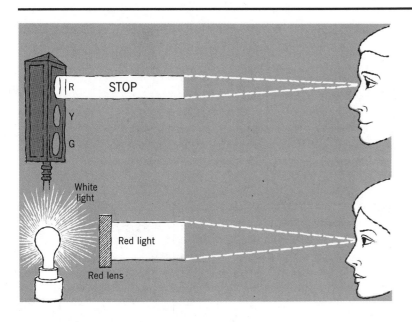

The usual choice of primary colors for simple-subtractive mixing is shown in capital letters.

A red stop light lens subtracts out, by absorption, all the components of white light except its own color, red.

Simple-Subtractive Mixing

Just as the term *additive mixing* is descriptive of the process of adding colored lights, *subtractive mixing* refers to the removal by an object of part of the light coming from a source. The ways in which this light can be removed (described on pages 10–13) include absorption and scattering. We call the case that involves only absorption without scattering *simple-subtractive* mixing. We call the more complex situation, where there is scattering as well as absorption, *complex-subtractive* mixing. This is discussed beginning on page 139.

The most useful primaries for subtractive mixing are yellow, cyan (blue-green), and magenta. The action of these primaries is shown in Plate VIII. Greens result from mixing yellow and cyan; blues, from mixing cyan and magenta; and reds, from mixing magenta and yellow. The relations between additive and subtractive mixing are nicely illustrated by the familiar "color wheel" arrangement; each additive primary has a subtractive primary as its complementary color, lying directly across the wheel. When the subtractive primaries are balanced in color and amount, the result of putting all three together is to subtract all the light from the source, leaving, of course, black.

Simple-subtractive colorant mixing is widely used in color photography (Kodak 1962, Yule 1967, Ohta 1971, Hunt 1975) and in the dyeing of transparent plastics (Billmeyer 1963b).

The prediction of the colors resulting from simple-subtractive colorant mixing is more complicated than for the case of additive mixing. The fundamental law of simple-subtractive mixing, Beer's law (page 10), is more complicated than Grassmann's laws because Beer's law holds for only one wavelength at a time. To compute the colors resulting from simple-subtractive colorant mixing, one has to make Beer's law calculations at many wavelengths across the spectrum to obtain the spectral transmittance curves of the mix-

Beer's law (more properly, the Beer-Lambert law) states that the logarithm of $1/T$, where T is the transmittance at a specified wavelength, is equal to the absorbance A. This quantity in turn is equal to the product of an absorptivity, a, characteristic of the colorant at the specified wavelength; the thickness of the sample, b; and the concentration of the colorant, c. . . .

$$\log\left(\frac{1}{T}\right) = A = abc$$

. . . If three colorants are used in simple-subtractive mixing, a second part of Beer's law, called the mixing law, tells what happens: the absorbances $a\ b\ c$ for each colorant add to give the total absorbance A of the sample. . . .

$$A = A_1 + A_2 + A_3$$
$$= a_1bc_1 + a_2bc_2 + a_3bc_3$$

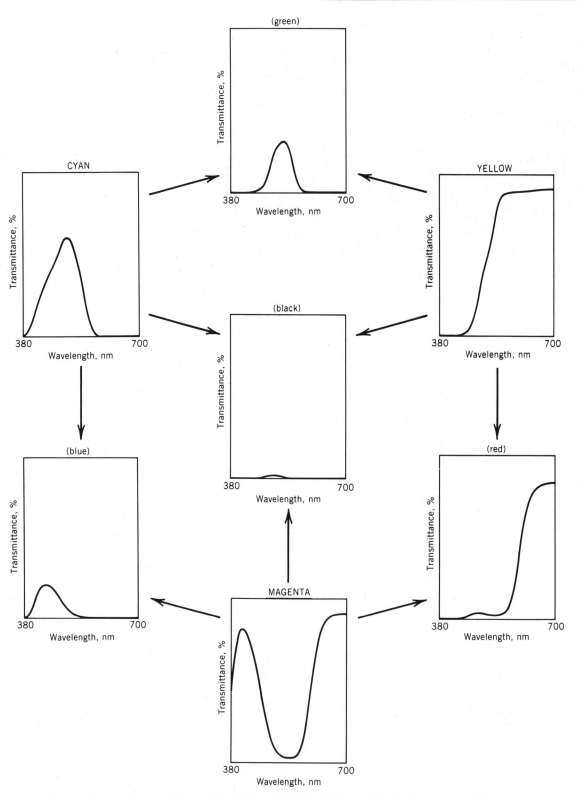

Spectrophotometric curves of a set of simple-subtractive primary filters and their mixtures, two and three at a time.

tures, and then obtain CIE coordinates by the integration techniques described in Section 2B. For this reason the spectral transmittance curves of the subtractive primaries have an important influence on colors resulting from subtractive mixing.

The Beer's law calculations and the subsequent integrations required to predict the colors resulting from simple-subtractive mixing are straightforward but cumbersome, and very little of this sort of work was done in industry before the introduction of digital computers. Today these calculations form the basis of the formulation of transparent colors by computer techniques (Billmeyer 1960a, Ohta 1972a).

The gamut of colors that can be made by simple-subtractive mixing is illustrated for a typical case in the figure on this page. Since the process is one of subtraction, the luminance factors of the mixtures are usually much lower than those of the primaries. Colors of relatively high purity can still be achieved.

Complex-Subtractive Mixing

By far the most common and, unfortunately, the most complex type of color mixing we experience is that in which the colorants scatter as well as absorb light. This type of colorant mixing does not even have a satisfactory name. We choose to call it *complex-*

. . . The transmittance T at the specified wavelength is obtained from A ("antilog" means "the number whose logarithm is") . . .

$$T = \frac{1}{\text{antilog } A}$$

. . . and the values of T at many wavelengths across the visible region (often 16, but better at least 30–33) can be used in the equations first given on page 47 to calculate the CIE tristimulus values of the color formed by the mixture of colorants.

$$X = k \sum PT\bar{x}$$
$$Y = k \sum PT\bar{y}$$
$$Z = k \sum PT\bar{z}$$

where

$$k = 100/\sum P\bar{y}$$

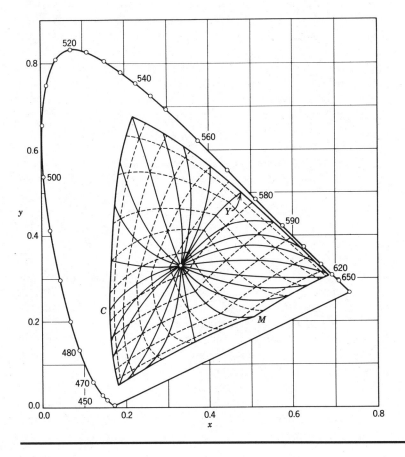

The gamut of chromaticities that can be made by mixing, two at a time, a cyan (C), a yellow (Y), and a magenta (M) dye used in a color photographic process. Points on solid lines locate mixtures in which the two dyes are taken in constant proportion, while points on dashed lines locate mixtures in which the concentration of one dye is kept constant (Evans 1948).

The Approximation to the Kubleka-Munk Equations Used for Opaque Samples

$$K/S = (1 - R)^2/2R$$

For a mixture of colorants,

$$(K/S)_{\text{mixture}} = \frac{K_{\text{mixture}}}{S_{\text{mixture}}}$$

$$= \frac{c_1 K_1 + c_2 K_2 + c_3 K_3 + \dots}{c_1 S_1 + c_2 S_2 + c_3 S_3 + \dots}$$

where c_1, c_2, $c_3 \dots$ are the colorant concentrations.

Note that in other books and articles R is sometimes called β, and K/S is sometimes called θ. R must be expressed as a fraction between 0 and 1, not in percent, in these equations. As in the case of Beer's Law (page 137), the Kubelka-Munk equations first define the quantity K/S (where K is an absorption coefficient and S is a scattering coefficient) in terms of a measured quantity R, and then provide a mixing law showing how the ratio K/S for a mixture of colorants depends on their concentrations.

If R' is the measured reflectance, with the specular component included, correct for surface reflections by calculating R (Saunderson 1942):

$$R = \frac{R' - k_1}{1 - k_1 - k_2(1 - R')}$$

and use R in the Kubelka-Munk equations on this page. Then, with new predicted values of R, calculate new values of R':

$$R' = k_1 + \frac{(1 - k_1)(1 - k_2)R}{1 - k_2 R}$$

where k_1 (sometimes called r_0) is the Fresnel reflection coefficient for collimated light (Campbell 1971) and k_2 (sometimes called r_i) is the Fresnel reflection coefficient for diffuse light striking the surface from the inside (Billmeyer 1973*b*).

subtractive mixing. Since complex-subtractive mixing involves the simultaneous absorption and scattering of light, both these quantities enter into the color-mixing laws for this case. These laws are correspondingly more complex than those for additive or simple-subtractive mixing. To write them down in exact form, as Beer's law for simple-subtractive mixing was written down on page 137, would give equations far too complicated for this book. For good summaries of them, see Johnston 1973, Judd 1975a. For most practical purposes, simplified equations, which are approximately correct, are commonly used to describe complex-subtractive mixing. The most widely used of these approximate equations were derived by Kubelka and Munk (Kubelka 1931, 1948, 1954). We write them here for the very simple case of a completely opaque sample.

Several of the major assumptions in the Kubelka-Munk treatment are the following: (1) There must be enough scattering for the light inside the sample to be completely diffused. This is usually true in textiles and paint films or plastics that are fully opaque. The much more complicated cases where this assumption is not valid are discussed briefly in Section 6B. (2) There is no change in refractive index at the sample's boundaries. The latter assumption is fulfilled for some cases, such as water-based paints in air, but not for most common pigmented mixtures. Saunderson (1942), however, modified the Kubelka-Munk equations to include the effects of reflection losses accompanying a change in refractive index at the sample boundaries. (3) Like the Beer's law calculations described for simple-subtractive mixing on page 137, calculations with the Kubelka-Munk equations must be made at many wavelengths across the spectrum; they cannot be correctly applied to tristimulus values except for spectrally nonselective materials.

The Kubelka-Munk equations form the basis of virtually all color-matching calculations in opaque systems. They were first applied by hand or desk-calculator methods (Saunderson 1942, Duncan 1949), then with analog computers (Davidson 1963), and today with digital-computer systems which are often proprietary to the extent that we do not know exactly how the equations are solved. (Fortunately, this does not make the systems any less useful.) The principles involved in computer color matching using the Kubelka-Munk equations are discussed by Stearns (1969), Gall (1973), Johnston (1973), Kuehni (1975b), and Allen (1978).

Considerable preparative work is required before the Kubelka-Munk equations can be used effectively. It must be established that the color production system is under complete control, and that the colorants follow the mixing laws in the system used. To establish these facts and determine all the necessary values of K and S, the Kubelka-Munk absorption and scattering coefficients, for each colorant at many wavelengths, requires extensive careful sample preparation and testing (Brockes 1974).

The colors resulting from complex-subtractive mixing are determined, in a general way, by calculations similar to those for simple-subtractive mixing. Computations based on the Kubelka-Munk equations are made at many wavelengths across the

spectrum to give a spectral reflectance curve, and are followed by integration to obtain the corresponding CIE coordinates. The additional complication of light scattering results in the need to adjust four variables instead of three: the three variables of color and the opacity. In textile systems scattering and opacity are supplied by the fabric, and the use of three colorants (dyes) suffices to provide a wide variety of colors. In other systems such as paints or plastics, opacity may be supplied by a chromatic pigment, but more often a white pigment is used for this purpose.

The gamut of colors obtainable through complex-subtractive mixing with a small number of colored pigments is more limited than that resulting from additive or simple-subtractive mixing. For example, brilliant oranges are obtained by the additive mixing of red and green lights and by the simple-subtractive mixing of yellow and magenta dyes, but result less often from complex-subtractive mixing of red and yellow pigments. For this reason, as well as for the "engineering" reasons discussed in Section 4E, a good many colored pigments are required to obtain a wide gamut of colors by complex-subtractive mixing, even though *any one* color requires the use of no more than three colored pigments plus white, or (with somewhat more flexibility) two chromatic pigments plus white and black (Davidson 1955a). In industrial practice more pigments may be used for "engineering" reasons.

B. Color Matching

The function of an industrial colorist is primarily to prepare colored material to meet the requirements of his industry, which may consist of meeting the demands of a stylist or of matching a competitive product. The colorist's job is to select the proper colorants and to adjust their amounts until a satisfactory result is obtained. He is concerned almost entirely with modifying the *object* in the triad of source, object and observer.

In industrial practice the process of determining the proper amounts of the chosen colorants is divided into two steps:

1. The preparation of an intial match, which in practice may include the selection of the colorants.

2. The adjustment of a previously formulated match to conform to a standard process (for example, scaling up a laboratory development to plant size) or to maintain the uniformity of the colored product. This latter procedure is commonly known as shading (in the paint industry), tinting, or by one of several other terms varying from industry to industry.

Since the techniques as well as the objectives of initial formulation and adjustment differ somewhat, we consider them separately. Most of all we wish to emphasize the importance of the proper selection of colorants, a step that is far too often not given serious enough consideration.

Types of Matches

In preparing a color match the first question to be answered is whether or not the two samples are required to look alike to all observers and under all light sources. As we saw in Section 1D, this

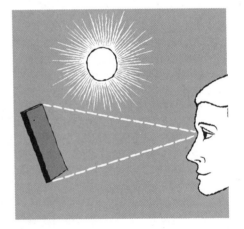

Steps in Color Matching

- selecting the colorants
- making the initial match
- adjusting the match

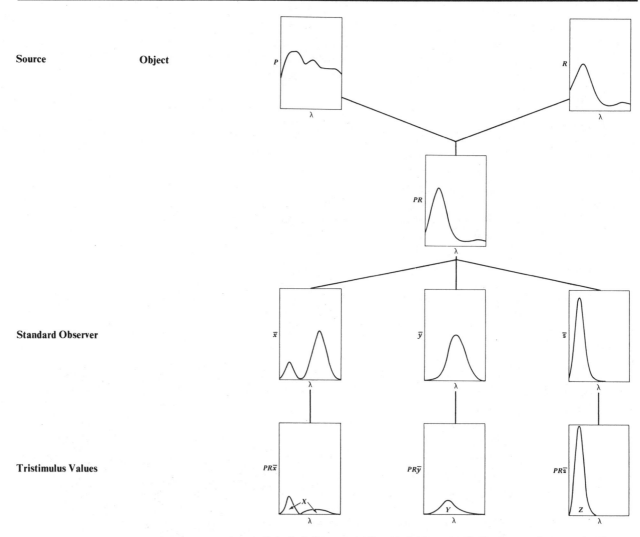

Source Object

Standard Observer

Tristimulus Values

Out of all these curves the colorist has control of only one: the spectral reflectance curve of the object, shown at the upper right. All the others are fixed.

An *invariant* match is one in which the two samples look alike to all observers and under all light sources.

requires that the two objects have identical or very nearly identical spectral reflectance curves. This type of match we call an *invariant* match.

Invariant Matches. The requirement just stated, that two objects must have identical spectrophotometric curves to be an invariant match, is a severe one but we cannot overemphasize how true it is. It requires several things.

First of all, the match must be made with the identical colorants used in the sample to be matched. This leads directly to the subject of how to determine what these colorants are, as discussed in the next section.

Second, primarily because of limitations set by the properties of colorants, the same type of material must be colored. It is quite unlikely that a dyed fabric could be formulated to be an invariant match to a pigmented paint film. A close match can be obtained, but since it is necessary to use different colorants in the two samples, and since the optical properties of the fabric and paint film are different, an invariant match can be achieved only with great difficulty if at all.

Third, the same or a very similar process of coloring must be used. This is especially important in complex-subtractive matching, where the color of a pigment depends on how well it is dispersed in the medium in which it is used. Other aspects of appearance, such as gloss, are also of great importance.

Finally, if instruments are to be used as aids in formulating invariant matches, spectrophotometers rather than colorimeters are required.

Even if a truly invariant match cannot be made, it may be possible by the judicious selection of colorants to produce a color that matches the sample submitted in several common light sources. This may be a satisfactory substitute for an exact spectral match (Longley 1976, Winey 1978). To achieve such a match it is usually necessary to use more than the minimum number of colorants to bring the spectral curves closer together by forcing them to cross more than the three times requires for a metameric match (page

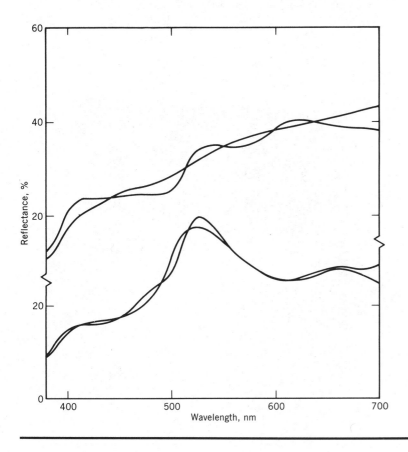

The spectral reflectance curves of two pairs of samples, each of which matches under daylight, incandescent light, and cool white fluorescent light, even though the match is not invariant (from Longley 1976).

53). Matches of this kind may well be more difficult to reproduce in production, because more variables must be controlled.

Matching colors in different materials, or using different methods of coloring, is a great challenge to colorists; the frequency with which such matches are achieved is a tribute to their skill.

Conditional Matches. In the many cases where an invariant match cannot be made, it is necessary for the colorist to be content with making a close match under a limited set of illuminating and viewing conditions. We define this as a *conditonal* match.

Some of the reasons why an invariant match cannot always be made have already been mentioned. If the same colorants that are in the sample to be matched cannot be used, a conditional match almost inevitably results. This may be the case if different materials or different methods of coloring are involved.

Even if the same materials and coloring methods are used, the customer may ask that the new samples have better lightfastness, be less expensive, nonbleeding, or differ in some other property from the sample submitted. Here, too, the problem cannot easily be resolved. If the same colorants are to be used, an invariant match can be obtained, but it is very unlikely that the new sample will have better lightfastness (unless a colorless stabilizer can be found) or be less expensive (unless someone is willing to cut the prices of the colorants). It is important to resolve the requirements of such a request at the very beginning to avoid a waste of time and effort.

Whenever it is agreed that a conditional match must be made, it is important to know under what conditions (e.g., preferred light

A *conditional* match is one in which the two samples look alike to some observers or under some light sources, but do not look alike to other observers or under other light sources.

A typical light booth, with several standard sources, useful for judging both invariant and conditional matches. (Courtesy Macbeth Division, Kollmorgen Corporation.)

source or sources) the match is to be judged, since the match is of necessity metameric and will vary with the nature of the source and the observer.

Little can be done to control the color-vision characteristics of the observers who will judge these conditional matches, except that in cases where observer differences are thought to be important, one can rely on the consensus of opinion of a panel of observers. It is important, however, that conditional matches be judged visually under the standard light sources that correspond most closely to the anticipated conditions of use. Light booths equipped with standard sources, often 7500 K daylight, incandescent, and cool white fluorescent lamps, are widely used. Supplier and customer should use the same make and model of booth, with identical sources and filters if possible. The quality of the light can differ markedly depending on these variables, particularly between filtered-incandescent and fluorescent daylight simulators. This can readily be checked by having one observer make a match on a Color Rule (Kaiser 1980, Billmeyer 1980a) (page 73) in each booth to be used: If the match points are identical, the booths can safely be used for evaluating conditional matches; if not, metamers that look alike in one booth may well look different to the same observer in another booth.

Despite the best of precautions in the control of the illumination, it is far more difficult for the visual color matcher to make a conditional than an invariant match. Derby (1971) points out that this is because he must try to achieve the best compromise under several different light sources. This is not a factor for invariant matches, but it may be critical for conditional matches.

While in the case of conditional matches it is less important to identify the colorants used (page 147), this identification can be very useful, particularly if the materials and coloring methods are the same but an improvement in some property is desired. Here the colorist can unwittingly make an invariant match when this is not desired.

In many cases only a limited number of colorants can be used in the material in which the match is to be made. An example is the coloring of nylon and other plastics, which must be processed at high temperatures. The color match must be made with the limited palette available. It is very important to have it understood by all concerned that in general a conditional match will be obtained, and to determine in advance what the preferred conditions for judging the match are to be.

In making a match using colorants other than those used in the original material, we will obtain more than just a conditional match for color. Metamerism, by itself, is not the greatest defect of such a match. The more important consideration stems from the fact that such matches will not have the same fastness properties as an invariant match, or will differ in other important properties.

Selection of Colorants

The need to balance the color properties, the working properties, and the cost to provide a specific color formulation calls for a

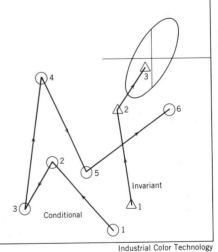

Industrial Color Technology

Relative difficulty of achieving a conditional or an invariant match, the match point being the center of the ellipse, by visual color matching. More trials are needed and the result is less satisfactory when metamerism is present (Derby 1971).

systematic approach to the selection of colorants. In this section we develop such an approach by considering the objectives of the color-matching process.

Objectives of Color Matching. We believe that there can be two purposes for producing a specific color: to create an original styling, or to match a competitive material—the latter task providing the greatest challenge to, and occupying the most time of, the colorist. For each of these objectives the selection of colorants depends on the type of match desired, invariant or conditional, and on the working properties required of the colorants. These in turn proscribe the range of colorants from which a selection can be made, and the number that are finally useful.

The working properties of colorants are of two general types. Some of them are inherent—that is, are required by the material to be colored and the system of coloring. Among these are, for example, the affinity of a dye for a particular fiber or the stability of the colorant at the high processing temperature of a plastic. Other working properties can be considered elective—desirable but not essential. Among these are various levels of lightfastness and cost. If necessary, these can be changed as part of a marketing strategy, whereas the inherent working properties cannot be altered.

The selection of colorants for the various objectives of color matching is illustrated by the table below:

| Type of formulation | Type of match | Working properties | No. of colorants | | Secondary objective |
			To select from	Usable	
Original styling	—	General	Large	Moderate	Intermix system
	—	Restricted	Limited	Limited	Satisfy properties
Match in same material	Invariant	Identical	Very limited	Extremely limited	Colorant identification
	Invariant	Modified	Large	Limited	Duplicate spectral curve
	Conditional	Equal	Limited	Limited	Duplicate properties
	Conditional	Modified	Large	Large	Intermix system
Match in different material	Invariant	Equal	Limited	Very limited	Duplicate spectral curve and properties
	Invariant	Modified	Large	Limited	Duplicate spectral curve
	Conditional	Equal	Limited	Limited	Duplicate properties
	Conditional	Modified	Large	Large	Intermix system

Original Formulations. There are two categories of original formulations as far as the use of colorants is concerned. The first type, prepared in response to the needs of the stylist or designer, is the case in which the working properties of the colorants are not severely limiting and the cost is not of the utmost importance. In such a case the colorants may be selected from a relatively large number meeting those general, nonrestrictive needs. Often a

reasonable number, from three or four to a dozen, is selected to be used in an intermix system from which the final colors are prepared. Some examples of this case are the trade-sales paint intermix systems, the four-color printing systems in the graphic arts, and the trichromatic fabric printing systems.

The second class of original formulations is those in which performance requirements or cost considerations severely limit the number of colorants that can be used. The gamut of colors available is often limited to that obtainable with the suitable colorants. Examples of such systems are the printing of poly(vinyl butyral) to produce tinted bands in automobile windshields or the dyeing of a high-temperature fiber such as Du Pont's "Nomex."

These examples are of colorant-limited systems, where the restricted gamut of colors results from severe restrictions on working properties, regardless of the cost of the colorants. Even more common are cost-limited situations, in which the gamut of colors is typically limited to those of low chroma in many hue regions.

Matching Identical Materials. This is the case in which a match must be made to a standard submitted to the colorist, using the same material and method of coloring: dyed cotton to match dyed cotton, automotive paint to match automotive paint, and so on. Four cases can be distinguished, the combinations of invariant and conditional matches with or without some modification in working properties allowed. The case requiring the most careful attention is that of an invariant match with no alteration of working properties, as for example in duplicating an automotive paint. A match of this kind can best be achieved by using the same colorants that are in the standard; this requires the identification of these colorants, as described below. If some of the working properties can be changed, different colorants can be used, but in this case it is necessary to select from a large number of colorants to duplicate the spectrophotometric curve of the standard as closely as possible.

If a conditional match is allowed, the restrictions on the number of useful colorants may be somewhat less severe, depending on the degree of metamerism that can be tolerated. If the working properties must be equal to those of the original sample, some limitations remain.

Matching Different Materials. If the match is to be made in a different material, it becomes almost impossible to guarantee an invariant match, with all aspects of appearance equal to those of the original sample. About the best that can be done is to select, from a wide choice of colorants, those that allow the spectral curve of the original sample to be matched as closely as possible. Then, at least, changes in the color of the sample and match when the illuminant or observer is changed should be similar, even if the appearance of the sample cannot be matched exactly. In other respects, that is, modified working properties or conditional matches, similar considerations apply to producing matches in the same or another material, as the table on page 146 shows.

Colorant Identification. If an invariant match is required the approach we have found most useful is to identify the principal dyes or pigments that have been used to color the submitted sample, and

to use those colorants in formulating the match. This type of matching (Judd 1975a, p. 438), known as *colorant* matching, is not used as much as we feel it should be, probably because it is not widely realized that the identification procedures are well worked out and relatively simple (Abbott 1944, Stearns 1944, Saltzman 1967, Venkataraman 1977). Briefly, they involve extracting the colorants from the sample and identifying them by simple chemical tests, spectrophotometric curve shape, or infrared spectra (Harkins 1959, McClure 1968). Examination of the spectral reflectance curves of the dyed or pigmented materials themselves, without extraction, is also useful for identifying colorants (Johnston 1973). Most laboratories engaged in color matching can easily use these techniques, or can have their colorant supplier use them, as an aid to color matching.

Coordinated Colors. It is sometimes desirable, for merchandising purposes, to provide close color matches in a variety of materials, so that the colors of, say ceramic bathroom tiles, plastics, paints, and textiles can be coordinated. In addition to the

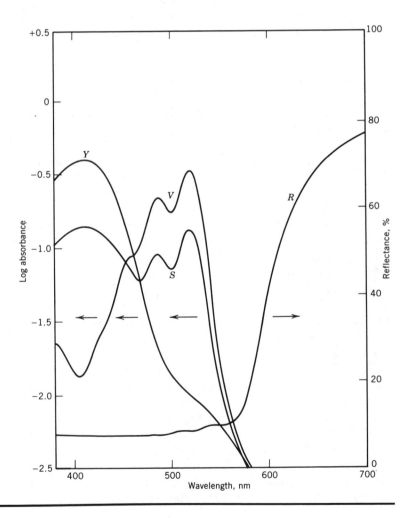

An example of the identification of organic pigments by solution spectrophotometry. The reflectance curve (R) of this red artist's paint provides little information on its composition. But the curve of its solution (S) in dimethyl formamide clearly shows that it is made by mixing a Hansa yellow (Pigment Yellow 1, C.I. No. 11680, curve Y) and quinacridone violet (Pigment Violet 19, C.I. No. 46500, curve V). The log-absorbance presentation (p. 154) is used for the solution curves.

considerations mentioned it is best to carry out the original styling in the material that has the most limited range of colors and palette of colorants. Samples in this material then become the master standards to be matched in the other systems, where more colorants are available. Problems arising from the scarcity of suitable colorants can thus be minimized.

Colorant Replacement. So far we have been considering the selection of colorants to match a single specific color. A far more difficult task arises if it is necessary to replace one colorant with another for use in the preparation of a large number of colors, as in an intermix system. Such replacements are becoming more common because of a variety of environmental considerations. An example from the paint industry, much in the minds of colorists in recent years, is the replacement of lead-containing yellows (chrome yellows) by organic pigments.

In colorant replacement it is desirable to replace a given amount of the original pigment by a constant amount, on a weight or a volume basis, of the substitute in such a way that all colors made with the substitute match the originals. A look at the Kubelka-Munk mixing laws on page 140 shows that to make this possible both pigments would have to provide identical relations between both absorption (K) and scattering (S) and the concentration, over the entire useful range, at all wavelengths. This is almost impossible to achieve. It may be possible to match certain colors when the pigment is replaced, say in mixtures with white in a certain range of concentrations, but it is unlikely that making the replacement in the same way will produce other colors, say greens or oranges, which also are acceptable matches to the originals. About the best one can do is to select the ratio of amounts of old and new pigments that yields the largest number of satisfactory matches, and to adjust the formulations of the colors that do not match. Even changing from one manufacturer to another of the same pigment may lead to similar, though usually less severe, difficulties.

Caution must also be observed in substituting another dye or pigment with the same five-digit Colour Index number. Pigments and dyes bearing the same number are usually *chemically* quite close, but the products from different manufacturers may differ *physically* in dispersibility, average particle size, or particle-size distribution. Their absorption and scattering properties then differ, and different color effects result even if the two materials are treated in the same way. The Colour Index number is a chemical identification, not a guarantee of identical physical characteristics.

Strength of Colorants

Following Berger-Schunn (1978), we define the strength of a colorant as its ability to modify the color of an otherwise colorless material, or its content of coloring substance, compared to that of another sample of the same colorant taken as the standard. Since color matching requires exact knowledge of the coloring behavior of a colorant, the determination of colorant strength (often called *tinting strength*) is an important prerequisite to the matching process.

At first glance it would seem that the determination of the strength of a colorant should be a simple matter. By using equal amounts of the standard pigment or dye and the sample to be tested, in an appropriate method to color a given amount of uncolored resin or fiber, it should be easy to determine by either visual or intrumental techniques whether the two samples have equal coloring power. Where supposedly identical dyes or pigments are being compared, the resulting colored materials should not vary in hue and the color difference, if any, between them should easily be seen. If it is zero, the two colorants are judged equal in strength. If they do not differ in cost, they are of equal "money value." The same amount of money spent for either of the colorants will permit the user to obtain the same color effect.

Unfortunately there are complicating factors in testing both dyes and pigments for this property of strength. The term *strength* has been applied to the results of several different tests and the different approaches used may not evaluate the same property. In most cases it is useful to consider dyes and pigments separately, since pigments must be dispersed in the medium in which they are used and the strength of a pigment is strongly influenced by the technique of dispersion. The dependence on degree of dispersion also applies to disperse and vat dyes.

The determination of tinting strength is an analytical procedure and all the precautions applicable to analytical chemistry must be followed. The sample must be taken in such a way that it truly represents the bulk of the material being examined. There must be agreement between the buyer and seller as to the standard used for comparison. The method of test must not only be agreed on but, as it is usually a laboratory method, the results must agree with those obtained in production.

Visual Method. Most standard pigment methods (for example, ASTM D 387) require that the test and standard pigments be prepared according to the method of use, say as a mixture with white in a paint drawdown, and compared side by side. Dyed textiles may be compared in a similar way. If the tolerances are large, say ± 5% or more, visual methods may be used with care. To achieve a result precise to ± 5% reliably it is necessary to compare the test colorant to dyeings or pigmentations of various concentrations of the standard around the 100% level. This so-called *ladder technique*, in which the test sample is compared to a range of standard preparations at (for example) 90, 95, 100, 105, and 110% of normal concentration, can yield results reliable to ± 5%. If closer conformance is needed, instrumental methods must be used.

The visual methods work well if the two colorants have the same hue, but the judgment of equal strength becomes very difficult if there is a hue difference. The inverse of the amount of test colorant required to give the same color as the standard is taken as its tinting strength.

Instrumental Methods—Dyes. A project committee of the Inter-Society Color Council (ISCC) has developed instrumental methods for measuring the strength of dyes. A spectrophotometric method based on transmission measurement of the dye in solution

(Commerford 1974, ISCC 1972, 1976) is preferred for its precision over methods in which actual dyeings are prepared (ISCC 1974).

In the solution method one measures the absorbance of the solution of the test dye in an appropriate solvent and compares it to that of the standard at a properly chosen analytical wavelength. This is usually the wavelength of maximum absorption, and the comparison is made in a simple Beer's law method (p. 137). The analytical precision of solution spectrophotometry is such that in most cases a result with a 95% confidence limit of 2% can be obtained if samples are run in duplicate.

This technique assumes that the spectrophotometric curves of the standard and the test sample are similar and that both have the absorption maximum at the same wavelength. When this is not true, the dyes differ in hue (or show a shade difference), and more refined techniques such as those of Rounds (1969) or Garland (1973) must be used to estimate relative tinting strength in the presence of a hue difference.

Tests of dyes in solution are appropriate where the dye is used in this manner, such as in the coloring of gasoline, the preparation of inks for felt-tipped markers, or the coloring of transparent plastics.

It is necessary to establish the agreement between solution tests and dyeing tests before relying completely on information obtained from solution testing. For some classes of dyes this cannot be done except in a general way. In such cases, only the results of dyeing tests can be used (Berger-Schunn 1978). Dyeing methods, even under the most closely controlled conditions, are rarely more precise than \pm 5% if only a single sample and dyeing are measured. If closer tolerances are needed, appropriate techniques of replicate sampling and multiple dyeings must be established (ISCC 1974).

Instrumental Methods—Pigments. The determination of the strength of pigments is more difficult than that of dyes for at least four reasons: (1) solution spectrophotometry cannot be used because pigments are not used in solution; (2) since pigments both scatter and absorb light it may be necessary to determine both their scattering strength and their absorption strength (Johnston 1973, Osmer 1979); (3) the selection of an appropriate method of test is highly dependent on the dispersibility of the pigment; and (4) the conversion of the dispersion, be it ink, paint, or colored plastic, to a final form for examination contributes another important variable.

The combination of the need to measure strength in a way that agrees with the actual use of the pigment, and the need to assess both the absorption and the scattering properties, leads to a wide variety of possible test methods for the strength of pigments.

It is extremely important to make certain that the proper combination of scattering and absorption is tested by the method chosen. Selection of a method simply on the basis of convenience can yield completely meaningless results. An example of this is the determination of the tinting strength of a pigment that is to be used with metallic aluminum flake, where scattering is almost completely avoided, by testing a mixture of the pigment with white.

In the testing of absorption strength the preferred technique is the measurement of the value of K/S at the wavelength of

Variation in the measurement of tinting strength of a single sample of phthalocyanine blue: 15 samples made up in duplicate as reductions with white over a 6-week period (Gall 1975).

minimum reflectance. This is especially true of chromatic pigments with strongly selective absorption. An example of the reproducibility of measurement of the strength of an organic pigment by this method is shown in the figure on this page.

At the present time there are committees of the ISCC and the ASTM working on recommendations for the determination of the strength of pigments, but as yet no agreement has been reached.

Depth of Shade. The term "depth of shade" (Gall 1970, 1971) refers to a visual phenomenon that is related to color in the same way that colorant concentration is related to strength. For example, one might say "this strong red dye produces a deep red color" (Kuehni 1978). The concept is useful for preparing samples for the determination of lightfastness and other application properties, and examples of constant depth of shade are available to aid in the selection of colorant concentrations for this purpose.

In spite of many efforts, no agreement has been reached on methods to relate depth of shade to instrumentally measurable quantities (Brockes 1975, Kuehni 1978). It must be emphasized that the concept of depth of shade was never intended to provide a method for testing the strength of colorants or for evaluating the "money value" of a colorant, which is related to strength.

The Initial Match

While the selection of the proper colorants is of major importance, especially in making invariant matches, it does not provide information on the correct amounts of colorants to use. These are traditionally determined by trial and error, relying on the skill of the visual color matcher, but more and more often instrumental and computational methods are supplementing this skill.

Visual Matching. As with so many processes in an industry where there is so much art as well as science, the experience of the color matcher must never be underrated. There is simply no substitute for it, and it would be foolish for us to attempt to condense it to a few words. Very seldom, however, is this skill applied without the use of some aids, whether they be merely a careful written record of past experience, the use of the results of color measurement, or more sophisticated calculations.

The visual color matcher usually keeps a file of all the color matches that have ever been made in the laboratory. Such a file is often called a "shade bank," and it can truly be a bank filled with treasure, the results of years of experience. Reference to such a file is almost always the first step taken by the colorist in making a visual match. The selection of the nearest color in the file is followed by appropriate modification to match the newly submitted color.

It seems obvious that the first requirement for a visual color matcher is normal color vision, yet all too often a person gets assigned this job without thorough color-vision testing. This testing (Wardell 1969) usually starts—and ends—with a series of tests using pseudoisochromatic plates (Plate IX) containing numbers or designs that appear different to people with normal color vision and those who are colorblind (Hardy 1954). While they serve well as

screening tests, these pseudoisochromatic plate tests are not suitable for quantitative color vision testing or even, for some sets of plates, for identifying the type of color-vision defect that is present. Better for these purposes are instruments called anomaloscopes, which measure the amounts of red and green light the observer requires to match a yellow test lamp, or the Farnsworth-Munsell 100 Hue test (Farnsworth 1943) in which the observer is required to arrange a series of samples in consecutive order according to hue (Plate X).

The 100 Hue test makes it possible to sort observers with normal color vision according to level of chromaticness discrimination and thus serves as a color aptitude test. Another test of this sort (Plate XI) is the ISCC Color Matching Aptitude Test (Dimmick 1956). This test requires the observer to discriminate small differences in chroma, and depends on experience as well as inborn capability. While no single test is likely to provide a true measure of "aptitude," the ISCC test is sometimes used to screen out those who do not have the ability (or the patience—and this is important too) for color matching.

A person who has normal color vision and does well on these tests might wish to follow the advice of Peacock (1953). He advocates first learning how to use the Munsell system (pages 28–30), and then learning the color mixing laws (pages 137–141). Working with the system or systems in which color matches are to be made, these color-mixing laws should be tested experimentally by making up a variety of mixtures of two or more chromatic colorants and seeing what results. The color wheel (page 137) can be developed into a blending chart to correlate the results of these tests in a qualitative way, by finding out exactly how one has to change the concentrations in the mixtures to move a certain way on the chart. A simple extension of these ideas, based on studying how the colorants to be used behave, allows one to control metamerism by a purely visual approach (Longley 1976).

But it is not possible to progress to more objective, quantitative results without utilizing some kind of instrumental aids. Since we strongly believe that these aids are extremely important, even frequently indispensable, we proceed to discuss them.

Instrumental Aids. The purpose of instrumentation and the chemical analysis of colorants is to reduce the amount of experience required in the field of color matching, where it is becoming more and more difficult to obtain experienced personnel. In the last analysis, however, it is true that there is no substitute for experience, and the colorist must acquire some experience in the use of instruments and in the interpretation of their results before he finds them useful aids in the color-matching process. One major advantage does appear to favor the use of instruments: it is found (Johnston 1965) that a previously unskilled person can learn to match colors with instrumental aids more rapidly than he can learn to do this by the time-honored visual method. Possibly because tradition dies hard, it is significantly more difficult for a skilled visual color matcher to adapt to the instrumental approach and derive the full benefits from it.

In discussing instrumental aids to color matching, we again find it useful to consider invariant matching and conditional matching separately. Again we find the spectrophotometer the most useful instrument to assist in the process of formulating invariant matches. Much can be learned from the spectrophotometric curve shape about the amounts as well as the identity of the colorants used in a sample.

Two accessories available for some spectrophotometers are particularly useful in interpreting spectrophotometric curve shape. One is the log-absorbance presentation, which plots the curves in such a way that their shape is the same regardless of the amount of colorant present. This accessory is particularly useful in simple-subtractive colorant matching. The basic principle that makes this plot useful is derived from Beer's law and states that, at any wavelength, vertical distances on the plot are proportional to the amounts of the colorants present, the contribution of each colorant adding independently to the total. A little arithmetic is all that is needed to calculate by Beer's law the concentrations of the various dyes needed for an initial match, once the dyes are identified, as shown in the numerical example on pages 156 and 157.

(Text continued on page 158)

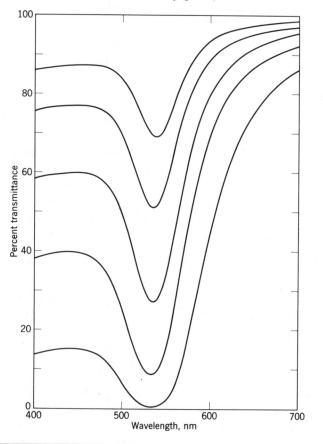

Special ways of presenting spectrophotometric data provide useful instrumental aids to color matching. These are conventional transmittance curves (corrected for surface reflections) for a series of magenta Lovibond glasses with different colorant concentrations. (Similar curves would be obtained with glasses having thicknesses proportional to these concentrations, all made from the same material.)

Absorbance curves for the samples of the preceding figure. Linear distances on this plot are the Beer's law absorbances $A = abc$ in the equations on p. 137 and the example problem on p. 156.

Log-absorbance curves for the samples of the preceding figure. Linear distances on this plot are proportional to ratios of sample thicknesses or concentrations, and the shape of the curves is almost independent of thickness or concentration and is characteristic of the colorant used.

(Text continued on page 158)

Curves showing absorbance *A* of yellow dye (Y) at *c* = 1.38, blue dye (B) at *c* = 1.07, and a mixture of y and b at unknown concentrations *c* to form a green (G).

Finding Dye Concentrations in a Transparent Sample by the Use of Beer's Law

The accompanying figure shows curves of absorbance vs. wavelength of three transparent plastic samples. Sample Y contains 1.38 (arbitrary) units of a yellow dye; sample B contains 1.07 units of a blue dye. Sample G, green in color, contains unknown amounts of the yellow and the blue dyes. Here is how to find these unknown dye concentrations.

Since there are two unknown concentrations to be determined, we need to consider what happens at two wavelengths. These should be chosen at relatively flat points on the absorbance curves, one where the yellow dye absorbs strongly (high absorbance) and the blue dye absorbs very little; the other where the reverse is true. A look at the figure shows that the wavelengths 415 nm and 610, 630, or 670 nm should be used. We will use 415 and 630 nm.

The first step is to read the absorbance A for each sample at each wavelength from the curves. We find from the original spectrophotometer chart:

| | Wavelength | |
Sample	415 nm	630 nm
Y	1.022	0.008
B	0.080	0.660
G	0.610	0.488

Next we calculate the absorptivities a for the yellow and blue dyes at each wavelength. Beer's Law states that $A = abc$, but since the sample thickness b is the same for all three samples, it cancels out in this calculation and we can say that $A = ac$, or $a = A/c$. We find the following values of a:

| | Wavelength | |
Sample	415 nm	630 nm
Y	0.741	0.006
B	0.075	0.617

We now use the mixing law, which says that $A_G = A_Y + A_B$, where these absorbances all refer to the green sample. Using the equivalent equation $A_G = a_Y c_Y + a_B c_B$, where c_Y and c_B are the concentrations we wish to find, we can write:

Wavelength	Mixing equation	
415 nm	$0.610 = 0.741 c_Y + 0.075 c_B$	(1)
630 nm	$0.488 = 0.006 c_Y + 0.617 c_B$	(2)

These two equations in the two unknowns, c_Y and c_B, can be solved as follows. Multiply eq. (1) by 0.006/0.741 to obtain eq. (3), and subtract eq. (3) from eq. (2) to give eq. (4). Then solve eq. (4) for c_B:

$$0.488 = 0.006 c_Y + 0.617 c_B \qquad (2)$$
$$0.005 = 0.006 c_Y + 0.001 c_B \qquad (3)$$
$$0.483 = \qquad\qquad 0.616 c_B \qquad (4)$$
$$\overline{0.784 = c_B}$$

Finally, this value of c_B can be substituted into eq. (1) to obtain c_Y:

$$0.610 = 0.741 c_Y + 0.075 c_B \qquad (1)$$
$$0.610 = 0.741 c_Y + 0.075 \times 0.784$$
$$\qquad = 0.741 c_Y + 0.059$$
$$0.551 = 0.741 c_Y$$
$$\overline{0.743 = c_Y}$$

The values $c_B = 0.784$ units and $c_Y = 0.743$ units are the desired concentrations. Mixtures of three dyes can be treated similarly, but the equations are more complicated.

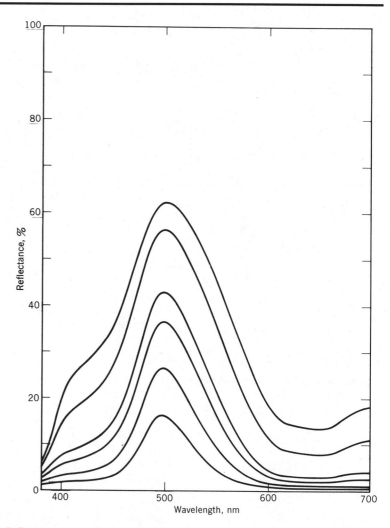

Reflectance curves for a series of samples made by mixing varying amounts of phthalocyanine green (C.I. Pigment Green 7, C.I. No. 74260) with titanium dioxide white in a plastic casting resin.

(Text continued from page 154)

For complex-subtractive mixing Beer's law does not hold, but the Kubelka-Munk equations are frequently accurate enough to be useful. If one is working with completely opaque specimens, such as paint films pigmented to complete hiding, these equations simplify, and show that a function of the reflectance R exists which has the same property of being proportional to pigment concentration as does log absorbance in simple-subtractive mixing. The second useful accessory to the spectrophotometer is the log (K/S) presentation (Pritchard 1952), which plots this function directly. Derby (1952) has described the use of this accessory as an aid in color matching in the textile industry.

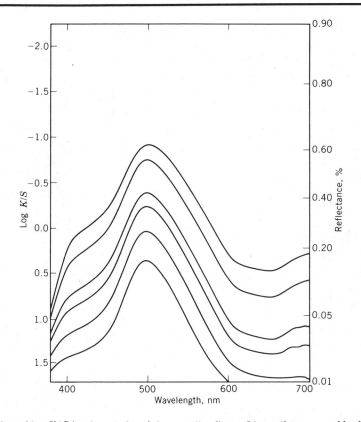

Plots of log K/S for the samples of the preceding figure. **Linear distances on this plot are proportional to the concentration of the green pigment in the sample. The shape of the curves is almost independent of the concentration, and is characteristic of the colorant used.**

The adage that one never gets something for nothing holds true here also. One must know the behavior of his individual colorants before distances on a log (K/S) or log-absorbance chart can be converted into concentrations. Thus it is necessary that samples be made up, in a range of concentrations of one colorant at a time, and measured on the spectrophotometer to provide the data to calibrate the system. Once this is done for a given substrate or medium and a given processing technique, all further samples made in the same way can be handled. The importance of this step cannot be overemphasized; see page 167 for further discussion.

Since all that we have said so far is based on duplicating the spectrophotometric curve of the sample to be matched, it applies only to the production of invariant matches. When the colorants to be used are different from those in the sample to be matched, and a conditional match is to be made, methods based on the spectrophotometric curve alone are of little value. Here one needs to

(Text continues on page 162)

(Text continued on page 162)

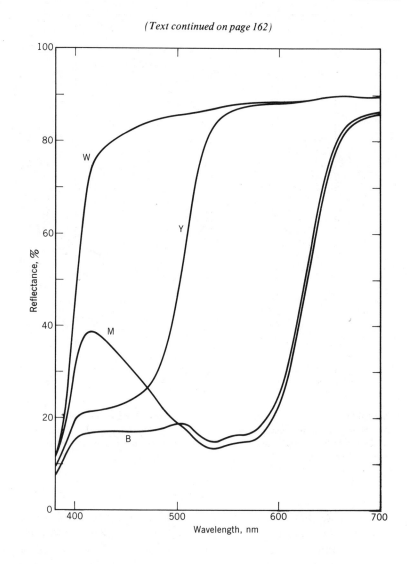

Finding Pigment Concentrations in an Opaque Sample by the Use of the Kubelka-Munk Law:

The accompanying figure shows curves of reflectance versus wavelength of four paint samples. Sample W contains white pigment only. Sample Y contains 18.5% yellow pigment in white, while sample M contains 13.6% magenta pigment in white. Sample B, brown in color, contains unknown percentages of the yellow and the magenta pigments in white. Here is how to find these unknown pigment concentrations. This treatment is based on the approximation to the Kubelka-Munk mixing law for samples with relatively small amounts of scattering arising from the colored pigments, given on page 164.

As in the Beer's Law problem on page 156, we select two suitable wavelengths for the calculations. Do you agree that 420 nm and 560 nm are good choices?

We read from the curves the reflectances R at these wavelengths. (To simplify the problem, we omit the Saunderson correction described on page 140.) From the original spectrophotometric curve we find these reflectances R, expressed as fractions instead of percent:

	Wavelength	
Sample	420 nm	560 nm
Y	0.216	0.872
M	0.384	0.146
B	0.167	0.163
W	0.768	0.882

Next we calculate $K/S = (1 - R)^2/2R$ (right margin):

	Wavelength	
Sample	420 nm	560 nm
Y	1.423	0.009
M	0.494	2.498
B	2.078	2.149
W	0.035	0.007

We must now account for the small contribution of white to K/S by subtracting K/S for the white from the other values:

	Wavelength	
Sample	420 nm	560 nm
Y	1.388	0.002
M	0.459	2.491
B	2.043	2.142

The next step is to find the so-called "unit K/S," the contribution to K/S from unit concentration of each of the pigments. We do this by dividing the corrected (for white) K/S above by the pigment concentration, which may be expressed as percent or as a fraction as long as we are consistent. We choose the fractions and divide the corrected K/S for the yellow sample by 0.185, and those for the magenta by 0.136 (right margin):

	Wavelength	
Sample	420 nm	560 nm
Y	7.50	0.01
M	3.38	18.32

We can now set up two equations based on the approximate Kubelka-Munk mixing law given on page 164:

Wavelength (nm)	Mixing equation
420	$2.043 = 7.50c_Y + 3.38c_M$
560	$2.142 = 0.01c_Y + 18.32c_M$

These two equations can be solved for c_Y and c_M exactly as we demonstrated in the preceding example based on Beer's Law. We leave it to the reader to confirm that $c_Y = 0.220$ and $c_M = 0.117$. That is, the brown sample contains 22.0% yellow pigment and 11.7% magenta pigment in white. Mixtures of three colored pigments in white can be treated similarly, but the calculations are more complicated.

(Text continued from page 159)

work with the color coordinates of the samples. Again, however, we wish to emphasize that conditional matches should be avoided if at all possible. It has not been idly said that "the only safe match is an invariant match."

It is true, however, that most color matches, whether made visually (with or without the aids we are talking about) or with the aid of a computer (as discussed below) are likely to be conditional—that is, at least slightly metameric. If instruments and computers are used, these are probably judged by some sort of index of metamerism (page 176). This judgment may not correlate well with the visual appearance of the match for several reasons: The metamerism indices, though the best we have, are not very good indicators of the acceptability of a match; the observer is probably not the "standard observer"; and the source used for the visual observations most likely is not exactly the same as the illuminant used in the calculation of the color coordinates.

Careful workers will wish to control these variables as closely as possible. Indices of metamerism will be used as first estimates but not trusted implicitly. A panel of observers will be used for critical visual judgments. And for most accurate results, the spectral power distribution of the actual source (the whole light booth, for example, not just the lamps) will be determined, and used in the computer to determine the color coordinates for exactly this illuminant. This is already being practiced for some unusual light sources.

Since only the color coordinates rather than the spectrophotometric curves are required for instrumental aids to conditional matching, one might think that colorimeters could be used to advantage in this situation. However, a word of caution is required: As pointed out in Section 3D, conventional filter colorimeters are basically suitable only for measuring small color differences between sample and standard when these are prepared with the same colorants. Their performance is poorest in the situation of conditional matching, since different sets of colorants are involved.

Given the color coordinates of a sample to be matched and those of the individual colorants to be used at various concentrations, how can one formulate an initial conditional match? Today the use of computers allows this problem to be solved easily but without their aid a formidable amount of calculation is involved.

About the best that one can do, short of lengthy calculations, is to build up a history of experience and work from it. This is largely a matter of systematic record keeping. Every sample that is made should be measured, and its color coordinates plotted, for reference when a similarly colored sample is next encountered. Skills can be built up, and the memory assisted and refreshed in this way. Like the visual color matcher's shade bank, this reference file will ultimately prove a highly valuable aid in predicting the initial formulation for a conditional *or* an invariant color match.

Computer-Assisted Formulation. The basic problem in formulating an initial color match is to predict the correct concentrations

Desired Color-Matching Calculation

Given color coordinates, what concentrations of colorants are required to obtain them?

Direct Color-Matching Calculation

Given colorant concentrations, to what color coordinates do they lead?

of the colorants used to match the sample submitted, starting from its color coordinates or its spectrophotometric curve. The library of experience referred to in the preceding paragraph is a collection of solutions to the reverse problem: Given the colorant concentrations, what are the color coordinates of the sample? This can be solved directly by calculation as well as experiment, provided that the color-mixing laws for the system, and the necessary data on the individual colorants, are known. Again, the amount of calculation involved is so great that, before computers, very few colorists undertook this on a large scale.

When computers became available, it was natural to inquire whether a calculated catalog of formulations, covering all color space and providing a "sample" close to anything that had to be matched, would be useful. The answer is only a qualified "yes." Such a catalog can be computed readily enough, but when it is big enough to contain all the data one would want, it is too big to be used easily. Although several such catalogs were computed, we know of none consisting only of formulas and color coordinates, with no actual samples, with any lasting utility.

It soon became apparent, however, that the step between calculating color coordinates from concentrations and the reverse computation was not a very big one. All that had to be done was to modify the concentrations to get a closer approximation than the first computed "trial" and then repeat the calculations. This can be done again and again until the calculated color coordinates are as close as one desires to those required. In mathematics this technique is known as an iterative method, and each step closer to the desired goal is known as an iteration. The problem of correcting the colorant concentrations so that each iteration is closer to the desired formulation than the previous one can be solved in two ways: by trial and error or mathematically.

We must point out that what we have described is exactly the procedure followed by the visual color matcher operating in the traditional way. He makes a first trial based on what his experience and memory tells him are the correct colorant concentrations. From the result of this test he corrects the concentrations by trial and error and makes a second iteration, and so on. There is just one important difference: The visual color matcher must make up each sample as he goes along, and then make estimates of the required change in concentrations based on his visual judgment and experience. The computer techniques, on the other hand, do not require that each sample be made up, and the corrections to the calculations are made more objectively in one of two ways: Either the corrections are computed mathematically according to color-mixing laws, or, if selected by trial and error, the result of applying them is seen instantaneously so that many changes can be made in rapid succession.

The latter technique, of displaying the results of a change in concentrations at once, works best with a computer having a visual display capability. The first commercial device marketed for com-

The essentials of the process called iteration.

The "COMIC" Approximation to the Kubelka-Munk Mixing Law

$$\left(\frac{K}{S}\right)_{mixture} = \left(\frac{K}{S}\right)_1 c_1 + \left(\frac{K}{S}\right)_2 c_2$$
$$+ \left(\frac{K}{S}\right)_3 c_3 + \left(\frac{K}{S}\right)_W c_W$$

for small amounts of colored pigments 1, 2, and 3 in paints or plastics containing large amounts of white, W. The concentrations may be expressed on a relative scale such that $c_1 + c_2 + c_3 + c_W = 1$.

$$\left(\frac{K}{S}\right)_{mixture} = \frac{K_1 c_1 + K_2 c_2 + K_3 c_3}{S_W}$$

for three nonscattering dyes on a scattering substrate such as a textile or paper.

The oscilloscope face of COMIC shows the difference in K/S between standard and calculated match, at each of 16 wavelengths (dots). By adjusting "concentration" dials, the operator could bring all these dots down to the zero line, at which point an invariant match should result.

The Davidson and Hemmendinger COMIC I Colorant Mixture Computer.

puter-assisted formulation worked in this way: the Davidson and Hemmendinger COMIC I analog *CO*lorant *MI*xture *C*omputer (Davidson 1963). Long since outmoded, it displayed intermediate data on an oscilloscope as the match was approached. The operator made adjustments equivalent to changing colorant concentrations until the best match was achieved.

The COMIC I did leave a useful legacy: To fit its limited computing power, it was necessary to simplify the Kubelka-Munk mixing law (page 140) by assuming that all the scattering comes from one colorant, usually the white (in pastel paints) or the substrate (in textiles). This simplification is still widely used because it requires far less effort to provide the necessary calibration information to make it work (see pages 166–167).

The current approach to computer-assisted formulation uses digital computers, often interfaced directly to the spectrophotometer. The basic principles of the technique predate the advent of the computers that made its application feasible (Park 1944); they have been stated by Allen (1966, 1974) and are discussed in books (Stearns 1969, Kuehni 1975b) and review articles

(Gall 1973, Allen 1978). The most widely used programs are proprietary (Applied Color Systems, Davidson Colleagues, Diano, IBM) and the details of how they operate are not disclosed. It is presumed that most if not all of them match color coordinates, though other techniques have been described, such as linear programming (Bélanger 1974) and spectral curve matching by least-squares techniques (Gugerli 1963, McGiness 1967) and by minimizing maximum errors (Ohta 1972b).

We discuss here only one simple type of computer-color-matching program, designed to calculate a match to the tristimulus values of the standard. The procedure, illustrated in the accompanying flowchart, is to supply the computer with data describing the illuminant in which the match is to be made, the colorants to be used, the color to be matched, and estimated colorant concentrations (which can be arbitrary if they are not known). The computer then calculates the color coordinates corresponding to the initial concentrations and the differences between them and those of the sample to be matched. These differences are then compared to the tolerance allowed in the final match. It is expected at this point that the differences will be large, so the next step is to correct the concentrations. This is done by computing quantities called partial derivatives, which describe the changes in color coordinates that result when small changes are made in the concentrations. This information allows corrections to the concentrations to be calculated and applied. At this point the cal-

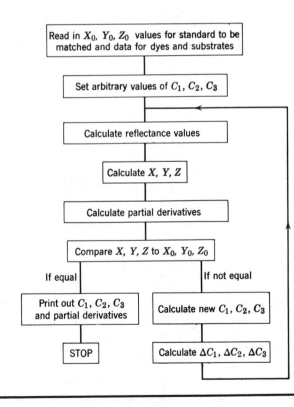

Flow chart for computer color matching (after Alderson 1961).

culation of the color coordinates is repeated using the new concentrations, and the cycle of evaluation, correction, and recalculation continues until a formulation within the desired tolerance is reached.

Most modern computer-color-matching programs differ from this example in several ways. It is now usual to store in the computer the data for a variety of illuminants and for a whole library of colorants. These are simply called for as required. Many programs are written to calculate matches for all possible combinations of colorants (combinatorial method) though most allow preselection to reduce the number of combinations that must be tried. Interactive programs, in which the operator has control over the selection process and can modify it as the calculations proceed, have been described (Davidson 1977, Winey 1978). Where several combinations of colorants are used, it is customary to calculate to a match in one illuminant (usually daylight quality), then from the spectral data generated for the match to calculate tristimulus values for one or more other illuminants (incandescent, fluorescent) and compute indices of metamerism for change in illuminant (page 176). Many programs then print out the formulas in order of metamerism index or cost.

If the above makes computer-assisted formulation sound easy, be assured that *preparing for* the process is far from that! It is indeed difficult and expensive, and computer color matching cannot be recommended for everyone, even though it works exceedingly well in many cases (Johnston 1969, McLean 1969, Brockes 1974). Here are some of the reasons for caution.

First, if the system is going to work, the entire coloring process must be under complete control to a high degree of accuracy. Before even considering trying a system out, much less purchasing

Portion of the chromaticity diagram showing the locations of intermediate samples in the approach to a match. In this example the computer calculated the color coordinates shown by the open circles along the dashed line while approaching a match to the sample whose coordinates are given by the filled circle. The human color matcher prepared the samples whose coordinates are the open circles connected by solid lines. The ellipse and the square represent the tolerance limits for the visual and the computed match, respectively. We have always been impressed by the direct, no-nonsense approach by computer calculation.

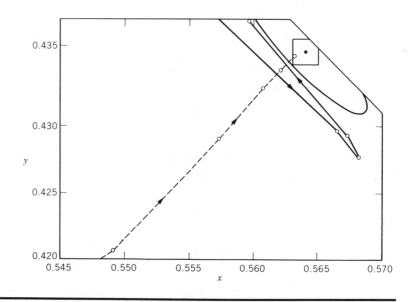

one, the prospective user should demonstrate, using instruments, that he can in fact go through the entire coloring process from incoming colorant testing to final product out the door with a reproducibility, in terms of color differences, that is satisfactorily small. Believe us, this is not easy, and many prospective users of computer color matching have (or should have) stopped right there.

Second, a major part of this overall reproducibility is associated with sample preparation, which we discussed also on pages 69–71. It is essential that the errors in this step be controlled and minimized. Since computer formulation is essentially a laboratory operation, to be tested by making up a laboratory-scale sample before going to production, the difficult problem exists of ensuring that the laboratory and plant-scale results are in good agreement.

Then comes the question of preparing the calibration samples to provide values of Kubelka-Munk K and S for storing in the computer. Since the Kubelka-Munk equations are usually not obeyed exactly, K and S are not strictly constant and must be determined at several levels of concentration, in duplicate at least, for every colorant used and for every substrate and coloring method. The number of samples to be prepared, with analytical accuracy, multiplies very rapidly.

One must also consider what fraction of the color-matching load can be handled by computer. Techniques for computer matching of a variety of unusual samples are in only the preliminary stages of development, and require a far greater understanding by the colorist of the underlying phenomena and theory. These include fluorescent samples, paints containing metallic colorants, translucent materials, and many others. They are discussed further in Section 6A.

In the last analysis whether to choose computer techniques for color matching hinges on economics. If enough use can be made of the system, it can pay for itself many times over in reduced time, colorant costs, and personnel requirements, and in a more consistent product. Only the prospective user can have access to all the information allowing an enlightened decision on its value to him (McLean 1969, Gall 1973, Brockes 1974, Saltzman 1976, Lowrey 1979).

Adjusting the Match

The dividing line between achieving an initial color match to a sample submitted and adjusting this match to conform to a plant (versus laboratory) process or to previous production is somewhat a matter of definition. There is, moreover, considerable overlap between adjustment and production control, which is further discussed in Section C of this chapter. Arbitrarily, we consider here those aspects of adjustment in which the sample to be matched is that submitted from outside the color matcher's laboratory, and leave to Section C consideration of the case in which the sample to be matched is a laboratory or production standard, which is made with the same material, colorants, and process as the lots on which adjustment is required.

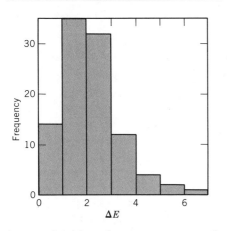

An example of how close one can come on the first trial using a well-controlled computer-assisted colorant-formulation system. (Gall 1980). A color difference of less than three ANLAB 40 units was achieved 80% of the time.

"If your product is colored, it may say to you,
'Color me red or color me blue
But color me the same whatever you do . . . ' "

Bill Bednar

In this sense the process of adjustment is, for the visual color matcher, identical to that of producing the initial match. He continues the process of repeated trials until, in his judgment, the match is close enough.

In the computer techniques (and in some of the simpler applications of instrumental aids as well), it is convenient to consider the first formulation actually made up as the initial match, and any subsequent samples that must be prepared as the products of adjustment.

If the computer techniques gave perfect results every time, there would be no need for adjustment. This is, of course, not the case. In all probability the initial match will be close, but not close enough. The reasons for the difference include color-measurement errors, batch-to-batch variation in sample preparation, data on the colorants which are nonrepresentative, and failure of the mixture to obey the color-mixing laws used.

The adjustment procedure involves calculating corrections to the concentrations used in the trial sample. The corrections required are those that will make its color coordinates the same as those of the standard. This is like the original calculation, except that a "local calibration" has been made in the region of color space of interest. This calibration can correct for such errors as nonrepresentative colorant data and failure to obey the mixing laws, but it *cannot* correct for color-measurement or sample-preparation error. Thus the need to have the process completely under control is emphasized. Any steps that place a process under better control will result in improved performance (Peacock 1953, McLean 1969).

In many cases the second computed trial—or first adjustment on the computer—provides a satisfactory match to the sample submitted. This is probably an average situation. It is difficult to say how this compares with the average number of trials to make a satisfactory visual color match, but it is certainly true that a substantial reduction can be made in the number of trials required (McLean 1969, Lowrey 1979). Derby (1973) has pointed out that making more than one or two adjustments seldom reduces the error in the computed match.

C. Color Control in Production

Just as color measurement is only a special form of analysis, so color control is but a special form of production control. The standard problems, such as sampling error, batch-to-batch variation in normal production, limits of acceptability, and so on, all play their part. The only difference seems to lie in the aura of mystery with which some people tend to surround color.

As outlined in Chapter 3, two of the basic requirements of color measurement, regardless of whether an instrument is involved, are: (1) a description of the permitted tolerance in language acceptable to all concerned, and (2) a standardized procedure for determining the difference between sample and standard with sufficient reliability. In discussing color control in production we assume that agreement has been reached on the nature of the variation in color that will be permitted and on the method of measuring this variability.

For the method of measurement any of the techniques described in Section 3E is satisfactory. It makes little basic difference whether an instrument is used; the same rules must be followed. (The element of time may, of course, become quite important in production control.)

Monitoring

The Value of Instruments. It is in monitoring the production of colored items that the use of color-measuring instruments becomes particularly valuable. Instrumental data provide a running record of the nature of the item being produced and of its variation from the standard in quantitative terms. If the instrumentation and sampling are sensitive enough, small trends may be detected and corrected even before the process goes out of control and non-standard material is produced.

While the eyes is a superb instrument for deciding whether the sample and standard are identical, it is not a good one for determining the exact size and direction of a difference between sample and standard (Thurner 1965). This is especially true if more than one aspect of the sample's color differs from that of the standard. Used correctly, instruments can characterize such a color change very well. Without this information a "corrective" measure might be applied which would do the opposite of what was needed (Derby 1971, 1973). Even the experienced colorist, who is familiar with his process and product, cannot always tell what is happening and what to do about it, and the inexperienced colorist is frequently at a total loss. Here the use of instruments can be of the greatest help. As in all control problems, however, the proper sampling and the proper use of the instruments are of the utmost importance.

The Effect of Process Variables. The final color of any item is usually determined not only by the colorant formulation used, but also by the effects of many other processing variables (Johnston 1964, Marshall 1968, Gailey 1977). One of the jobs of the colorist is to determine as best he or she can the effects of such processing variables. It is far better to bring them under control than to attempt to compensate for their effects by changing the formulation. To do this may require considerable work, but the more that is known about the ability of a process to produce uniform-colored material, the better the colorist can advise the production department what to do about material that departs from standard.

More Than Measurement Alone. In addition to determining how the color of a product has changed, good color measurement, with enough preliminary work, can also help determine the reason for the variation. It cannot, however, control the uniformity of the color merely by furnishing measurements. This is where the understanding of the process must come in, so that the proper remedial action can be recognized and applied. In this respect color measurement is, again, just like any other analytical procedure.

Adjusting

The main function of most colorists in industry is to maintain the uniformity of the color of a product once the formulation has been

Examination

a. Light source
b. Sample and standard
c. Detector

Assessment

a. Difference or not
b. Description of difference
c. Acceptable or not

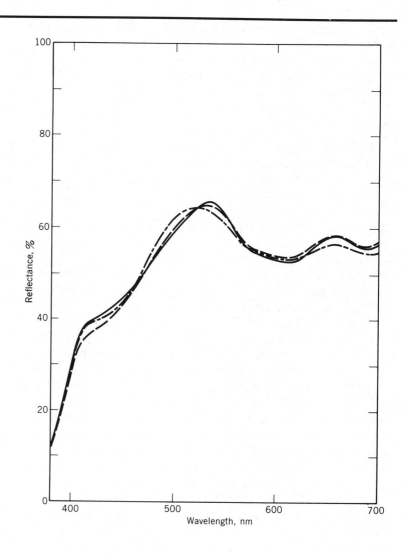

These spectrophotometric curves were measured from three different "standards" for the same color, in use at the same time in three different areas of a paint plant—and they are all metameric to one another!

NO COLORANT OTHER THAN THOSE SPECIFIED IN THE FOR- MULATION MAY BE ADDED TO MAKE A MATCH.

established. That is, they work to reduce the difference in color between a production sample and the standard, Usually, the standard has been made with the same material, the same colorants, and the same coloring process as the production sample. (If it has not, it *should* be! But even at this writing, we find far too many cases where this is not so, as the figure on this page shows!)

Regardless of how well the process is controlled, there comes a time when the color of the product must be modified by altering the colorant formulation. Whether this is done by an experienced color matcher using only skill and experience, or with the most complex system of color measurement and computers, there is one major point to be made about this type of adjustment: *No colorant other than those specified in the formulation may be added to make a match.* This admonition ought to be displayed on a large permanent sign in every color-matching laboratory. Once the formulation has been established, no matter how simple or complex it is, no other dyes or pigments should be used in making adjustments to match the

standard. Unless this rule is adhered to, so-called standard color matches will become metameric and distinctly nonstandard. In practice, it is amazing to see how many times "foreign" pigments appear in a finished formula. They have never "been added;" they just "show up."

One of the consequences of this rule is that, for any coloring operation, the colorants must be selected and standardized so that they always give the same result when used in the same way. A good color match cannot be made unless this is done. That is, the color match is no better than the quality of the colorants allows. By quality, we mean not only the colorimetric properties but also the working properties of the colorants—the rate of exhaustion in a dye bath, the ease of color development in a pigment, and so forth.

The comparison of a production sample to its standard is an ideal example of the kind of measurement for which colorimeters are best suited (Cook 1979, Lowrey 1979). The color differences involved are small and there are no problems of metamerism. (If these conditions are not met, the colorist is in real trouble! And we find it both surprising and dismaying that cases in which a production batch and its standard are *metameric* keep on turning up!)

Instruments and computers can be used both qualitatively and quantitatively to aid the colorist in this situation. In the qualitative sense they can show in what way the sample differs from the standard. As indicated earlier in this section, the smaller the color difference, the more difficult it is for the visual color matcher to ascertain the direction of the difference, although he may have a very good idea of its magnitude. Quantitatively, the computers are used in much the same way as they are for original formulation, except that now the colorants are known. But the task of making a small correction is not as easy as it sounds using essentially the original formulation method. Sample-preparation errors tend to throw off the results which, after all, can be no better than the quality of the data going into them (Derby 1973).

If spectrophotometers and computers are not available, even colorimeters can provide very useful quantitative assistance as to how to change the formulation to bring a production sample "on standard." Simple graphical methods can be used if the differences are small enough (Derby 1952, Berger 1964, MacAdam 1965).

The experience gained in formulating one color, carefully recorded and preserved, provides a starting point for the next similar color to be matched. This is true of all colorant formulation data, regardless of how obtained. Systematic storage of this information, plus facilities for its retrieval, constitute an invaluable "memory" for the colorist (Ingle 1947, Goodwin 1955). Storage may well be in terms of the variables of perceived color, such as Munsell Hue, Value, and Chroma, or of their computed counterparts such as CIE 1976 metric color coordinates or dominant wavelength, luminance factor, and purity.

Controlling

The ultimate aim in applying any analytical procedure to a production situation is to develop a technique that will not only detect a

Effect of errors in sample preparation and measurement on color correction (after Derby 1971, 1973). Suppose that, in the computation of a match to target T, the first calculated formula gives point 1 based on a single sample measured once, whereas its true chromaticity evaluated from multiple samples and measurements lies at the average position A. A calculated correction (arrow) which would move a sample at the erroneous point 1 "on target" instead produces a sample with true chromaticity at 2, considerably farther away from the target than A.

variation but serve as a direct signal for corrective action. The same considerations apply also to color measurement. Here we have progressed to the point where continuous monitoring can be carried out on processes that are reliable and well controlled, but the transition to the next step, namely, what to do with the data obtained, is more difficult.

If the departure from normal color is known to be dependent entirely on a single process variable, such as an oven temperature, the result of a color measurement could well be used to generate a signal controlling the temperature in a predetermined way. On the other hand, if it is known that the variation in color is almost completely dependent on the colorant concentrations, continuous color measurement may give enough information to control the process, but some analog computation may be required to obtain the proper feedback signal.

Despite considerable interest in this field, not much progress has been made. Continuous color-monitoring equipment is available from several manufacturers, but its application in "closed-loop" control situations is still a rarity (Wickstrom 1972).

D. Those Other Aspects of Appearance

The colorist must keep in mind at all times that color is only one of several factors contributing to the appearance of an object. Variations in any of these other aspects of appearance—gloss, metallic reflex, haze, fluorescence—will inevitably affect the perception of the object's color. Thus a change in gloss or a variation in surface texture may result in a product that appears to deviate from specifications for its color. Instruments, as well as the eye, can be fooled. The colorist must determine the cause of the variation before the necessary correction can be made. Hunter (1975) has discussed aspects of appearance other than color in a readable and useful way.

Problems and Future Directions in Color Technology

A. Unsolved Problems

Despite the advances in color technology discussed in the preceding chapters, many serious problems remain essentially unsolved, hindering the application of this technology in industry. In this section we outline what we consider to be the most important of these unsolved problems, and comment as best we can on the possibilities for their solution or circumvention. We discuss them in the approximate order of the appearance of the topics in the remainder of the book, with no attempt to rank them in order of importance.

Problems Relate to Colorimetry

Standard Sources. As mentioned on page 37, the CIE has made no recommendation for standard sources simulating the daylight *D* series of illuminants recommended beginning in 1965. Such sources are not often required, for either visual or instrumental color measurement, but when they are—as for the measurement of fluorescent samples described on page 183—*D* sources are seriously needed. It will be recalled that the *D* series of illuminants was defined to provide enough ultraviolet power to simulate natural daylight for measuring fluorescent samples. Sources *B* and *C* do not do this; and evidence is beginning to appear that they are not as easily produced as the simple CIE recipes would suggest.

Gundlach (1973) has described a precise but very complicated source simulating D_{65} with high accuracy but scarcely suitable for use outside a national standardizing laboratory. The CIE (1981) has recommended a method for testing sources for conformance to standard illuminants, from among several described in the literature, and these methods (all derived theoretically) have been assessed visually by Chong (1981). The CIE Colorimetry Commit-

tee hopes to make progress in locating suitable standard sources simulating the *D* illuminants by 1983.

An additional problem arises when the *D* illuminants are used in computer-assisted color-matching programs. Even for nonfluorescent materials their use (now becoming widespread) can lead to computed conditional matches for an illuminant which cannot be obtained as a real source. This can give rise to considerable confusion when the colorist attempts to judge these computed metameric matches visually.

A second aspect of this problem, even more important in our opinion, is the need to calculate CIE tristimulus values using the spectral power distribution data for the specific light source under which the materials will be observed. This need, while contrary to the spirit of the CIE recommendations for standardization, is especially important for metameric samples and for a number of modern energy-efficient fluorescent sources, known as prime-color lamps (Haft 1972) and sold under various trade names such as Westinghouse's "Ultralume," which have discontinuous spectral power distributions such as the one shown on this page. Failure to use the data specific to these sources will completely invalidate the results obtained when conditional matches are calculated with computer-assisted color-matching programs.

Observer Variability. The CIE 1931 2° standard observer and 1964 10° supplementary standard observer continue to serve the needs of colorimetry well, although they incorporate the 1924 CIE V(λ) function, known to be inaccurate at short wavelengths. For workers needing a more refined set of color-matching functions for color-vision research, Vos (1978) has recommended a set of "fundamental" 2° observer functions (see also Estéves 1979).

What is more important, but not yet widely taken into account, is the large spread in observer characteristics within the range considered to have normal color vision. Our warning of the seriousness of this spread in the first edition of this book was largely ignored or disbelieved. We have recently documented it (Billmeyer 1980a) using a Color Rule: When observers of a wide range of ages

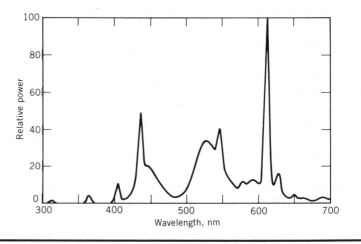

The spectral power distribution of a "prime-color" fluorescent lamp, Westinghouse's "Ultralume," 5000 K (courtesy W. A. Thornton).

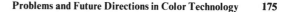

This figure shows the number-and-letter settings for a group of observers with normal color vision on a D&H Color Rule (from Billmeyer 1980a). Two light sources were used: 6500 K Daylight (lower half) and Horizon sunlight (incandescent) (upper half). On the average the spread in the settings of these observers is about the same as the difference in settings resulting from the change between daylight and incandescent light.

(roughly 20–60) are considered, the spread in their settings on the Color Rule is as wide as the difference between 6500 K daylight and "horizon sunlight" in a standard color-matching booth! If the reader has any doubts that this is an important variable in colorimetry, let him observe the difference in appearance of a metameric match using these two sources!

It is well known that a major part of this spread among normal observers results from the gradual yellowing of the lens of the eye with increasing age. Nardi (1980) has followed up our research to show that in a group of college-age observers (17–29 years old) the spread is about a quarter as great as that indicated above.

The importance of this variation in observers for visual color matching should not be overlooked, especially when it is necessary to prepare conditional matches. Unless it is possible to select observers—an unusual circumstance to say the least—about the only control one has over this situation is to rely on the consensus judgment of a panel of observers, as mentioned on page 145. They should be selected with the aid of a Color Rule and color-vision tests to ensure that the range is covered adequately and that they all have normal color vision.

For instrumental color measurement it is important to remember, as noted on page 42, that it is unlikely that any real

observer, selected at random, is identical to the CIE standard observer in response functions. Coupled with the fact that visual observations are virtually never made under sources identical to CIE standard illuminants, this discrepancy makes it most unlikely that measured color coordinates and color differences for conditional matches and metameric pairs correspond even closely to what one sees.

Indices of Metamerism. The word *metamerism,* in the sense of the CIE definition of two colors that match exactly for a known source-observer combination, is often misused in industry. The industrial color matcher often uses the term to describe colors that are a near match in one case, but change differently when the source (or less often the observer) is changed, leading to a more obvious mismatch. There is a need for more precise terminology here (Rodrigues 1980).

Regardless of the words used, there is a real need for an answer to the question of how one may determine the degree of metamerism, that is, the magnitude of the effect, for a given pair of samples. Two ways of doing this have been suggested, leading to *general* and *special* indices of metamerism.

The only metamerism indices that have come into wide use to date are special indices of metamerism. What one does here is to select a special set of conditions under which the pair of samples does *not* match, and calculate the color difference between them. This color difference is called a special index of metamerism for the particular change of conditions, from those for which the colors match to those for which the calculation is made.

The CIE (1972) has recommended a special index of metamerism for change of illuminant. This recommendation merely says that, given two colors that match for one illuminant but not for another, calculate the color difference between the two for the case where they do not match. Since it is by now well known (Longley 1976) that metameric pairs can be produced which match for not only one, but several, common illuminants, one might have to calculate several different special indices of metamerism to estimate accurately the degree of metamerism of a sample pair (Brockes 1969). Moreover, the recommendation does not deal adequately with the problem of two samples that nearly, but do not exactly, match under any known illuminant. The CIE index is calculated in many computer-color-matching programs to allow the user to select the least metameric formulations, but there is more than a little dissatisfaction with how well it works.

One could also have a special index of metamerism for change of observer. The CIE Colorimetry Committee has a subcommittee considering this problem. The difficulty lies in defining one or more "deviate" observers (Allen 1970) representing the range of differences from the standard observer likely to be obtained.

A perfectly general index of metamerism should be independent of special conditions of mismatch, but should be derivable from the conditions holding when the two colors match. Nimeroff (1965) suggested a means of calculating a general index of metamerism from differences in the spectral curves of two samples. It is well

known (for example, Wright 1969, Thornton 1978b) that these curves must cross at least three times if the samples are metameric. One gets the general feeling that the more crossings there are, and the closer the curves approximate one another, the less must be the degree of metamerism.

Nimeroff's metamerism index is based on differences between the spectral reflectance curves of the two samples, weighted by the CIE standard observer functions and the spectral power distribution of the light source for which the two match. The difficulty with the general metamerism index is that it is based on spectral differences when there is no color difference. Hence it is impossible to correlate the magnitude of metamerism by any visual means. The difficulty with the special metamerism indices is that they are based on color differences when there is no match. Since there are many conditions of mismatch the magnitude of metamerism is not uniquely defined.

Color-Rendering Indices. The color-rendering properties of a light source define its performance in reproducing the colors of objects in the same way that they are seen when illuminated by some standard or reference source, such as daylight or incandescent light (Halstead 1978). Indices of color rendering, describing this performance, began to be important when fluorescent sources of various kinds became common, since they often distort colors, that is, render them quite differently, compared to the more familiar older sources.

The CIE (1974) has developed a method of evaluating indices of color rendering based on a test-color method. The test colors are eight Munsell papers making a rough hue circle, supplemented with a few others representing such natural colors as flesh and foliage. A reference illuminant is selected having the same color temperature (page 5) as the test illuminant, preferably from the CIE *D* illuminants (for high color temperatures) or the blackbody radiators (for low ones). The color coordinates of the test colors are calculated for both illuminants, and the color difference corresponding to the change in illuminant is calculated for each test color. These may be examined separately, or averaged and scaled so that 100 represents no color difference for any of the test colors (perfect performance) and lower numbers represent poorer color rendering. Color-rendering indices above 90 have been accepted to mean that the test source's color-rendering ability is close enough to that of the reference source to match the latter's performance for practical commercial purposes (Jerome 1976). Farther down the scale, the common cool-white fluorescent lamps have color-rendering indices in the sixties.

Just as the color-rendering index rates sources used for the critical examination of colors, so one could devise a color-preference index for those used for the appreciative viewing of colors. Judd (1967) proposed such an index, in which the base from which the color differences are calculated is the set of colors people would prefer to see, rather than the actual colors of the test samples—bluer skies, greener grass, ruddier Caucasian flesh tones, and so on. Another index that has been proposed (Thornton 1972a) is

An example of color memory (see Bartleson 1960).

designed to assess the ease with which small color differences are discriminated under the test source. These indices—color rendering, color preference, and color discrimination, and perhaps others not yet identified—should provide a truly meaningful definition of color quality in illumination.

The CIE color-rendering index was designed in studies of, and works best for, sources with continuous spectral power distributions. However, a number of modern energy-efficient fluorescent sources, known as prime-color lamps (Haft 1972) and sold under various trade names such as Westinghouse's Ultralume, have discontinuous distributions such as the one shown on page 174. The various indices described in this section, for both metamerism and color rendering, do not appear to work well for sources with these unusual spectral power distributions.

The Color-Difference Problem. There is no doubt that deriving a color-difference equation giving good agreement with visual data throughout color space is a major unsolved problem. Even though almost any equation will correlate well with properly scaled visual judgments over a limited region (Marcus 1975, Zeller 1979), all know equations fail dismally when tested simultaneously for all colors and all directions of color change. Why should this be so? We do not know.

There are some clues. First of all, the color-vision theories underlying many color-difference equations may not represent the visual processes involved with finite-sized color differences. It is difficult for those not expert in this field to judge the consequences of this problem, but the literature (Wasserman 1978, Boynton 1979) suggests that our state of knowledge in this area is far from complete. Second, the bodies of experimental data may well not be representative of the sizes of color differences that are industrially important in the colorant-using industries. For example, most color-difference perceptibility data, including those of MacAdam, are based on determinations of the threshold, that is, the smallest color difference that can be detected with statistical significance. On the other hand, the sizes of color differences among the samples forming the basis of the equal visual spacing of the *Munsell Book of Color* are several times those encountered in industrially important decisions. Only recently has this been recognized, and the need for new data obtained at intermediate color-difference levels emphasized (Kuehni 1977, Robertson 1978).

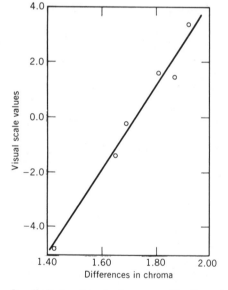

In a limited region of color space, with all sample pairs varying in the same manner (here chroma differences only—Marcus 1975), almost any calculated measure of the sizes of the differences correlates well with their visually perceived sizes . . .

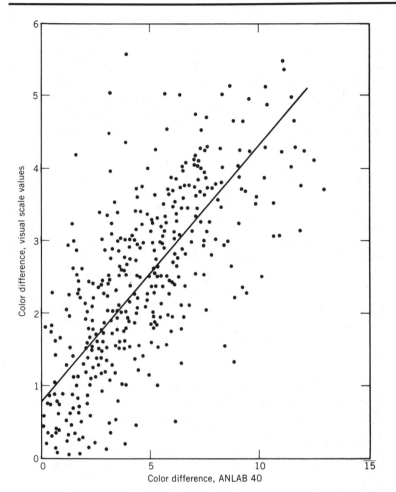

... but when a calculated measure of color differences (here, CIELAB values) is compared to visually perceived differences for a wide variety of colors and directions of color differences, the correlations are typically as poor as this one (data of Morley 1975).

The CIE has published (Robertson 1978) guidelines for a four-step program of coordinated research on the problem: First, study methods for collecting and analyzing new visual data. Second, study systematically the effect of important variables (size of color difference, sample size and separation, texture, level of illumination) for a few colors. Third, extend the studies to a wide range of colors. Fourth, derive a formula to fit the resulting data and test it in practice.

Some useful results are already at hand. Pointer (1973) has shown, for example, that color-discrimination thresholds do not vary with chromatic adaptation over a range of white-light illuminants from daylight to tungsten. This implies that color-difference equations should work equally well over the same region.

New equations, of even greater complexity, are still being proposed. Along with one such proposal, Friele (1978, 1979) has shown in detail just how difficult it is to devise such a new color-difference formula, and what some of the problems are with the existing visual data.

Many of these problems result from the variability of visual judgments. An illuminating example is that Rich (1975) found, in show-

ing observers a pair of samples and asking whether they matched, that two identical samples were judged *not* to match between 20 and 50% of the time. A "false-alarm" parameter, not uncommon in psychological studies, was required to account for this in deriving color-difference perceptibility ellipses.

Despite the 1976 recommendation of the CIE to use either the CIELAB or the CIELUV color-difference equation "for uniformity of practice," new equations continue to appear (Friele 1978, 1979; Richter 1980), and two of the equations with demonstrated poorer correlations to visual results in many studies, FMC-2 and Hunter *L a b,* continue to be the most widely used in the United States, largely because of their widespread adoption by instrument manufacturers before the CIE equations were developed and recommended in 1976.

It is important to emphasize that the 1976 recommendations were made for "uniformity of practice" and not because of any overwhelming superiority in performance of the equations. Now that they have obtained international approval, the CIE recommendations should be followed in all transactions among companies, as it is becoming apparent that they will be in all national standardization programs. The work on improved color-difference equations should continue, by all means, following the CIE recommendations just discussed (Robertson 1978).

In a series of important papers, McDonald (1980) has described a new set of visual data and a new color-difference formula for industrial "pass-fail" color-matching decisions.

Problems Related to Measurements

Before discussing some of the more serious measurement problems facing the colorist, we wish to reemphasize the very great importance of preparing the best and most representative samples for measurement, and of providing someone sufficiently skilled to interpret the results of color measurements properly. Without careful attention to these essentials, one can scarcely recognize and define, much less solve, measurement problems.

Instrument Agreement. Two problems appear under this heading. The first is that of obtaining agreement among instruments. A recent study (Billmeyer 1979a) showed that excellent agreement among several modern color-measuring spectrophotometers from different manufacturers could be obtained under special circumstances, but not when the instruments were used in the usual way. Two problems were identified. One related to the inclusion or exclusion of the specular component in these integrating-sphere instruments; this is discussed in the following paragraphs. The second problem is that the various instrument manufacturers do not use the same sets of tristimulus weighting factors in their computations of X, Y, and Z. Thus even identical spectral reflectance data lead to different color coordinates from different instruments. A little standardization would be highly useful here, and action by the CIE to recommend the means to achieve it is badly needed. In its absence, we give here our best recommended 16-point weighting factors (Stearns 1975).

Sixteen-Point Weights for Calculating Tristimulus Values (Stearns 1975)

CIE 1931 2° Standard Observer

λ (nm)	Ill. C			Ill. D_{65}			Ill. A		
	$P\bar{x}$	$P\bar{y}$	$P\bar{z}$	$P\bar{x}$	$P\bar{y}$	$P\bar{z}$	$P\bar{x}$	$P\bar{y}$	$P\bar{z}$
400	0.044	−0.001	0.187	0.136	0.002	0.628	0.012	0.000	0.050
420	2.926	0.085	14.064	2.548	0.070	12.221	0.616	0.017	2.954
440	7.680	0.513	38.643	6.680	0.455	33.666	1.814	0.119	9.124
460	6.633	1.383	38.087	6.364	1.322	36.507	1.985	0.413	11.441
480	2.345	3.210	19.464	2.190	2.939	18.157	0.886	1.210	7.420
500	0.069	6.884	5.725	0.051	6.822	5.515	0.025	3.691	3.022
520	1.193	12.882	1.450	1.342	14.121	1.621	0.897	9.459	1.095
540	5.588	18.268	0.365	5.778	19.013	0.389	4.619	15.191	0.316
560	11.751	19.606	0.074	11.290	18.861	0.069	11.068	18.432	0.070
580	16.801	15.989	0.026	16.260	15.462	0.025	19.465	18.418	0.031
600	17.896	10.684	0.012	17.922	10.673	0.012	25.309	15.104	0.018
620	14.031	6.264	0.003	14.047	6.288	0.003	22.557	10.095	0.005
640	7.437	2.897	0.000	7.029	2.734	0.000	13.166	5.136	0.000
660	2.728	1.003	0.000	2.507	0.922	0.000	5.270	1.941	0.000
680	0.749	0.271	0.000	0.707	0.256	0.000	1.650	0.598	0.000
700	0.175	0.063	0.000	0.166	0.060	0.000	0.491	0.177	0.000

CIE 1964 10° Supplementary Standard Observer

λ (nm)	Ill. C			Ill. D_{65}			Ill. A		
	$P\bar{x}$	$P\bar{y}$	$P\bar{z}$	$P\bar{x}$	$P\bar{y}$	$P\bar{z}$	$P\bar{x}$	$P\bar{y}$	$P\bar{z}$
400	0.143	0.011	0.581	0.251	0.023	1.090	0.034	0.003	0.139
420	3.593	0.373	17.172	3.232	0.330	15.383	0.792	0.081	3.780
440	7.663	1.252	39.355	6.679	1.106	34.376	1.896	0.305	9.734
460	6.330	2.732	36.753	6.096	2.620	35.355	1.978	0.859	11.522
480	1.837	5.344	16.979	1.721	4.938	15.897	0.037	2.135	6.770
500	0.061	8.752	4.151	0.059	8.668	3.997	1.523	4.886	2.299
520	1.958	12.591	0.924	2.184	13.846	1.046	1.523	9.652	0.747
540	6.555	16.615	0.221	6.810	17.355	0.237	5.674	14.463	0.200
560	12.618	17.777	0.004	12.165	17.157	0.002	12.437	17.484	0.005
580	16.960	14.582	−0.002	16.467	14.148	−0.002	20.545	17.580	−0.002
600	17.157	10.079	0.000	17.233	10.105	0.000	25.371	14.906	0.000
620	12.833	5.979	0.000	12.894	6.020	0.000	21.591	10.080	0.000
640	6.566	2.731	0.000	6.226	2.587	0.000	12.158	5.062	0.000
660	2.291	0.898	0.000	2.111	0.827	0.000	4.635	1.819	0.000
680	0.604	0.234	0.000	0.573	0.222	0.000	1.393	0.541	0.000
700	0.127	0.049	0.000	0.120	0.047	0.000	0.374	0.145	0.000

The second type of agreement that would be desirable is between the instrument and visual observations. In the case of the sizes of color differences, the unsatisfactory correlation of the color-difference equation is the major source of error, and this has already been discussed. About the only other case in which agreement could reasonably be hoped for is the question of whether metameric pairs match or not. The problem lies again in the selection of tristimulus weighting factors. It is important, but not sufficient, to use the spectral power distribution of the source utilized for the visual observations in the integration to obtain tristimulus values. Addi-

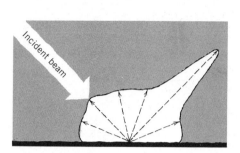

Indicatrix of a typical "glossy" sample.

$$R = \frac{R' - k_1}{1 - k_1 - k_2(1 - R')}$$

$$R' = k_1 + \frac{(1 - k_1)(1 - k_2)R}{1 - k_2 R}$$

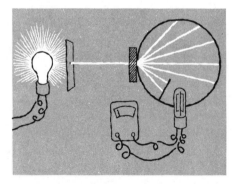

Diffuse transmittance measurement, with the sample against the port of an integrating sphere.

tionally one would like to be able to use the color-matching functions of the actual observer. This is not now possible, however, as these functions are so difficult to obtain experimentally that they are essentially unavailable. Further study to devise a way around this difficulty would be most welcome.

Problems of Geometry. We pointed out on page 80 that the selection of illuminating and viewing geometries in color-measuring instruments is very limited compared to the conditions used by human observers. Perhaps the most serious aspect of this difference lies in the inclusion or exclusion of the specular component of the light reflected from a glossy or semiglossy sample. The human observer is almost invariably interested in the appearance of the sample with the specular component excluded, for this gives him the most information about its color. Unfortunately, most color-measuring instruments use integrating-sphere geometry, and the inability of the integrating sphere to exclude the specular component completely for any but *very* highly glossy samples poses a serious problem. Many samples important in everyday life have indicatrices of the type shown on this page, and there is just no way that a measurement with the specular component "excluded" can be meaningful for such a sample (Budde 1980).

The serious nature of this problem should not be underestimated. The paint colorist should know that she has to get the gloss right before measuring the color, but even this (in terms of glossmeter readings) may not be enough. Writers of computer-color-matching programs often recommend measuring with the specular component included and provide in their programs a calculated correction using Saunderson's equation. But this involves assuming values for the reflection coefficient k_1 (and k_2 also, but it is the "gloss" reflection k_1 that it is important here). Sometimes this does not work. In the instrument study discussed above (Billmeyer 1979a), it was found that the various instruments excluded between 2.7 and 6.3% of the reflected light as the "specular component," depending on instrument and sample (all nominally glossy). Using the National Physical Laboratory standard ceramic tiles (page 84), good agreement among instruments could be obtained (being sure that the spectral data were all integrated exactly alike) for measurements made with the specular component included, but not for those made with it "excluded."

It seems likely that the use of 45°/0° geometry would circumvent most of these problems, since the specular reflection is never measured, and the indicatrices of most samples are thought to be reasonably free from the influence of specular reflection at the 0° viewing angle, for 45° illumination. More studies are needed, and should be forthcoming with the recent availability of 45°/0° and 0°/45° spectrophotometers; there appears to be a strong argument here in favor of these bidirectional geometries.

Special Samples. While most modern color-measuring spectrophotometers can measure a wide variety of samples well, some serious problems exist in the measurement of unusual samples.

Translucent specimens cannot be fully described by a single measurement. Their reflectance depends on what kind of material

is placed behind the specimen, and it is sometimes possible to characterize them by measurements with white and black backing materials. If their transmittance is to be measured, it is necessary to place the specimen flush against the entrance port of the integrating sphere, as shown in the figure on page 182. This cannot be done with some instruments. Even so, the measurement of translucent specimens is fraught with serious difficulties (Atkins 1966, Hsia 1976).

Fluorescent samples require the use of polychromatic illumination if the results are to correlate with the visual appearance of the samples. Even so, exactly the same source must be used for both the visual and instrumental evaluations to develop the correlation. This is not always possible. Many instruments provide a simulated daylight for such measurements, but this may not be the same from one instrument to another, nor a good enough representation of a standard daylight such as CIE D_{65} to correlate with the daylight appearance of such samples. Standardization of the measurement of fluorescent samples is only now being attempted (Billmeyer 1979c). In the absence of suitable measurements with closely simulated D_{65} or another standard source in the instrument, accurate but very difficult calculation methods for achieving the same result have been studied (Billmeyer 1980c).

Retroreflective samples, such as traffic control signs, require special instrumentation for measurement of their nighttime (retro-reflected) color. What is required here is that the illuminating and viewing angles be only a fraction of a degree apart, to detect the light reflected back in the direction of the source. With the finite sizes of sources and detectors, this usually means that the sample must be 15–30 m from the source and detector. Measurement of the daytime color of retroreflective samples is done conventionally, but the specifications that must be met call for the use of 45°/0° geometry (Ascher 1978, Eckerle 1980).

Metallized samples, such as paints containing aluminum flakes as a colorant, so popular for automotive use, also require special equipment for measurement, since their color varies with the illuminating and viewing conditions (Billmeyer 1974). Flexibility in the selection of illuminating and viewing angles is required to allow the characterization of these materials (Hemmendinger 1970, Armstrong 1972).

Problems Related to Computer Color Matching

Problems with Conventional Samples and Theory. By conventional samples, in these paragraphs, we mean essentially opaque samples such as paints, plastics, and textiles, free from fluorescence and metallic or other unusual colorants; and by conventional theory we mean the simple Kubelka-Munk theory outlined on pages 139–141. Gall (1973) discusses the problems one can expect in these cases; see also Brockes (1974), Kuehni (1975b), Stearns (1976), Allen (1978), and Guthrie (1978).

We must again begin by emphasizing the need for extreme care in sample preparation for computer color matching, and in having the entire coloring process under complete control. This is in

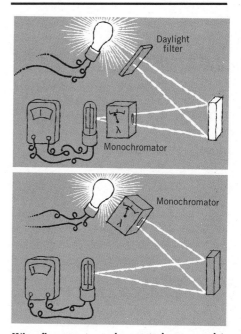

When fluorescent samples are to be measured to provide results correlating with their visible appearance, it is necessary to illuminate them directly with the light source used for the visual judgments (polychromatic illumination, above) and not with monochromatic light (below).

$$\frac{K}{S} = \frac{(1 - R)^2}{2R}$$

$$\left(\frac{K}{S}\right)_{\text{mixture}} = \frac{K_{\text{mixture}}}{S_{\text{mixture}}}$$

$$= \frac{c_1 K_1 + c_2 K_2 + c_3 K_3 + \cdots}{c_1 S_1 + c_2 S_2 + c_3 S_3 + \cdots}$$

essence an analytical procedure, and to ensure its success each step must be carried out with analytical accuracy! Gall (1973) noted that, particularly for dark shades, uncertainties resulting from sample preparation and in measurement with the then-existing instruments constituted a major source of failure in computer formulation. Since that time the instruments have been improved but, alas, our ability to make the necessary samples has not. In our observation it may even have deteriorated as colorists have become familiar to the point of carelessness with the success of computer color matching. Although the colorist has, with the currently available instruments, the ability to measure the quality of the samples she makes, this is too often ignored. Instead, one hopes or pretends that any sample-preparation method gives good results instead of studying the problem and arriving at a demonstrated suitable procedure.

It has been said that the most remarkable thing about computer formulation is that it works at all. The experience of those active in the field indicates that computer techniques are being pushed empirically far beyond the ranges where their simpler equations are known to hold accurately, and yet with considerable success. It seems as if the computer's repetitive or iterative techniques are so powerful that, properly applied, they almost invariably "zero in" on an acceptable match. What are some of the reasons for this point of view? Certainly the Kubelka-Munk theory contains many assumptions that are not fulfilled in the experiments we do. Among them are the following: measurements must be made at a single wavelength; the sample must be illuminated and viewed diffusely; there must be no reflections at the surface of the sample; there must be no losses of light at the edges of the sample; and the

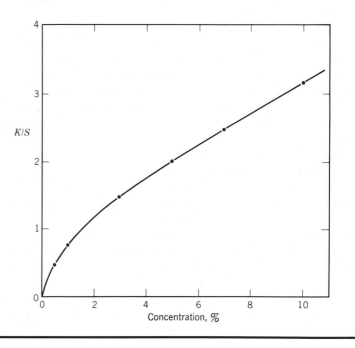

For various reasons, some of which are cited in the text, K/S may not be directly proportional to colorant concentration, even though the simple Kubelka-Munk theory says it should be (from Gall 1973), with permission of the copyright owner, the Institute of Physics, Bristol).

sample must be homogeneous to diffuse light. Fortunately, by using only opaque samples, in which there is enough scattering to cause an incoming beam of light to be fully diffused within the sample, using a sufficiently narrow range of wavelengths that the Kubelka-Munk constants K and S are constant over the range, and applying the Saunderson correction when required to account for surface reflections, the theory can be "patched up" fairly well.

More difficult to handle are deviations in the commonly used mixing laws, which say that the effect of each colorant in the mixture is exactly proportional to its concentration. Gall (1973) points out many reasons why this may not be true in real systems. As he shows, it is only necessary to do a few experiments to demonstrate that this is often not true. There may, in textile dyeing, be incomplete or irregular transfer of the dyes from the dye bath to the fabric; there may be too little scattering to cause full diffusion of the light at low pigment concentrations (Phillips 1976); there may be "crowding" of pigment particles at high concentrations, making the scattering from one dependent on the presence of others (Bruehlman 1969, Ross 1971); or the Saunderson correction for surface reflections may not have been applied correctly. Usually these problems are overcome by evaluating K and S at a number of concentrations over the range that will be used, and inserting in the calculations the values for the concentration closest to that required to make the match.

The determination of K and S for each colorant and substrate (for the values are never the same in different systems) and wavelength and concentration of interest involves problems of the accurate preparation and measurement of many samples, as well as much data handling. Exactly how to go about determining these constants also brings up problems; there are several ways to do it (Billmeyer 1973a, Kuehni 1975b, Cairns 1976, Allen 1978, Marcus 1978b). Commercial computer-formulation programs usually do not disclose the details of this step. Some of the methods for evaluating K and S require the use of translucent (incomplete-hiding) samples, introducing problems in both measurement and calculation, the latter discussed below.

Special Samples. As with their measurement, computer formulation of unusual samples is fraught with difficult problems, which we can only mention. The techniques for solving them are in the very early stages of development; to improve them and bring them to full fruition will require much research and development work by the most skilled and knowledgeable colorists. Most of the approaches used are empirical and limited, though they work well in a great many cases.

Translucent samples can be handled by the extension of the Kubelka-Munk equations to translucent systems, as long as there is enough scattering to diffuse the light completely. The equations become mathematically more complex, as the example on this page shows, but this is not a problem with the aid of computers. However, more calibration samples and more data handling are required. In addition, knowing exactly what to do to utilize the results of the calculations fully, say to match both the transmitted-

$$R = \frac{1 - R_g(a - b \, \text{ctgh} \, bSX)}{a - R_g + b \, \text{ctgh} \, bSX}$$

$$T_i = \frac{b}{a \, \sinh bSX + b \, \cosh bSX}$$

where

R = reflectance
R_g = reflectance of material behind the translucent sample
T_i = transmittance within the sample
$a = (K + S)/S$
$b = (a^2 - 1)^{1/2}$
K = absorption coefficient
S = scattering coefficient
X = sample thickness
ctgh = hyperbolic cotangent
sinh = hyperbolic sine
cosh = hyperbolic cosine

One form of the Kubelka-Munk equations. For others, conveniently summarized, see Johnston 1973, Judd 1975a.

Reflected plus fluoresced power

Wavelength

One way to eliminate the effect of fluorescence in reflectance measurement (Ganz 1977).

(Perceived) color

Attribute of visual perception that can be described by color names: white, grey, black, yellow, orange, brown, red, green, blue, purple, and so on, or by combinations of such names.

Hue

Attribute of a visual sensation according to which an area appears to be similar to one, or to proportions of two, of the perceived colors red, yellow, orange, green, blue, and purple.

Achromatic (perceived) color

Perceived color devoid of hue.

Chromatic (perceived) color

Perceived color possessing a hue.

Colorfulness

Attribute of a visual sensation according to which an area appears to exhibit more or less chromatic color.

Brightness

Attribute of a visual sensation according to which an area appears to be emitting, transmitting, or reflecting more or less light.

light color and the reflected-light color of a translucent plastic, is a more serious problem, the solution to which has not yet appeared to our knowledge.

Fluorescent samples require new theory before they can be formulated correctly. Ganz (1977) has summarized some of the problems involved and concludes that a full solution would be so complicated and elaborate that it would not pay. He suggests some alternatives, one of which is illustrated in the figure on this page.

Metallized samples can probably be formulated according to an "exact" theory that has been outlined in principle (Billmeyer 1976) but not yet applied to our knowledge. Advanced turbid-medium theory, described briefly in Section B, is required. The approaches utilized in commercial computer-formulation programs are, as noted above, empirical and dependent on much careful calibration (Armstrong 1972).

B. Future Directions

The Specification of Color Appearance

It will be recalled that in Chapter 2 we described three different sorts of color-order systems: first, those systems associated with physical samples, and which in one way or another attempt to describe in an orderly way the perceived colors of those samples; second, the CIE system, which is completely dissociated from the appearances of samples except to tell whether they match or not, but is closely related to certain measurable physical quantities; and third, transformations of the CIE system which attempt to relate the first two by providing objective measures correlating with our subjective perceptions of color.

In this section we examine the interrelations among these three types of systems with the objective of developing numerical specifications of how colors really look. We must first examine the distinctions among the terms and definitions for the things we are talking about. The careful study of color terminology has been an active project of the CIE Colorimetry Committee in recent years, in anticipation of a fourth edition of the International Lighting Vocabulary which will replace the third edition (CIE 1970) and contain most of what is presented here. We follow for the most part a series of publications by that committee's chairman, R. W. G. Hunt (1977, 1978a,b). Many of the concepts he presents are new and still controversial, and there may be further changes and developments before these ideas and terms are fully accepted.

Subjective (Perceptual) Color Terms. We start with attention to the terms that describe the response of the observer, that is, what he perceives. We define *perceived color* in a very simple way, in terms of the common color names so familiar to all. They describe the attribute of *hue*, and its definition is equally simple. It follows that we can divide all colors into *chromatic* and *achromatic* colors, those that do and those that do not possess hue. In a color possessing hue, the hue may be exhibited weakly or strongly, leading us to the concept of *colorfulness*. This is a new term (Hunt 1977), and we discuss shortly its relation to older, more common names for the quantity it describes. Hue and colorfulness describe two of the

three attributes of color, and the third is most directly described by *brightness* (in the sense that a light may be bright or dim—not the "dyers brightness" discussed on page 20).

At this point something new has been added. Why did we talk about lightness in more qualitative discussions throughout the book, but introduce brightness here? To understand this, we must look at other ways of distinguishing among various classes of color. First, we must distinguish between *luminous* and *nonluminous colors*, corresponding approximately to the distinction between the illuminant and the object modes of viewing introduced on page 2. It is luminous colors, those that behave like light sources, that are best described by their hue, colorfulness, and brightness. Nonluminous objects, on the other hand, are often recognized by their *saturation*, which we now define as relative colorfulness. To distinguish between saturation and colorfulness, consider a colored light and its reflection in a mirror: The reflection is usually seen as less bright and less colorful (for example, pink instead of red), but when judged relative to its brightness, its "color" appearance is likely to be the same, and the two lights are seen as having the same saturation.

Nonluminous perceived colors are usually produced by reflecting objects, and the colors of such objects are not usually seen in complete isolation, but in relation to the colors of other objects around them; thus we must distinguish between *related* and *unrelated colors*. Now at last we can reintroduce the concept of *lightness*, since it is the fraction of the light reflected by the color, relative to the usual reference of the whitest object in the scene. Lightness is, in fact, relative brightness in the same sense that saturation is relative colorfulness.

Unlike luminous colors, nonluminous related colors require one more term to describe their relative colorfulness. This is *perceived chroma*, where the word perceived is included to distinguish this property from others for which the word chroma is used, such as Munsell Chroma.

Finally, when taken together, the hue and saturation of a perceived color are called its *chromaticness*.

The distinctions among colorfulness, saturation, and perceived chroma are fine ones, and a full understanding of them is not essential for this book. For a given perceived color, colorfulness normally increases as the brightness increases, whereas such a color exhibits approximately constant saturation as the brightness is changed. A given color also exhibits approximately constant perceived chroma for all levels of brightness, but for a given brightness level the perceived chroma generally increases as the lightness of that color is increased, relative to the lightnesses of white objects in the scene.

Objective Color Terms. Next we turn our attention to terms that describe the color stimulus, rather than the observer's response. Since this stimulus can be measured, these are objective terms. We must, however, distinguish between *psychophysical* terms, which are evaluated directly from such important quantities as spectral power distributions, spectral reflectances, and observer

Luminous (perceived) color

Color perceived to belong to an area that appears to be emitting light as a source.

Nonluminous (perceived) color

Color perceived to belong to an area that appears to be transmitting or diffusely reflecting light.

Saturation

Attribute of a visual sensation according to which an area appears to exhibit more or less chromatic color, judged in proportion to its brightness.

Related (perceived) color

Color perceived to belong to an area or object seen in relation to other colors.

Unrelated (perceived) color

Color perceived to belong to an area or object seen in isolation from other colors.

Lightness (of a nonluminous related color)

Attribute of a visual sensation according to which an area appears to reflect diffusely or transmit a greater or smaller fraction of incident light.

Perceived chroma (of a nonluminous related color)

Attribute of a visual sensation according to which a nonluminous related color appears to exhibit more or less chromatic color, judged in proportion to the brightness of a white object color similarly illuminated.

Chromaticness

Attribute of a visual sensation consisting of the hue and the saturation.

Psychophysical terms

Terms denoting objective measures of physical variables that are evaluated so as to relate to equality of magnitudes of important attributes of light and color. These measures identify stimuli that produce equal response in a visual process in specified viewing conditions.

Luminance factor

Ratio of the tristimulus value Y of the sample to that of a perfect reflecting or transmitting diffuser identically illuminated.

Psychometric lightness

Quantity defined by a suitable function of psychophysical measures (principally luminance factor) such that equal scale intervals correspond as closely as possible to equal differences in lightness for nonluminous related colors.

$$L^* = 116 \left(\frac{Y}{Y_n}\right)^{1/3} - 16$$

spectral responses (as we saw in the CIE system), and *psychometric* terms, computed from these so as to correspond more nearly to what we perceive.

As an example of the difference between the two, consider the *luminance factor, Y/Y_n*. It is a psychophysical term. As we saw on page 61, the corresponding psychometric term is *metric lightness*, where again we abbreviate psychometric as metric for common use. In the CIE system CIE 1976 metric lightness is L^*. Both Y/Y_n and L^* are the correlates of the perceptual quantity lightness.

The most common psychophysical and psychometric color terms are summarized in the table on page 189 together with terms for the corresponding perceptual quantities that they approximate. The psychophysical quantities important for this book have already been defined, as have most of the psychometric terms.

These terms and quantities lay the groundwork for what appears to us to be one of the most important directions in which color technology is beginning to move: to expand from the description of color matches, done rather well by the CIE system, and the description of color differences, admittedly not done too well by our present equations, to the description of the way colors really look in the complex scenes of our daily lives.

Chromatic Adaptation

Before the appearance of colors can be fully and accurately specified, the means must be found to specify in quantitative terms the remarkable ability of the human eye to adapt to changes in the illumination while still recognizing colors as if they were unchanged. This phenomenon has been studied since the 1860s but is even today not understood. Why is it that, when one goes indoors from the bluish light of the north sky to the warm tones of incandescent lamps, whites still look white and all colors are recognizable despite drastic changes in the physical stimuli reaching the eye? What are the color-vision mechanisms responsible for this chromatic adaptation? How can the results be predicted by calculations based on measurement of the physical stimuli? Of what value would be the practical application of these calculations to, for example, color reproduction? These and other questions are still largely unanswered, but there is much recent progress, with the promise of more to come. Bartleson (1978) summarized a review of chromatic adaptation as follows: The physiological color-vision mechanisms underlying the phenomenon are not yet obvious. As yet we cannot point to a successful model for the phenomenon. The one most commonly used, due to von Kries, dates back over 100 years. It is used by default, for example, in the CIE color-rendering calculation, because we have nothing better, and despite the fact that it is based on assumptions known to be in error, especially for large changes in the illumination. There are a number of better models in various states of development, but to choose among them we must have reliable experimental data. There are several methods to obtain such data, but there are disconcerting differences among the results of the experiments.

| Perceptual, Psychometric, and Psychophysical Terms | | |
| Subjective | Objective | |
Perceptual term	Psychometric term	Psychophysical term[b]
Brightness	Psychometric brightness	Luminance
Lightness[a]	Psychometric lightness[a]	Luminance factor[a]
Hue	Psychometric hue	Dominant wavelength
Colorfulness	Psychometric colorfulness	
Saturation	Psychometric saturation	
	Psychometric purity	Purity
Perceived chroma[a]	Psychometric chroma[a]	
Chromaticness	Psychometric chromaticity	Chromaticity

[a] These terms are applicable only to nonluminous related colors.
[b] These are the terms defined in Section 2B.

Despite this not-too-optimistic view, Bartleson went on to solve many of these problems and develop surprisingly successful methods for predicting changes in color appearance with variations in chromatic adaptation and identifying colors that appear the same to the eye when it is under different states of adaptation (Bartleson 1979a,b).

Advanced Turbid-Medium Theory

Recognizing a turbid-medium theory as one that describes the scattering and absorbing properties of samples, we define advanced theories of this type as those that go beyond the Kubelka-Munk theory described in Chapter 5. To understand what advanced theories can do that the Kubelka-Munk equations cannot handle, and to reach a decision as to when such theories might be useful, we must define three kinds of optical systems: optically thin, intermediate, and optically thick (Craker 1967, Billmeyer 1973c). Most pigmented objects fall into the optically thick category, even though they may be physically thin, such as an opaque paint film. (It is the amount of scattering, not the physical thickness, that counts. The space between us and the distant stars is vast, but for the most part there is so little scattering of light in it that we see the images of those stars clearly; it is an optically thin system.)

Billmeyer and Richards (1973c) examined various turbid-medium theories for their applicability in these three regions of optical thickness. We do not consider them all here, but select only the one that has the advantage of working well in all three regions: the so-called many-flux theory of Richards (Richards 1970, Mudgett 1971, 1972, 1973). This is an extension of the Kubelka-Munk theory in the following sense: Kubelka and Munk (1931) (and others before them) considered scattering and absorption in light which moves either up or down diffusely within the sample (assuming that any direction of movement with an up component in it is counted in the upward flux of light, and vice versa). This is why it is

Psychometric terms

Terms denoting objective measures of physical variables that are evaluated so as to relate to differences between magnitudes of important attributes of light and color and such that equal scale intervals represent approximately equal perceived differences in the attribute considered. These measures identify pairs of stimuli that produce equally perceptible differences in response in a visual process in specified viewing conditions.

Three Regions of Optical Behavior of Turbid Media

Optically thin

Most scattered light that is observed has been scattered only once; much unscattered light emerges from the sample.

Intermediate

Most scattered light has been multiply scattered, but some unscattered light still emerges from the sample.

Optically thick

All light has been multiply scattered.

Diffuse incident light

Background

Diffuse light fluxes moving "up" and "down" form the basis of the simple Kubelka-Munk theory, most useful for describing "optically thick" samples. . . .

Collimated flux

Diffuse flux

Collimated fluxes

Diffuse fluxes

Background

. . . When more detail is needed, more fluxes must be considered. In "four-flux" theories two collimated fluxes, representing the illuminating beam and its reflection from the background, are added . . .

Applicability of Various Turbid-Medium Theories in the Three Regions of Optical Thickness (Billmeyer 1973c)

Theory	Optically thin	Intermediate	Optically thick
Kubelka-Munk	No	No	Yes
Four-Flux	Yes	Limited	Yes
Many-Flux	Yes	Yes	Yes
Doubling	Yes	Yes	Limited
Monte Carlo	Yes	Limited	No
Scattering Order	Yes	Limited	No
Diffusion	No	No	Yes

called a two-flux theory. Many years later, Beasley and others (1967; see also Atkins 1968) and Völz (1962, 1964) independently derived theories utilizing four fluxes, the two diffuse fluxes of Kubelka and Munk and two collimated fluxes representing, for example, the illuminating beam in a spectrophotometer and its reflection from the bottom face of the sample. These theories proved useful in describing nonhiding translucent plastics, which belong in the intermediate class of optical thickness. Richards generalized this approach to include as many fluxes or channels as the situation requires. This provided for the first time the opportunity of describing the angular dependence of light emerging from a sample.

We can now summarize the value of advanced turbid-medium theories. They allow one to study cases in which the amount of light reflected from a sample depends on the angle of observation. There are, in fact, not many cases where this is important. Two such cases are (1) those in which there is not enough scattering to allow the light fluxes to become completely diffuse, for example, the translucent plastics mentioned above; and (2) those in which some unusual colorant, such as flake metal, imparts an angular dependence to the light, such as metallized paint samples.

Another type of angular dependence is also important in scattering theories. This appears in the theory describing the scattering and absorption of light from single isolated pigment particles—at the very far end of the "optically thin" region. This theory, derived for spherical particles by Mie (1908), shows that the two variables determining the amount of scattering in any system are the particle size, relative to the wavelength of light, and the refractive index of the pigment, relative to that of its binder.

Before discussing angular dependence in the Mie theory, let us point out that it is often these two quantities that dictate the properties and choice of pigments for a given application. Inorganic pigments usually have refractive indices much different from those of their binders. They are usually made to have the optimum particle size for scattering, as determined by the Mie theory and confirmed by experience. This particle size, and the smaller

amounts of scattering at larger and smaller sizes, are shown in the figures on page 12 and on this page.

Organic pigments, on the other hand, usually have refractive indices very near those of their (organic) binders; they have inherently low levels of scattering. Therefore they are usually made to have very small particle size to produce the largest possible amount of absorption and therefore the highest tinting strength. This is practiced except when another by-product of small particle size, poor lightfastness, intervenes. For further discussion, see Sections 4B and 5B.

The angular dependence of light scattering is described in the Mie theory by what is known as the phase function, termed $p(\theta)$ where θ is the angle through which the light is scattered. This angular dependence has no direct effect on the angular distribution of light reflected from a truly turbid sample, since the multiple scattering in optically thick media leads to the same amount of flux traveling in every direction within the sample. The phase function is important, we believe, because of its relation to such fundamental pigment properties as their absorption and scattering coefficients. Although a number of theoretical papers on the phase function have appeared, for example, Allen (1975), only one laboratory appears to be performing experiments to determine these functions (Phillips 1976, Billmeyer 1980b). Other work on advanced turbid-medium theories is reviewed by Guthrie (1978).

C. Educational Opportunities

As we look back we note that one trend we alluded to in the first edition of this book has become established even more strongly

... but a fully satisfactory treatment requires consideration of many fluxes, each describing light moving in a specified direction or channel (**Mudgett 1971**).

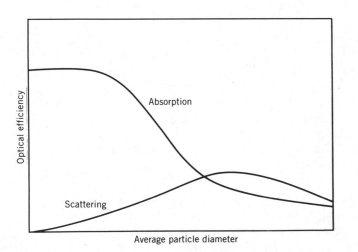

Whereas the scattering power of a pigment reaches a maximum at a specific optimum particle size, its absorbing power, closely related to its tinting strength, continues to increase until very small particle sizes are reached (Gall 1971). This is why many organic pigments, which do not scatter much light anyway because their refractive indices are similar to those of the organic media in which they are used, are made with quite small particle sizes.

"Theoretical knowledge alone cannot make a successful [colorist], but it certainly proves of great value in explaining the true causes of failure and in directing the conditions which lead to success."

Paterson 1900

than we anticipated: Color technology has become very complicated and very sophisticated.

All the easy advances seem to have been made; all the routine things are done for us. The fine instruments and computer programs we now have are "black boxes;" it seems as though no one cares, any more, how they work or how to get the best out of them. The simplest ones, with the least buttons to push, are preferred even if they are more limited. We find these trends most disturbing.

It seems clear to us that there is a challenge in the increased sophistication of color technology that must be met by increased sophistication on the part of those who practice it. To do your job better, you must work not just harder but at a more advanced level to solve the more difficult problems that face you. And this requires better knowledge and understanding of color technology.

It has been said several times (for example, Billmeyer 1975) that the half-life of effective knowledge in a highly technical field is about five years. That is, in five years the amount of technical know-how you have that allows you to do your job properly will be reduced to half; in another five years, to half of that, and so on. No doubt about it, you have to replenish that knowledge just to stay at your present level of skills, much less to advance. In this final section we suggest some ways in which you can sharpen your skills, stay up to date, and do your job better.

Continuing-Education Courses

In the first edition we noted the beginnings of the establishment of continuing-education courses in color science and technology. Happily, this trend has continued, and the courses have become quite varied and quite good. They are now available from three kinds of sources.

University Courses. At this writing there are at least four universities in the United States with regular annual programs of continuing-education courses. Their content is dictated by the interests of the university's corresponding graduate-education program. They range from broad programs following the content of this book at several levels and including laboratory sessions (Rensselaer Polytechnic Institute) through colorimetry (University of Rochester) and textile color science (Clemson University) to specialization in computer color matching (Lehigh University). As a compromise between the demands of the academic year and the summer vacation period, these courses are given annually in May and June.

Technical Society Courses. On a less regular basis courses are offered by several technical societies in their respective fields. Notable among these are courses sponsored by the American Association of Textile Chemists and Colorists, the various Coatings Society members of the Federation of Societies for Coatings Technology, by the Color and Appearance Division of the Society of Plastics Engineers, and by the Plastics Institute of America.

Manufacturers' Courses. The third type of course is those given by the manufacturers of colorants, the manufacturers of color-measuring instruments, and the companies providing computer-

color-matching programs, including Applied Color Systems, Diano, Hunter, Macbeth, and Ciba-Geigy among others at various times. Emphasis is placed, as expected, on the products of the company involved, but the basic material is fairly presented and a successful effort is made to prevent these courses from becoming hard-sell forums.

Professional Societies

A professional is defined as one whose occupation is predominantly intellectual and nonroutine, requires the consistent exercise of judgment and discretion, cannot be characterized by a standard output per unit time, and requires specialized study and advanced knowledge. We know of few colorists who would fail to meet this definition. Thus most of you who are reading this book are professionals in the field of color technology. But being a professional carries with it the previously mentioned responsibility to keep your advanced knowledge up to date. Being a member of the professional societies concerned with color can help you do this.

There is one (at least) of these societies in your own field. Some of them, which we feel will include the fields of many of our readers, are: the American Association of Textile Chemists and Colorists (AATCC), the constituent societies of the Federation of Societies for Coatings Technology (FSCT), the Illuminating Engineering Society (IES), the Optical Society of America (OSA), the Society of Plastics Engineers (SPE), Color and Appearance Division, and the Technical Association of the Pulp and Paper Industry (TAPPI). Their addresses are included in the Bibliography.

Each of the above societies, plus some 30 more, is a Member Body of a professional society devoted since 1931 to color in all its aspects, the Inter-Society Color Council (ISCC). This is a national organization of societies and individuals—artists, designers, educators, industrial colorists, scientists—interested in the description and standardization of color, the practical application of color knowledge to problems in art, science, and industry, communication among all interested in color, educational activities, and the interchange of ideas on color and appearance.

Membership in the professional society for your industry and in the Inter-Society Color Council will bring you many benefits: newsletters to keep you up to date on society activities and the changing situations in color technology; technical journals; symposia and papers at meetings, where you can not only listen but meet (and learn from) the people involved; committee efforts to which you can contribute and from which you can benefit at the same time; trade shows; and more.

The Inter-Society Color Council represents the United States as one of 17 national member bodies of the International Colour Association, known as the AIC from the initials of its French name, Association Internationale de la Couleur. The AIC is noted for sponsorship since 1969 of a major color conference every four

years, with attendance of several hundred and published Proceedings (for example, Billmeyer 1978a).

The CIE (Commission International de l'Éclairage, International Commission on Illumination), mentioned so frequently in this book, is independent of the chain of societies discussed above. It is also older than any of them, going back to the early 1900s. Devoted primarily to standardization in illumination and related areas, including color, it operates through Technical Committees and also holds a major congress every four years, for example its 19th in Kyoto, Japan, in 1979. Among the CIE Technical Committees concerned with color are 1.2, Photometry and Radiometry; 1.3, Colorimetry; 1.4, Color Vision; 1.6, Visual Signalling; 2.3, Materials; and 3.2, Color Rendering. Voting membership on CIE Technical Committees is limited to one member of each of the 32 member countries of the CIE, but most of the committees also have consultants, whose opinions carry weight in all but the final decisions. In the United States the CIE is represented by its U.S. National Committee (USNC-CIE).

The Color Literature

The final action we would urge on all professionals in color technology is to become familiar with, and read on a regular basis, the literature devoted to the field. Our emphasis on the importance of doing so is evident in our devotion of an entire chapter (Chapter 7) to an annotated bibliography and in the extensive bibliography that follows of books and articles referred to in the text. Only a little more needs to be said.

Books and journal articles already in existence will serve the very useful purpose of bringing you up to date (Veal 1980), but it is only by reading the major technical journals devoted to color that you can stay up to date. There are two types of these.

The first are the journals of the various professional societies. In no case are they devoted entirely to color, since they must cover all the technical aspects of their field. You will find at best a few articles on color out of many on other topics in these journals, but those few may be important because they are directly in your field.

The second class of color journal has at present only a single member in the Western Hemisphere. It is the journal devoted solely to color, and the only one in the English-speaking world is *Color Research and Application*. Founded in 1976, it is published by the publishers of this book with the endorsement of the Inter-Society Color Council, The Colour Group (Great Britain), the Canadian Society for Color, and the Color Science Association of Japan.

D. Back to Principles

In contrast to technical information in what is considered high technology or advanced technology, which we said on page 192 has a limited half life, we firmly believe that there is a fund of knowledge of the basic principles of color technology that is essential to all those in the field and which must never be permitted to be lost. To lose the basic principles is to lose the foundation of all knowledge in

the field, and any high technology on a foundation that slips from beneath it is useless.

We recognize three basic principles without which color technology cannot be applied successfully. The first and most important of these is that color is what is seen, the result of the interpretation by the brain of the stimulus received by the eye. That stimulus in turn depends upon the nature of the light source and of the object. If any of the three—light source, object, or the response of the eye—is changed, the color is changed.

It is this principle that explains why conditional or metameric matches cause so much trouble in the practical world of color technology. Where it is necessary to use different colorants, for example when making a match in a different material, a conditional match will result that will not hold if the conditions of illumination or the nature of the observer is changed. If the match is computed, as is so often the case today, the match may be exact only for a CIE standard observer viewing it under a CIE standard source—a situation far removed from reality. The various aspects of this problem cannot be ignored. It is possible today to utilize in the computer the spectral power distribution of the source actually used. To date we see no simple solution to the equally important problem of the spread in color-matching functions among real observers, measured for example by their match points on the Color Rule. The only true solution to the problem is to adhere to the principles for avoiding metamerism.

The second basic principle of color technology, which must never be ignored, is that the sample being judged must be representative of the material to be evaluated for color. The means for adhering to this principle lie in well-developed, standard techniques of analysis and statistics. Unfortunately they are all too often ignored in color technology. We continue to find it difficult to understand why so little care is taken to follow well-established sampling procedures, and so little attention is paid to sample preparation, in so many instances. The fact that these problems are not considered very seriously does not diminish their importance.

The third basic principle of color technology we wish to emphasize is the need to recognize, assess, and compensate for the variability that is inherent in every step of the process of preparing and judging samples for color, whether the judgment is made by visual or instrumental techniques. In every phase of every measurement process we can think of, there is an inherent error or uncertainty. The objective must be to keep the total of all these uncertainties small in comparison to the tolerances that one wishes to hold. The means to do this, as before, lie in the understanding and proper application of analytical and statistical methods. The need for making replicate samples and replicate measurements may provide the means for reducing the variability of the process to provide statistically valid answers at the level of risk that one wishes to accept.

Although we have discussed at least the first of these principles in terms of instruments and computers, the basics of all of them apply to purely visual color concepts as well as to the higher

technology of instrumental color measurements, its associated calculations, and computer-assisted color matching. This leads us to state a fourth principle: that the instruments and computers are no more than the tools to aid the colorist in carrying out his assignments. And, just as the instrumental results are no more representative than the samples presented to the instruments, even the best results can be of no more value than the colorist can extract from them.

Inevitably, to convert measured and computed numbers into useful results requires a full understanding of where they came from, how they were obtained, how to utilize them properly, and how to modify them for improved results in the future. In view of these facts, which seem obvious to us, we find great difficulty in understanding what seems to us to be a very disturbing trend in attitude of the users of color technology: that somehow the instruments and computers are "black boxes" that will solve all the problems by the mere pressing of a few buttons—and the best "black box" is the one with the fewest buttons to press because it is the simplest. How is it, we wonder, that one can become so beguiled by technology!

We hear much about the need to improve the productivity of our nation's industry. We feel that proper attention to and application of the principles of color technology can contribute its small part to this goal. We doubt that it can be accomplished through adherence to the "black box" syndrome. We hope that our readers will instead recognize the need to master, rather than be slave to, the "black boxes." Perhaps it is, in the last analysis, to the stimulation of a sense of inquiry that will lead in this direction that we have devoted this book to the principles of color technology.

Annotated Bibliography

Entries have been selected on the basis of importance in the literature of color technology and availability to the reader, in that order.

In our opinion anyone who is seriously interested in color technology should own some of the books and articles annotated in this chapter. The particular entries that we feel should be on each serious reader's bookshelf are indicated by the use of **boldface type**.

No references in foreign languages have been annotated. The interested reader who is proficient in French, German, or Russian will have no difficulty in locating material in these languages among the references in this book and in other works in the Bibliography.

The items in the Bibliography are arranged as follows: first, books and general works; second, journals in which papers on color appear most frequently, collections such as conference proceedings, and other serial publications; and, finally, references according to subject matter in the same order as in this book. With the aid of the cross-references, the reader should be able to find an annotated reference to almost any subject mentioned in the text.

A. Books

BOYNTON 1979

Robert M. Boynton, *Human Color Vision*, Holt, Rinehart and Winston, New York, 1979.

One of the best books available on the subject of human color vision. Covers both the physiological and psychological approaches, written in terms that the colorist can understand and apply.

BURNHAM 1963

Robert W. Burnham, Randall M. Hanes, and C. James Bartleson, *Color: A Guide to Basic Facts and Concepts,* John Wiley & Sons, New York, 1963.

A collection of basic facts and concepts dealing extensively with color vision and perception but not with the coloring of materials. The text is written in outline form, and each statement is self-contained. As a result, the thread of development from one statement to the next is very tenuous and the book does not lend itself to being read through. Excellent color plates. A report of the ISCC Subcommittee for Problem 20: Basic Elements of Color Education. Unfortunately, out of print.

CIE 1971

International Commission on Illumination, *Colorimetry: Official Recommendations of the International Commission on Illumination,* Publication CIE No. 15 (E-1.3.1) 1971, Bureau Central de la CIE, Paris, 1971. Available in the U.S. from the USNC-CIE.

Official listing of all CIE recommendations on colorimetry in force in 1971, including data for standard illuminants and observers. Supplement 1 (1972) contains the recommendation on Special Metamerism Index: Change of Illuminant. Supplement 2 (1978) contains recommendations on Uniform Color

Spaces, Color-Difference Equations, and Psychometric Color Terms.

EVANS 1948

Ralph M. Evans, *An Introduction to Color,* John Wiley & Sons, New York, 1948.

A highly authoritative, highly readable book. Unsurpassed in its treatment of the perception of color. The text is enhanced by illustrations, in color, of the effects of illumination and mode of viewing on perception. Much excellent material on the interaction of color and the visual process. Unfortunately, out of print.

EVANS 1974

Ralph M. Evans, *The Perception of Color,* Wiley-Interscience, John Wiley & Sons, New York, 1974.

Based on Evans' discovery that in the general case there are not three but five independent variables of perceived color. For the advanced color scientist, enough food for thought and ideas for future research to last a lifetime.

GALL 1971

Dr. L. Gall, *The Colour Science of Pigments,* Badische Anilin- & Soda-Fabrik AG, Ludwigshafen, Germany, 1971.

Collected reprints and translations on optical properties of pigments, color measurement, depth of shade, and computer formulation. Authoritative and well written, an important source of information on topics not well treated elsewhere.

HARDY 1936

Arthur C. Hardy (Director), *Handbook of Colorimetry,* The Technology Press, Cambridge, Massachusetts, 1936.

In its day the bible for the determination of CIE tristimulus values because of its extensive tables of data. These have been superseded by CIE 1971, but the many conversion charts still provide the most convenient way of finding dominant wavelength and purity.

HUNT 1975

R. W. G. Hunt, *The Reproduction of Colour,* 3rd edition, Fountain Press, London, 1975.

The most authoritative book on the reproduction of color in photography, printing, and television, by an outstanding expert in the field. Required reading for those concerned with these topics.

HUNTER 1975

Richard S. Hunter, *The Measurement of Appearance,* John Wiley & Sons, New York, 1975.

The only book available dealing with the broad topic of appearance, including color. Very well done, and an essential addition to the library of anyone who wants to place color properly in its context with all the rest of what we see. Extensive coverage of color measurement, gloss, and other aspects of appearance.

IES 1981

Illuminating Engineering Society, *IES Lighting Handbook—1981 Applications Volume; IES Lighting Handbook—1981 Reference Volume,* Illuminating Engineering Society, New York, 1981.

Primarily concerned with the design and practice of lighting installations for all types of applications—industry, residences, public buildings, sports, transportation, and many others. Extensive sections on light sources and lighting calculations.

JUDD 1975a

Deane B. Judd and Günter Wyszecki, *Color in Business, Science and Industry,* 3rd edition, John Wiley & Sons, New York, 1975.

Authoritative and complete. Excellent treatment of color-order systems, color scales, and color standards. The beginner will find, however, that careful reading and rereading are required. Some sections presuppose a knowledge of mathematics beyond the calculus. This classic is now in its third edition, considerably expanded and better than ever. Judd's name remains, but the revision is largely Wyszecki's work done after Judd's death. Owners of the first and second editions will want this one too, because much new material has been added.

JUDD 1975b

Deane B. Judd, *Color in Our Daily Lives,* U.S. Department of Commerce, National Bureau of Standards, NBS Consumer Information Series No. 6, U.S. Government Printing Office (cat. no. C13. 53:6), Washington, D.C., 1975.

Conceived and written by Deane B. Judd just before he died. Beautifully illustrated. See review in ISCC *Newsletter* 238, 1 (September-October 1975).

KELLY 1976

Kenneth L. Kelly and Deane B. Judd, *COLOR: Universal Language and Dictionary of Names,* NBS Special Publication 440, U.S. Government

Printing Office (cat. no. C13. 10:440), Washington, D.C., 1976.

Replaces NBS Circular 533, *The ISCC-NBS Color System and a Dictionary of Color Names* (1955), a description of a logical system of designating the names of colors, and a dictionary of 7500 color names indexed to the ISCC-NBS system. An excellent description of how the Munsell system is actually used. Good historical background material as well. If you want to know what color is meant by Intimate Mood, Wafted Feather, Kitten's Ear, or Griseo-Viridis, you can find out here. Kelly's 1965 paper, "A Universal Color Language," and several color plates are added. Also available with a set of the ISCC-NBS Centroid Colors (SRM 2106), as NBS Standard Reference Material 2107.

KODAK 1962

Kodak Publication No. E-74, *Color as Seen and Photographed*. Eastman Kodak Co., Rochester, New York, 1962.

While originally intended to provide background information for color photography, the book provides an excellent treatment of the basic concepts of color and is a fine introduction to the field. Only half of its pages are directly concerned with photography (and much of this is of general interest), the rest being devoted to well-illustrated descriptions of light and color, color and its characteristics, and psychophysical attributes of color. Available irregularly.

KUEHNI 1975b

Rolf G. Kuehni, *Computer Colorant Formulation*, Lexington Books, D.C. Heath and Company, Lexington, Massachusetts, 1975.

The first book to deal with this subject. Much valuable information for those who are involved in computer color matching. Covers both the one-constant technique used for textiles [see also Stearns 1969 (Sec. A)] and the two-constant technique required for most paints and plastics. Goes a long way toward taking computer-color-matching programs out of the "black box" category.

LEGRAND 1968

Yves LeGrand, *Light, Colour, and Vision,* 2nd edition, translated by R. W. G. Hunt, J. W. T. Walsh, and F. R. W. Hunt, Chapman and Hall, London, 1968.

An excellent discussion of "the ways in which the optics of the eye and the retina provide us with our perception of the universe: form, colour, depth, and movement." Complete and detailed, but quite readable.

MACKINNEY 1962

Gordon Mackinney and Angela C. Little, *Color of Foods*, AVI Publishing Co., Westport, Conn. 1962.

Despite its title, this book is more concerned with general problems of color than specifically with the color of foods. It deals with color-order systems, color measurement, color tolerances, and color differences. While the examples are drawn from the food industry, they are applicable to any colored material. The many detailed calculations associated with color measurement and color tolerances are very useful for the beginner.

MUNSELL 1963

A. H. Munsell, *A Color Notation*, Munsell Color Co., Baltimore, 1936–1963.

Description of the origins and the workings of the Munsell color-order system. See also Munsell 1929 (Sec. D), Munsell 1969.

NEWTON 1730

Sir Isaac Newton, *OPTICKS: or A Treatise of the Reflections, Refractions, Inflections & Colours of Light*, Dover Publications, New York, 1952. (Reprint based on the 4th edition, London 1730.)

It is amazing and illuminating to see how many of the basic facts of color were first discovered by this remarkable scientist. Not eminently readable, in eighteenth century English, but well worth the effort.

OSA 1953

Optical Society of America, Committee on Colorimetry, *The Science of Color*, Thomas Y. Crowell Co., New York, 1953.

An authoritative book on the general subject of color. An advanced treatise and a true sourcebook for the expert. Reprinted by the Optical Society of America in 1963.

PEACOCK 1953

William H. Peacock, *The Practical Art of Color Matching*, American Cyanamid Co., Bound Brook, New Jersey, 1953.

A practical guide to color matching, covering both the techniques for manipulating colorants to approach a color match and the factors influencing the visual judgment of the match.

STEARNS 1969

Edwin I. Stearns, *The Practice of Absorption Spectroscopy,* Wiley-Interscience, John Wiley & Sons, New York, 1969.

An authoritative text on absorption spectrophotometry, with emphasis on its application in the analytical aspects of color technology, written by an expert in color. Goes well beyond its title to cover such topics as computer color matching in textiles. Unfortunately, out of print.

WRIGHT 1969

W. D. Wright, *The Measurement of Colour,* 4th edition, Van Nostrand, New York, 1969.

An authoritative, precisely written book "concerned with the principles, methods, and applications of the trichromatic system of colour measurement" by the British expert whose own contributions add to the soundness of his opinions.

WYSZECKI 1967

Gunter Wyszecki and W. S. Stiles, *Color Science— Concepts and Methods, Quantitative Data and Formulas,* John Wiley & Sons, New York, 1967.

Perhaps the most important book on color science to appear from the standpoint of completeness, but difficult to read or locate topics in. Nevertheless, almost anything you want to know about colorimetry is there for the digging out. A few misconceptions exist. CIE 1971 should be used for the authoritative CIE standard illuminant and observer data.

B. Journals and Collected Works

AATCC *Technical Manual of the American Association of Textile Chemists and Colorists,* American Association of Textile Chemists and Colorists, Research Triangle Park, North Carolina, annually.

Contains information on the AATCC, its Committee reports, a compilation of its test methods, a bibliography of books and articles relating to textiles, extensive lists of American dyes and textile chemical specialties, and a buyer's guide. Valuable for the user of dyes.

American Dyestuff Reporter, Howes Publishing Co., Inc., New York, biweekly.

A leading journal of the American textile industry. Contains many good articles on color as related to dyeing and textiles.

Applied Optics, Optical Society of America, Washington, D.C., semimonthly.

The more applied, in contrast to the more theoretical Journal, of the Optical Society of America. Not too many papers on color appear, but the ones that do are of excellent quality.

BILLMEYER 1978a

Fred W. Billmeyer, Jr., and Gunter Wyszecki, editors, *AIC COLOR 77,* Adam Hilger, Bristol, 1978.

Invited papers in full and long abstracts of contributed papers presented at COLOR 77, the third quadrennial congress of the International Colour Association. This and other proceedings like it appearing at four-year intervals provide excellent introductions to the advances in color technology in the period prior to their publication.

Color Research and Application, John Wiley & Sons, New York, quarterly.

Beginning publication in 1976 with the endorsement of the Inter-Society Color Council, The Colour Group (Great Britain), and the Canadian Society for Color, this journal is the most widely circulated journal dealing exclusively with color in the world.

Die Farbe, Musterschmidt, Göttingen, Germany, irregular.

An international journal devoted exclusively to color in all its aspects. For the English-speaking reader, the earlier preponderance of articles in German is a disadvantage. Recently more articles are appearing in English, making much valuable material available.

GRUM 1980

Franc Grum and C. James Bartleson, Eds., *Color Measurement,* Vol. 2 in Franc Grum, Ed., *Optical Radiation Measurements,* Academic Press, New York, 1980.

Authoritative and up-to-date reviews of various aspects of color measurement, by expert authors writing at the highest level. The chapters on "Colorimetry" by C. J. Bartleson, "Modern Illuminants" by Frederick T. Simon, "Color Order" by Simon, and "Colorant Formulation and Shading" by Eugene Allen are particularly recommended. Volume 1 of the series, *Radiometry,* edited by Grum and Richard J. Becherer, is also of the highest quality and interest to color scientists. Three more volumes, at least, are in the planning stages.

Inter-Society Color Council News, **Inter-Society Color Council (c/o Dr. Fred W. Billmeyer, Jr., Rensselaer Polytechnic Institute, Troy, New York, 12181), Troy, New York, bimonthly.**

The Newsletter of the ISCC, whose member bodies encompass the world of color. Small in size but concentrated. Many items on color appear in the Newsletter which can be found in no other source in English.

JOHNSTON 1972

Ruth M. Johnston and Max Saltzman, Symposium Chairmen, *Industrial Color Technology,* Volume 107 in Robert F. Gould, editor, Advances in Chemistry Series, American Chemical Society, Washington, D.C., 1972.

A series of excellent papers presented in 1968. That by Evans (Sec. C) is outstanding; one or two were somewhat out of date even when published because of the four-year lapse between presentation and publication.

Journal of Coatings Technology (formerly *Journal of Paint Technology, Official Digest,* Federation of Societies for Paint Technology; *Official Digest,* Federation of Paint & Varnish Production Clubs), Federation of Societies for Coatings Technology, Philadelphia, monthly.

The outstanding American journal of the paint industry. Contains many excellent and important articles on color.

Journal of the Oil and Colour Chemists' Association, The Oil & Colour Chemists' Association, London, monthly.

The publication of the British counterpart of the Federation of Societies for Coatings Technology. Contains regular information and occasional articles on color and colorants, and every once in a while a magnificent one [see Gaertner 1963 (Sec. G)].

Journal of the Optical Society of America, Optical Society of America, Washington, D.C., monthly.

As this bibliography suggests, the *JOSA* probably contains more important articles on optical aspects of color than any other in the world. Articles on color more often appear here than in its sister journal, *Applied Optics.*

***Journal of the Society of Dyers and Colourists,* The Society of Dyers and Colourists, Bradford, England, monthly.**

One of the best journals in the world for people interested in color. Well edited, with a good balance between theory and practice. Publishes excellent abstracts of literature relating to the field.

KELLY 1974

Kenneth L. Kelly, *Colorimetry and Spectrophotometry: A Bibliography of NBS Publications January 1906 through January 1973,* NBS Special Publication 393, U.S. Government Printing Office (cat. no. C13. 10:393), Washington, D.C., 1974.

This publication lists 623 papers on colorimetry and spectrophotometry authored by members of the staff of the NBS from its founding in 1901 (there were no pertinent papers before 1906) to 1973. Publications of Research Associates and Guest Workers are included. It serves as the key to the large amount of research into color measurement and specification, as well as color vision, carried out by the NBS staff over the years.

MACADAM 1979

David L. MacAdam, editor, *Contributions to Color Science by Deane B. Judd,* National Bureau of Standards Special Publication 545, U.S. Government Printing Office (stock no. 003-003-02126-1), Washington, D.C., 1979.

This book is a collection of 57 papers written by Deane B. Judd, a staff member of the National Bureau of Standards from 1926 to 1969, and an internationally recognized authority on color. The contents of this collection include some of the major contributions of Dr. Judd to such areas as the measurement and specification of color, spectrophotometry, color appearance and spacing, and color vision. Each paper is preceded by an introduction which provides general commentary on the article and explains the terminology used. Some introductions also direct the reader to related articles in the collection and point out significant developments, such as international agreements, which were based on Judd's work. A list of more than 200 articles written by Dr. Judd is included in an appendix.

PATTON 1973

Temple C. Patton, editor, *Pigments Handbook,* Volumes I–III, John Wiley & Sons, New York, 1973.

An extensive and authoritative review of pigments and pigmentation. The preface states that Volume I (Properties and Economics) provides information on

the nature of the individual pigments, their physical and chemical properties, relevant economic data, historical background, major reasons for use, method of manufacture, grades, specifications, and manufacturers. Volume II (Applications and Markets) takes up the major applications of these pigments by industry, discussing the scope of the application, typical pigment usage, properties contributed by proper pigmentation, formulation techniques, and the like. Volume III (Characterization and Physical Relationships) considers the theoretical and practical physical aspects of pigments, ranging from the nature of pigments, particle size measurement and characterization, pigment geometry, pigment processing, and pigment identification, to the contribution of pigments to color, opaqueness, surface appearance, esthetic appeal, rheology, substrate protection, corrosion inhibition, and the like.

Review of Progress in Coloration and Related Topics, The Society of Dyers and Colourists, Bradford, England, annually.

An annual publication that presents reviews covering 5 to 10 year progress on subjects as diverse as the chemistry of dyes, application techniques, and ecological considerations in the use of colorants. Although its primary emphasis is on textile dyes, each issue carries at least one review of pigmentation. There have also been several excellent review articles on color science.

SDC AND AATCC 1971, 1976

Colour Index, Society of Dyers and Colourists, Yorkshire, England; and American Association of Textile Chemists and Colorists, Research Triangle Park, North Carolina, 3rd edition, 1971; supplement, 1976.

An extensive and international compilation of the structure and properties of dyes and pigments, as well as a system of numbering these materials. Regular (quarterly) additions and amendments keep this monumental work up to date.

Textile Chemist and Colorist, American Association of Textile Chemists and Colorists, Research Triangle Park, North Carolina, monthly.

Journal of the AATCC, and the major outlet in the U.S. for papers on dyeing and textile coloring.

VENKATARAMAN 1952–1978

K. Venkataraman, editor, *The Chemistry of Synthetic Dyes,* Vols. I–VIII, Academic Press, New York, 1952–1978.

A monumental many-volume collection of excellent contributed chapters on the chemistry of synthetic dyes and organic pigments, and related topics.

VOS 1972

J. J. Vos, L. F. C. Friele, and P. L. Walraven, editors, *Color Metrics,* AIC/Holland, Soesterberg, The Netherlands, 1972.

Proceedings of the Helmholtz Memorial Symposium on Color Metrics held at Driebergen, Holland, in 1971. Thirty-one invited papers by outstanding experts, covering color spaces and color-difference measurement.

World Surface Coating Abstracts, Paint Research Station, Teddington, England.

The single most complete abstract journal in the coatings field. Although it is not as current as some abstract journals, its coverage is by far the best for the paint and related industries. Formerly called the *Review of Current Literature in the Paint & Allied Industries.*

C. Color Perception, Description, and Appearance*

BARTLESON 1978, 1979a, 1979b

C. J. Bartleson, "A Review of Chromatic Adaptation," in Fred W. Billmeyer, Jr., and Gunter Wyszecki, editors, *AIC COLOR 77,* Adam Hilger, Bristol, 1978, pp. 63–96; "Changes in Color Appearance with Variations in Chromatic Adaptation," *Color Res. Appl.,* **4,** 119–138 (1979); "Predicting Corresponding Colors with Changes in Adaptation," *Color Res. Appl.,* **4,** 143–155 (1979).

Three papers summarizing the present state of the field of chromatic adaption. Bartleson (1978) reviews the history of the field, and the first of his 1979 papers presents a detailed study of the way the appearances of colors change as the state of adaptation of the eye changes from daylight to incandescent light. The results allow one to find and describe the colors that look alike when the conditions of chromatic adaptation are changed. In the second 1979 paper mathematical equations are presented that allow determination of the chromaticity coordinates of colors that have the same appearance when chromatic adaptation is changed. The results agree well with data from many sources beyond those used to derive the equations.

* See also Evans 1958, 1974; Hunter 1975; Judd 1975a (Sec. A

BILLMEYER 1980a

Fred W. Billmeyer, Jr., and Max Saltzman, "Observer Metamerism," *Color Res. Appl.,* **5,** 72 (1980).

Tested with a Color Rule, the spread in color-vision characteristics among some 75 normal observers was found to be as great, for matching metameric pairs, as the difference between daylight and incandescent light. An accompanying note (Nardi 1980) shows that about three-quarters of this spread results from changes in color-vision characteristics with the age of the observer.

EVANS 1972

Ralph M. Evans, "The Perception of Color," in Ruth M. Johnston and Max Saltzman, editors, *Industrial Color Technology,* Advances in Chemistry Series No. 107, American Chemical Society, Washington, D.C., 1972, pp. 43–68.

The only modern illustrated paper based on Evans' unforgettable lectures. Beautiful color photographs and demonstrations of phenomena in the perception of color. Worth many times the price of the entire volume.

HAFT 1972

H. H. Haft and W. A. Thornton, "High Performance Fluorescent Lamps," *J. Illum. Eng. Soc.,* **2,** 29–35 (1972–1973).

The philosophy of the "prime-color" lamps, and their spectral characteristics, are described.

HALSTEAD 1978

M. B. Halstead, "Colour Rendering: Past, Present, and Future," in Fred W. Billmeyer, Jr., and Gunter Wyszecki, editors, *AIC Color 77,* Adam Hilger, Bristol, 1978, pp. 97–127.

A good review of the history of color rendering, the calculation of color-rendering indices, and the problems and future prospects in the field, by the chairperson of the CIE Technical Committee on the subject.

HUNT 1977, 1978a, 1978b

R. W. G. Hunt, "The Specification of Color Appearance. I. Concepts and Terms," *Color Res. Appl.,* **2, 53–66 (1977); "Part II, Effects of Changes in Viewing Conditions,"** *Color Res. Appl.,* **2, pp. 109–120; "Terms and Formulae for Specifying Colour Appearance," in Fred W. Billmeyer, Jr., and Gunter Wyszecki, editors,** *AIC Color 77,* **Adam Hilger, Bristol, 1978, pp.**

321–327; "Colour Terminology," *Color Res. Appl.,* **3, 79–87 (1978) [see also 4, 140 (1979)].**

Three landmark papers presenting concepts, terms, and formulas for describing the appearance of color. Not easy to understand fully, but essential reading for all who attempt to correlate color information derived from instruments with what we see. Hunt 1978b revises and updates some of the new concepts presented in his 1977 paper, and the discussion in Section 6B of this book presents still later definitions of a few terms.

WYSZECKI 1970

Gunter Wyszecki, "Development of New CIE Standard Sources for Colorimetry," *Farbe,* **19,** 43–76 (1970).

Status report on the search for sources simulating the CIE daylight D illuminants. None of those studied (filtered incandescent, fluorescent, or arc lamps) was adequate to warrant a CIE recommendation, a situation that has not changed. Contains many useful data on spectral power distributions.

D. Color-Order Systems*

ADAMS 1942

Elliòt Q. Adams, "X-Z Planes in the 1931 ICI [CIE] System of Colorimetry," *J. Opt. Soc. Am.,* **32,** 168–173 (1942).

The paper defining the Adams chromatic-value system widely used in color-difference calculations.

ASTM D 1535

Method for Specifying Color by the Munsell System, **ASTM Designation: D 1535, American Society for Testing and Materials, Philadelphia.**

A method for determining the Munsell coordinates of a sample, either by visual comparison to the samples of the *Munsell Book of Color* [Munsell 1929 (Sec. D)] or from CIE data. Tables and graphs facilitating the latter conversion are included. Today use of a computer program, where available, would be preferred; sources of some programs are cited.

GANZ 1976

Ernst Ganz, "Whiteness: Photometric Specification and Colorimetric Evaluation," *Appl. Opt.,* **15,** 2039–2058 (1976).

An extensive and complete review of the then existing formulas for specifying whiteness and an explanation

* See also CIE 1971, Kelly 1976, Munsell 1963 (Sec. A), MacAdam 1965 (Sec. F).

of the experimental techniques needed to measure fluorescent white samples.

JOHNSTON 1971b

Ruth M. Johnston, "Colorimetry of Transparent Materials," *J. Paint Technol.,* **43,** No. 553, 42–50 (1971).

An ISCC report summarizing and interrelating a wide variety of single-number color scales, mostly for describing the degree of yellowness-to-redness of everything from beer and honey to lubricating oils.

MACADAM 1974

David L. MacAdam, "Uniform Color Scales," *J. Opt. Soc. Am.,* **64,** 1619–1702 (1974).

At the culmination of many years' work, the OSA Committee on Uniform Color Scales reports on a new sampling of color space, in a radically different way, thought to be the most nearly equal visually spaced in existence. This paper describes the technical aspects of the system and gives the equations relating it to the CIE system; see also Nickerson 1981 (Sec. D).

MUNSELL 1929

Munsell Book of Color, **Munsell Color Co., Baltimore, Maryland, 1929–1980.**

Collections of painted samples based on the Munsell color-order system. Both matte and glossy-finish collections are available in various sizes and numbers of samples, up to about 1500.

NEWHALL 1943

Sidney M. Newhall, Dorothy Nickerson, and Deane B. Judd, "Final Report of the O.S.A. Subcommittee on the Spacing of the Munsell Colors," *J. Opt. Soc. Am.,* **33,** 385–418 (1943).

This paper defines the Munsell Renotation System in numerical terms by giving the CIE coordinates corresponding to whole-number Munsell Renotations. See also Nickerson 1940 and the following papers in that symposium, Munsell 1929 (Sec. D), and Munsell 1963 (Sec. A). The Newhall paper is one of several in that issue of *J. Opt. Soc. Am.* describing color measurements of the Munsell samples.

NICKERSON 1981

Dorothy Nickerson, "OSA Uniform Color Scales Samples—A Unique Set," *Color Res. Appl.,* **6,** 7–33 (1981).

Qualitative description of the locations of samples in the OSA Uniform Color Scales collection [OSA 1977 (Sec. D)], showing how each (interior) sample is part of the collection is surrounded by 12 neighbors equidistant from it in color space, and how each sample is part of seven different equally spaced color scales, many of which were never seen until these samples became available. See also MacAdam 1974 (Sec. D).

OSA 1977

Optical Society of America, *Uniformly Spaced Color Samples,* Washington, D.C., 1977.

A set of 558 2 × 2-in. painted samples illustrating the OSA Uniform Color Scales system. A limited edition, which may not be resupplied once the 1977 stock is exhausted. See MacAdam 1974, Nickerson 1981 (Sec. D).

SAUNDERSON 1946

J. L. Saunderson and B. I. Milner, "Modified Chromatic Value Color Space," *J. Opt. Soc. Am.,* **36,** 36–42 (1946).

The defining paper for the Saunderson-Milner Zeta Space, the color-order system that seems to approach equal visual perception about as closely as any other amenable to analytical calculations.

E. Color Measurement*

ASTM E 308

Recommended Practice for Spectrophotometry and Description of Color in CIE 1931 System, ASTM Designation: E 308, American Society for Testing and Materials, Philadelphia.

Methods and procedures for color measurement with a spectrophotometer and the calculation of CIE color coordinates.

BILLMEYER 1962

Fred W. Billmeyer, Jr., "Caution Required in Absolute Color Measurement with Colorimeters," *Off. Dig.,* **34,** 1333–1342 (1962).

The precision and accuracy of color measurement are determined for spectrophotometers and for differential colorimeters. It is shown that colorimeters should be used only for the measurement of small color differences between pairs of almost identical samples.

BILLMEYER 1979a

Fred W. Billmeyer, Jr., and Paula J. Alessi, *Assessment of Color-Measuring Instruments for Objective Textile Acceptability Judgement,* Natick

* See also Hardy 1936, Hunter 1975 (Sec. A); Johnston 1963, MacAdam 1965 (Sec. F); Derby 1973 (Sec. H).

Technical Report TR-79/044, U.S. Army Natick Research and Development Command, Natick, Massachusetts, 1979.

Extensive studies of the performance of several modern color-measuring instruments are reported. Tests included precision and accuracy of color measurement, precision of color-difference measurement, sensitivity of the instruments to various sample and measurement parameters, and the statistical evaluation of the distributions of the data obtained.

BILLMEYER 1979c

Fred W. Billmeyer, Jr., Ph.D., *Colorimetry of Fluorescent Specimens: A State-of-the-Art Report,* National Bureau of Standards Technical Report NBS-GCR 79-185, National Bureau of Standards, Washington, D.C. 20234, 1979.

This report describes the state of the art of the color measurement of fluorescent materials; describes, compares, and assesses various methods of providing accurate and reproducible laboratory measurements correlating with visual experience and allowing assessment of conformance to specifications; proposes a field test instrument and method; and makes recommendations to national standardizing laboratories, instrument manufacturers, user laboratories, and field test users.

BUDDE 1980

Wolfgang Budde, "The Gloss Trap in Diffuse Reflectance Measurements," *Color Res. Appl.,* **5,** 73–75 (1980).

Pitfalls in color measurement associated with the inclusion or exclusion of the specular component in integrating-sphere instruments are discussed, and recommendations on which method to use are made.

CARTER 1978, 1979

Ellen C. Carter and Fred W. Billmeyer, Jr., *Guide to Material Standards and Their Use in Color Measurement,* **ISCC Technical Report 78-2, Inter-Society Color Council, Troy, New York, 1978; "Material Standards and Their Use in Color Measurement,"** *Color Res. Appl.,* **4, 96–100 (1979).**

Standardization of color-measuring instruments is considered from the standpoints of calibration, performance testing, and diagnostic testing. Material standards for these purposes are described and procedures for their use are given. Carter 1978 includes a glossary, an annotated bibliography, and tables of commercially available standard materials, material standards, and standardization services for color measurement.

ERB 1979

W. Erb and W. Budde, "Properties of Standard Materials for Reflection," *Color Res. Appl.,* **4,** 113–118 (1979).

This article surveys the literature on the calibration, suitability, properties, and use of the various materials that are or have been used as (white) standards of reflectance for color measurement.

GIBSON 1949

Kasson S. Gibson, *Spectrophotometry (200–1000 Millimicrons).* National Bureau of Standards Circular 484, U.S. Government Printing Office, Washington, D.C., 1949.

Thorough discussion of the principles, techniques, and errors of spectrophotometric measurements. Despite its age, valuable reading for all who use a spectrophotometer.

GRUM 1972

Franc Grum, "Visible and Ultraviolet Spectroscopy," Chapter III in Arnold Weissberger and Bryant W. Rossiter, editors, *Physical Methods of Chemistry,* Vol. I of A. Weissberger, editor, *Techniques of Chemistry,* Part IIIB, Wiley-Interscience, John Wiley & Sons, New York, 1972.

An excellent review article of 220 pages with 459 references. Covers properties of electromagnetic radiation, spectrophotometric components, errors, and a variety of miscellaneous techniques. Reflectance and color are not slighted.

GUTHRIE 1978

J. C. Guthrie and Jean Moir, "The Application of Colour Measurement," *Rev. Prog. Coloration* **9,** 1–12 (1978).

A review with 210 references, assessing the then present situation in computer-assisted color matching, including topics such as whiteness and fluorescence, metamerism, blends of colored fibers, and the production of color-separation transparencies in printing.

HUNTER 1942

Richard S. Hunter, *Photoelectric Tristimulus Colorimetry With Three Filters.* National Bureau of Standards Circular C 429, U.S. Government Printing Office, Washington, D.C., 1942. Re-

printed in *J. Opt. Soc. Am.,* **32,** 509–538 (1942).

A thorough discussion of the principles of construction and operation of colorimeters, their inherent errors and limitations, and their use for the measurement of color and color difference. Defines the NBS unit of color difference and the Hunter α, β color-order system. Despite its age, still valuable reading.

JOHNSTON 1970, 1971a

Ruth M. Johnston, *A Catalog of Color Measuring Instruments and a Guide to Their Selection,* **Report of ISCC Subcommittee for Problem 24, Inter-Society Color Council, Troy, New York, 1970; "Color Measuring Instruments: A Guide to their Selection,"** *J. Color Appearance,* **1, No. 2, 27–38 (1971).**

Preamble to a "Catalog of Color Measuring Instruments," a report of ISCC Problems Subcommittee 24. Excellent summary of what instruments will and will not do, and how to define your measurement problem and select the best instrument to solve it.

JUDD 1950

Deane B. Judd, *Colorimetry,* National Bureau of Standards Circular 478, U.S. Government Printing Office, Washington, D.C., 1950.

Discussion of the CIE system, small-difference colorimetry, material standards for color, one-dimensional color scales, and instrumental methods. Much of the material is covered in Judd 1975a (Sec. A).

NICKERSON 1957

Dorothy Nickerson, *Color Measurement and Its Application to the Grading of Agricultural Products: A Handbook on the Method of Disk Colorimetry,* U.S. Department of Agriculture, Misc. Publ. #580, U.S. Government Printing Office, Washington, D.C., 1957.

A thorough discussion (and almost the only one available) of disk colorimetry, of the Munsell System, and of their application to agricultural products. Valuable reading for all those seriously concerned with production control of color.

SALTZMAN 1965

Max Saltzman and A. M. Keay, "Variables in the Measurement of Color Samples," *Color Eng.,* **3,** No. 5, 14–19 (Sept.–Oct., 1965).

Variations found in sample preparation and color measurement were studied statistically in a vinyl plastic system. Improvements in the precision of the final results with increases in the numbers of samples and of measurements of each sample were illustrated quantitatively.

F. Color-Difference Measurement*

ASTM D 1729

Recommended Practice for Visual Evaluation of Color Differences of Opaque Materials, ASTM Designation: D 1729, American Society for Testing and Materials, Philadelphia.

"This method covers the spectral, photometric, and geometric characteristics of light sources, illuminating and viewing conditions, sizes of specimens and general procedures to be used in the visual evaluation of color differences of opaque materials."

BROWN 1949

W. R. J. Brown and D. L. MacAdam, "Visual Sensitivities to Combined Chromaticity and Luminance Differences," *J. Opt. Soc. Am.,* **39,** 808–834 (1949).

A classic paper extending the well-known studies of MacAdam (1942, 1943) (Sec. F) to cases where luminance as well as chromaticity differences are involved. One of the most thorough studies ever made of the visual perception of small color differences.

BROWN 1957

W. R. J. Brown, "Color Discrimination of Twelve Observers," *J. Opt. Soc. Am.,* **47,** 137–143 (1957).

An extension of the classic work of Brown and MacAdam [Brown 1949 (Sec. F)] in which the sensitivities of 12 observers (with normal color vision) to small color differences were studied. Significant differences were noted among the observers in the nature of the color difference most readily seen, as well as in the size of the difference barely seen.

CHICKERING 1967

K. D. Chickering, "Optimization of the MacAdam-Modified 1965 Friele Color-Difference Formula," *J. Opt. Soc. Am.,* **57,** 537–541 (1967).

The data of MacAdam 1942 (Sec. F) were incorporated by extensive mathematical treatment into a framework for a color-difference equation developed by Friele. The result was the Friele-MacAdam-Chickering FMC-1 color-difference equation. See also Friele 1978, 1979 (Sec. F).

* See also Hunter 1975 (Sec. A); Vos 1972 (Sec. B); Adams 1942, Saunderson 1942 (Sec. D).

CHICKERING 1971

K. D. Chickering, "FMC Color-Difference Formulas: Clarification Concerning Usage," *J. Opt. Soc. Am.,* **61,** 118–122 (1971).

The FMC-1 color-difference equation was modified to include variation of the size of the unit and the relative weighting of chromaticity and lightness differences as a function of lightness level, in agreement with the results of the Munsell System. The modified equations constitute the widely used FMC-2 color-difference equation.

DAVIDSON 1953

Hugh R. Davidson and Elaine Friede, "The Size of Acceptable Color Differences," *J. Opt. Soc. Am.,* **43,** 581–589 (1953).

A large number of visual observations of small color differences in dyed wool samples were used to rate samples as accepted or rejected as a commercial match. The percentage acceptable was compared with color differences calculated by several formulas. A modification of the MacAdam formula [MacAdam 1943 (Sec. F)] correlated best with the visual results.

FRIELE 1978, 1979

L. F. C. Friele, "Fine Color Metric (FCM)," *Color Res. Appl.,* **3,** 53–64 (1978); "Color Metrics—Facts and Formulae," *Color Res. Appl,* **4,** 194–199 (1979).

The various steps in the derivation of a color-difference equation based on a theory of color vision are discussed in detail and illustrated by the derivation of a new equation called FCM—"fine color metric."

HUEY 1972

Sam J. Huey, "Standard Practices for Visual Examination of Small Color Differences," *J. Color Appearance,* 1, No. 4, 24–26 (1972).

"This recommended practice covers (all important aspects of) procedures to be used in the visual evaluation of color differences . . . for critical color matching." Particular emphasis is placed on the need for the selection and maintenance of a standard light source and on the need for *large* samples (up to 6 × 10 in. for critical work). An ISCC Problems Subcommittee report.

JOHNSTON 1963

Ruth M. Johnston, "Pitfalls in Color Specifications," *Off. Dig.,* 35, 259–274 (1963).

The errors in each step of the initial formulation and production control of a color match are analyzed for the case where instruments are used throughout for color measurement. Writing practical and realizable color specifications is discussed with these errors considered.

JUDD 1970

D. B. Judd, "Ideal Color Space," *Color Eng.,* **8,** No. 2, 36–52 (1970).

A lucid discussion of whether color space is curved, and of the derivation and use of several color-difference equations, including those based on the Munsell System.

LONGLEY 1979

William V. Longley, "Color-Difference Terminology," *Color Res. Appl.,* 4, 45 (1979).

Standard terminology is recommended for the description of color differences, using only the terms redder, yellower, greener, bluer, lighter, darker, cleaner, and grayer. Others are extraneous except in special cases. In later communications, it was suggested that the last two (chroma) terms be replaced by stronger and weaker: It makes little difference as long as a standard pair is accepted and adhered to.

MACADAM 1942

David L. MacAdam, "Visual Sensitivities to Color Differences in Daylight," *J. Opt. Soc. Am.,* **32,** 247–274 (1942).

This classic paper describes extensive studies of the visual perception of small color differences, and lays the groundwork for the development of the MacAdam color-difference equation [MacAdam 1943 (Sec. F)]. Extended to color differences involving luminance as well as chromaticity by Brown and MacAdam [Brown 1949 (Sec. F)].

MACADAM 1943

David L. MacAdam, "Specification of Small Chromaticity Differences," *J. Opt. Soc. Am.,* **33,** 18–26 (1943).

The studies of the perceptibility of small chromaticity differences [MacAdam 1942 (Sec. F)] are extended to form the basis of a well-known and widely used method of calculating color differences. See also Simon 1958 (Sec. F), MacAdam 1965 (Sec. F).

MACADAM 1965

David L. MacAdam, "Color Measurement and Tolerances," *Official Digest,* 37, 1487–1531 (1965); errata, *J. Paint Technol.,* 38, 70 (1966).

An outstanding discussion of this subject. A brief review of spectrophotometry and colorimetry makes special reference to establishing and using color tolerances based on objective methods. Includes a description of the CIE 1960 uniform-chromaticity space, with a color plate. The summary on page 1530 of the reference is especially recommended.

MCLAREN 1970

K. McLaren, "The Adams-Nickerson Colour-Difference Formula," *J. Soc. Dyers Colour.,* **86,** 354–366 (1970).

A discussion of how to use a color-difference formula effectively for defining limits and tolerances. Uses the ANLAB formula, but the analysis is completely compatible with CIELAB.

NCCA

Technical Section Committee on Color, *Visual Examples of Measured Color Differences,* National Coil Coaters Association, Philadelphia, undated.

Sixteen pages of painted color chips giving, for each of eight colors, visual examples of measured color differences of one and of five Hunter units. Each page contains a central reference color chip surrounded by six others differing by one (on one page) or five (on a companion page) units in $\pm L$, $\pm a$, and $\pm b$ in the Hunter system. Calculated values of MacAdam (FMC-1) color differences are also given. A small collection but valuable for illustrating what a color difference of a given size looks like.

NICKERSON 1944

Dorothy Nickerson and Keith F. Stultz, "Color Tolerance Specification," *J. Opt. Soc. Am.,* **34,** 550–570 (1944).

Visual observations were compared with color differences calculated from instrumental measurements by several formulas. Although some equations [for example that of MacAdam 1943 (Sec. F)] were not included here, the general conclusions found in studies of this sort have changed remarkably little over the years.

RICHTER 1980

Klaus Richter, "Cube-Root Color Spaces and Chromatic Adaptation," *Color Res. Appl.,* **5,** 25–43 (1980).

The CIELAB and CIELUV color spaces and color-difference equations are analyzed in detail, and modi-

fications providing better spacing, independent of the chromatic adaptation of the eye, are proposed. Color plates show the spacing of the Munsell colors on CIELAB, CIELUV, and two new color spaces.

ROBERTSON 1977

Alan R. Robertson, "The CIE 1976 Color-Difference Formulae," *Color Res. Appl.,* 2, 7–11 (1977).

A thorough description of the CIELAB and CIELUV color spaces and color-difference equations, comparing them to the MacAdam 1942 (Sec. F) and Munsell spacing.

ROBERTSON 1978

Alan R. Robertson, "CIE Guidelines for Coordinated Research on Colour-Difference Evaluation," *Color Res. Appl.,* **3,** 149–151 (1978).

The Color-Difference subcommittee of the CIE Colorimetry committee proposes the following guidelines for research: (1) Study methodology, to select the simplest and most efficient techniques for later use. (2) Study systematically the effects of such parameters as texture, sample size and separation, illumination level, size of color difference, and so forth. (3) Study color-difference perception over the whole of color space. (4) Derive a formula to fit the data.

SIMON 1958

F. T. Simon and W. J. Goodwin, "Rapid Graphical Computation of Small Color Differences," *Am. Dyest. Rep.,* **47,** No. 4, 105–112 (Feb. 1958).

This paper describes a set of charts for the rapid hand calculation of color difference by the MacAdam formula [MacAdam 1943 (Sec. F)]. The charts are currently (1980) available from Diano.

G. Colorants*

ATHERTON 1955

E. Atherton and R. H. Peters, "Colour Gamuts of Pigments," *Congrès FATIPEC,* **III,** 147–158 (1955).

The MacAdam limits defining the theoretical gamuts of ideal colorants [MacAdam 1935 (Sec. G)] are modified to take account of surface reflection losses as in paint films, and the performance of some actual pigments is compared to these limits.

* See also AATCC, Patton 1973, SDC and AATCC 1971, 1976, and Venkataraman 1952–1978 (Sec. B).

GAERTNER 1963

H. Gaertner, "Modern Chemistry of Organic Pigments," *J. Oil Colour Chem. Assoc.,* **46,** 13–44 (1963).

A beautifully illustrated article describing the structures and properties of high-grade organic pigments of the time. For earlier pigments, see Vesce 1956 (Sec. G).

LENOIR 1971

J. Lenoir, "Organic Pigments," in K. Venkataraman, editor, *The Chemistry of Synthetic Dyes,* Vol V, Academic Press, New York, 1971, pp. 313–474.

Detailed information on the structures, properties, and chemistry of organic pigments available at the beginning of the 1970s.

MACADAM 1935

David L. MacAdam, "Maximum Visual Efficiency of Colored Materials," *J. Opt. Soc. Am.,* **25,** 361–367 (1935).

The theoretical gamut (maximum chromaticity at constant lightness) that could be achieved with ideal pigments is calculated for CIE illuminants *A* and *C.*

POINTER 1980

M. R. Pointer, "The Gamut of Real Surface Colours," *Color Res. Appl.,* **5,** 145–155 (1980).

A maximum gamut for real surface colors, expressed in CIELAB and CIELUV spaces, has been derived by analysis of the colors of over 4000 selected samples.

SALTZMAN 1963a

Max Saltzman, "Colored Organic Pigments: Why So Many? Why So Few?" *Off. Dig.,* **35,** 245–258 (1963).

The gamuts of colors available with pigments are examined with respect to colorant cost, conditions of use, and chemical and weather resistance.

SMITH 1954

F. M. Smith and D. M. Stead, "The Meaning and Assessment of Light Fastness in Relation to Pigments," *J. Oil Colour Chem. Assoc.,* **37,** 117–130 (1954).

The authors contend (and how right they are) that the lightfastness of a pigment by itself has no meaning, and that it is only the lightfastness of a pigmented system that can be measured and has any

value. The exposure studies leading to this conclusion are described.

VESCE 1956

Vincent C. Vesce, "Vivid Light Fast Organic Pigments," *Off. Dig.,* **28,** No. 377, Part 2, 1–48 (Dec. 1956).

Structures, properties, samples (in paint formulations) and spectrophotometric curves of the most important organic pigments to 1956. For later developments, see Gaertner 1963, Lenoir 1971 (Sec. G).

VESCE 1959

Vincent C. Vesce, "Exposure Studies of Organic Pigments in Paint Systems," *Off. Dig.,* **31, No. 419, Part 2, 1–143 (Dec. 1959).**

A comprehensive, illustrated, study of the behavior on outdoor exposure of paint systems colored with organic pigments. Results are given in terms of numerical color differences as a function of time, with the pigments identified as to structure. In all cases several paint formulations were used.

VICKERSTAFF 1949

T. Vickerstaff and D. Tough, "The Quantitative Measurement of Lightfastness," *J. Soc. Dyers Colour.,* **65, 606–612 (1949).**

One of the earliest and best papers on the subject. The method presented by the authors, utilizing the Adams chromatic value formula to indicate total color change after exposure to a known amount of light, is, in our opinion, a method that will one day be widely used.

WICH 1977

Emil Wich, "The Colour Index," *Color Res. Appl.,* **2, 77–80 (1977).**

The arrangement, contents, and use of the third edition of the *Colour Index* [SDC and AATCC 1971, 1976 (Sec. B)] are discussed, with examples. Beginning users of the *Colour Index* will find this paper an invaluable guide.

H. Color Matching*

ALLEN 1966

Eugene Allen, "Basic Equations Used in Computer Color Matching," *J. Opt. Soc. Am.,* **56,** 1256–1259 (1966).

* See also Gall 1971, Kuehni 1975b, Peacock 1953, Stearns 1969 (Sec. A).

An introduction to the basic mathematics (including matrix algebra) of computer matching of tristimulus values using the single-constant Kubelka-Munk method.

ALLEN 1974

Eugene Allen, "Basic Equations Used in Computer Color Matching, II. Tristimulus Match, Two-Constant Theory," *J. Opt. Soc. Am.*, **64**, 991–993 (1974).

Extension of Allen 1966 to the two-constant Kubelka-Munk method.

ALLEN 1978

Eugene Allen, "Advances in Colorant Formulation and Shading," in Fred W. Billmeyer, Jr., and Gunter Wyszecki, editors, *AIC Color 77*, Adam Hilger, Bristol, 1978, pp. 153–179.

A review paper providing excellent, lucid coverage of computer color matching, including Kubelka-Munk theory, characterization of colorants, algorithms for formulation, and advanced theory.

BROCKES 1974

A. Brockes, "Computer Color Matching: A Review of its Limitations," *Text. Chem. Color.*, 6, 98–103 (1974).

An excellent discussion of the present status of computer-assisted colorant formulation. While written about dyes on textiles, it is equally applicable to pigments in any of a variety of materials. Emphasizes the importance of calibration and the need for complete control of a coloration process.

DERBY 1973

Roland E. Derby, Jr., "Color Measurement and Colorant Formulation in the Textile Industry," *Text. Chem. Color.*, 5, 47–55 (1973).

An inimitable discussion of the problems and pitfalls lurking in color measurement, color-difference measurement, and computer color matching by one who could say without boasting that he had measured over 100,000 colors by spectrophotometry—and who had probably calculated almost as many matches.

DUNCAN 1949

D. R. Duncan, "The Colour of Pigment Mixtures," *J. Oil Colour Chem. Assoc.*, **32**, 296–321 (1949).

A classic paper describing the various types of color mixing and the laws that they follow. The laws best describing the mixing of pigments are applied to show how to predict the colors of pigment mixtures and the range of colors obtainable with a given set of pigments.

DUNCAN 1962

D. R. Duncan, "The Identification and Estimation of Pigments in Pigmented Compositions by Reflectance Spectrophotometry," *J. Oil Colour Chem. Assoc.*, **45**, 300–324 (1962).

The use of the Kubelka-Munk colorant mixing law to determine the colors of pigment mixtures. See also Duncan 1949 (Sec. H).

GALL 1973

L. Gall, "Computer Colour Matching," in *Colour 73*, Adam Hilger, London, 1973, pp. 153–178.

An excellent review of the state of the art of computer color matching, with particular emphasis on the problems that can and do arise and how to circumvent them.

JOHNSTON 1969

Ruth M. Johnston, "Color Control in the Small Paint Plant," *J. Paint Technol.*, 41, 415–421 (1969).

The problems contributing to poor color control in manufacturing plants (certainly not limited to small plants or paint plants, as in the title) are enumerated. The use of simple instrumentation to help bring them under control, and the resulting benefits, are discussed.

JOHNSTON 1973

Ruth M. Johnston, "Color Theory," in Temple C. Patton, editor, *Pigments Handbook*, Vol. III, John Wiley & Sons, New York, 1973, pp. 229–288.

A thorough discussion of color measurement, color matching, colorant identification, strength of colorants, and many related topics. Required reading for anyone using or contemplating the use of instrumental and computational methods in color technology.

LOWREY 1979

Edwin J. Lowrey, "Practical Aspects of Instrumental and Computer Color Control in a Small Paint Plant," *J. Coatings Technol.*, **51**, No. 653, 75–79 (1979).

An excellent brief paper giving a step-by-step description of the conversion of color control from simple visual techniques, through early instrumentation, up to the present computer-control methods. Written from the practical point of view.

MCLEAN 1969

Earle R. McLean, "A Millman's Use of the Computer," *Text. Chem. Color.,* **1, 192–197 (1969).**

"This paper discusses the practical use of a computer for color matching. The author describes his experience with instrumental color measurement and matching since 1954. Problems involved in computerizing a dye system are presented, with an emphasis on practical application." This is an out-and-out success story.

RICHARDS 1970

L. Willard Richards, "Calculation of the Optical Performance of Paint Films," *J. Paint Technol.,* **42,** 276–286 (1970).

Introduces the many-flux advanced turbid-medium theory, which has so far proved unnecessary in routine computer color matching, but provides the best approach we know of for tackling the difficult problems of dealing with unusual samples such as translucents or metallics.

SAUNDERSON 1942

J. L. Saunderson, "Calculation of the Color of Pigmented Plastics," *J. Opt. Soc. Am.,* **32,** 727–736 (1942).

The equations of Kubelka and Munk (Kubelka 1931), describing the color-mixing laws for opaque pigmented systems, are extended empirically and applied to the calculation of the colors of known mixtures of pigments in plastics.

Bibliography

AATCC†

American Association of Textile Chemists and Colorists, AATCC Technical Center, Post Office Box 12215, Research Triangle Park, North Carolina 27709.

AATCC Technical Manual

AATCC Technical Manual, American Association of Textile Chemists and Colorists, Research Triangle Park, North Carolina, annually.

Abbott 1944

R. Abbott and E. I. Stearns, *Identification of Organic Pigments by Spectrophotometric Curve Shape*, Calco Technical Bulletin No. 754, American Cyanamid Co., Bound Brook, New Jersey, 1944.

***Adams 1942**

Elliot Q. Adams, "X–Z Planes in the 1931 I.C.I. (CIE) System of Colorimetry," *J. Opt. Soc. Am.,* **32,** 168–173 (1942).

Albers 1963

Josef Albers, *Interaction of Color*, Yale University Press, New Haven, 1963.

Alderson 1961

J. V. Alderson, E. Atherton, and A. N. Derbyshire, "Modern Physical Techniques in Colour Formulation," *J. Soc. Dyers Colour.,* **77,** 657–668 (1961).

***Allen 1966**

Eugene Allen, "Basic Equations Used in Computer Color Matching," *J. Opt. Soc. Am.,* **56,** 1256–1259 (1966).

Allen 1970

Eugene Allen, "An Index of Metamerism for Observer differences," in Manfred Richter, editor, *Color 69*, Musterschmidt, Göttingen, 1970, pp. 771–784.

***Allen 1974**

Eugene Allen, "Basic Equations Used in Computer Color Matching, II. Tristimulus Match, Two-Constant Theory," *J. Opt. Soc. Am.,* **64,** 991–993 (1974).

Allen 1975

Eugene Allen, "Simplified Phase Functions for Colorant Characterization," *J. Opt. Soc. Am.,* **65,** 839–841 (1975).

***Allen 1978**

Eugene Allen, "Advances in Colorant Formulation and Shading," in Fred W. Billmeyer, Jr., and Gunter Wyszecki, editors, *AIC Color 77*, Adam Hilger, Bristol, 1978, pp. 153–179.

Applied Color Systems

Applied Color Systems, Post Office Box 5800, Princeton, New Jersey 08540.

Armstrong 1972

William S. Armstrong, Jr., Webster H. Edwards, Joseph P. Laird, and Roy H. Vining (assigned to E. I. du Pont de Nemours and Co.), "Method and Apparatus for

† References designated by an asterisk (*) are annotated in Chapter 7.

Instrumentally Shading Metallic Paints," U.S. Patent 3, 690,771 (1972).

Ascher 1978

L. B. Ascher, T. L. Harrington, and H. F. Stephenson, "Colorimetric Measurement of Retroreflective Materials. II. Daytime Conditions," *Color Res. Appl.,* **3,** 23–28 (1978).

ASTM D 387

Standard Test Method for Mass Color and Tinting Strength of Color Pigments, ANSI/ASTM Designation: D 387, American Society for Testing and Materials, Philadelphia, Pennsylvania.

*ASTM D 1535

Method for Specifying Color by the Munsell System, ASTM Designation: D 1535, American Society for Testing and Materials, Philadelphia, Pennsylvania.

*ASTM D 1729

Recommended Practice for Visual Examination of Color Differences of Opaque Materials, ASTM Designation: D 1729, American Society for Testing and Materials, Philadelphia, Pennsylvania.

ASTM D 1925

Method of Test for Yellowness Index of Plastics, ASTM Designation: D 1925, American Society for Testing and Materials, Philadelphia, Pennsylvania.

*ASTM E 308

Recommended Practice for Spectrophotometry and Description of Color in CIE 1931 System, ASTM Designation: E 308, American Society for Testing and Materials, Philadelphia, Pennsylvania.

*Atherton 1955

E. Atherton and R. H. Peters, "Colour Gamut of Pigments," *Congres FATIPEC* **III,** 147–158 (1955).

Atkins 1966

J. T. Atkins and F. W. Billmeyer, Jr., "Edge-Loss Errors in Reflectance and Transmittance Measurement of Translucent Materials," *Mater. Res. Stand.,* **6,** 564–569 (1966).

Atkins 1968

Joseph T. Atkins and Fred W. Billmeyer, Jr., "On the Interaction of Light with Matter," *Color Eng.,* **6,** No. 3, 40–47, 56 (1968).

Balinkin 1939

I. A. Balinkin, "Industrial Color Tolerances," *Am. J. Psychol.,* **52,** 428–448 (1939).

Balinkin 1941

Isay A. Balinkin, "Measurement and Designation of Small Color Differences," *Bull. Am. Ceram. Soc.,* **20,** 392–402 (1941).

Bartleson 1960

C. J. Bartleson, "Memory Colors of Familiar Objects," *J. Opt. Soc. Am.,* **50,** 73–77 (1960).

*Bartleson 1978

C. J. Bartleson, "A Review of Chromatic Adaptation," in Fred W. Billmeyer, Jr., and Gunter Wyszecki, editors, *AIC Color 77*, Adam Hilger, Bristol, 1978, pp. 63–96.

*Bartleson 1979a

C. J. Bartleson, "Changes in Color Appearance with Variations in Chromatic Adaptation," *Color Res. Appl.,* **4,** 119–138 (1979).

*Bartleson 1979b

C. J. Bartleson, "Predicting Corresponding Colors with Changes in Adaptation," *Color Res. Appl.,* **4,** 143–155 (1979).

Beasley 1967

J. K. Beasley, J. T. Atkins, and F. W. Billmeyer, Jr., "Scattering and Absorption of Light in Turbid Media," in R. L. Rowell and R. S. Stein, editors, *Electromagnetic Scattering*, Gordon and Breach, New York, 1967, pp. 765–785.

Bélanger 1974

Pierre R. Bélanger, "Linear-Programming Approach to Color-Recipe Formulations," *J. Opt. Soc. Am.,* **64,** 1541–1544 (1974).

Berger 1964

Anni Berger and Andreas Brockes with N. Dalal, *"Color Measurement in Textile Industry,"* Bayer Farben Revue, special edition No. 3, Farbenfabriken Bayer, Leverkusen, Germany, 1964.

Berger-Schunn 1978

Anni Berger-Schunn, "Color and Quality Control in Industry," in Fred W. Billmeyer, Jr., and Gunter Wyszecki, editors, *AIC Color 77*, Adam Hilger, Bristol, 1978, pp. 181–197.

Bertin 1978

Nadine Bertin, "The House & Garden Color Program," *Color Res. Appl.* **3,** 71–78 (1978).

Billmeyer 1960a

F. W. Billmeyer, Jr., J. K. Beasley, and J. A. Sheldon, "Formulation of Transparent Colors with a Digital Computer," *J. Opt. Soc. Am.,* **50,** 70–72 (1960).

*Billmeyer 1962

Fred W. Billmeyer, Jr., "Caution Required in Absolute Color Measurement with Colorimeters," *Off. Dig.,* **34,** 1333–1342 (1962).

Billmeyer 1963a

Fred W. Billmeyer, Jr., "Tables of Adams Chromatic-Value Color Coordinates," *J. Opt. Soc. Am.,* **53,** 1317 (1963).

Billmeyer 1963b

Fred W. Billmeyer, "An Objective Approach to Coloring," *Farbe,* **12,** 151–164 (1963).

Billmeyer 1965

Fred W. Billmeyer, Jr., "Precision and Accuracy of Industrial Color Measurement," in Manfred Richter, editor, *Proceedings of the International Colour Meeting, Lucerne (Switzerland) 1965,* Musterschmidt, Göttingen, 1965, pp. 445–456.

Billmeyer 1966a

Fred. W. Billmeyer, Jr., "The Present and Future of Color Measurement in Industry," *Color Eng.,* **4,** No. 4, 15–19 (1966). (Same text as Billmeyer 1965.)

Billmeyer 1966b

Fred W. Billmeyer, Jr., "Yellowness Measurement of Plastics for Lighting Use," *Mater. Res. Stand.,* **6,** 295–301 (1966).

Billmeyer 1969

Fred W. Billmeyer, Jr., and Robert T. Marcus, "Effect of Illuminating and Viewing Geometry on the Color Coordinates of Samples with Various Surface Textures," *Appl. Opt.,* **8,** 763–768 (1969).

Billmeyer 1970

Fred W. Billmeyer, Jr., "Optical Aspects of Color, Part XVI. Appropriate Use of Color-Difference Equations," *Opt. Spectra,* **4,** No. 2, 63–66 (1970).

Billmeyer 1973a

Fred W. Billmeyer, Jr., and Richard L. Abrams, "Predicting Reflectance and Color of Paint Films by Kubelka-Munk Analysis. I. Turbid-Medium Theory," *J. Paint Technol.,* **45,** No. 579, 23–30 (1973).

Billmeyer 1973b

Fred W. Billmeyer, Jr., and David H. Alman, "Exact Calculation of Fresnel Reflection Coefficients for Diffuse Light," *J. Color Appearance,* **2,** No. 1, 36–38 (1973).

Billmeyer 1973c

Fred W. Billmeyer, Jr., and L. Willard Richards, "Scattering and Absorption of Radiation by Lighting Materials," *J. Color Appearance,* **2,** No. 2, 4–15 (1973).

Billmeyer 1974

Fred W. Billmeyer, Jr., and James G. Davidson, "Color and Appearance of Metallized Paint Films. I. Characterization," *J. Paint Technol.,* **46,** No. 593, 31–37 (1974).

Billmeyer 1975

Fred W. Billmeyer, Jr., and Richard N. Kelley, *Entering Industry—A Guide for Young Professionals,* John Wiley & Sons, New York, 1975.

Billmeyer 1976

Fred W. Billmeyer, Jr., and Ellen Campbell Carter, "Color and Appearance of Metallized Paint Films. II. Initial Application of Turbid-Medium Theory," *J. Coatings Technol.,* **48,** No. 613, 53–60 (1976).

*Billmeyer 1978a

Fred W. Billmeyer, Jr., and Gunter Wyszecki, editors, *AIC Color 77,* Adam Hilger, Bristol, 1978.

Billmeyer 1978b

Fred W. Billmeyer, Jr., "Step Size in the Munsell Color-Order System II. Pair Comparisons Near 2.5 YR 6/8 and 2.5 PB 5/8," in Fred W. Billmeyer, Jr., and Gunter Wyszecki, editors, *AIC Color 77,* Adam Hilger, Bristol, 1978, pp. 448–491.

Billmeyer 1978c

Fred W. Billmeyer, Jr., and Danny C. Rich, "Color Measurement in the Computer Age," *Plast. Eng.,* **34,** No. 12, 35–39 (1978).

*Billmeyer 1979a

Fred W. Billmeyer, Jr., and Paula J. Alessi, *Assessment of Color-Measuring Instruments for Objective Textile Acceptability Judgement,* Natick Technical Report TR-79/044, U.S. Army Natick Research and Development Command, Natick, Massachusetts, 1979.

Billmeyer 1979b

Fred W. Billmeyer, Jr., "Current Status of the Color-Difference Problem," *J. Coatings Technol.,* **51,** No. 652, 46–47 (1979).

*Billmeyer 1979c

Fred W. Billmeyer, Jr., Ph.D., *Colorimetry of Fluorescent Specimens: A State-of-the-Art Report,* National Bureau of Standards Technical Report NBS-GCR 79-185, National Bureau of Standards, Washington, D.C., 1979.

*Billmeyer 1980a

Fred W. Billmeyer, Jr., and Max Saltzman, "Observer Metamerism," *Color Res. Appl.,* **5,** 72 (1980).

Billmeyer 1980b

Fred W. Billmeyer, Jr., Patrick G. Chassaigne, and Jean F. Dubois, "Determining Pigment Optical Properties for Use in the Mie and Many-Flux Theories," *Color Res. Appl.,* **5,** 108–112 (1980).

Billmeyer 1980c

Fred W. Billmeyer, Jr., and Tak-Fu Chong, "Calculation of the Spectral Radiance Factors of Luminescent Samples," *Color Res. Appl.,* **5,** 156–168 (1980).

Birren 1969

Faber Birren, *Principles of Color,* Van Nostrand-Reinhold, New York, 1969.

Birren 1979

Faber Birren, "Chroma Cosmos 5000," *Color Res. Appl.* **4,** 171–172 (1979).

Bolomey 1972

R. A. Bolomey and L. M. Greenstein, "Optical Characteristics of Iridescence and Interference Pigments," *J. Paint Technol.,* **44,** 39–50 (1972).

Bouma 1971

Dr. P. J. Bouma, *Physical Aspects of Colour,* 2nd edition, W. De Groot, A. A. Kruithof, and J. L. Ouweltjes, editors, Macmillan, New York, 1971.

*Boynton 1979

Robert M. Boynton, *Human Color Vision,* Holt, Rinehart and Winston, New York, 1979.

Breckenridge 1939

F. C. Breckenridge and W. R. Schaub, "Rectangular Uniform-Chromaticity-Scale Coordinates," *J. Opt. Soc. Am.,* **29,** 370–380 (1939).

Brockes 1969

Andreas Brockes, "Vergleich der Metamerie-Indizes bei Lichtartwechsel von Tageslicht zur Glühlampe und zu verschiedenen Leuchtstofflampen" (in German), *Farbe,* **18,** 233–239 (1969).

Brockes 1974

A. Brockes, "Computer Color Matching: A Review of Its Limitations," *Text. Chem. Color.,* **6,** 98–103 (1974).

Brockes 1975

A. Brockes, "Zur Problematik von Farbstärke und Farbtiefe" (in German), *Textilveredlung,* **10,** 47–52 (1975).

*Brown 1949

W. R. J. Brown and D. L. MacAdam, "Visual Sensitivities to Combined Chromaticity and Luminance Differences," *J. Opt. Soc. Am.,* **39,** 808–834 (1949).

*Brown 1957

W. R. J. Brown, "Color Discrimination of Twelve Observers," *J. Opt. Soc. Am.,* **47,** 137–143 (1957).

Bruehlman 1969

Richard J. Bruehlman and William D. Ross, "Hiding Power from Transmission Measurements: Theory and Practice," *J. Paint Technol.,* **41,** 584–596 (1969).

*Budde 1980

Wolfgang Budde, "The Gloss Trap in Diffuse Reflectance Measurements," *Color Res. Appl.,* **5,** 73–75 (1980).

*Burnham 1963

Robert W. Burnham, Randall M. Hanes, and C. James Bartleson, *Color: A Guide to Basic Facts and Concepts,.* John Wiley & Sons, New York, 1963.

Burns 1980

Margaret Burns, "You can Check Color Appearance by Spectrophotometer," *Ind. Res. Dev.,* **22,** No. 3, 126–130 (1980).

Cairns 1976

Edward L. Cairns, Dwight A. Holtzen, and David L. Spooner, "Determining Absorption and Scattering Constants for Pigments," *Color Res. Appl.,* **1,** 174–180 (1976).

Campbell 1971

Ellen D. Campbell and Fred W. Billmeyer, Jr., "Fresnel Reflection Coefficients for Diffuse and Collimated Light," *J. Color Appearance,* **1,** No. 2, 39–41 (1971).

Carr 1957

W. Carr and C. Musgrave, "Behavior of Organic Pigments in High Temperature Systems," *J. Oil Colour Chem. Assoc.,* **40,** 51–61 (1957).

Carroll 1960

Lewis Carroll, *Alice's Adventures in Wonderland and Through the Looking Glass,* with introduction and notes by Martin Gardner, Clarkson N. Potter, New York, 1960.

*Carter 1978

Ellen C. Carter and Fred W. Billmeyer, Jr., *Guide to Material Standards and Their Use in Color Measurement,* ISCC Technical Report 78-2, Inter-Society Color Council, Troy, New York, 1978.

*Carter 1979

Ellen C. Carter and Fred W. Billmeyer, Jr., "Material Standards and Their Use in Color Measurement," *Color Res. Appl.,* **4,** 96–100 (1979).

Chamberlin 1955

G. J. Chamberlin, *The C.I.E. International Colour System Explained,* 2nd edition, The Tintometer Ltd., Salisbury, England, 1955.

Chevreul 1854

M. E. Chevreul, *The Principles of Harmony and Contrast of Colors and Their Application to the Arts*, based on the first English edition of 1854, with a special introduction and explanatory notes by Faber Birren, Reinhold, New York, 1967.

*Chickering 1967

K. D. Chickering, "Optimization of the MacAdam-Modified 1965 Friele Color-Difference Formula," *J. Opt. Soc. Am.,* **57,** 537–541 (1967).

*Chickering 1971

K. D. Chickering, "FMC Color-Difference Formulas: Clarification Concerning Usage," *J. Opt. Soc. Am.,* **61,** 118–122 (1971).

Chong 1981

Tak-Fu Chong and Fred W. Billmeyer, Jr., "Visual Evaluation of Daylight Simulators for the Colorimetry of Luminescent Materials," *Color Res. Appl.,* **6,** in press (1981).

Christie 1978

J. S. Christie and George McConnell, "A New Flexible Spectrophotometer for Color Measurements," in Fred W. Billmeyer, Jr., and Gunter Wyszecki, editors, *AIC Color 77,* Adam Hilger, Bristol, 1978, p. 309.

Christie 1979

J. S. Christie, Jr., "Review of Geometric Aspects of Appearance," *J. Coatings Technol.,* **51,** 64–73 (1979).

Ciba-Geigy

Ciba-Geigy Corporation, 444 Saw Mill River Road, Ardsley, New York 10502.

CIE 1931

International Commission on Illumination, *Proceedings of the Eighth Session,* Cambridge, England, 1931, Bureau Central de la CIE, Paris, 1931.

CIE 1970

International Commission on Illumination, *International Lighting Vocabulary,* 3rd edition, Publication CIE No. 17 (E-1.1) 1970, Bureau Central de la CIE, Paris, 1970.

*CIE 1971

International Commission on Illumination, *Colorimetry: Official Recommendations of the International Commission on Illumination,* Publication CIE No. 15 (E-1.3.1) 1971, Bureau Central de la CIE, Paris, 1971.

CIE 1972

International Commission on Illumination, *CIE Recommendation for a Special Metamerism Index: Change of Illuminant* (September 1972), Supplement No. 1 to Publication CIE No. 15, *Colorimetry* (E-1.3.1) 1971, Bureau Central de la CIE, Paris, 1972.

CIE 1974

International Commission on Illumination, *Method of Measuring and Specifying Colour Rendering Properties of Light Sources,* Publication CIE No. 13.2 (TC-3.2), Bureau Central de la CIE, Paris, 1974.

CIE 1978

International Commission on Illumination, *Recommendations on Uniform Color Spaces, Color-Difference Equations, Psychometric Color Terms,* Supplement No. 2 to CIE Publication No. 15, (E-1.3.1) 1971,/(TC-1.3) 1978, Bureau Central de la CIE, Paris, 1978.

CIE 1981

International Commission on Illumination, Standard Sources Subcommittee, CIE Technical Committee 1.3 (Colorimetry), *A Method for Assessing the Quality of Daylight Simulators for Colorimetry,* Publication CIE No. 51 (TC-1.3), Bureau Central de la CIE, Paris, 1981.

Clarke 1968

F. J. J. Clarke and P. R. Samways, *The Spectrophotometric Properties of a Selection of Ceramic Tiles,* NPL Metrology Centre Report MC2, National Physical Laboratory, Teddington, England, 1968.

Clarke 1969

F. J. J. Clarke, "Ceramic Colour Standards—An Aid for Industrial Colour Control," *Print. Technol.,* **13,** 101–113 (1969).

Commerford 1974

Therese R. Commerford, "Difficulties in Preparing Dye Solutions for Accurate Strength Measurements," *Text. Chem. Color.,* **6,** 14–21 (1974).

Consterdine 1976

J. Consterdine, "Heat Transfer Printing," *Rev. Prog. Coloration,* **7,** 34–43 (1976).

Cook 1979

Donald H. Cook, "Interplant Quality Control by Means of Simple Tristimulus Instruments," *J. Coatings Technol.,* **5,** No. 651, 64–65 (1979).

Craker 1967

W. E. Craker and P. F. Robinson, "The Effect of Pigment Volume Concentration and Film Thickness on the Optical Properties of Surface Coatings," *J. Oil Colour Chem. Assoc.,* **50,** 111–133 (1967).

Diano

Diano Corporation, 8 Commonwealth Avenue, Woburn, Massachusetts 01801.

Davidson 1950

H. R. Davidson and I. H. Godlove, "Applications of the Automatic Tristimulus Integrator to Textile Mill Practice," *Am. Dyest. Rep.,* **39,** 78–84 (1950).

*Davidson 1953

Hugh R. Davidson and Elaine Friede, "The Size of Acceptable Color Differences," *J. Opt. Soc. Am.,* **43,** 581–589 (1953).

Davidson 1955a

H. R. Davidson and Henry Hemmendinger, "Colorimetric Calibration of Colorant Systems," *J. Opt. Soc. Am.,* **45,** 216–219 (1955).

Davidson 1955b

Hugh R. Davidson and J. J. Hanlon, "Use of Charts for Rapid Calculation of Color Difference," *J. Opt. Soc. Am.,* **45,** 617–620 (1955).

Davidson 1957

Hugh R. Davidson, Margaret N. Godlove, and Henry Hemmendinger, "A Munsell Book in High-Gloss Colors," *J. Opt. Soc. Am.,* **47,** 336–337 (1957) (abstract of paper).

Davidson 1963

Hugh R. Davidson, Henry Hemmendinger, and J. L. R. Landry, Jr., "A System of Instrumental Colour Control for the Textile Industry," *J. Soc. Dyers Colour.,* **79,** 577–589 (1963).

Davidson 1977

Hugh R. Davidson, "Advantages of a Semiautomatic Color-Control Computer Program," *Color Res. Appl.,* **3,** 38–40 (1977).

Davidson Colleagues

Davidson Colleagues, Post Office Box 157, Tatamy, Pennsylvania 18085.

Davies 1980

Duncan S. Davies, "Appearance, Utility, Simplicity, Cheapness and Design," *J. Soc. Dyers Colour.,* **96,** 42–45 (1980).

Davis 1953

Raymond Davis, Kasson S. Gibson, and Geraldine W. Haupt, "Spectral Energy Distribution of the International Commission on Illumination Light Sources *A, B,* and *C,"* *J. Res. Natl. Bur. Stand.,* **50,** 31–37 (1953).

Derby 1952

R. E. Derby, Jr., "Applied Spectrophotometry. I. Color Matching with the Aid of the 'R' Cam," *Am. Dyest. Rep.,* **41,** 550–557 (1952).

Derby 1971

Roland E. Derby, Jr., "Colorant Formulation and Color Control in the Textile Industry," in Ruth M. Johnston and Max Saltzman, editors, *Industrial Color Technology,* Advances in Chemistry Series No. 107, American Chemical Society, Washington, D.C., 1971, pp. 95–118.

*Derby 1973

Roland E. Derby, Jr., "Color, Color Measurement and Colorant Formulation in the Textile Industry," *Text. Chem. Color.,* **5,** 47–55 (1973).

Dimmick 1956

Forrest L. Dimmick, "Specifications and Calibration of the 1953 Edition of the Inter-Society Color Council Color Aptitude Test," *J. Opt. Soc. Am.,* **46,** 389–393 (1956).

Donaldson 1947

R. Donaldson, "A Colorimeter with Six Matching Stimuli," *Proc. Phys. Soc.,* **59,** 554–560 (1947).

*Duncan 1949

D. R. Duncan, "The Colour of Pigment Mixtures," *J. Oil Colour Chem. Assoc.,* **32,** 296–321 (1949).

Eastwood 1973

D. Eastwood, "A Simple Modification to Improve the Visual Uniformity of the CIE 1964 U*V*W* Colour Space," in *Colour 73,* Adam Hilger, London, 1973, pp. 293–296.

Eckerle 1977

K. L. Eckerle and W. H. Venable, Jr., "1976 Remeasurement of NBS Spectrophotometer-Integrator Filters," *Color Res. Appl.,* **2,** 137–141 (1977).

Eckerle 1980

Kenneth L. Eckerle, "Photometry and Colorimetry of Retroreflection: State-of-Measurement-Accuracy Report," NBS Technical Note 1125, U.S. Government Printing Office, Washington, D.C., 1980.

*Erb 1979

W. Erb and W. Budde, "Properties of Standard Materials for Reflection," *Color Res. Appl.,* **4,** 113–118 (1979).

Estéves 1979

Oscar Estéves Uscanga, *On the Fundamental Data-Base of Normal and Dichromatic Color Vision,* Ph.D. Thesis, University of Amsterdam, The Netherlands, 1979.

*Evans 1948

Ralph M. Evans, *An Introduction to Color,* John Wiley & Sons, New York, 1948.

*Evans 1972

Ralph M. Evans, "The Perception of Color," in Ruth M. Johnston and Max Saltzman, editors, *Industrial Color Technology,* Advances in Chemistry Series No. 107, American Chemical Society, Washington, D.C., 1972, pp. 43–68.

*Evans 1974

Ralph M. Evans, *The Perception of Color,* John Wiley & Sons, New York, 1974.

Farnsworth 1943

Dean Farnsworth, "The Farnsworth-Munsell 100-Hue and Dichotomous Tests for Color Vision," *J. Opt. Soc. Am.,* **33,** 568–578 (1943).

Fink 1960

Donald G. Fink and David M. Luytens, *The Physics of Television* (Science Study Series No. S8), Anchor Books, Doubleday and Co., Inc., Garden City, New York, 1960.

Foster 1966

Robert S. Foster, "A New Simplified System of Charts for Rapid Color Difference Calculations," *Color Eng.,* **4,** No. 1, 17–19, 26 (1966).

Foster 1970

Walter H. Foster, Jr., Richard Gans, E. I. Stearns, and R. E. Stearns, "Weights for Calculation of Tristimulus Values from Sixteen Reflectance Values," *Color Eng.,* **8,** No. 3, 35–47 (1970).

Fournier 1978

A. Fournier, "Statistique et Colorimétrie" (in French), *Teintex,* **43,** 461–473 (1978).

Friele 1972

L. F. C. Friele, "A Survey of Some Color-Difference Formulae," in J. J. Vos, L. F. C. Friele, and P. L. Walraven, editors, *Color Metrics,* AIC/Holland, Soesterberg, The Netherlands, 1972, pp. 380–385.

*Friele 1978

L. F. C. Friele, "Fine Color Metric (FCM)," *Color Res. Appl.,* **3,** 53–64 (1978).

*Friele 1979

L. F. C. Friele, "Color Metrics—Facts and Formulae," *Color Res. Appl.,* **4,** 194–199 (1979).

FSCT

Federation of Societies for Coatings Technology, 1315 Walnut Street, Suite 850, Philadelphia, Pennsylvania 19107.

*Gaertner 1963

H. Gaertner, "Modern Chemistry of Organic Pigments," *J. Oil Colour Chem. Assoc.,* **46,** 13–44 (1963).

Gailey 1977

Ian Gailey, "Automation: Damned if You Do, Damned if You Don't," *Text. Chem. Color.,* **9,** 11–19 (1977).

Gall 1970

Ludwig Gall, "Versuche zur farbmetrischen Erfassung der Standardfarbtiefe" (in German), in Manfred Richter, editor, *Color 69,* Musterschmidt, Göttingen, 1970, pp. 563–580.

*Gall 1971

Dr. L. Gall, *The Colour Science of Pigments,* Badische Anilin- & Soda-Fabrik AG, Ludwigshafen, Germany, 1971.

*Gall 1973

L. Gall, "Computer Colour Matching," in *Colour 73,* Adam Hilger, London, 1973, pp. 153–178.

Gall 1975

Dr. Ludwig Gall, "Prüffehler, Signifikanz- und Toleranzgrenzen in der Qualitätskontrolle" (in German), *Farbe und Lack,* **81,** 1015–1018 (1975).

Gall 1980

L. Gall, BASF Aktiengesellschaft, Ludwigshafen, Germany, personal communication, 1980.

*Ganz 1976

Ernst Ganz, "Whiteness: Photometric Specification and Colorimetric Evaluation," *Appl. Opt.,* **15,** 2039–2058 (1976).

Ganz 1977

Ernst Ganz, "Problems of Fluorescence in Colorant Formulation," *Color Res. Appl.,* **2,** 81–84 (1977).

Ganz 1979

Ernst Ganz, "Whiteness Perception: Individual Differences and Common Trends," *Appl. Opt.,* **18,** 2963–2970 (1979).

Gardner

Gardner Laboratory Division, Pacific Scientific Co., Post Office Box 5728, Bethesda, Maryland 20014.

Garland 1973

Charles E. Garland, "Shade and Strength Predictions and Tolerances from Spectral Analysis of Solutions," *Text. Chem. Color.,* **5,** 227–231 (1973).

Gerritsen 1975

Frans Gerritsen, *Theory and Practice of Color: A Color Theory Based on Laws of Perception,* translated by Ruth de Vriendt, Van Nostrand-Reinhold, New York, 1975.

Gerritsen 1979

Frans Gerritsen, "Evolution of the Color Diagram," *Color Res. Appl.*, **4**, 33–38 (1979).

*Gibson 1949

Kasson S. Gibson, *Spectrophotometry (200–1000 Millimicrons)*, NBS Circular 484, U.S. Government Printing Office, Washington, D.C., 1949.

Glasser 1958

L. G. Glasser, A. H. McKinney, C. D. Reilly, and P. D. Schnelle, "Cube-Root Color Coordinate System," *J. Opt. Soc. Am.*, **48**, 736–740 (1958).

Godlove 1951

I. H. Godlove, "Improved Color-Difference Formula, with Applications to the Perceptibility of Fading," *J. Opt. Soc. Am.*, **41**, 760–772 (1951).

Goebel 1967

David G. Goebel, "Generalized Integrating Sphere Theory," *Appl. Opt.*, **6**, 125–128 (1967).

Goodwin 1955

W. J. Goodwin, "Measurement and Specification of Color and Small Color Differences," *Mod. Plast.*, **32**, No. 10, 143–146, 235, 239–240, 245, 248 (1955).

Granville 1944

Walter C. Granville and Egbert Jacobson, "Colorimetric Specification of the *Color Harmony Manual* from Spectrophotometric Measurements," *J. Opt. Soc. Am.*, **34**, 382–395 (1944).

Grassmann 1853

H. Grassmann, "Zur Theorie der Farbenmischung," *Ann. Phys. Chem.*, **89**, 69–84 (1853); Prof. (H.) Grassmann, "On the Theory of Compound Colors," *Lond., Edinb. Dublin Philos. Mag. J. Sci.*, 7[4], 254–264 (1854).

*Grum 1972

Franc Grum, "Visible and Ultraviolet Spectroscopy," Chapter III in Arnold Weissberger and Bryant W. Rossiter, editors, *Physical Methods of Chemistry*, Vol. I of A. Weissberger, editor, *Techniques of Chemistry*, Part IIIB, Wiley-Interscience, John Wiley & Sons, New York, 1972.

Grum 1976

F. Grum and M. Saltzman, "New White Standard of Reflectance," in *Proceedings 18th Session CIE, London, 1975*, Publication CIE No. 36 (1976), Bureau Central de la CIE, Paris, 1976, pp. 91–98.

Grum 1977

F. Grum and T. E. Wightman, "Absolute Reflectance of Eastman White Reflectance Standard," *Appl. Opt.*, **16**, 2775–2776 (1977).

*Grum 1980

Franc Grum and C. James Bartleson, Eds., *Color Measurement*, Vol. 2 in Franc Grum, Ed., *Optical Radiation Measurements*, Academic Press, New York, 1980.

Gugerli 1963

U. Gugerli and P. Buchner, "The Gradient Method—A Contribution to Metameric Colour Formulation on the Basis of Colour-difference Measurements," *J. Soc. Dyers Colour.*, **79**, 637–650 (1963).

Gundlach 1978

Dietrich Gundlach, "Annäherung von Normlichtart D_{65} für Zwecke der Farbmessung" (in German), in Fred W. Billmeyer, Jr., and Gunter Wyszecki, editors, *AIC Color 77*, Adam Hilger, Bristol, 1978, pp. 218–222.

*Guthrie 1978

J. C. Guthrie and Jean Moir, "The Application of Colour Measurement," *Rev. Prog. Coloration* **9**, 1–12 (1978).

*Haft 1972

H. H. Haft and W. A. Thornton, "High Performance Fluorescent Lamps," *J. Illum. Eng. Soc.*, **2**, 29–35 (1972–1973).

*Halstead 1978

M. B. Halstead, "Colour Rendering: Past, Present and Future," in Fred W. Billmeyer, Jr., and Gunter Wyszecki, editors, *AIC Color 77*, Adam Hilger, Bristol, 1978, pp. 97–127.

Hård 1970

Anders Hård, "Qualitative Aspects of Color Perception," in Manfred Richter, editors, *Color 69*, Musterschmidt, Göttingen, 1970, pp. 351–368.

Hardy 1935

Arthur C. Hardy, "A New Recording Spectrophotometer," *J. Opt. Soc. Am.*, **25**, 305–311 (1935).

*Hardy 1936

Arthur C. Hardy, *Handbook of Colorimetry*, The Technology Press, Cambridge, Massachusetts, 1936.

Hardy 1938

Arthur C. Hardy, "History of the Design of the Recording Spectrophotometer," *J. Opt. Soc. Am.*, **28**, 360–364 (1938).

Hardy 1954

LeGrand H. Hardy, Gertrude Rand, and M. Catherine Rittler, "H-R-R Polychromatic Plates," *J. Opt. Soc. Am.*, **44**, 509–523 (1954).

Harkins 1959

T. R. Harkins, Jr., J. T. Harris, and O. D. Shreve, "Identification of Pigments in Paints by Infrared Spectroscopy," *Anal. Chem.*, **31**, 541–545 (1959).

Hemmendinger 1967

H. Hemmendinger and H. R. Davidson, "The Calibration of a Recording Spectrophotometer," in *A Symposium on Colour Measurement in Industry,* The Colour Group (Great Britain), London, 1967, pp. 1–24.

Hemmendinger 1970

Henry Hemmendinger and Ruth M. Johnston, "A Goniospectrophotometer for Color Measurements," in Manfred Richter, editor, *Color 69*, Musterschmidt, Göttingen, 1970.

Hemmendinger 1980

Henry Hemmendinger, Letter to the Editor, *Color Res. Appl.,* **5,** 144 (1980).

Hering 1964

Ewald Hering, *Outlines of a Theory of the Light Sense,* translated by Leo M. Hurvich and Dorothea Jameson, Harvard University Press, Cambridge, Massachusetts, 1964.

Herzog 1965

H. Herzog and J. Koszticza, "The Influence of Resin Finishing on the Shade and the Fastness to Light of Naphtanilide Dyed Piece Goods," *Am. Dyest. Rep.,* **54,** 34–38 (1965).

Hodgins 1946

Eric Hodgins, *Mr. Blandings Builds His Dream House,* Simon & Schuster, New York, 1946.

Hsia 1976

Jack J. Hsia, *Optical Radiation Measurements: The Translucent Blurring Effect—Method of Evaluation and Estimation,* National Bureau of Standards Technical Note 594-12, U.S. Government Printing Office, Washington, D.C., 1976.

***Huey 1972**

Sam J. Huey, "Standard Practices for Visual Examination of Small Color Differences," *J. Color Appearance,* **1,** No. 4, 24–26 (1972).

***Hunt 1975**

Robert W. G. Hunt, *The Reproduction of Colour,* 3rd edition, Fountain Press, London, 1975.

***Hunt 1977**

R. W. G. Hunt, "The Specification of Colour Appearance. I. Concepts and Terms," *Color Res. Appl.,* **2,** 53–66 (1977); "Part II, Effects of Changes in Viewing Conditions," pp. 109–120.

Hunt 1978a

R. W. G. Hunt, "Terms and Formulae for Specifying Colour Appearance," in Fred W. Billmeyer, Jr., and Gunter Wyszecki, editors, *AIC Color 77*, Adam Hilger, Bristol, 1978, pp. 321–327.

***Hunt 1978b**

R. W. G. Hunt, "Colour Terminology," *Color Res. Appl.,* **3,** 79–87 (1978) [see also **4,** 140 (1979)].

Hunter

Hunter Associates Laboratory, Inc., 11495 Sunset Hills Road, Reston, Virginia 22090.

***Hunter 1942**

Richard S. Hunter, *Photoelectric Tristimulus Colorimetry with Three Filters*, NBS Circular 429, U.S. Government Printing Office, Washington, D.C., 1942. Reprinted in *J. Opt. Soc. Am.,* **32,** 509–538 (1942).

Hunter 1958

Richard S. Hunter, "Photoelectric Color Difference Meter," *J. Opt. Soc. Am.,* **48,** 985–995 (1958).

Hunter 1966

R. S. Hunter and J. S. Christie, *Improved Natick Laboratories Colorimeter for Textile Fabric Inspection,* U.S. Army Natick Laboratory Technical Report 66-19-CM, Natick Army Research and Development Command, Natick, Massachusetts, 1966.

***Hunter 1975**

Richard S. Hunter, *The Measurement of Appearance,* John Wiley & Sons, New York, 1975.

IBM

IBM Instrument Systems, 1000 Westchester Avenue, White Plains, New York 10604.

IES

Illuminating Engineering Society of North America, 345 East 47th Street, New York, New York 10017.

***IES 1981**

IES Lighting Handbook—1981 Applications Volume; IES Lighting Handbook—1981 Reference Volume, Illuminating Engineering Society, New York, 1981.

Ingle 1947

George W. Ingle, "Using 3 Dimensions of Color in Plastics," *Mod. Plast.,* **24,** No. 9, 131–133 (1947).

Ingle 1962

George W. Ingle, Frederick D. Stockton, and Henry Hemmendinger, "Analytic Comparison of Color-Difference Equations," *J. Opt. Soc. Am.,* **52,** 1075–1077 (1962).

ISCC

Inter-Society Color Council, c/o Department of Chemistry, Rensselaer Polytechnic Institute, Troy, New York 12181.

ISCC 1972

Inter-Society Color Council, "A General Procedure for the Determination of Relative Dye Strength by Spectrophotometric Transmittance Measurement," *Text. Chem. Color.,* **4,** 134–142 (1972).

ISCC 1974

Inter-Society Color Council, "A General Procedure for the Determination of Relative Dye Strength by Spectrophotometric Measurement of Reflectance Factor," *Text. Chem. Color.,* **6,** 104–108 (1974).

ISCC 1976

Inter-Society Color Council, "Reproducibility of Dye Strength Evaluation by Spectrophotometric Transmission Measurement," *Text. Chem. Color.,* **8,** 36–39 (1976).

Jacobson 1948

Egbert Jacobson, *Basic Color: An Interpretation of the Ostwald Color System*, Paul Theobald, Chicago, 1948.

Jerome 1976

Charles W. Jerome, "Color Rendering Properties of Light Sources," *Color Res. Appl.,* **1,** 37–42 (1976).

***Johnston 1963**

Ruth M. Johnston, "Pitfalls in Color Specifications," *Off. Dig.,* **35,** 259–274 (1963).

Johnston 1964

R. M. Johnston and R. E. Park, "Coloring of Unsaturated Polyester Resin Laminates and Gel Coats," *SPE J.,* **20,** 1211–1217 (1964).

Johnston 1965

Ruth Johnston, "Selecting and Training Color Matchers for a Computer Color Control Program," *Color Eng.,* **3,** No. 6, 20–21 (1965).

***Johnston 1969**

Ruth M. Johnston, "Color Control in the Small Paint Plant," *J. Paint Technol.,* **41,** 415–421 (1969).

***Johnston 1970**

Ruth M. Johnston, *A Catalog of Color Measuring Instruments and a Guide to Their Selection*, Report of ISCC Subcommittee for Problem 24, Inter-Society Color Council, Troy, New York, 1970.

***Johnston 1971a**

Ruth M. Johnston, "Color Measuring Instruments: A Guide to Their Selection," *J. Color Appearance,* **1,** No. 2, 27–38 (1971).

***Johnston 1971b**

Ruth M. Johnston, "Colorimetry of Transparent Materials," *J. Paint Technol.,* **43,** No. 553, 42–50 (1971).

***Johnston 1972**

Ruth M. Johnston and Max Saltzman, Symposium Chairmen, *Industrial Color Technology,* Vol. 107 in Robert F. Gould, editor, Advances in Chemistry Series, American Chemical Society, Washington, D.C., 1972.

***Johnston 1973**

Ruth M. Johnston, "Color Theory," in Temple C. Patton, editor, *Pigments Handbook,* Vol. III, John Wiley & Sons, New York, 1973, pp. 229–288.

Judd 1933

Deane B. Judd, "The 1931 I.C.I. Standard Observer and Coordinate System for Colorimetry," *J. Opt. Soc. Am.,* **23,** 359–374 (1933).

Judd 1935

Deane B. Judd, "A Maxwell Triangle Yielding Uniform Chromaticity Scales," *J. Opt. Soc. Am.,* **25,** 24–35 (1935).

***Judd 1950**

Deane B. Judd, *Colorimetry,* NBS Circular 478, U.S. Government Printing Office, Washington, D.C., 1950.

Judd 1952

Deane B. Judd, *Color in Business, Science and Industry*, 1st edition, John Wiley & Sons, New York, 1952.

Judd 1961

Deane B. Judd, *A Five-Attribute System of Describing Visual Appearance*, ASTM Special Technical Publication No. 297, American Society for Testing and Materials, Philadelphia, 1961.

Judd 1962a

Deane B. Judd, G. J. Chamberlin and Geraldine W. Haupt, "The Ideal Lovibond System," *J. Res. Natl. Bur. Stand.,* **66C,** 121–136 (1962).

Judd 1962b

Deane B. Judd, G. J. Chamberlin, and Geraldine W. Haupt, "Ideal Lovibond Color System," *J. Opt. Soc. Am.,* **52,** 813–819 (1962).

Judd 1963

Deane B. Judd and Günter Wyszecki, *Color in Business, Science and Industry*, 2nd edition, John Wiley & Sons, New York, 1963.

Judd 1964

Deane B. Judd, David L. MacAdam, and Günter Wyszecki (with the collaboration of H. W. Budde, H. R. Condit, S. T. Henderson, and J. L. Simonds), "Spectral Distribution of Typical Daylight as a Function of Correlated Color Temperature," *J. Opt. Soc. Am.,* **54,** 1031–1040, 1382 (1964).

Judd 1967

Deane B. Judd, "A Flattery Index for Artificial Illuminants," *Illum. Eng., 42,* 593–598 (1967).

*Judd 1970

D. B. Judd, "Ideal Color Space," *Color Eng., 8,* No. 2, 36–52 (1970).

*Judd 1975a

Deane B. Judd and Günter Wyszecki, *Color in Business, Science and Industry,* 3rd edition, John Wiley & Sons, New York, 1975.

*Judd 1975b

Deane B. Judd, *Color in Our Daily Lives,* NBS Consumer Information Series No. 6, U.S. Government Printing Office, Washington, D.C., 1975.

Kaiser 1980

Peter K. Kaiser and Henry Hemmendinger, "The Color Rule: A Device for Color-Vision Testing," *Color Res. Appl., 5,* 65–71 (1980).

Keegan 1962

Harry J. Keegan, John C. Schleter, and Deane B. Judd, "Glass Filters for Checking Performance of Spectrophotometer-Integrator Systems of Color Measurement," *J. Res. Natl. Bur. Stand., 66A,* 203–221 (1962).

Kelly 1955

Kenneth L. Kelly and Deane B. Judd, *The ISCC-NBS Method of Designating Colors and a Dictionary of Color Names,* NBS Circular 553, U.S. Government Printing Office, Washington, D.C., 1955.

Kelly 1958

Kenneth L. Kelly, "Centroid Notations for the Revised ISCC-NBS Color-Name Blocks," *J. Res. Natl. Bur. Stand., 61,* 427–431 (1958).

Kelly 1965

Kenneth L. Kelly, "A Universal Color Language," *Color Eng., 3,* No. 2, 16–21 (1965). Reprinted in Kelly 1976.

*Kelly 1974

Kenneth L. Kelly, *Colorimetry and Spectrophotometry: A Bibliography of NBS Publications January 1906 through January 1973,* NBS Special Publication 393, U.S. Government Printing Office, Washington, D.C., 1974.

*Kelly 1976

Kenneth L. Kelly and Deane B. Judd, *Color: Universal Language and Dictionary of Names,* NBS Special Publication 440, U.S. Government Printing Office, Washington, D.C., 1976.

Kishner 1978

S. J. Kishner, "A Pulsed-Xenon Spectrophotometer with Parallel Wavelength Sensing," in Fred W. Billmeyer, Jr., and Gunter Wyszecki, editors, *AIC Color 77,* Adam Hilger, Bristol, 1978, pp. 305–308.

*Kodak 1962

Kodak Color Data Book E-74, *Color as Seen and Photographed,* Eastman Kodak Co., Rochester, New York, 1962.

Kodak 1965

Eastman Kodak Co., Rochester, New York, "Uncertainty Searching," [advertisement appearing in *Science, 149,* 809 (1965) and elsewhere].

Kubelka 1931

Paul Kubelka and Franz Munk, "Ein Beitrag zur Optik der Farbanstriche" (in German), *Z. tech. Phys., 12,* 593–601 (1931).

Kubelka 1948

Paul Kubelka, "New Contributions to the Optics of Intensely Light-Scattering Materials. Part I," *J. Opt. Soc. Am., 38,* 448–457, 1067 (1948).

Kubelka 1954

Paul Kubelka, "New Contributions to the Optics of Intensely Light-Scattering Materials. Part II. Nonhomogeneous Layers," *J. Opt. Soc. Am., 44,* 330–355 (1954).

Kuehni 1971

Rolf G. Kuehni, "Acceptability Contours of Selected Textile Matches in Color Space," *Text. Chem. Color., 3,* 248–255 (1971).

Kuehni 1972

Rolf Kuehni, "Color Difference and Objective Acceptability Evaluation," *J. Color Appearance, 1,* No. 3, 4–10, 15 (1972).

Kuehni 1975a

R. Kuehni, "Visual and Instrumental Determination of Small Color Differences; A Contribution," *J. Soc. Dyers Colourists, 91,* 68–71 (1975).

*Kuehni 1975b

Rolf G. Kuehni, *Computer Colorant Formulation,* Lexington Books, D. C. Heath and Company, Lexington, Massachusetts, 1975.

Kuehni 1977

Rolf G. Kuehni, "Need for Further Visual Studies of Small Color Differences," *Color Res. Appl., 2,* 187–188 (1977).

Kuehni 1978

Rolf G. Kuehni, "Standard Depth and its Determination," *Text. Chem. Color.*, **10**, 75–79 (1978).

Küppers 1973

Harald Küppers, *Color: Origins, Systems, Uses*, Van Nostrand-Reinhold, New York, 1973.

Küppers 1979

Harald Küppers, "Let's Say Goodbye to the Color Circle," *Color Res. Appl.*, **4**, 19–24 (1979).

***LeGrand 1968**

Yves LeGrand, *Light, Colour, and Vision*, 2nd edition, translated by R. W. G. Hunt, J. W. T. Walsh, and F. R. W. Hunt, Chapman and Hall, London, 1968.

***Lenoir 1971**

J. Lenoir, "Organic Pigments," in K. Venkataraman, editor, *The Chemistry of Synthetic Dyes*, Vol. V, Academic Press, New York, 1971, pp. 313–474.

Little 1963

Angela C. Little, "Evaluation of Single-Number Expressions of Color Difference," *J. Opt. Soc. Am.*, **53**, 293–296 (1963).

Longley 1976

William V. Longley, "A Visual Approach to Controlling Metamerism," *Color Res. Appl.*, **1**, 43–49 (1976).

***Longley 1979**

William V. Longley, "Color-Difference Terminology," *Color Res. Appl.*, **4**, 45 (1979).

***Lowrey 1979**

Edwin J. Lowrey, "Practical Aspects of Instrumental and Computer Color Control in a Small Paint Plant," *J. Coatings Technol.*, **51**, No. 653, 75–79 (1979).

***MacAdam 1935**

David L. MacAdam, "Maximum Visual Efficiency of Colored Materials," *J. Opt. Soc. Am.*, **25**, 361–367 (1935).

MacAdam 1937

David L. MacAdam, "Projective Transformations of the I.C.I. Color Specifications," *J. Opt. Soc. Am.*, **27**, 294–299 (1937).

***MacAdam 1942**

David L. MacAdam, "Visual Sensitivities to Color Differences in Daylight," *J. Opt. Soc. Am.*, **32**, 247–274 (1942).

***MacAdam 1943**

David L. MacAdam, "Specification of Small Chromaticity Differences," *J. Opt. Soc. Am.*, **33**, 18–26 (1943).

MacAdam 1957

David L. MacAdam, "Analytical Approximations for Color Metric Coefficients," *J. Opt. Soc. Am.*, **47**, 268–274 (1957).

***MacAdam 1965**

David L. MacAdam, "Color Measurement and Tolerances," *Off. Dig.* **37**, 1487–1531 (1965); errata, *J. Paint Technol.*, **38**, 70 (1966).

***MacAdam 1974**

David L. MacAdam, "Uniform Color Scales," *J. Opt. Soc. Am.*, **64**, 1619–1702 (1974).

MacAdam 1978

David L. MacAdam, "Colorimetric Data for Samples of OSA Uniform Color Scales," *J. Opt. Soc. Am.*, **68**, 121–130 (1978).

***MacAdam 1979**

David L. MacAdam, editor, *Contributions to Color Science by Deane B. Judd*, National Bureau of Standards Special Publication 545, U.S. Government Printing Office, Washington, D.C., 1979.

Macbeth

Macbeth, A Division of Kollmorgen Corporation, Little Britain Road, Post Office Drawer 950, Newburgh, New York 12550.

***Mackinney 1962**

Gordon Mackinney and Angela C. Little, *Color of Foods*, AVI Publishing Co., Westport, Connecticut, 1962.

Maerz 1930

A. Maerz and M. Rea Paul, *A Dictionary of Color*, McGraw-Hill Book Company, New York, 1930.

Marcus 1975

Robert T. Marcus and Fred W. Billmeyer, Jr., "Step Size in the Munsell Color Order System by Pair Comparison Near 5Y 7.5/1 and Bisections Near 10R 7/8," *J. Opt. Soc. Am.*, **65**, 208–212 (1975).

Marcus 1978a

Robert T. Marcus, "Long-Term Repeatability of Color-Measuring Instrumentation: Storing Numerical Standards," *Color Res. Appl.*, **3**, 29–33 (1978).

Marcus 1978b

Robert T. Marcus, "Determining Dimensioned Values of Kubelka-Munk Scattering and Absorption Coefficients," *Color Res. Appl.*, **3**, 183–187 (1978).

Marshall 1968

W. J. Marshall and D. Tough, "Color Measurements and Colour Tolerance in Relation to Automation and Instrumentation in Textile Dyeing," *J. Soc. Dyers Col-*

our., **84,** 108–119 (1968).

McClure 1968

A. McClure, J. Thomson, and J. Tannahill, "The Identification of Pigments," *J. Oil Colour Chem. Assoc.,* **51,** 580–635 (1968).

McDonald 1980

Roderick McDonald, "Industrial Pass/Fail Colour Matching. Part I—Preparation of Visual Colour-Matching Data," *J. Soc. Dyers Colourists* **96,** 372–376 (1980); "Part II—Methods of Fitting Tolerance Ellipsoids," *ibid.,* pp. 418–433; "Part III—Development of Pass/Fail Formula for use with Instrumental Measurement of Colour Difference," *ibid.,* pp. 486–495.

McGinnis 1967

Paul H. McGinnis, Jr., "Spectrophotometric Color Matching with the Least Squares Technique," *Color Eng.,* **5** (6), 22–27 (1967).

***McLaren 1970**

K. McLaren, "The Adams-Nickerson Colour-Difference Formula," *J. Soc. Dyers Colour.,* **86,** 354–366 (1970).

McLaren 1980

Keith McLaren, "CIELAB Hue-Angle Anomalies at Low Tristimulus Ratios," *Color Res. Appl.,* **5,** 139–143 (1980).

***McLean 1969**

Earle R. McLean, "A Millman's Use of the Computer," *Text. Chem. Color.* **1,** 192–197 (1969).

McNicholas 1928

H. J. McNicholas, "Equipment for Routine Spectral Transmission and Reflectance Measurements," *J. Res. Natl. Bur. Stand.,* **1,** 793–857 (1928).

Middleton 1953

W. E. Knowles Middleton, "Comparison of Colorimetric Results from a Normal-Diffuse Spectrophotometer with Those from a 45-Degree-Normal Colorimeter for Semiglossy Specimens," *J. Opt. Soc. Am.,* **43,** 1141–1143 (1953).

Mie 1908

G. Mie, "Beiträge zur Optik trüber Medien, speziell kolloidalen Metallösungen" (in German), *Ann. Phys.,* **25,** 377–445 (1908).

Modern Plastics Encyclopedia

Joan Agranoff, editor, *Modern Plastics Encyclopedia,* McGraw-Hill Book Company, New York, annually.

Moll 1960

I. S. Moll, "Aspects of Pigment Dispersion related to Usage," *J. Soc. Dyers Colour.,* **76,** 141–150 (1960).

Moon 1943

Parry Moon and Domina Eberle Spencer, "A Metric for Colorspace," *J. Opt. Soc. Am.,* **33,** 260–269 (1943); "A Metric Based on the Composite Color Stimulus," *J. Opt. Soc. Am.,* **33,** 270–277 (1943).

Morley 1975

Dorothy I. Morley, Ruth Munn, and Fred W. Billmeyer, Jr., "Small and Moderate Colour Differences. II. The Morley Data," *J. Soc. Dyers Colour.,* **91,** 229–242 (1975); see also Dorothy I. Morley, Ruth Munn Rich, and Fred W. Billmeyer, Jr., *J. Soc. Dyers Colour.,* **93,** 459–460 (1977).

Mudgett 1971

P. S. Mudgett and L. W. Richards, "Multiple Scattering Calculations for Technology," *Appl. Opt.,* **10,** 1485–1502 (1971).

Mudgett 1972

P. S. Mudgett and L. Willard Richards, "Multiple Scattering Calculations for Technology. II," *J. Colloid Interface Sci.* **39,** 551–567 (1972).

Mudgett 1973

P. S. Mudgett and L. Willard Richards, "Kubelka-Munk Scattering and Absorption Coefficients for Use with Glossy, Opaque Objects," *J. Paint Technol.,* **45,** No. 586, 43–53 (1973).

***Munsell 1929**

Munsell Book of Color, Munsell Color Co., Baltimore, Maryland, 1929 to date.

***Munsell 1963**

A. H. Munsell, *A Color Notation,* Munsell Color Co., Baltimore, Maryland, 1936–1963.

Munsell 1969

Albert H. Munsell, *A Grammar of Color* (1921), edited and with an introduction by Faber Birren, Van Nostrand-Reinhold, New York, 1969.

Nardi 1980

Michael A. Nardi, "Observer Metamerism in College-Age Students," *Color Res. Appl.,* **5,** 73 (1980).

NBS 1965

ISCC-NBS Color Name Charts Illustrated with Centroid Colors, Standard Reference Material No. 2106, National Bureau of Standards, Washington, D.C., 1965. Available with Kelly 1976 as Standard Reference Material No. 2107.

***NCCA**

Technical Section Committee on Color, *Visual Examples of Measured Color Differences,* National Coil

Coaters Association, 1900 Arch Street, Philadelphia, Pennsylvania 19103, undated.

Nemcsics 1980

Antal Nemcsics, "The Coloroid Color System," *Color Res. Appl.,* **5,** 113–120 (1980).

*Newhall 1943

Sidney M. Newhall, Dorothy Nickerson and Deane B. Judd, "Final Report of the O.S.A. Subcommittee on the Spacing of the Munsell Colors," *J. Opt. Soc. Am.,* **33,** 385–418 (1943).

Newhall 1957

S. M. Newhall, R. W. Burnham, and Joyce R. Clark, "Comparison of Successive with Simultaneous Color Matching," *J. Opt. Soc. Am.,* **47,** 43–56 (1957).

*Newton 1730

Sir Isaac Newton, *OPTICKS, or a Treatise of the Reflections, Refractions, Inflections & Colours of Light* (Reprint based on the 4th edition, London 1730), Dover Publications, New York, 1952.

Nickerson 1936

Dorothy Nickerson, "The Specification of Color Tolerances," *Text. Res.,* **6,** 505–514 (1936).

*Nickerson 1940

Dorothy Nickerson, "History of the Munsell Color System and Its Scientific Application," J. Opt. Soc. Am., **30,** 575–580 (1940); reprinted in *Color Res. Appl.,* **1,** 69–77 (1976).

*Nickerson 1944

Dorothy Nickerson and Keith F. Stultz, "Color Tolerance Specification," *J. Opt. Soc. Am.,* **34,** 550–570 (1944).

Nickerson 1950a

Dorothy Nickerson, "Munsell Renotations Used to Study Color Space of Hunter and Adams," *J. Opt. Soc. Am.,* **40,** 85–88 (1950).

Nickerson 1950b

Dorothy Nickerson, "Tables for Use in Computing Small Color Differences," *Am. Dyest. Rep.,* **39,** 541–549 (1950).

*Nickerson 1957

Dorothy Nickerson, *Color Measurement and Its Application to the Grading of Agricultural Products,* U.S. Dept. of Agriculture Misc. Publ. 580, U.S. Government Printing Office, Washington, D.C., 1957.

*Nickerson 1963

Dorothy Nickerson, "History of the Munsell Color

System," *Color Eng.,* **7,** (5), 42–51 (1963); reprinted in *Color Res. Appl.,* **1,** 121–130 (1976).

Nickerson 1978

Dorothy Nickerson, "Munsell Renotations for Samples of OSA Uniform Color Scales," *J. Opt. Soc. Am.,* **68,** 1343–1347 (1978).

*Nickerson 1981

Dorothy Nickerson, "OSA Uniform Color Scales Samples—A Unique Set," *Color Res. Appl.,* **6,** 7–33 (1981).

Nimeroff 1962

I. Nimeroff, Joan R. Rosenblatt, and Mary C. Dannemiller, "Variability of Spectral Tristimulus Values," *J. Opt. Soc. Am.,* **52,** 685–691 (1962).

Nimeroff 1965

I. Nimeroff and J. A. Yurow, "Degree of Metamerism," *J. Opt. Soc. Am.,* **55,** 185–190 (1965).

Oehlcke 1954

C. R. M. Oehlcke, "The Use of Organic Colouring Matters in Plastics," *J. Soc. Dyers Colour.,* **70,** 137–145 (1954).

Ohta 1971

Noboru Ohta, "The Color Gamut Available by the Combination of Subtractive Color Dyes. I. Actual Dyes in Color Film. (1) Optimum Peak Wavelengths and Breadths of Cyan, Magenta, and Yellow," *Photogr. Sci. Eng.,* **15,** 399–415 (1971).

Ohta 1972a

Noboru Ohta, "Minimizing Maximum Error in Matching Spectral Absorption Curves in Color Photography," *Photogr. Sci. Eng.* **16,** 296–299 (1972).

Ohta 1972b

Noboru Ohta and H. Urabe, "Spectral Color Matching by Means of Minimax Approximation," *Appl. Opt.,* **11,** 2551–2553 (1972).

OSA

Optical Society of America, 1816 Jefferson Place, Washington, D.C., 20036.

*OSA 1953

Optical Society of America, Committee on Colorimetry, *The Science of Color,* Thomas Y. Crowell Co., New York 1953. Reprinted by the Optical Society of America, 1963.

*OSA 1977

Optical Society of America, *Uniformly Spaced Color Samples,* Washington, D.C., 1977.

Osmer 1979

Dennis Osmer and Reinhold W. Bartsch, "Assessing Pigment Strength," *Plast. Compd.,* **2,** No. 6, 38–50 (1979).

Ostwald 1931

Wilhelm Ostwald, *Colour Science* (authorized Translation with an Introduction and Notes by J. Scott Taylor). Part I, "Colour Theory and Colour Standardization" (1931); Part II, "Applied Colour Science" (1933); Winsor and Newton, Ltd., London, England.

Ostwald 1969

Wilhelm Ostwald, *The Color Primer,* [translated and] edited and with a foreword and evaluation by Faber Birren, Van Nostrand-Reinhold, New York, 1969.

Park 1944

R. H. Park and E. I. Stearns, "Spectrophotometric Formulation," *J. Opt. Soc. Am.,* **34,** 112–113 (1944).

Paterson 1900

David Paterson, *The Science of Colour Mixing,* Scott, Greenwood and Co., London, 1900.

*Patton 1973

Temple C. Patton, editor, *Pigments Handbook,* Vol. I, "Properties and Economics," Vol. II, "Applications and Markets," Vol. III, "Characterization and Physical Relationships," John Wiley & Sons, New York, 1973.

*Peacock 1953

W. H. Peacock, *The Practical Art of Color Matching,* American Cyanamid Co., Bound Brook, New Jersey, 1953.

Phillips 1976

Daniel G. Phillips and Fred W. Billmeyer, Jr., "Predicting Reflectance and Color of Paint Films by Kubelka-Munk Analysis. IV. Kubelka-Munk Scattering Coefficient," *J. Coatings Technol.,* **48,** No. 616, 30–36 (1976).

Pivovonski 1961

Mark Pivovonski and Max T. Nagel, *Tables of Blackbody Radiation Functions,* Macmillan, New York, 1961.

Pointer 1973

M. R. Pointer, "The Effect of White Light Adaptation on Colour Discrimination," in *Colour 73,* Adam Hilger, London, 1973, pp. 283–286.

*Pointer 1980

M. R. Pointer, "The Gamut of Real Surface Colours," *Color Res. Appl.,* **5,** 145–155 (1980).

Priest 1920

I. G. Priest, K. S. Gibson, and J. J. McNicholas, "An Examination of the Munsell Color System. I. Spectral and Total Reflection and the Munsell Scale of Value," *Technol. Pap. Bur. Stand.* No. 167, Washington, D.C., 1920.

Priest 1935

Irwin G. Priest, "The Priest-Lange Reflectometer Applied to Nearly White Porcelain Enamels," *J. Res. Natl. Bur. Stand.,* **15,** 529–550 (1935).

Pritchard 1952

B. S. Pritchard and E. I. Stearns, "Dye Control with the *R*-Cam and Ruler," *J. Opt. Soc. Am.,* **42,** 752–753 (1952); **73,** 212 (1953).

Rattee 1965

I. D. Rattee, "Discovery or Invention?" *J. Soc. Dyers Colour.,* **81,** 145–150 (1965).

Reilly 1963

Charles D. Reilly, unpublished, 1963, cited in Gunter Wyszecki, "Recent Agreements Reached by the Colorimetry Committee of the Commission Internationale de l'Eclairage," *J. Opt. Soc. Am.,* **58,** 290–292 (1968).

Rheinboldt 1960

W. C. Rheinboldt and J. P. Menard, "Mechanized Conversion of Colorimetric Data to Munsell Renotations," *J. Opt. Soc. Am.,* **50,** 802–807 (1960).

Rich 1975

Ruth M. Rich, Fred W. Billmeyer, Jr., and William G. Howe, "Method for Deriving Color-Difference-Perceptibility Ellipses for Surface-Color Samples," *J. Opt. Soc. Am.,* **65,** 956–959, 1389 (1975).

Rich 1979

Danny C. Rich and Fred W. Billmeyer, Jr., "Practical Aspects of Current Color-Measurement Instrumentation for Coatings Technology," *J. Coatings Technol.,* **51,** No. 650, 45–47 (1979).

*Richards 1970

L. Willard Richards, "Calculation of the Optical Performance of Paint Films," *J. Paint Technol.,* **42,** 276–286 (1970).

Richter 1955

Manfred Richter, "The Official German Standard Color Chart," *J. Opt. Soc. Am.,* **45,** 223–226 (1955).

*Richter 1980

Klaus Richter, "Cube-Root Color Spaces and Chromatic Adaptation," *Color Res. Appl.,* **5,** 25–43 (1980).

Ridgway 1912

Robert Ridgway, *Color Standards and Color Nomenclature,* published by the author, Washington, D.C., 1912.

*Robertson 1977

Alan R. Robertson, "The CIE 1976 Color-Difference Formulae," *Color Res. Appl.*, **2**, 7–11 (1977).

*Robertson 1978

Alan R. Robertson, "CIE Guidelines for Coordinated Research on Colour-Difference Evaluation," *Color Res. Appl.*, **3**, 149–151 (1978).

Rodrigues 1980

Allan B. J. Rodrigues and Ralph Besnoy, "What is Metamerism?," *Color Res. Appl.*, **5**, 220–221 (1980).

Rösch 1929

Siegfried Rösch, "Darstellung der Farbenlehre für die Zwecke des Mineralogen" (in German), *Fortsch. Mineral., Kristallogr., Petrogr.*, **13**, 73–234 (1929).

Rosenthal 1976

Peter Rosenthal, "The Chemistry and Application of Reactive Dyes—A Literature Review, Sept 1971–July 1975," *Rev. Prog. Coloration*, **7**, 23–43 (1976).

Ross 1971

William D. Ross, "Theoretical Computation of Light-Scattering Power: Comparison Between TiO_2 and Air Bubbles," *J. Paint Technol.*, **43**, No. 563, 49–66 (1971).

Rounds 1969

Roger L. Rounds, "A Color System for Absorption Spectroscopy," *Text. Chem. Color.*, **1**, 297–300 (1969).

Rushton 1962

W. A. H. Rushton, *Visual Pigments in Man*, Liverpool University Press, 1962.

*Saltzman 1963a

Max Saltzman, "Colored Organic Pigments: Why So Many? Why So Few?," *Off. Dig.*, **35**, 245–258 (1963).

Saltzman 1963b

Max Saltzman, "Color as an Engineering Material," *SPE J.*, **19**, 476–479 (1963).

Saltzman 1965

Max Saltzman and A. M. Keay, "Variables in the Measurement of Color Samples," *Color Eng.*, **3**, No. 5, 14–19 (1965).

Saltzman 1967

Max Saltzman and A. M. Keay, "Colorant Identification," *J. Paint Technol.*, **39**, 360–367 (1967).

Saltzman 1976

Max Saltzman, "Computer Color Matching—A View from Retirement," *Color Res. Appl.*, **1**, 167–169 (1976).

*Saunderson 1942

J. L. Saunderson, "Calculation of the Color of Pigmented Plastics," *J. Opt. Soc. Am.*, **32**, 727–736 (1942).

*Saunderson 1946

J. L. Saunderson and B. I. Milner, "Modified Chromatic Value Color Space," *J. Opt. Soc. Am.*, **36**, 36–42 (1946).

Schlaeppi 1974

Fernand Schlaeppi, "Part One: International Colorfastness Test Methods," *Text. Chem. Color.*, **6**, 117–124 (1974); "Part Two: International Colorfastness Test Methods," *Text. Chem. Color.*, **6**, 141–147 (1974).

Schultz 1931

Ludwig Lehmann, *Farbstofftabellen von Gustav Schultz* (in German), 7th edition, Akademische Verlagsgesellschaft M. B. H., Leipzig, Vol. 1, 1931, Supplement 1934; Vol. II, 1932; Supplement 1939.

*SDC and AATCC 1971, 1976

Society of Dyers and Colourists, *Colour Index*, 3rd edition and revised 3rd edition, Vols. 1–6, The Society of Dyers and Colourists, Bradford, England, and the American Association of Textile Chemists and Colorists, Research Triangle Park, North Carolina, 1971, 1976.

*Simon 1958

F. T. Simon and W. J. Goodwin, "Rapid Graphical Computation of Small Color Differences," *Am. Dyest. Rep.*, **47**, No. 4, 105–112 (1958).

Simon 1961

Frederick T. Simon, "Small Color Difference Computation and Control," *Farbe*, **10**, 225–234 (1961).

Simpson 1963

J. E. Simpson, *Coloring Plastics*, Color Division, Ferro Corporation, Cleveland, Ohio, 1963.

*Smith 1954

F. M. Smith and D. M. Stead, "The Meaning and Assessment of Light Fastness in Relation to Pigments," *J. Oil Colour Chem. Assoc.*, **37**, 117–130 (1954).

Smith 1962

F. M. Smith, "An Introduction to Organic Pigments," *J. Soc. Dyers Colour.*, **78**, 222–231 (1962).

Smith 1963

Daniel Smith, "Visual Color Evaluation: Lighting and the Observer," *Am. Dyest. Rep.*, **53**, P207–P209, P213 (1963).

SPE

Society of Plastics Engineers, Color and Appearance Division, 656 West Putnam Avenue, Greenwich, Connecticut 06830.

Stanziola 1979

Ralph Stanziola, Boris Momiroff, and Henry Hemmendinger, "The Spectro Sensor—A New Generation Spectrophotometer," *Color Res. Appl.*, **4**, 157–163 (1979).

Stearns 1944

E. I. Stearns, "Spectrophotometry and the Colorist," *Am. Dyest. Rep.*, **33**, 1–6, 16–20 (1944).

***Stearns 1969**

Edwin I. Stearns, *The Practice of Absorption Spectroscopy*, Wiley-Interscience, John Wiley & Sons, New York, 1969.

Stearns 1975

E. I. Stearns, "Weights for Calculation of Tristimulus Values," *Clemson Rev. Ind. Manage. Text. Sci.*, **14**, No. 1, 79–113 (1975).

Stearns 1976

Edwin I. Stearns, "Where Instrumental Color Matching Is Today," *Color Res. Appl*, **1**, 169–173 (1976).

Strahler 1965

Arthur N. Strahler, *Introduction to Physical Geography*, John Wiley & Sons, New York, 1965.

Strocka 1970

Dietrich Strocka and Andreas Brockes, "Comparison of the CIE (1931) 2° and the CIE (1964) 10° Colorimetric Standard Observers with Individual Observers in the Assessment of Metameric Matches," in Manfred Richter, editor, *Color 69*, Musterschmidt, Göttingen, 1970, pp. 785–792.

Syme 1814

Patrick Syme, *Werner's Nomenclature of Colours*, James Ballantyne and Co., Edinburgh, 1814.

TAPPI

Technical Association of the Pulp and Paper Industry, One Dunwoody Park, Atlanta, Georgia 30338.

Thornton 1972a

W. A. Thornton, "Color-Discrimination Index," *J. Opt. Soc. Am.*, **62**, 191–194 (1972).

Thornton 1972b

W. A. Thornton, "Three-Color Visual Response," *J. Opt. Soc. Am.*, **62**, 457–459 (1972).

Thurner 1965

Karl Thurner, *Colorimetry in Textile Dyeing—Theory and Practice*, Badische Anilin- & Soda-Fabrik AG, Ludwigshafen am Rhein, Germany, 1965.

USNC-CIE

United States National Committee, CIE, c/o National Bureau of Standards, Washington, D.C., 20234.

Veal 1980

Douglas C. Veal, "Information Retrieval in Colour Chemistry," *J. Soc. Dyers Colour.*, **96**, 46–51 (1980).

***Venkataraman 1952–1978**

K. Venkataraman, editor, *The Chemistry of Synthetic Dyes*, Vols. I–VIII, Academic Press, New York, 1952–1978.

Venkataraman 1977

K. Venkataraman, *The Analytical Chemistry of Synthetic Dyes*, John Wiley & Sons, New York, 1977.

***Vesce 1956**

Vincent C. Vesce, "Vivid Light Fast Organic Pigments," *Off. Dig.*, **28**, Part 2, 1–48 (1956).

***Vesce 1959**

Vincent C. Vesce, "Exposure Studies of Organic Pigments in Paint Systems," *Off. Dig.*, **31**, Part 2, 1–143 (1959).

***Vickerstaff 1949**

T. Vickerstaff and D. Tough, "The Quantitative Measure of Lightfastness," *J. Soc. Dyers Colour.*, **65**, 606–612 (1949).

Völz 1962

Hans G. Völz, "Ein Beitrag zur phänomenologischen Theorie licht-streuender und -absorbierender Medien" (in German), Congrès FATIPEC **VI**, 98–103 (1962).

Völz 1964

Hans G. Völz, "Ein Beitrag zur phänomenologischen Theorie licht-streuender und -absorbierender Medien. Teil II; Möglichkeiten zur experimentellen Bestimmung der Konstanten" (in German), Congrès FATIPEC **VII**, 194–201 (1964).

***Vos 1972**

J. J. Vos, L. F. C. Friele, and P. L. Walraven, editors, *Color Metrics*, AIC/Holland, Soesterberg, The Netherlands, 1972.

Vos 1978

J. J. Vos, "Colorimetric and Photometric Properties of a 2° Fundamental Observer," *Color Res. Appl.*, **3**, 125–128 (1978).

Walton 1959

William W. Walton and James I. Hoffman, "Principles and Methods of Sampling," Chapter 4 in I. M. Kolthoff, Philip J. Elving and Ernest B. Sandell, editors, *Treatise on Analytical Chemistry*, Vol. 1, Interscience, New York, 1959, Part I, pp. 67–97.

Wardell 1969

Dwight L. Wardell, "Eyes Right: The Tests for Color Matching," *Am. Dyest. Rep.*, **58** (13), 17–22 (1969).

Warschewski 1980

Dirk Warschewski and Michael P. Brungs, "A Compact Computer Programme for the Specification of Dominant Wavelength and Purity," *Color Res. Appl.,* **5,** 173–174 (1980).

Wasserman 1978

Gerald S. Wasserman, *Color Vision: An Historical Approach,* John Wiley & Sons, New York, 1978.

Webber 1976

Thomas G. Webber, "Colorants for Plastics: The Buyer-Seller Dialogue," *Color Res. Appl.,* **1,** 51–52 (1976).

Webber 1979

Thomas G. Webber, editor, *Coloring of Plastics,* John Wiley & Sons, New York, 1979.

Webster 1961

Webster's Third New International Dictionary—Unabridged, G. and C. Merriam Co., Springfield, Massachusetts, 1961.

Wegmann 1960

J. Wegmann, "Effect of Structure on the Change in Colour of Vat Dyes on Soaping," *J. Soc. Dyers Colour.,* **76,** 282–300 (1960).

White 1960

G. S. J. White, "How Much Research? A Critical Problem in the Manufacture of Textile Dyes," *J. Soc. Dyers Colour.,* **76,** 16–22 (1960).

***Wich 1977**

Emil Wich, "The Colour Index," *Color Res. Appl.,* **2,** 77–80 (1977).

Wickstrom 1972

Warren A. Wickstrom, "On-Line Color Measurement and Control: State of the Art," *TAPPI,* **55,** 1558–1591 (1972).

Winey 1978

Ray K. Winey, "Computer Color Matching with the Aid of Visual Techniques," *Color Res. Appl.,* **3,** 165–167 (1978).

Wood 1917

Robert William Wood, *How to Tell the Birds from the Flowers and Other Woodcuts* (reprint of the original edition, Dodd, Mead and Co., New York, 1917), Dover Publications, New York, 1959.

Wright 1941

W. D. Wright, "The Sensitivity of the Eye to Small Colour Differences," *Proc. Phys. Soc. (Lond.),* **53,** 93–112 (1941).

Wright 1946

W. D. Wright, *Researches on Normal and Defective Colour Vision,* Kimpton, London, 1946.

Wright 1959

W. D. Wright, "Color Standards in Commerce and Industry," *J. Opt. Soc. Am.,* **49,** 384–388 (1959).

***Wright 1969**

W. D. Wright, *The Measurement of Colour,* 4th edition, Van Nostrand, New York, 1969.

Wyszecki 1963

Günter Wyszecki, "Proposal for a New Color-Difference Formula," *J. Opt. Soc. Am.,* **53,** 1318–1319 (1963).

***Wyszecki 1967**

Gunter Wyszecki and W. S. Stiles, *Color Science—Concepts and Methods, Quantitative Data and Formulas,* John Wiley & Sons, New York, 1967.

***Wyszecki 1970**

Gunter Wyszecki, "Development of New CIE Standard Sources for Colorimetry," *Farbe,* **19,** 43–76 (1970).

Wyszecki 1971

G. Wyszecki and G. H. Fielder, "New Color-Matching Ellipses," *J. Opt. Soc. Am.,* **61,** 1135–1152 (1971).

Wyszecki 1972

Gunter Wyszecki, "Recent Developments on Color-Difference Evaluations," in J. J. Vos, L. F. C. Friele, and P. L. Walraven, editors, *Color Metrics,* AIC/Holland, Soesterberg, The Netherlands, 1972, pp. 339–379.

Yule 1967

John A. C. Yule, *Principles of Color Reproduction,* John Wiley & Sons, New York, 1967.

Zeller 1979

Robert Charles Zeller and Henry Hemmendinger, "Evaluation of Color-Difference Equations: A New Approach," *Color Res. Appl.,* **4,** 71–77 (1979).

Author Index

Except in Chapter 7, Annotated Bibliography, coauthors are not named in the text, but they are cited in this index. For example, the entry "Dannemiller, M. C., 72(Nimeroff 1962)" means that M. C. Dannemiller is one of the coauthors whose work is referred to on page 72 by the words "Nimeroff 1962." The full citation may be found in the Bibliography (Pages 213–230) under the citation "Nimeroff 1962."

Subject Index